The Open Work

The Open Work

Umberto Eco

Translated by Anna Cancogni

With an Introduction
by David Robey

HARVARD UNIVERSITY PRESS

Cambridge, Massachusetts · 1989

Chapters 1, 2, 3, 4, 5, and 6 are from *Opera aperta;* Chapters 9 and 10 are
from *Apocalittici e integrati* and *La struttura assente,* respectively; © Gruppo
Editoriale Fabbri, Bompiani, Sonzogno, Etas S.p.A., Milan, © 1962, 1964,
and 1968, respectively. Chapter 7 is from *Lettere italiane;* Chapter 8, from *La
definizione dell'arte;* they appear here in English translation by arrangement
with the author. Chapter 11 is from *Quindici.* The English translations of
Chapters 1 and 11 are by Bruce Merry and are reprinted with the permis-
sion of *Twentieth-Century Studies.*

This book is printed on acid-free paper, and its binding materials have
been chosen for strength and durability.

Library of Congress Cataloging-in-Publication Data

Eco, Umberto.
 [Opera aperta. English]
 The open work / Umberto Eco; translated by Anna Cancogni: with an introduction
by David Robey.
 p. cm.
Translation of: Opera aperta.
 Bibliography: p.
 Includes index.
 ISBN 0-674-63975-8 (alk. paper)
 ISBN 0-674-63976-6 (pbk.: alk. paper)
 1. Aesthetics. 2. Poetry. 3. Semiotics. 4. Joyce, James, 1882–1941—Criticism and in-
terpretation. 5. Wiener, Norbert, 1894–1964. I. Title.
BH39.E2913 1989 88–21399
111'.85—dc19 CIP

Contents

Introduction

by David Robey

Umberto Eco's first published book was the dissertation he wrote at the University of Turin, on problems of aesthetics in the work of Saint Thomas Aquinas.[1] His first novel, published twenty-four years later in 1980, continues this early interest in the high Middle Ages. As so many readers of *The Name of the Rose* can testify, few, if any, works of fiction have brought the cultural and intellectual world of this period, or of any other period, so successfully to life. But medieval studies have been only a minor if persistent interest in Eco's work as a whole. Since he wrote his dissertation, his remarkable energies have been mainly directed at the problems and issues of the present: modern art and modern culture, mass communications, and the discipline of semiotics.

This book collects for the first time in English Eco's major "pre-semiotic" writings on modern literature and art—writings, that is, which predate the publication in 1968 of his first semiotic or semiological book (the terms "semiotics" and "semiology" can be used interchangeably), *La struttura assente* (The absent structure). Most of them are taken from one or more of the many editions of

1. *Il problema estetico in San Tommaso* (Turin, 1956); now revised by the author and recently translated into English as *The Aesthetics of Thomas Aquinas* (Cambridge, Mass.: Harvard University Press, 1988). Much of this introduction appeared in my chapter on Umberto Eco in M. Caesar and P. Hainsworth, eds., *Writers and Society in Contemporary Italy* (Leamington Spa, England: Berg Publishers, 1984), pp. 63–87. Readers are referred to this volume for further information on the literary context of Eco's writing, and especially to the chapter by C. Wagstaff, "The Neo-Avantgarde." I am grateful to the publishers for permission to reprint parts of my chapter here. Some of the material was also previously published in the *Times Higher Education Supplement*.

Opera aperta (The open work), published in 1962, the first of Eco's books on a modern topic and the work with which he made his name in Italy. Two chapters of the present volume were originally written after Eco's conversion to semiotics. The first, "The Death of the Gruppo 63," is included here because it deals with an artistic movement with which Eco became closely associated immediately after the publication of *Opera aperta*. The other, "Series and Structure," is of particular interest because it deals with the relationship between the poetics of the "open work" and the structuralist theory which was the starting point of Eco's semiotics.

Since *Opera aperta* first appeared, Eco's thinking has developed in a great many ways. But, as we shall see, there is a substantial and striking continuity between his early and his later writings. More important in the present connection, there is a great deal in *Opera aperta* and in Eco's writings of the same period that has not been superseded in his subsequent development, and that remains of considerable relevance and interest. *Opera aperta* in particular is still a significant work, both on account of the enduring historical usefulness of its concept of "openness," and because of the striking way in which it anticipates two of the major themes of contemporary literary theory from the mid-sixties onward: the insistence on the element of multiplicity, plurality, or polysemy in art, and the emphasis on the role of the reader, on literary interpretation and response as an interactive process between reader and text. The questions the book raises, and the answers it gives, are very much part of the continuing contemporary debate on literature, art, and culture in general.

Opera aperta is a polemical book, in marked conflict with the Crocean aesthetics that dominated the Italian academic world in the early sixties. There are a great many references to Croce in the chapters that follow, testifying to the strength of his philosophical influence on thinkers of Eco's generation; indeed, the hegemony Croce exercised over Italian intellectual life throughout the Fascist period and for the first two postwar decades is probably without parallel in modern European history. The problematic concept of pure intuition/expression, which constitutes the foundation of Crocean aesthetics, is something we need not consider here, but some of the consequences it entails are worth recalling if we want

to understand *Opera aperta* in its original context.[2] Art for Croce was a purely mental phenomenon that could be communicated directly from the mind of the artist to that of the reader, viewer, or listener. The intuition/expression which constituted the essence of the work of art was thus an unchanging entity; it also necessarily possessed unity, which Croce tended to speak of as a dominant lyrical feeling or sentiment. The material medium of the artistic work was of no real significance; it merely served as a stimulus to enable the reader to reproduce in him- or herself the artist's original intuition. Equally, the material historical circumstances in which the artist lived, the artist's biography, the artist's intentions—all were irrelevant to the proper understanding of the work, since they were the concern of human faculties quite distinct from those that generated artistic expression. To all of these principles, *Opera aperta* is completely and radically opposed.

Opera aperta arose partly out of Eco's work on general questions of aesthetics, which was strongly influenced by the anti-Crocean, though still idealist, philosophy of his mentor at the University of Turin, Luigi Pareyson, the subject of Chapter 7 (unless otherwise specified, references to chapters and pages are to those in the present volume). But the immediate stimulus for writing it came from his contacts with avant-garde artists, together with his study of the work of James Joyce, a writer in whom he had a particular personal interest. In fact, the book has the air of a theoretical manifesto for certain kinds of avant-garde art; for the Gruppo 63 (see Chapter 11), which was formed in the year after its publication and of which Eco himself became a member, it effectively served as such.

In *Opera aperta* the idea of the open work serves to explain and justify the apparently radical difference in character between modern and traditional art. The idea is illustrated in its most extreme form by what Eco calls "works in motion" (*opere in movimento*); he cites (Chapter 1) the aleatory music of Stockhausen, Berio, and Pousseur, Calder's mobiles, and Mallarmé's *Livre*. What such works have in common is the artist's decision to leave the arrangement of some of their constituents either to the public or to chance, thus giving them not a single definitive order but a multiplicity of

2. For an introduction to Croce's work, see his *Breviario di estetica* (Bari: Laterza, 1951; orig. pub. 1913), tr. as *The Essence of Aesthetic* (London: Heinemann, 1921).

possible orders; if Mallarmé had ever finished his *Livre,* for instance, the reader would have been left, at least up to a point, to arrange its pages for him- or herself in a variety of different sequences. Works of this kind are for the most part of recent origin, evidently, and even today are very much the exception rather than the rule. Eco's point, however, is that the intention behind them is fundamentally similar to the intention behind a great deal of modern art since the Symbolist movement at the end of the nineteenth century.

Traditional or "classical" art, Eco argues, was in an essential sense unambiguous. It could give rise to various responses, but its nature was such as to channel these responses in a particular direction; for readers, viewers, and listeners there was in general only one way of understanding what a text was about, what a painting or sculpture stood for, what the tune was of a piece of music. Much modern art, on the other hand, is deliberately and systematically ambiguous. A text like *Finnegans Wake,* for Eco the exemplary modern open work, cannot be said to be about a particular subject; a great variety of potential meanings coexist in it, and none can be said to be the main or dominant one. The text presents the reader with a "field" of possibilities and leaves it in large part to him or her to decide what approach to take. The same can be said, Eco argues, of many other modern texts that are less radically avant-garde than the *Wake*—for instance, Symbolist poems, Brecht's plays, Kafka's novels.

This is where the analogy with works like Mallarmé's *Livre* obtains: just as Mallarmé's reader would have arranged the pages of the book in a number of different sequences, so the reader of the *Wake* perceives a number of different patterns of meaning in Joyce's language. In the *Livre* it is the material form that is open, whereas in the *Wake* it is the semantic content; but in each case, according to Eco, the reader is in substantially the same position, because in each case he or she moves freely amid a multiplicity of different interpretations. The same analogy obtains, he argues, between abstract visual art and mobiles; and between the aleatory music of Stockhausen, Berio, or Pousseur and the serial music of a composer like Webern (see particularly Chapter 10). All these characteristically modern forms of art are said by Eco to mark a radical shift in the relationship between artist and public, by requiring of the public a

much greater degree of collaboration and personal involvement than was ever required by the traditional art of the past.

The deliberate and systematic ambiguity of the open work is associated by Eco with a well-known feature of modern art, namely its high degree of formal innovation. Ambiguity, for Eco, is the product of the contravention of established conventions of expression: the less conventional forms of expression are, the more scope they allow for interpretation and therefore the more ambiguous they can be said to be. In traditional art, contraventions occurred only within very definite limits, and forms of expression remained substantially conventional; its ambiguity, therefore, was of a clearly circumscribed kind. In the modern open work, on the other hand, the contravention of conventions is far more radical, and it is this that gives it its very high degree of ambiguity; since ordinary rules of expression no longer apply, the scope for interpretation becomes enormous. Moreover, conventional forms of expression convey conventional meanings, and conventional meanings are parts of a conventional view of the world. Thus, according to Eco, traditional art confirms conventional views of the world, whereas the modern open work implicitly denies them.

"Ambiguity" is one term used by Eco to represent the effect of formal innovation in art. Another is "information"; Chapter 3 below deals with the connection between the mathematical theory of information and the idea of openness. What interests Eco about this theory, in brief, is the principle that the information (as opposed to the "meaning") of a message is in inverse proportion to its probability or predictability. This suggests to him a parallel between the concept of information and the effect of art, particularly modern art, since the forms of art can be said to possess a high degree of improbability or unpredictability by virtue of their contravention of established conventions of expression. Thus, Eco argues, art in general may be seen as conveying a much higher degree of information, though not necessarily a higher degree of meaning, than more conventional kinds of communication; and the modern open work may be seen as conveying an exceptionally high degree of information, because of the radical contraventions of established conventions that characterize it. Eco's interest in information theory was clearly one of the factors that led him shortly afterward to the study of semiotics. (Readers may notice that in the present

volume, Eco's chapter "Openness, Information, Communication" contains, as does the preceding chapter, a number of structuralist or semiotic arguments. These were inserted by Eco in later editions of *Opera aperta*.)

Opera aperta thus proposes an equation between the degree of openness, the degree of information, the degree of ambiguity, and the degree of contravention of conventions in a work, an equation which serves to distinguish traditional and modern art from one another, but which does not in itself tell us anything about the distinction between art and nonart or good art and bad, since the contravention of conventions and the consequent proliferation of possibilities of interpretation are not in themselves a guarantee of artistic value. To distinguish good art from bad, Eco takes over from Pareyson's aesthetics of "formativity" the concept of organic form, which for him as for Pareyson is closely allied to that of artistic intention. Thus he argues, first, that the contravention of conventions in modern art must, if it is to be aesthetically successful, produce "controlled disorder" (Chapter 3), the "organic fusion of multiple elements" (Chapter 4). Second, the interpretation of the modern open work is far from entirely free; a formative intention is manifest in every work, and this intention must be a determining factor in the interpretive process. For all its openness, the work nonetheless directs the public's response; there are right ways and wrong ways, for instance, of reading *Finnegans Wake*.

The concepts of organic form and artistic intention are important qualifications of Eco's notion of openness, but it must be said that they are qualifications of a somewhat problematic and elusive kind, as modern literary theory has shown. How does one distinguish between organic and nonorganic or "failed" form, especially in a work characterized by a multiplicity of different meanings? How does one identify, especially in a work of this kind, the "intentions implicitly manifested" by the author (Chapter 4), and why in any case should one's interpretation be bound by them? Eco gives no real answer to the latter questions. He gives a partial and not wholly satisfactory answer to the first in his discussion (Chapter 2) on the analysis of poetic language, which, drawing on *The Meaning of Meaning* by Ogden and Richards, the work of the American New Critics, and the theories of the semiotician C. W. Morris, explains the structure of poetic language in terms of an "iconic" function, a

special union of sound and sense; but the explanation seems to cre-
ate more problems than it resolves. We shall return to this answer,
and to these questions, in connection with his later work.

Such difficulties are not, of course, serious grounds for objecting
to the thesis of *Opera aperta*. As Eco emphasized in the preface to
the second edition,[3] the book is more concerned with the aims of
certain kinds of art than with their success or failure, with questions
of poetics (*poetica:* a work's artistic purpose) rather than aesthetics.
This claim is anticipated in the essay "Two Hypotheses about the
Death of Art," written in 1962 and now Chapter 8 below. Here Eco
argues that questions of poetics are central to the discussion of all
modern works of art, although their treatment needs to be comple-
mented by acts of aesthetic judgment (in connection with which he
once again invokes Pareyson's theory of formativity). This insis-
tence on the importance of poetics is a major part of Eco's, and
many of his contemporaries', polemic against the then dominant
"aesthetic criticism" inspired by Croce, for whom the act of aes-
thetic judgment was the essential task of the critic, and questions of
poetics of second-order interest.

Nevertheless, much of the impetus of *Opera aperta* derives from
its conception of the special function or effect of the modern open
work in relation to the world in which we live, and this conception
depends to a large extent on Eco's (and Pareyson's) general aesthetic
theory. The conception is most fully developed in an essay pub-
lished shortly after the book appeared, reprinted in subsequent edi-
tions (for example, the second), and now Chapter 6 below: "Form
as Social Commitment" ("Del modo di formare come impegno
sulla realtà"). This essay was written for the journal *Il Menabò*,
apparently at the suggestion of its editor, the prominent socialist
novelist Elio Vittorini, and appeared in the second of two issues on
the relationship between literature and industry; it represents a
viewpoint quite closely allied to Vittorini's own. Even more than
the first edition of *Opera aperta* it has the character of a manifesto
for certain kinds of avant-garde art, by virtue of the conviction it
expresses, characteristic of the Gruppo 63 and of Vittorini, about
avant-garde art's special political function.

In this essay, as in *Opera aperta*, Eco argues that the modern open

3. *Opera aperta,* 2nd ed. (Milan: Bompiani, 1972), p. 8.

work represents through its formal properties a characteristically modern experience of the world. Like all art, it is an "epistemological metaphor": not only does it reflect aspects of modern philosophy (phenomenology, Pareyson's aesthetics) and modern science (the theory of relativity, mathematical information theory), but what is equally important, through its lack of conventional sense and order, it represents by analogy the feeling of senselessness, disorder, "discontinuity" that the modern world generates in all of us. Thus, although open works are not the only kind of art to be produced in our time, they are the only kind that is appropriate to it; the conventional sense and order of traditional art reflect an experience of the world wholly different from ours, and we deceive ourselves if we try to make this sense and order our own.

What, then, do we gain from art forms that reflect what can only seem a negative aspect of the world in which we live? Eco's essay answers this question through a discussion of the concept of alienation, in which he outlines a position that has remained characteristic of all his activity as an intellectual. In one sense alienation is both necessary and desirable, in that we can say that we are alienated *to* something other than ourselves, and therefore lose full possession of ourselves, whenever we become involved in it. Losing possession of ourselves is not something to be lamented; it is simply part of the back-and-forth movement between self and the world that is the condition of a truly human existence. What we must do is accept our involvement in things other than ourselves, and at the same time assert our selfhood in the face of the world by actively seeking to understand it and transform it. Art, Eco argues, can contribute significantly to this process of understanding and transforming the world, because its function is essentially cognitive. "Art knows the world through its own formative structures," he proposes (Chapter 6), referring to the aesthetics of Pareyson once again. Art represents the world—or more exactly our experience of the world—through the way it organizes its constituents (the *modo di formare*) rather than through what the constituents themselves represent. This representation is a type of knowledge by virtue of the element of organic form: "Where a form is realized there is a conscious operation on an amorphous material that has been brought under human control" (Chapter 6). Thus, the modern open work is a form of knowledge of the world in which we

live, insofar as it constitutes a bringing to consciousness of the nature of the contemporary "crisis." As Eco said in the first preface to *Opera aperta,* contemporary art seeks a solution to this crisis by offering us a "new way of seeing, feeling, understanding, and accepting a universe in which traditional relationships have been shattered and new possibilities of relationship are being laboriously sketched out."[4] Art is therefore political in its own special way; it produces new knowledge that can serve as a basis for changing the world, but it does not necessarily have an explicitly political content.

Together with "Form as Social Commitment," *Opera aperta* contains, if sometimes only in germ, features that are fundamental to Eco's later semiotic theory: the notion of the special function of art; the sense of living in an age of instability and crisis; the theme of the senselessness and disorder of the modern experience of the world; and at the same time the emphasis on awareness, involvement, and the need for change. The book's style of thought has remained characteristic as well: a taste for broad, synthesizing generalizations, and a consequent tendency to stress the similarities between concepts and phenomena at the expense of the differences, and on occasion to neglect local problems in the interests of the overall view. In a more specific, personal, and paradoxical way, also, *Opera aperta* looks forward to Eco's shift of interest to semiotics. A large section of the first edition consists of a discussion of the poetics (*poetica*) of James Joyce, which was removed from subsequent editions to be published separately.[5] As well as providing further illustration of the main theme of *Opera aperta,* this discussion points to a clear analogy between Joyce's artistic development, as Eco sees it, and Eco's own personal history. What interests him in Joyce is the novelist's move from a Catholic, Thomist position to the disordered, decentered, anarchic vision of life that seems to characterize *Ulysses* and *Finnegans Wake.* Yet Eco also finds in Joyce's mature work a degree of persistence of his youthful faith, a nostalgia for the ordered world of medieval thought that is most notably expressed in the system of symbolic correspondences

4. *Opera aperta* (Milan: Bompiani, 1962), p. 9.
5. Now published in English as a companion to the present volume: Umberto Eco, *The Aesthetics of Chaosmos: The Middle Ages of James Joyce* (Cambridge, Mass.: Harvard University Press, 1989).

underlying the surface chaos of *Ulysses; Ulysses,* he suggests, is a "reverse [Thomist] *summa*" (*The Aesthetics of Chaosmos,* Chapter 2). Similarly, as he himself tells us, when Eco began working on his doctoral thesis, he did so in a "spirit of adherence to the religious world of Thomas Aquinas," a spirit which he then lost as he worked on it (*The Aesthetics of Thomas Aquinas,* p. i). Yet a nostalgia for the ordered world of medieval thought seems to have remained with him as well, expressing itself not only in occasional excursions to the Middle Ages, culminating with *The Name of the Rose,* but also, much more indirectly, in his interest in semiotics. For Eco's semiotic theory has an ordered, comprehensive, rationalist, architectural character that also bears comparison with that of the Thomist *summae,* though with at least one radical qualification: whereas Saint Thomas's system is metaphysical, Eco's very definitely is not; as we shall see, the urge to system and order is displaced by him from the sphere of being to that of method alone.

But between *Opera aperta* and Eco's first major semiotic text there came another book which pursued a line of interest that has since constituted an important part of Eco's activities: the study of mass culture and the mass media. Chapter 9 below ("The Structure of Bad Taste") is an excerpt from it. Published in 1964, the book had as its title *Apocalittici e integrati* (Apocalyptic and integrated [intellectuals]), the two terms standing for two opposite attitudes to the mass media and their effect on contemporary culture: the apocalyptic view that culture has been irredeemably debased by the mass media, and that the only proper way to treat these is to disregard them; and the wholly positive view of those who are so well integrated in the modern world that they see the nature and effect of the mass media as necessary and even desirable. Eco's own view lies between these two extremes. The mass media, he argues, are such an important feature of modern society as to require the serious attention of intellectuals, and, far from being a necessarily negative influence, they are to be welcomed for providing universal access to cultural experiences previously restricted to an elite. They are not to be accepted as they are, however; the intellectual's task is to analyze their nature and effect and to seek actively to transform them, by criticizing their deleterious features and pointing the way to the improvement of their cultural content.

What this means in practice is shown by the discussion in *Apoca-*

littici e integrati of such things as comic strips, pop songs, and television programs, a discussion which is supplemented by two essays, published the following year, on Eugène Sue's *Mystères de Paris* and on the James Bond novels of Ian Fleming.[6] The main purpose of these essays and of the discussion of specific mass media in the book is to lay bare the ideological implications of different forms of popular entertainment, particularly, in the case of the comic strips and the novels, the relationship between ideology and narrative structures. From the analysis a distinct set of common themes emerges. The kind of entertainment that Eco criticizes, as did Vittorini, is that which is consolatory, in the sense of reaffirming the public's sense of the essential rightness and permanence of the world in which they live. The great fault of the mass media, for Eco, is to convey a standardized, oversimplified, static, and complacent vision that masks the real complexity of things and implicitly denies the possibility of change.

There is nothing intrinsically wrong, Eco suggests, with pure popular entertainment; all of us feel the need to read a James Bond novel or listen to pop music from time to time. The problem is that for most people *bad* popular entertainment has come to be a major part of their cultural experience, and its effect has been to exercise a strongly reactionary influence. The solution, therefore, is not to raise popular entertainment to the level of art—Eco is not saying that the public should be fed on a diet of modern open works—but to work for forms of entertainment that are "honest." This means, on the one hand, entertainment that does not have false artistic pretensions; the concept of Kitsch is discussed at some length in *Apocalittici e integrati*, in the chapter translated below, and is defined as nonart that aspires to artistic status by borrowing devices from true artworks, devices that automatically cease to be artistic when they are used outside their original "organic" context. On the other hand, what is more important, "honest" entertainment is that which is ideologically sound, not in the sense of propagating the dogma of a political party, but by virtue of more widely acceptable qualities: because it acknowledges the complexity, the problematic

6. Now in *Il superuomo di massa* (Milan: Bompiani, 1978), pp. 27–67 and 145–184; and translated into English in *The Role of the Reader: Explorations in the Semiotics of Texts* (Bloomington, Ind.: Indiana University Press, 1979).

character of the historical circumstances in which we live, because it allows for the possibility of change and serves as a stimulus to reflection and criticism, because it generates a sense of independence and choice instead of conformism and passivity.

This should help make clear what kind of political commitment Eco expresses in his writings. The emphasis on change, the hostility to conformism and conservatism must mark him as a man of the left. Yet however he personally may vote, there is no recognizably party-political element in his books. This is partly because his intellectual task, as he conceives it, is cultural rather than narrowly political, but more because his values are broadly democratic rather than specifically socialist or communist. In particular, as a writer, he has always kept his distance from the Italian Communist Party. *Opera aperta,* with its insistence on the special function of the modern open work, was in conflict with the view of art at that time favored by the Party. In *Apocalittici e integrati* the emphasis on criticism, debate, and the complexity of things also seems implicitly opposed to the Party line, at least at that period. Eco particularly favors the television discussion program "Tribuna Politica" as a form of "education for democracy" that helped viewers become aware of the "relative" character of politicians' opinions (*Apocalittici e integrati,* p. 351); and in his analysis of the Bond novels (*The Role of the Reader,* p. 162) he argues that the "democratic" man is the one who "recognizes nuances and distinctions and who admits contradictions." Finally, the themes of disorder and incomprehensibility in *Opera aperta,* and the arguments about the limitations of systematic worldviews in his later semiotic works again tend to set him apart from mainstream Marxist ideas. Marxism has been an important influence on Eco's thinking, but this relativism and individualism are major qualifications of his left-wing position.

Eco's shift of interest to semiotics began as he was supervising the translation of *Opera aperta* into French. He was introduced to the structuralism of Jakobson and Lévi-Strauss,[7] and as a result revised sections of the book along structuralist lines (Chapters 2 and 3 below), as has already been mentioned. This contact with structuralist thought was the main source of Eco's semiotics or semiology, and in particular of his first major semiotic work, *La struttura*

7. *Opera aperta,* 3rd ed. (Milan: Bompiani, 1976), pp. v–vii.

assente (The absent structure), an "introduction to semiological research," according to the subtitle.[8] This was followed by two less substantial theoretical texts,[9] and, in 1976, by Eco's most advanced and systematic semiotic work so far, which incorporates and elaborates most of his previous thinking on the subject: *A Theory of Semiotics,* written originally in English and then translated into Italian.[10] This was in turn supplemented by the essays collected in *Semiotics and the Philosophy of Language.*[11]

In discussing Eco's semiotic theory I shall have to treat it as a single system, even though there are important developments from one book to the next. In a general way, however, we can note a difference of emphasis between the earlier and the later semiotic works that seems to reflect something of a shift in Eco's interests and concerns after *La struttura assente* was written. Whereas the earlier book shows much the same polemical and socially committed character that we saw in *Opera aperta* and *Apocalittici e integrati,* such a character is much less apparent in *A Theory of Semiotics.* This is not to say that Eco has abandoned his earlier view of the intellectual's task, but simply that a clearer separation of functions has come to govern his writing: in his journalism he pursues the line of attack mapped out in *Apocalittici e integrati,* but his theoretical work becomes much more specialized and academic. Eco himself says something to this effect in his preface to *The Name of the Rose* (p. 5),[12] though it is not certain to what extent he is really speaking in his own person; around 1968, he suggests, it was widely held that one should write "only out of a commitment to the present, in order to change the world," whereas now, in 1980, "the man of letters . . . can happily write out of pure love of writing."

This element of specialization and academicism in Eco's writing in the 1970s must to some extent be a consequence of his increasing

8. Milan: Bompiani, 1968.

9. *Le forme del contenuto* [The forms of content] (Milan: Bompiani, 1971); *Segno* [The sign] (Milan: ISEDI, 1973).

10. *A Theory of Semiotics* (Bloomington, Ind.: Indiana University Press, and London: Macmillan, 1976). In Italian, *Trattato di semiotica generale* (Milan: Bompiani, 1975).

11. Bloomington, Ind.: Indiana University Press, 1984.

12. *Il nome della rosa* (Milan: Bompiani, 1980). Translated as *The Name of the Rose* (San Diego, Calif.: Harcourt Brace Jovanovich, and London: Secker and Warburg, 1983). Page references are to the London edition.

institutional commitment to semiotics as a discipline—founding
and editing the semiotic journal called *VS,* acting as secretary-
general of the International Association for Semiotic Studies, and
occupying the first chair of semiotics at the University of Bologna.
But it is also interesting to relate it to the political events of 1968
and the consequent dissolution of the Gruppo 63. Eco himself tells,
in his article of 1972 on "The Death of the Gruppo 63" (Chapter 11
below), how the 1968 workers' and students' movements had an
outflanking effect on the group's, and Eco's own, position concern-
ing the artist's duty to attack the social system indirectly, through
the aesthetic medium, rather than by direct political action. In
1968, according to Eco, artists and intellectuals were confronted,
for the first time in years, with the opportunity and challenge to
involve themselves directly in politics, an opportunity and chal-
lenge which the Gruppo 63 failed to take up, thereby bringing
about its own demise. One effect of this crisis on Eco, it would
seem, was to reduce his polemical insistence on the special political
function of art, though his new interest in semiotics no doubt con-
tributed to the same effect. It is noteworthy, however, that Eco's
response does not seem to have taken the form of a more direct
involvement in political affairs, at least in his main writings, and
that he seems to have moved, if anything, in quite the opposite
direction. There may be, in the new specialization and academicism
of his theoretical work, signs of a degree of post-1968 disillusion-
ment.

To turn now to semiotics, what sort of subject is it, and what can a
theory of it do? Semiotics or semiology is the science of signs, and
Eco's theory has been mainly concerned with what he calls general
semiotics, the general theory of signs. All forms of social, cultural,
and intellectual life can be viewed as sign systems: as forms of com-
munication, and therefore as verbal or nonverbal languages. The
task of general semiotics, for Eco, is to develop a single, compre-
hensive conceptual framework within which all these sign systems
may be studied, not because they are all fundamentally identical but
because a systematic and coherent approach has intrinsic merits,
and because such an approach facilitates cross-fertilization between
the different fields that it covers. Thus, *A Theory of Semiotics* is not
principally concerned with the specific features of these different

fields, but concentrates instead on proposing a theory of signs, or "sign functions," and a related theory of codes that can be applied to all of them. Eco's conception of his subject is avowedly imperialistic; semiotics is proposed as a master discipline which will eventually unite into a single theoretical framework all the different branches of study concerned with culture in the broadest sense.

In its all-embracing, systematic character Eco's general semiotics has more than a little in common, as noted above, with the philosophical system of Thomas Aquinas, the subject of his doctoral thesis. But a major difference between Eco's theory and most philosophical or scientific systems is his distinctive insistence that the theory makes no claim to represent the real nature of things. It is here that we can see the most conspicuous and important connection with *Opera aperta* and its theme of the disorder, instability, and essential incomprehensibility of the modern world. The theme lies behind the title and much of the argument of *La struttura assente* which, while taking over many of the fundamentals of structuralist thought, contains a vigorous criticism of the French structuralism of the sixties—which Eco himself compares (*The Aesthetics of Thomas Aquinas*, p. v) to Thomist thought—for what he calls its "ontological" rather than "methodological" character: its conviction that the ordered systems it describes are the systems of the world, a conviction illustrated in its most extreme form in Lévi-Strauss's belief that structural analysis serves ultimately to reveal the perennial laws governing the working of the human mind. Eco maintains that structures are "methodological" in that they are provisional, hypothetical products of the mind, and at most only partially reflect the essential nature of things. The ultimate truth, the structure behind all structures, is permanently absent, beyond our intellectual grasp. The chapter below entitled "Series and Structure," which is taken from *La struttura assente*, illustrates this aspect of Eco's thinking, showing very clearly how his theory of the open work is carried over into his semiotics and gives it much of its distinctive character.

One of the most interesting features of Eco's semiotic theory is this association of order and disorder, of a rationalist explanatory structure with the conviction that nothing, finally, can ever be explained. In a general way it seems to lie behind the broad eclecticism of his approach, his distinctive combination of Continental

and Anglo-Saxon theoretical sources, and in particular the extensive use he has made of the work of the American philosopher C. S. Peirce, whose current vogue must be due in large part to Eco's interest in him. More particularly, the association has determined three central concepts in Eco's theory, the first and last of which derive from Peirce: *unlimited semiosis, encyclopedia,* and *abduction.* The principle of unlimited semiosis is, Eco argues, vital to the constitution of semiotics as an academic discipline. According to this principle, the meaning of any sign, both verbal and nonverbal, can be seen only as another sign or signs—its "interpretant(s)," in Peirce's terminology—whose meaning, in turn, can be seen only as yet another sign or signs, and so on ad infinitum. Meaning is an infinite regress within a closed sphere, a sort of parallel universe related in various ways to the "real" world but not directly connected to it; there is no immediate contact between the world of signs and the world of the things they refer to. Eco thus frees the study of signs from involvement with the study of their "real" referents, and lays the foundations for an autonomous science of semiotics by justifying the analysis of sign systems in terms specific to them, without interference, at least in the first instance, from other branches of knowledge.

The principle of unlimited semiosis thus has much in common with the Saussurean axiom that meaning is the product of structure and with the structuralist semantic theories derived from this axiom. Its advantage for Eco is that it avoids the connotations of stability and organization that the concept of structure carries with it, and makes greater allowance for the shifting, elusive nature of our knowledge of the world. For the same sort of reasons, Eco now prefers the notion of encyclopedia to the structuralist notion of code, to stand for the knowledge or competence that allows people to use signs to communicate—though, as we shall see, codes nevertheless figure largely in much of his semiotic theory. The notion of code implies a view of this competence as a set of one-to-one, dictionary-like equivalences between expression and content, signifier and signified. In contrast, the encyclopedia, as Eco conceives it, is much more complex and variable; it is like a net, a rhizome—a tangled clump of bulbs and tubers—or a labyrinth, a vast aggregation of units of meaning among which an infinite variety of connections can be made.

With the notion of code, communication becomes simply a matter of recognizing the one-to-one equivalences. With that of encyclopedia, it becomes a matter of tracing out one of all the possible paths that can be taken through the network, rhizome, or labyrinth, and it is for this process that Eco uses Peirce's term "abduction." The example par excellence of abduction is the act of criminal detection. Eco's argument is that, just as the detective finds the author of a crime by postulating certain rules concerning the connections between human motives and actions and physical events, so in the normal processes of communication we find the meaning of a sign by postulating certain rules concerning the relationship between that sign and others. Both cases involve finding one's way through the labyrinth; in the latter case the rule may be more regularly applied (it may be "overcoded"), but the difference is one only of degree, not of kind. All forms of communication, interpretation, and understanding are by their nature, for Eco, tentative and hazardous acts of inference.

What has been said so far about Eco's semiotics may make it sound abstruse and unworldly. But it must be emphasized, first of all, that Eco is not denying that we use signs to refer to the real world, and still less is he denying that the real world exists; he is simply maintaining, with the structuralists, that sign systems are grids which we impose upon reality and in this sense preexist any use to which they may be put. Moreover, to view them in this way certainly does not entail cutting semiotics off from history. For Eco there are two vital ways in which semiotics and the historical process are integrally connected. On the one hand, viewing the structures of sign systems as methodological rather than ontological in character entails accepting our description of them not only as hypothetical and provisional, but also as the product of history, and subject to negation by history, as is argued in the chapter "Series and Structure." By this means, Eco meets the objection of a-historicity with which Marxists have often attacked structuralist thought, and constructs a semiotic theory at least partially reconcilable with Marxist historicism. On the other hand, semiotics is itself an instrument of intervention in the historical process, a powerful practical tool for cultural, social, and potentially political change. This is a further element of continuity with *Opera aperta* and *Apocalittici e integrati,* and their insistence on social engagement.

Since Eco has told us that his interest in semiotics arose out of his work on art in *Opera aperta*,[13] and since this interest is also closely connected to his work on mass communications in *Apocalittici e integrati*, what changes did his new theoretical framework bring to the ideas of the earlier books? Although his new interests broadened Eco's horizons considerably, it is notable that the subjects of art and mass communications occupy almost half the pages of *La struttura assente*, and could still be said to be a central, if less prominent, object of attention in *A Theory of Semiotics* as well. To begin with the theory of art, it is perhaps surprising how many of the aesthetic principles of *Opera aperta* remain in the later works. In *A Theory of Semiotics*, as in *Opera aperta*, Eco maintains that art produces an essential effect of ambiguity through the contravention of conventions of expression, but that such contraventions are properly artistic only if they are part of a specifically aesthetic form. What the later work does, first, is express these ideas in more wideranging theoretical terms; like all other forms of cultural activity, the production and consumption of art is seen as governed by codes, and it is the violation of these codes that is said to be the source of the effect of ambiguity. This new formulation opens the way to a different conception of the function of art; whereas in *Opera aperta* the function was said to be essentially cognitive, in the later books it is explained according to the structuralist principle that the effect of the violation of codes in a work of art is to focus attention first on the structure of the work itself, then on the codes which the work employs, and finally on the relationship between the codes and reality, thus generating in the reader or viewer a renovated perception of him - or herself and the world.

In *A Theory of Semiotics*, also, Eco argues that in art the violation of codes occurs according to a specific structural pattern, a pattern which is said to be the distinguishing feature of artistic form, and replaces the much vaguer notion of "organic" properties in *Opera aperta*. There Eco had argued that the language of poetry is distinguished by its "iconic" properties, a special relationship between sound and sense. Extending and developing this notion, he now suggests that all kinds of art are characterized by what he calls a "super-system of homologous structural relationships" (p. 271);

13. *Lector in fabula* (Milan: Bompiani, 1979), p. 8.

that is, a code is violated not just at one level of a work, but at all of its levels, and between these different violations there is a fundamental similarity of structure. This structural pattern constitutes what he calls the "aesthetic idiolect": just as the term "idiolect" is employed in linguistics to mean the language habits peculiar to an individual, so here it stands for the overall pattern of deviation, the "general deviational matrix" (p. 271) peculiar to and characteristic of each work of art.

The trouble is, of course, that it is very difficult to see how such a pattern might be realized in practice. It is true that there are numerous cases in literature in which the sound seems to be an echo to the sense (though not as many cases as sometimes is supposed), and stylistic analyses such as Leo Spitzer's have shown parallels between the meaning of texts and other levels of expression, for instance syntax. But to suggest, as Eco does, that there is a multiple set of correspondences in all works of art, beginning from their physical substance—to which Eco attaches special importance: in art, matter is "rendered semiotically interesting" (p. 266)—and proceeding down to the various aspects of their content, seems to require a good deal of clarification and empirical verification, neither of which has been adequately provided in any of Eco's works.

The continuity in Eco's aesthetic theory between his earlier and his more recent books also testifies to the continuing influence of Pareyson. For the notion of aesthetic idiolect is not only a revision of Pareyson's notion of organic form but is also strikingly reminiscent of his insistence that it is the "modo di formare," or style, that constitutes the aesthetic essence of any work of art. In another respect as well Eco has remained faithful to Pareyson's principles: in his view that the intention implicit in a work must be the determining factor in its interpretation, a view which in *A Theory of Semiotics* is asserted but not seriously discussed, as in *Opera aperta,* except for the apparent suggestion—the point is far from clear—that it is the aesthetic idiolect by which the intention is manifested. Thus, on these two scores, as on others, *A Theory of Semiotics* shows not only a striking continuity with Eco's earlier work but also the same tendency which we noted in *Opera aperta* to develop broad generalizations at the expense of more specific problems; and in this case, as modern literary theory has shown, the problems are very much a matter of contemporary debate. Although the systematic character

of Eco's theory has a great deal of attraction, it is clear that a price has been paid for it.

Between them, *La struttura assente* and *A Theory of Semiotics* offer general models of the process of aesthetic communication and the structure of works of art. These models are supplemented by the more recent *Lector in fabula* (the title, meaning literally "The reader in the tale," is a pun on the Latin expression *lupus in fabula,* meaning "talk of the devil"), which is exclusively concerned with the process of reading narrative literature.[14] Here Eco stays within the framework of ideas developed in the previous semiotic works, but follows the move in much recent literary theory to a more detailed study of reader response, thus also continuing an important theme of *Opera aperta.* The book begins with an attack on the structuralism of the 1960s for its insistence on the intrinsic, "objective" properties of works of literary art. What is offered instead is the idea of interpretive cooperation between reader and text, a cooperation that brings into play, according to Eco, not unchanging universal structures of the mind but sets of presuppositions that vary with the passing of time. The main object of *Lector in fabula* is to develop general sets of categories that describe the process of interpretive cooperation, at the same time making due allowance for its provisional, historical character.

As I have said, the sense of the social and political role of art becomes much weaker in Eco's work after 1968. It is thus not in the sphere of aesthetics but in the study of mass communications that the social relevance of his semiotics is most apparent. For Eco, semiotic theories of meaning serve to expose the ideological (in the sense of false) nature of forms of persuasion, when these suppress parts of the meaning of signs and privilege others in order to further the purposes of specific interest groups, a process Eco terms "code switching." This process is one to which he attaches particular weight, and his discussion of it is one of the culminating points of *A Theory of Semiotics.* The "heuristic and practical power" of a semiotic theory lies in its ability to show how acts of communication can "respect or betray" the real complexity of the various sign

14. Ibid. This book is not the same as *The Role of the Reader,* which is a translation into English of a variety of earlier essays; it does however extend and develop the first chapter of the English book.

systems that constitute culture (p. 297). By describing the structure of these sign systems in their totality and the structure of the messages generated from them, semiotics can enable us to see how messages can manipulate and distort our knowledge of the world, and it is in this sense that it is a form of "social criticism" and "social practice"(p. 298). As Eco says in a note (p. 312), "Semiotics helps us to analyze different ideological choices; it does not help us to choose." It serves the cause of social and cultural awareness and provides a basis for political action, but it does not itself provide instructions as to the kind of political action one should take. Like his earlier work on mass communications, Eco's semiotics is associated with a democratic, pluralistic attitude to politics and culture. It means in particular a hostility to any fixed system of thought or belief, since any such system must necessarily misrepresent the real nature of our knowledge of the world.

It should be clear, therefore, that over and above a personal urge toward system there were powerful intellectual reasons of a much more specific kind for Eco's interest in semiotic theory. Semiotics provided him with concepts and principles that refined and expanded the ideas of his earlier works; it united them within a single theoretical framework giving an enviable sense of clarity, confidence, and purpose to the work of cultural criticism, which he regards as the intellectual's task. It is true that the claims Eco makes about semiotic theory's future academic role do seem rather inflated. Semiotics in general—and Eco's work in particular—has served an extremely valuable purpose by bringing to the different disciplines a greater awareness of the nature and scope of processes of communication, and by encouraging the interdisciplinary movement of ideas and methods. But Eco's imperialistic hope that most of the arts and social sciences will eventually be united within a comprehensive semiotic theory seems to ignore both the practical realities of the academic world, and the necessarily open-ended and approximative nature of theoretical work in many of these subjects. This last criticism, however, is directed more at Eco's conception of semiotic theory as a subject than at his conception of his own contribution to it. He believes far too strongly in the value of dissent and discussion, he has been far too actively engaged in the revision of his own past work, and he is far too aware of the limits of human knowledge, to regard the ideas he proposes as anything other than

tentative and provisional, as work-in-progress and as part of a continuing public debate.

I have so far concentrated on the theoretical side of Eco's writing. However, much of it has been very far from theoretical in character, although it has been to a significant extent inspired by his theoretical concerns. Four of his books[15] are collections of articles of a more or less journalistic kind, originally published in dailies or weeklies such as the *Corriere della Sera, Il Manifesto,* and *L'Espresso,* as well as in more intellectual or artistic periodicals like *Quindici* and *Il Verri.* Before he became famous as a novelist, Eco was already widely known in Italy as a journalist. Unlike the greater part of his theoretical writings, Eco's journalism is often extremely funny; indeed, humor is a property to which he attaches considerable importance. As well as a number of parodies, *Diario minimo* (1963) contains the well-known "Elogio di Franti" (In praise of Franti), written in 1962, a celebration of the villain of Edmondo De Amicis's sentimental and moralistic schoolboy novel *Cuore.* The infamous Franti, who respects nothing and laughs at everything including his dying mother, is a model of evil for De Amicis's schoolboy narrator, but for Eco his smile is better seen as a healthy assault on the dominant social and cultural order. Laughter, Eco says, is the "instrument with which the secret innovator places in doubt that which society holds to be good" (p. 94), and such an instrument is clearly, for Eco, an important one. This view of laughter underlies much of Eco's journalism, insofar as its humor or wit is usually directed at objects of a wholly serious kind, objects which for the most part belong to the areas of interest explored in his more academic studies.

Most of the articles in the three later journalistic collections were written between the mid-sixties and the early eighties, and can in a sense be described as practical extensions of Eco's semiotic theory. This is not to say that his arguments are conducted at a high level of theoretical sophistication, or that he draws to a conspicuous ex-

15. *Diario minimo* (Milan: Mondadori, 1963), *Il costume di casa* (Milan: Bompiani, 1973), *Dalla periferia dell'impero* (Milan: Bompiani, 1977), and *Sette anni di desiderio* (Milan: Bompiani, 1983). A selection of the work in these books has been published in English as *Travels in Hyperreality* (London: Picador, 1987), formerly *Faith in Fakes* (London: Secker and Warburg, 1986).

tent on scientific notions that he himself has elaborated; the theo-
retical work seems merely to have prescribed the area in which for
the most part he has worked as a journalist, and provides his jour-
nalism with certain simple general principles and simple conceptual
tools. Between them the later collections cover a wide variety of
topics, almost all of which are semiotic in the broad sense that they
concern modes of communication or signification. A number of
articles deal with aspects of modern art or Kitsch; others look at
forms of popular entertainment, political debates and criminal
cases, comics, films, advertising, the press, television and radio,
and various public events. All of them are highly topical, or were
when they were written, and all of them participate to a greater or
lesser extent in a common undertaking, what Eco calls (in *Il costume
di casa*, p. 251) the "clarification of the contemporary world." This
means analyzing the ideological implications of political, social,
and cultural products and events through a "critical, rational, and
conscious reading" of their meaning (*Dalla periferia dell'impero*, p.
235); laying bare the confusion, mystification, and manipulation to
which the contemporary public is subjected; inculcating in readers
a constant attitude of healthy suspicion (*diffidenza*). Eco sees him-
self engaged in a form of permanent semiological guerrilla warfare
(*Travels in Hyperreality*, pp. 135–144) against the mass media and
political power, in the cause of an open-minded, tolerant awareness
of the complexities, ambiguities, and nuances in life.

Eco's novel *The Name of the Rose* is a suitable topic on which to end
this introduction. The book cannot properly be termed an open
work—in his *Postscript* to it Eco describes it instead as "post-
modernistic"[16]—but it contains, in varying forms, most of the ma-
jor themes of his work, and shows very clearly how far the ideas
and concerns of his presemiotic writings have continued to deter-
mine his thinking. At the most obvious level it is a return to his
original medievalist interests. The measured succession of the mo-
nastic life he describes, the geometric layout of the buildings in
which it is set, and the striking image of the library, with its maze-
like structure and the initially incomprehensible but actually intri-

16. *Postscript to The Name of the Rose* (San Diego, Calif.: Harcourt Brace Jo-
vanovich, 1984).

cate and highly organized classification of its books, all can be seen as a nostalgic material correlative of the ordered system of medieval scholastic thought, which Eco initially adhered to and then abandoned early in his career. The connections between the novel and Eco's subsequent, more modern interests are less obvious but, to my mind, equally striking. I say "to my mind" especially because, even if the novel is not an open work, Eco nonetheless insists, in his *Postscript,* that it is capable of a number of interpretations, none of which should be regarded as definitive.

At the very start of Eco's *Postscript* the connection is made clear between the novel's title and the principle of unlimited semiosis, although the point is not spelled out. The reference to the rose in the Latin hexameter with which the narrative ends ("The former rose survives in its name; bare names are what we have") seems to assert for Eco the unbridgeable gap between the world of signs and the world of things. On the other hand, there is also, clearly, a contrast between the picture of instability, disorder, and incomprehensibility offered by Eco's view of semiotics in particular and knowledge in general, and the stable, ordered world of the monastery in which the story is set. Eco himself points out in the *Postscript* that the labyrinth of the monastery library is not the same as the rhizome-like labyrinth or net of the encyclopedia. Far from permitting an infinite variety of possible connections, it is a labyrinth through which there is only one path—a material image, we may take it, of the intellectual world of the books it contains and the monastic community it serves. We can read the burning down of the library at the end of the novel as anticipating, metaphorically, the final destruction of this world, already seriously threatened, as Eco's characters repeatedly observe, by the new culture of the cities and their secular universities.

To say that the Holmes-like William of Baskerville represents the modern world which replaces that of the monastery is to put it rather crudely; but he does display a striking acquaintance with semiotic theory (according to Eco's notes, Franciscan thought of the period shows considerable awareness of the nature of signs) as well as a characteristically modern view, as Eco sees it, of knowledge in general. Not only does he illustrate, through his acts of detection, the essential nature of all semiotic processes according to Eco; he also proposes a theory of detection strikingly similar to

Eco's and Peirce's, repeating verbatim passages from Eco's contribution to *The Sign of Three,* a recent collection of articles on Dupin (Poe's famous detective), Sherlock Holmes, and C. S. Peirce.[17] More generally, he seems to share Eco's view of the essentially unknowable nature of things and of the provisional, hypothetical nature of the structures we find in them.

"Relations," William says at one point in the novel, "are the ways in which my mind perceives the connections between single entities, but what is the guarantee that this is universal and stable?" (p. 207). This doubt is confirmed for him by his discovery, at the end of the book, that the series of murders was not the product of a single design drawn, as he had supposed, from the book of the Apocalypse, but was in large part determined by chance. "I behaved stubbornly," he says, "pursuing a semblance of order, when I should have known well that there is no order in the universe" (p. 492). His final advice to his pupil Adso of Melk, the narrator, is that the "order that our mind imagines is like a net, or like a ladder, built to attain something"; but—and here William quotes a Wittgensteinian "mystic" from Adso's homeland, Austria—"afterward you must throw the ladder away, because you discover that, even if it was useful, it was meaningless" (p. 492). Unlike his pupil and the rest of the characters in the book, William is aware, as Eco hints in the *Postscript,* that our knowledge of reality is a rhizome-like labyrinth and that no single path through it can be said to constitute the truth.

If William of Baskerville is only partially a semiotic theorist, he wholly shares the broad intellectual and political values that Eco's semiotics carries with it, and that have governed his work from *Opera aperta* onward. In the face of the conflict between the savagely oppressive representatives of the Papacy and the equally narrow and intolerant Franciscan mendicants, not to mention their outlaw offshoot, the revolutionary followers of the renegade Fra Dolcino (the Red Brigades of the fourteenth century), William's attitude is to agree with neither side but to see right and wrong in both, to make distinctions where others confuse issues and see similarities where others see utter opposition. Like Eco, he is a doubter by

17. Edited by Umberto Eco and Thomas A. Sebeok (Bloomington, Ind.: Indiana University Press, 1983).

principle who believes in democracy rather than oppression and in discussion rather than revelation, all in accordance with his theoretical recognition of the impossibility of certain knowledge. He dislikes purity, he says (in a phrase which, we learn from the *Postscript*, Eco is particularly proud of), because it acts in too much haste.

Like Eco, finally, William of Baskerville believes in the salutary power of laughter. As he eventually discovers, most of the murders were caused by the attempt of the blind monk Jorge of Burgos (a name not without reference to that of another writer with an interest in labyrinths) to keep concealed the lost second book of Aristotle's *Poetics*, which dealt with the subject of comedy. The danger lay in the book's potentially corrupting and subversive effect: it made laughter respectable. William's response is to argue a point that is wholly typical of Eco's view of his practical duty as an intellectual: "Perhaps the mission of those who love mankind is to make people laugh at the truth, *to make truth laugh,* because the only truth lies in learning to free ourselves from insane passion for the truth" (p. 491).

The Open Work

I

The Poetics of the Open Work

A number of recent pieces of instrumental music are linked by a common feature: the considerable autonomy left to the individual performer in the way he chooses to play the work. Thus, he is not merely free to interpret the composer's instructions following his own discretion (which in fact happens in traditional music), but he must impose his judgment on the form of the piece, as when he decides how long to hold a note or in what order to group the sounds: all this amounts to an act of improvised creation. Here are some of the best-known examples of the process.

1. In *Klavierstück XI,* by Karlheinz Stockhausen, the composer presents the performer a single large sheet of music paper with a series of note groupings. The performer then has to choose among these groupings, first for the one to start the piece and, next, for the successive units in the order in which he elects to weld them together. In this type of performance, the instrumentalist's freedom is a function of the "narrative" structure of the piece, which allows him to "mount" the sequence of musical units in the order he chooses.

2. In Luciano Berio's *Sequence for Solo Flute,* the composer presents the performer a text which predetermines the sequence and intensity of the sounds to be played. But the performer is free to choose how long to hold a note inside the fixed framework imposed on him, which in turn is established by the fixed pattern of the metronome's beat.

3. Henri Pousseur has offered the following description of his piece *Scambi:*

> *Scambi* is not so much a musical composition as a *field of possibilities,* an explicit invitation to exercise choice. It is made up of

sixteen sections. Each of these can be linked to any two others, without weakening the logical continuity of the musical process. Two of its sections, for example, are introduced by similar motifs (after which they evolve in divergent patterns); another pair of sections, on the contrary, tends to develop towards the same climax. Since the performer can start or finish with any one section, a considerable number of sequential permutations are made available to him. Furthermore, the two sections which begin on the same motif can be played simultaneously, so as to present a more complex structural polyphony. It is not out of the question that we conceive these formal notations as a marketable product: if they were tape-recorded and the purchaser had a sufficiently sophisticated reception apparatus, then the general public would be in a position to develop a private musical construct of its own and a new collective sensibility in matters of musical presentation and duration could emerge.

4. In Pierre Boulez's *Third Sonata for Piano,* the first section (*Antiphonie, Formant 1*) is made up of ten different pieces on ten corresponding sheets of music paper. These can be arranged in different sequences like a stack of filing cards, though not all possible permutations are permissible. The second part (*Formant 2, Thrope*) is made up of four parts with an internal circularity, so that the performer can commence with any one of them, linking it successively to the others until he comes round full circle. No major interpretative variants are permitted inside the various sections, but one of them, *Parenthèse,* opens with a prescribed time beat, which is followed by extensive pauses in which the beat is left to the player's discretion. A further prescriptive note is evinced by the composer's instructions on the manner of linking one piece to the next (for example, *sans retenir, enchaîner sans interruption,* and so on).

What is immediately striking in such cases is the macroscopic divergence between these forms of musical communication and the time-honored tradition of the classics. This difference can be formulated in elementary terms as follows: a classical composition, whether it be a Bach fugue, Verdi's *Aïda,* or Stravinsky's *Rite of Spring,* posits an assemblage of sound units which the composer arranged in a closed, well-defined manner before presenting it to

the listener. He converted his idea into conventional symbols which more or less oblige the eventual performer to reproduce the format devised by the composer himself, whereas the new musical works referred to above reject the definitive, concluded message and multiply the formal possibilities of the distribution of their elements. They appeal to the initiative of the individual performer, and hence they offer themselves not as finite works which prescribe specific repetition along given structural coordinates but as "open" works, which are brought to their conclusion by the performer at the same time as he experiences them on an aesthetic plane.[1]

To avoid any confusion in terminology, it is important to specify that here the definition of the "open work," despite its relevance in formulating a fresh dialectics between the work of art and its performer, still requires to be separated from other conventional applications of this term. Aesthetic theorists, for example, often have recourse to the notions of "completeness" and "openness" in connection with a given work of art. These two expressions refer to a standard situation of which we are all aware in our reception of a work of art: we see it as the end product of an author's effort to arrange a sequence of communicative effects in such a way that each individual addressee can refashion the original composition devised by the author. The addressee is bound to enter into an interplay of stimulus and response which depends on his unique capacity for sensitive reception of the piece. In this sense the author presents a finished product with the intention that this particular composition should be appreciated and received in the same form as he devised it. As he reacts to the play of stimuli and his own response to their patterning, the individual addressee is bound to supply his own existential credentials, the sense conditioning which is peculiarly his own, a defined culture, a set of tastes, personal inclinations, and prejudices. Thus, his comprehension of the original artifact is always modified by his particular and individual perspective. In fact, the form of the work of art gains its aesthetic validity precisely in proportion to the number of different perspectives from which it can be viewed and understood. These give it a wealth of different resonances and echoes without impairing its original essence; a road traffic sign, on the other hand, can be viewed in only one sense, and, if it is transfigured into some fantastic meaning by an imaginative driver, it merely ceases to be *that* particular traffic sign

with that particular meaning. A work of art, therefore, is a complete and *closed* form in its uniqueness as a balanced organic whole, while at the same time constituting an *open* product on account of its susceptibility to countless different interpretations which do not impinge on its unadulterable specificity. Hence, every reception of a work of art is both an *interpretation* and a *performance* of it, because in every reception the work takes on a fresh perspective for itself.

Nonetheless, it is obvious that works like those of Berio and Stockhausen are "open" in a far more tangible sense. In primitive terms we can say that they are quite literally "unfinished": the author seems to hand them on to the performer more or less like the components of a construction kit. He seems to be unconcerned about the manner of their eventual deployment. This is a loose and paradoxical interpretation of the phenomenon, but the most immediately striking aspect of these musical forms can lead to this kind of uncertainty, although the very fact of our uncertainty is itself a positive feature: it invites us to consider *why* the contemporary artist feels the need to work in this kind of direction, to try to work out what historical evolution of aesthetic sensibility led up to it and which factors in modern culture reinforced it. We are then in a position to surmise how these experiences should be viewed in the spectrum of a theoretical aesthetics.

Pousseur has observed that the poetics of the "open" work tends to encourage "acts of conscious freedom" on the part of the performer and place him at the focal point of a network of limitless interrelations, among which he chooses to set up his own form without being influenced by an external *necessity* which definitively prescribes the organization of the work in hand.[2] At this point one could object (with reference to the wider meaning of "openness" already introduced in this essay) that any work of art, even if it is not passed on to the addressee in an unfinished state, demands a free, inventive response, if only because it cannot really be appreciated unless the performer somehow reinvents it in psychological collaboration with the author himself. Yet this remark represents the theoretical perception of contemporary aesthetics, achieved only after painstaking consideration of the function of artistic performance; certainly an artist of a few centuries ago was far from being aware of these issues. Instead nowadays it is primarily the

artist who is aware of its implications. In fact, rather than submit to the "openness" as an inescapable element of artistic interpretation, he subsumes it into a positive aspect of his production, recasting the work so as to expose it to the maximum possible "opening."

The force of the subjective element in the interpretation of a work of art (any interpretation implies an interplay between the addressee and the work as an objective fact) was noticed by classical writers, especially when they set themselves to consider the figurative arts. In the *Sophist* Plato observes that painters suggest proportions not by following some objective canon but by judging them in relation to the angle from which they are seen by the observer. Vitruvius makes a distinction between "symmetry" and "eurhythmy," meaning by this latter term an adjustment of objective proportions to the requirements of a subjective vision. The scientific and practical development of the technique of perspective bears witness to the gradual maturation of this awareness of an interpretative subjectivity pitted against the work of art. Yet it is equally certain that this awareness has led to a tendency to operate against the "openness" of the work, to favor its "closing out." The various devices of perspective were just so many different concessions to the actual location of the observer in order to ensure that he looked at the figure in *the only possible right way*—that is, the way the author of the work had prescribed, by providing various visual devices for the observer's attention to focus on.

Let us consider another example. In the Middle Ages there grew up a theory of allegory which posited the possibility of reading the Scriptures (and eventually poetry, figurative arts) not just in the literal sense but also in three other senses: the moral, the allegorical, and the anagogical. This theory is well known from a passage in Dante, but its roots go back to Saint Paul ("videmus nunc per speculum in aenigmate, tunc autem facie ad faciem"), and it was developed by Saint Jerome, Augustine, Bede, Scotus Erigena, Hugh and Richard of Saint Victor, Alain of Lille, Bonaventure, Aquinas, and others in such a way as to represent a cardinal point of medieval poetics. A work in this sense is undoubtedly endowed with a measure of "openness." The reader of the text knows that every sentence and every trope is "open" to a multiplicity of meanings which he must hunt for and find. Indeed, according to how he feels at one particular moment, the reader might choose a possible interpreta-

tive key which strikes him as exemplary of this spiritual state. He will *use* the work according to the desired meaning (causing it to come alive again, somehow different from the way he viewed it at an earlier reading). However, in this type of operation, "openness" is far removed from meaning "indefiniteness" of communication, "infinite" possibilities of form, and complete freedom of reception. What in fact is made available is a range of rigidly preestablished and ordained interpretative solutions, and these never allow the reader to move outside the strict control of the author. Dante sums up the issue in his thirteenth Letter:

> We shall consider the following lines in order to make this type of treatment clearer: *In exitu Israel de Egypto, domus Jacob de populo barbaro, facta est Judea sanctificatio eius, Israel potestas eius.* Now if we just consider the literal meaning, what is meant here is the departure of the children of Israel from Egypt at the time of Moses. If we consider the allegory, what is meant is our human redemption through Christ. If we consider the moral sense, what is meant is the conversion of the soul from the torment and agony of sin to a state of grace. Finally, if we consider the anagogical sense, what is meant is the release of the spirit from the bondage of this corruption to the freedom of eternal glory.

It is obvious at this point that all available possibilities of interpretation have been exhausted. The reader can concentrate his attention on one sense rather than on another, in the limited space of this four-tiered sentence, but he must always follow rules that entail a rigid univocality. The meaning of allegorical figures and emblems which the medieval reader is likely to encounter is already prescribed by his encyclopedias, bestiaries, and lapidaries. Any symbolism is objectively defined and organized into a system. Underpinning this poetics of the necessary and the univocal is an ordered cosmos, a hierarchy of essences and laws which poetic discourse can clarify at several levels, but which each individual must understand in the only possible way, the one determined by the creative *logos*. The order of a work of art in this period is a mirror of imperial and theocratic society. The laws governing textual interpretation are the laws of an authoritarian regime which guide the indi-

vidual in his every action, prescribing the ends for him and offering him the means to attain them.

It is not that the *four* solutions of the allegorical passage are quantitatively more limited than the *many* possible solutions of a contemporary "open" work. As I shall try to show, it is a different vision of the world which lies under these different aesthetic experiences.

If we limit ourselves to a number of cursory historical glimpses, we can find one striking aspect of "openness" in the "open form" of Baroque. Here it is precisely the static and unquestionable definitiveness of the classical Renaissance form which is denied: the canons of space extended round a central axis, closed in by symmetrical lines and shut angles which cajole the eye toward the center in such a way as to suggest an idea of "essential" eternity rather than movement. Baroque form is dynamic; it tends to an indeterminacy of effect (in its play of solid and void, light and darkness, with its curvature, its broken surfaces, its widely diversified angles of inclination); it conveys the idea of space being progressively dilated. Its search for kinetic excitement and illusory effect leads to a situation where the plastic mass in the Baroque work of art never allows a privileged, definitive, frontal view; rather, it induces the spectator to shift his position continuously in order to see the work in constantly new aspects, as if it were in a state of perpetual transformation. Now if Baroque spirituality is to be seen as the first clear manifestation of modern culture and sensitivity, it is because here, for the first time, man opts out of the canon of authorized responses and finds that he is faced (both in art and in science) by a world in a fluid state which requires corresponding creativity on his part. The poetic treatises concerning *"maraviglia," "wit," "agudezas,"* and so on really strain to go further than their apparently Byzantine appearance: they seek to establish the new man's inventive role. He is no longer to see the work of art as an object which draws on given links with experience and which demands to be enjoyed; now he sees it as a potential mystery to be solved, a role to fulfill, a stimulus to quicken his imagination. Nonetheless, even these conclusions have been codified by modern criticism and organized into aesthetic canons. In fact, it would be rash to interpret Baroque poetics as a conscious theory of the "open work."

Between classicism and the Enlightenment, there developed a

further concept which is of interest to us in the present context. The concept of "pure poetry" gained currency for the very reason that general notions and abstract canons fell out of fashion, while the tradition of English empiricism increasingly argued in favor of the "freedom" of the poet and set the stage for the coming theories of creativity. From Burke's declarations about the emotional power of words, it was a short step to Novalis's view of the pure evocative power of poetry as an art of blurred sense and vague outlines. An idea is now held to be all the more original and stimulating insofar as it "allows for a greater interplay and mutual convergence of concepts, life-views, and attitudes. When a work offers a multitude of intentions, a plurality of meaning, and above all a wide variety of different ways of being understood and appreciated, then under these conditions we can only conclude that it is of vital interest and that it is a pure expression of personality."[3]

To close our consideration of the Romantic period, it will be useful to refer to the first occasion when a conscious poetics of the open work appears. The moment is late-nineteenth-century Symbolism; the text is Verlaine's *Art Poétique*:

> De la musique avant toute chose,
> et pour cela préfère l'impair
> plus vague et plus soluble dans l'air
> sans rien en lui qui pèse et qui pose.

> Music before everything else,
> and, to that end, prefer the uneven
> more vague and more soluble in air
> with nothing in it that is heavy or still.

Mallarmé's programmatic statement is even more explicit and pronounced in this context: "Nommer un objet c'est supprimer les trois quarts de la jouissance du poème, qui est faite du bonheur de deviner peu à peu: le suggérer . . . voilà le rêve" ("To name an object is to suppress three-fourths of the enjoyment of the poem, which is composed of the pleasure of guessing little by little: to suggest . . . there is the dream"). The important thing is to prevent a single sense from imposing itself at the very outset of the receptive process. Blank space surrounding a word, typographical adjustments, and spatial composition in the page setting of the poetic

text—all contribute to create a halo of indefiniteness and to make the text pregnant with infinite suggestive possibilities.

This search for *suggestiveness* is a deliberate move to "open" the work to the free response of the addressee. An artistic work that suggests is also one that can be performed with the full emotional and imaginative resources of the interpreter. Whenever we read poetry there is a process by which we try to adapt our personal world to the emotional world proposed by the text. This is all the more true of poetic works that are deliberately based on suggestiveness, since the text sets out to stimulate the private world of the addressee so that he can draw from inside himself some deeper response that mirrors the subtler resonances underlying the text.

A strong current in contemporary literature follows this use of symbol as a communicative channel for the indefinite, open to constantly shifting responses and interpretative stances. It is easy to think of Kafka's work as "open": trial, castle, waiting, passing sentence, sickness, metamorphosis, and torture—none of these narrative situations is to be understood in the immediate literal sense. But, unlike the constructions of medieval allegory, where the superimposed layers of meaning are rigidly prescribed, in Kafka there is no confirmation in an encyclopedia, no matching paradigm in the cosmos, to provide a key to the symbolism. The various existentialist, theological, clinical, and psychoanalytic interpretations of Kafka's symbols cannot exhaust all the possibilities of his works. The work remains inexhaustible insofar as it is "open," because in it an ordered world based on universally acknowledged laws is being replaced by a world based on ambiguity, both in the negative sense that directional centers are missing and in a positive sense, because values and dogma are constantly being placed in question.

Even when it is difficult to determine whether a given author had symbolist intentions or was aiming at effects of ambivalence or indeterminacy, there is a school of criticism nowadays which tends to view all modern literature as built upon symbolic patterns. W. Y. Tindall, in his book on the literary symbol, offers an analysis of some of the greatest modern literary works in order to test Valéry's declaration that "il n'y a pas de vrai sens d'un texte" ("there is no true meaning of a text"). Tindall eventually concludes that a work of art is a construct which anyone at all, including its author, can put to any use whatsoever, as he chooses. This type of criticism

views the literary work as a continuous potentiality of "openness"—in other words, an indefinite reserve of meanings. This is the scope of the wave of American studies on the structure of metaphor, or of modern work on "types of ambiguity" offered by poetic discourse.[4]

Clearly, the work of James Joyce is a major example of an "open" mode, since it deliberately seeks to offer an image of the ontological and existential situation of the contemporary world. The "Wandering Rocks" chapter in *Ulysses* amounts to a tiny universe that can be viewed from different perspectives: the last residue of Aristotelian categories has now disappeared. Joyce is not concerned with a consistent unfolding of time or a plausible spatial continuum in which to stage his characters' movements. Edmund Wilson has observed that, like Proust's or Whitehead's or Einstein's world, "Joyce's world is always changing as it is perceived by different observers and by them at different times."[5]

In *Finnegans Wake* we are faced with an even more startling process of "openness": the book is molded into a curve that bends back on itself, like the Einsteinian universe. The opening word of the first page is the same as the closing word of the last page of the novel. Thus, the work is *finite* in one sense, but in another sense it is *unlimited*. Each occurrence, each word stands in a series of possible relations with all the others in the text. According to the semantic choice which we make in the case of one unit, so goes the way we interpret all the other units in the text. This does not mean that the book lacks specific sense. If Joyce does introduce some keys into the text, it is precisely because he wants the work to be read in a certain sense. But this particular "sense" has all the richness of the cosmos itself. Ambitiously, the author intends his book to imply the totality of space and time, of all spaces and all times that are possible. The principal tool for this all-pervading ambiguity is the pun, the *calembour,* by which two, three, or even ten different etymological roots are combined in such a way that a single word can set up a knot of different submeanings, each of which in turn coincides and interrelates with other local allusions, which are themselves "open" to new configurations and probabilities of interpretation. The reader of *Finnegans Wake* is in a position similar to that of the person listening to postdodecaphonic serial composition as he appears in a striking definition by Pousseur: "Since the phenom-

ena are no longer tied to one another by a term-to-term determination, it is up to the listener to place himself deliberately in the midst of an inexhaustible network of relationships and to choose for himself, so to speak, his own modes of approach, his reference points and his scale, and to endeavor to use as many dimensions as he possibly can at the same time and thus dynamize, multiply, and extend to the utmost degree his perceptual faculties."[6]

Nor should we imagine that the tendency toward openness operates only at the level of indefinite suggestion and stimulation of emotional response. In Brecht's theoretical work on drama, we shall see that dramatic action is conceived as the problematic exposition of specific points of tension. Having presented these tension points (by following the well-known technique of epic recitation, which does not seek to influence the audience, but rather to offer a series of facts to be observed, employing the device of "defamiliarization"), Brecht's plays do not, in the strict sense, devise solutions at all. It is up to the audience to draw its own conclusions from what it has seen on stage. Brecht's plays also end in a situation of ambiguity (typically, and more than any other, his *Galileo*), although it is no longer the morbid ambiguousness of a half-perceived infinitude or an anguish-laden mystery, but the specific concreteness of an ambiguity in social intercourse, a conflict of unresolved problems taxing the ingenuity of playwright, actors, and audience alike. Here the work is "open" in the same sense that a debate is "open." A solution is seen as desirable and is actually anticipated, but it must come from the collective enterprise of the audience. In this case the "openness" is converted into an instrument of revolutionary pedagogics.

In all the phenomena we have so far examined, I have employed the category of "openness" to define widely differing situations, but on the whole the sorts of works taken into consideration are substantially different from the post-Webernian musical composers whom I considered at the opening of this essay. From the Baroque to modern Symbolist poetics, there has been an ever-sharpening awareness of the concept of the work susceptible to many different interpretations. However, the examples considered in the preceding section propose an "openness" based on the *theoretical, mental* collaboration of the consumer, who must freely interpret an artistic datum, a

product which has already been organized in its structural entirety (even if this structure allows for an indefinite plurality of interpretations). On the other hand, a composition like *Scambi,* by Pousseur, represents a fresh advance. Somebody listening to a work by Webern freely reorganizes and enjoys a series of interrelations inside the context of the sound system offered to him in that particular (already fully produced) composition. But in listening to *Scambi* the auditor is required to do some of this organizing and structuring of the musical discourse. He collaborates with the composer in *making* the composition.

None of this argument should be conceived as passing an aesthetic judgment on the relative validity of the various types of works under consideration. However, it is clear that a composition such as *Scambi* poses a completely new problem. It invites us to identify inside the category of "open" works a further, more restricted classification of works which can be defined as "works in movement," because they characteristically consist of unplanned or physically incomplete structural units.

In the present cultural context, the phenomenon of the "work in movement" is certainly not limited to music. There are, for example, artistic products which display an intrinsic mobility, a kaleidoscopic capacity to suggest themselves in constantly renewed aspects to the consumer. A simple example is provided by Calder's mobiles or by mobile compositions by other artists: elementary structures which can move in the air and assume different spatial dispositions. They continuously create their own space and the shapes to fill it.

If we turn to literary production to try to isolate an example of a "work in movement," we are immediately obliged to take into consideration Mallarmé's *Livre,* a colossal and far-reaching work, the quintessence of the poet's production. He conceived it as the work which would constitute not only the goal of his activities but also the end goal of the world: "Le monde existe pour aboutir à un livre." Mallarmé never finished the book, although he worked on it at different periods throughout his life. But there are sketches for the ending which have recently been brought to light by the acute philological research of Jacques Schérer.[7]

The metaphysical premises for Mallarmé's *Livre* are enormous and possibly questionable. I would prefer to leave them aside in

order to concentrate on the dynamic structure of this artistic object which deliberately set out to validate a specific poetic principle: "Un livre ni commence ni ne finit; tout au plus fait-il semblant." The *Livre* was conceived as a mobile apparatus, not just in the mobile and "open" sense of a composition such as *Un coup de dès,* where grammar, syntax, and typesetting introduced a plurality of elements, polymorphous in their indeterminate relation to each other.

However, Mallarmé's immense enterprise was utopian: it was embroidered with evermore disconcerting aspirations and ingenuities, and it is not surprising that it was never brought to completion. We do not know whether, had the work been completed, the whole project would have had any real value. It might well have turned out to be a dubious mystical and esoteric incarnation of a decadent sensitivity that had reached the extreme point of its creative parabola. I am inclined to this second view, but it is certainly interesting to find at the very threshold of the modern period such a vigorous program for a *work in movement,* and this is a sign that certain intellectual currents circulate imperceptibly until they are adopted and justified as cultural data which have to be organically integrated into the panorama of a whole period.

In every century, the way that artistic forms are structured reflects the way in which science or contemporary culture views reality. The closed, single conception in a work by a medieval artist reflected the conception of the cosmos as a hierarchy of fixed, pre-ordained orders. The work as a pedagogical vehicle, as a monocentric and necessary apparatus (incorporating a rigid internal pattern of meter and rhymes) simply reflects the syllogistic system, a logic of necessity, a deductive consciousness by means of which reality could be made manifest step by step without unforeseen interruptions, moving forward in a single direction, proceeding from first principles of science which were seen as one and the same with the first principles of reality. The openness and dynamism of the Baroque mark, in fact, the advent of a new scientific awareness: the *tactile* is replaced by the *visual* (meaning that the subjective element comes to prevail) and attention is shifted from the *essence* to the *appearance* of architectural and pictorial products. It reflects the rising interest in a psychology of impression and sensation—in short,

an empiricism which converts the Aristotelian concept of real substance into a series of subjective perceptions by the viewer. On the other hand, by giving up the essential focus of the composition and the prescribed point of view for its viewer, aesthetic innovations were in fact mirroring the Copernican vision of the universe. This definitively eliminated the notion of geocentricity and its allied metaphysical constructs. In the modern scientific universe, as in architecture and in Baroque pictorial production, the various component parts are all endowed with equal value and dignity, and the whole construct expands toward a totality which is close to the infinite. It refuses to be hemmed in by any ideal normative conception of the world. It shares in a general urge toward discovery and constantly renewed contact with reality.

In its own way, the "openness" that we meet in the decadent strain of Symbolism reflects a cultural striving to unfold new vistas. For example, one of Mallarmé's projects for a multidimensional, deconstructible book envisaged the breaking down of the initial unit into sections which could be reformulated and which could express new perspectives by being deconstructed into correspondingly smaller units which were also mobile and reducible. This project obviously suggests the universe as it is conceived by modern, non-Euclidean geometries.

Hence, it is not overambitious to detect in the poetics of the "open" work—and even less so in the "work in movement"— more or less specific overtones of trends in contemporary scientific thought. For example, it is a critical commonplace to refer to the spatiotemporal continuum in order to account for the structure of the universe in Joyce's works. Pousseur has offered a tentative definition of his musical work which involves the term "field of possibilities." In fact, this shows that he is prepared to borrow two extremely revealing technical terms from contemporary culture. The notion of "field" is provided by physics and implies a revised vision of the classic relationship posited between cause and effect as a rigid, one-directional system: now a complex interplay of motive forces is envisaged, a configuration of possible events, a complete dynamism of structure. The notion of "possibility" is a philosophical canon which reflects a widespread tendency in contemporary science; the discarding of a static, syllogistic view of order, and a

corresponding devolution of intellectual authority to personal decision, choice, and social context.

If a musical pattern no longer necessarily determines the immediately following one, if there is no tonal basis which allows the listener to infer the next steps in the arrangement of the musical discourse from what has physically preceded them, this is just part of a general breakdown in the concept of causation. The two-value truth logic which follows the classical *aut-aut*, the disjunctive dilemma between *true* and *false*, a fact and its contradictory, is no longer the only instrument of philosophical experiment. Multivalue logics are now gaining currency, and these are quite capable of incorporating *indeterminacy* as a valid stepping-stone in the cognitive process. In this general intellectual atmosphere, the poetics of the open work is peculiarly relevant: it posits the work of art stripped of necessary and foreseeable conclusions, works in which the performer's freedom functions as part of the *discontinuity* which contemporary physics recognizes, not as an element of disorientation, but as an essential stage in all scientific verification procedures and also as the verifiable pattern of events in the subatomic world.

From Mallarmé's *Livre* to the musical compositions which we have considered, there is a tendency to see every execution of the work of art as divorced from its ultimate definition. Every performance *explains* the composition but does not *exhaust* it. Every performance makes the work an actuality, but is itself only complementary to all possible other performances of the work. In short, we can say that every performance offers us a complete and satisfying version of the work, but at the same time makes it incomplete for us, because it cannot simultaneously give all the other artistic solutions which the work may admit.

Perhaps it is no accident that these poetic systems emerge at the same period as the physicists' principle of *complementarity*, which rules that it is not possible to indicate the different behavior patterns of an elementary particle simultaneously. To describe these different behavior patterns, different *models*, which Heisenberg has defined as adequate when properly utilized, are put to use, but, since they contradict one another, they are therefore also complementary.[8] Perhaps we are in a position to state that for these works of art an incomplete knowledge of the system is in fact an essential feature in its formulation. Hence one could argue, with Bohr, that

the data collected in the course of experimental situations cannot be gathered in one image but should be considered as complementary, since only the sum of all the phenomena could exhaust the possibilities of information.[9]

Above I discussed the principle of ambiguity as moral disposition and problematic construct. Again, modern psychology and phenomenology use the term "perceptive ambiguities," which indicates the availability of new cognitive positions that fall short of conventional epistemological stances and that allow the observer to conceive the world in a fresh dynamics of potentiality before the fixative process of habit and familiarity comes into play. Husserl observed that

> each state of consciousness implies the existence of a horizon which varies with the modification of its connections together with other states, and also with its own phases of duration . . . In each external perception, for instance, the sides of the objects which are *actually perceived* suggest to the viewer's attention the unperceived sides which, at the present, are viewed only in a nonintuitive manner and are expected to become elements of the succeeding perception. This process is similar to a continuous *projection* which takes on a new meaning with each phase of the perceptive process. Moreover, perception itself includes horizons which encompass other perceptive possibilities, such as a person might experience by changing deliberately the direction of his perception, by turning his eyes one way instead of another, or by taking a step forward or sideways, and so forth.[10]

Sartre notes that the existent object can never be reduced to a given series of manifestations, because each of these is bound to stand in relationship with a continuously altering subject. Not only does an object present different *Abschattungen* (or profiles), but also different points of view are available by way of the same *Abschattung*. In order to be defined, the object must be related back to the total series of which, by virtue of being one possible apparition, it is a member. In this way the traditional dualism between being and appearance is replaced by a straight polarity of finite and infinite, which locates the infinite at the very core of the finite. This sort of "openness" is at the heart of every act of perception. It characterizes every moment of our cognitive experience. It means that each phe-

nomenon seems to be "inhabited" by a certain *power*—in other words, "the ability to manifest itself by a series of real or likely manifestations." The problem of the relationship of a phenomenon to its ontological basis is altered by the perspective of perceptive "openness" to the problem of its relationship to the multiplicity of different-order perceptions which we can derive from it.[11]

This intellectual position is further accentuated in Merleau-Ponty:

> How can anything ever *present itself* truly to us since its synthesis is never completed? How could I gain the experience of the world, as I would of an individual actuating his own existence, since none of the views or perceptions I have of it can exhaust it and the horizons remain forever *open*? . . . The belief in things and in the world can only express the assumption of a complete synthesis. Its completion, however, is made impossible by the very nature of the perspectives to be connected, since each of them sends back to other perspectives through its own horizons . . . The contradiction which we feel exists between the world's reality and its incompleteness is identical to the one that exists between the ubiquity of consciousness and its commitment to a field of presence. This ambiguousness does not represent an imperfection in the nature of existence or in that of consciousness; it is its very definition . . . Consciousness, which is commonly taken as an extremely enlightened region, is, on the contrary, the very region of indetermination.[12]

These are the sorts of problems which phenomenology picks out at the very heart of our existential situation. It proposes to the artist, as well as to the philosopher and the psychologist, a series of declarations which are bound to act as a stimulus to his creative activity in the world of forms: "It is therefore essential for an object and also for the world to present themselves to us as 'open' . . . and as always promising future perceptions."[13]

It would be quite natural for us to think that this flight away from the old, solid concept of necessity and the tendency toward the ambiguous and the indeterminate reflect a crisis of contemporary civilization. On the other hand, we might see these poetical systems, in harmony with modern science, as expressing the positive possibility of thought and action made available to an individual who is

open to the continuous renewal of his life patterns and cognitive processes. Such an individual is productively committed to the development of his own mental faculties and experiential horizons. This contrast is too facile and Manichaean. Our main intent has been to pick out a number of analogies which reveal a reciprocal play of problems in the most disparate areas of contemporary culture and which point to the common elements in a new way of looking at the world.

What is at stake is a convergence of new canons and requirements which the forms of art reflect by way of what we could term *structural homologies*. This need not commit us to assembling a rigorous parallelism—it is simply a case of phenomena like the "work in movement" simultaneously reflecting mutually contrasted epistemological situations, as yet contradictory and not satisfactorily reconciled. Thus, the concepts of "openness" and dynamism may recall the terminology of quantum physics: indeterminacy and discontinuity. But at the same time they also exemplify a number of situations in Einsteinian physics.

The multiple polarity of a serial composition in music, where the listener is not faced by an absolute conditioning center of reference, requires him to constitute his own system of auditory relationships.[14] He must allow such a center to emerge from the sound continuum. Here are no privileged points of view, and all available perspectives are equally valid and rich in potential. Now, this multiple polarity is extremely close to the spatiotemporal conception of the universe which we owe to Einstein. The thing which distinguishes the Einsteinian concept of the universe from quantum epistemology is precisely this faith in the totality of the universe, a universe in which discontinuity and indeterminacy can admittedly upset us with their surprise apparitions, but in fact, to use Einstein's words, presuppose not a God playing random games with dice but the Divinity of Spinoza, who rules the world according to perfectly regulated laws. In this kind of universe, relativity means the infinite variability of experience as well as the infinite multiplication of possible ways of measuring things and viewing their position. But the objective side of the whole system can be found in the invariance of the simple formal descriptions (of the differential equations) which establish once and for all the relativity of empirical measurement.

* * *

This is not the place to pass judgment on the scientific validity of the metaphysical construct implied by Einstein's system. But there is a striking analogy between his universe and the universe of the work in movement. The God in Spinoza, who is made into an untestable hypothesis by Einsteinian metaphysics, becomes a cogent reality for the work of art and matches the organizing impulse of its creator.

The *possibilities* which the work's openness makes available always work within a given *field of relations*. As in the Einsteinian universe, in the "work in movement" we may well deny that there is a single prescribed point of view. But this does not mean complete chaos in its internal relations. What it does imply is an organizing rule which governs these relations. Therefore, to sum up, we can say that the "work in movement" is the possibility of numerous different personal interventions, but it is not an amorphous invitation to indiscriminate participation. The invitation offers the performer the opportunity for an oriented insertion into something which always remains the world intended by the author.

In other words, the author offers the interpreter, the performer, the addressee a work *to be completed*. He does not know the exact fashion in which his work will be concluded, but he is aware that once completed the work in question will still be his own. It will not be a different work, and, at the end of the interpretative dialogue, a form which is *his* form will have been organized, even though it may have been assembled by an outside party in a particular way that he could not have foreseen. The author is the one who proposed a number of possibilities which had already been rationally organized, oriented, and endowed with specifications for proper development.

Berio's *Sequence,* which is played by different flutists, Stockhausen's *Klavierstück XI,* or Pousseur's *Mobiles,* which are played by different pianists (or performed twice over by the same pianists), will never be quite the same on different occasions. Yet they will never be gratuitously different. They are to be seen as the actualization of a series of consequences whose premises are firmly rooted in the original data provided by the author.

This happens in the musical works which we have already examined, and it happens also in the plastic artifacts we considered. The common factor is a mutability which is always deployed

within the specific limits of a given taste, or of predetermined formal tendencies, and is authorized by the concrete pliability of the material offered for the performer's manipulation. Brecht's plays appear to elicit free and arbitrary response on the part of the audience. Yet they are also rhetorically constructed in such a way as to elicit a reaction oriented toward, and ultimately anticipating, a Marxist dialectic logic as the basis for the whole field of possible responses.

All these examples of "open" works and "works in movement" have this latent characteristic, which guarantees that they will always be seen as "works" and not just as a conglomeration of random components ready to emerge from the chaos in which they previously stood and permitted to assume any form whatsoever.

Now, a dictionary clearly presents us with thousands upon thousands of words which we could freely use to compose poetry, essays on physics, anonymous letters, or grocery lists. In this sense the dictionary is clearly open to the reconstitution of its raw material in any way that the manipulator wishes. But this does not make it a "work." The "openness" and dynamism of an artistic work consist in factors which make it susceptible to a whole range of integrations. They provide it with organic complements which they graft into the structural vitality which the work already possesses, even if it is incomplete. This structural vitality is still seen as a positive property of the work, even though it admits of all kinds of different conclusions and solutions for it.

The preceding observations are necessary because, when we speak of a work of art, our Western aesthetic tradition forces us to take "work" in the sense of a personal production which may well vary in the ways it can be received but which always maintains a coherent identity of its own and which displays the personal imprint that makes it a specific, vital, and significant act of communication. Aesthetic theory is quite content to conceive of a variety of different poetics, but ultimately it aspires to general definitions, not necessarily dogmatic or *sub specie aeternitatis,* which are capable of applying the category of the "work of art" broadly speaking to a whole variety of experiences, which can range from the *Divine Comedy* to, say, electronic composition based on the different permutations of sonic components.

We have, therefore, seen that (1) "open" works, insofar as they are *in movement,* are characterized by the invitation to *make the work* together with the author and that (2) on a wider level (as a sub*genus* in the *species* "work in movement") there exist works which, though organically completed, are "open" to a continuous generation of internal relations which the addressee must uncover and select in his act of perceiving the totality of incoming stimuli. (3) *Every* work of art, even though it is produced by following an explicit or implicit poetics of necessity, is effectively open to a virtually unlimited range of possible readings, each of which causes the work to acquire new vitality in terms of one particular taste, or perspective, or personal *performance.*

Contemporary aesthetics has frequently pointed out this last characteristic of *every* work of art. According to Luigi Pareyson:

> The work of art . . . is a form, namely of movement, that has been concluded; or we can see it as an infinite contained within finiteness . . . The work therefore has infinite aspects, which are not just "parts" or fragments of it, because each of them contains the totality of the work, and reveals it according to a given perspective. So the variety of performances is founded both in the complex factor of the performer's individuality and in that of the work to be performed . . . The infinite points of view of the performers and the infinite aspects of the work interact with each other, come into juxtaposition and clarify each other by a reciprocal process, in such a way that a given point of view is capable of revealing the whole work only if it grasps it in the relevant, highly personalized aspect. Analogously, a single aspect of the work can only reveal the totality of the work in a new light if it is prepared to wait for the right point of view capable of grasping and proposing the work in all its vitality.

The foregoing allows Pareyson to move on to the assertion that

> all performances are definitive in the sense that each one is for the performer, tantamount to the work itself; equally, all performances are bound to be provisional in the sense that each performer knows that he must always try to deepen his own interpretation of the work. Insofar as they are definitive, these

interpretations are parallel, and each of them is such as to exclude the others without in any way negating them.[15]

This doctrine can be applied to all artistic phenomena and to artworks throughout the ages. But it is useful to have underlined that now is the period when aesthetics has paid especial attention to the whole notion of "openness" and sought to expand it. In a sense these requirements, which aesthetics has referred widely to every type of artistic production, are the same as those posed by the poetics of the "open work" in a more decisive and explicit fashion. Yet this does not mean that the existence of "open" works and of "works in movement" adds absolutely nothing to our experience because everything in the world is already implied and subsumed by everything else, from the beginning of time, in the same way that it now appears that every discovery has already been made by the Chinese. Here we have to distinguish between the theoretical level of aesthetics as a philosophical discipline which attempts to formulate definitions and the practical level of poetics as programmatic projects for creation. While aesthetics brings to light one of the fundamental demands of contemporary culture, it also reveals the latent possibilities of a certain type of experience in every artistic product, independently of the operative criteria which presided over its moment of inception.

The poetic theory or practice of the "work in movement" senses this possibility as a specific vocation. It allies itself openly and self-consciously to current trends in scientific method and puts into action and tangible form the very trend which aesthetics has already acknowledged as the general background to performance. These poetic systems recognize "openness" as *the* fundamental possibility of the contemporary artist or consumer. The aesthetic theoretician, in his turn, will see a confirmation of his own intuitions in these practical manifestations: they constitute the ultimate realization of a receptive mode which can function at many different levels of intensity.

Certainly this new receptive mode vis-à-vis the work of art opens up a much vaster phase in culture and in this sense is not intellectually confined to the problems of aesthetics. The poetics of the "work in movement" (and partly that of the "open" work) sets in motion a new cycle of relations between the artist and his audi-

ence, a new mechanics of aesthetic perception, a different status for the artistic product in contemporary society. It opens a new page in sociology and in pedagogy, as well as a new chapter in the history of art. It poses new practical problems by organizing new communicative situations. In short, it installs a new relationship between the *contemplation* and the *utilization* of a work of art.

Seen in these terms and against the background of historical influences and cultural interplay which links art by analogy to widely diversified aspects of the contemporary worldview, the situation of art has now become a situation in the process of development. Far from being fully accounted for and catalogued, it deploys and poses problems in several dimensions. In short, it is an "open" situation, *in movement*. A work in progress.

II

Analysis of Poetic Language

Contemporary poetics proposes a whole gamut of forms—ranging from structures *that move* to the structures *within which* we move—that call for changing perspectives and multiple interpretations. But, as I have already pointed out, a work of art is never really "closed," because even the most definitive exterior always encloses an infinity of possible "readings."

If we want to pursue our analysis of the "openness" proposed by contemporary poetics, and establish the degree of novelty it has brought to the historical development of aesthetics, we must first find out what, in fact, distinguishes the intentional "openness" advocated by contemporary art movements from that which we consider typical of all works of art.

In other words, we shall examine how every work of art can be said to be "open," how this openness manifests itself structurally, and to what extent structural differences entail different levels of openness.

Croce and Dewey

Every work of art, from a petroglyph to *The Scarlet Letter,* is open to a variety of readings—not only because it inevitably lends itself to the whims of any subjectivity in search of a mirror for its moods, but also because it wants to be an inexhaustible source of experiences which, focusing on it from different points of view, keep bringing new aspects out of it. Contemporary poetics has long dwelled on this point, and has turned it into one of its main themes.

The very concept of universality that we often apply to an aesthetic experience refers to this particular phenomenon. The statement "The square of the length of the hypotenuse of a right triangle

equals the sum of the squares of the lengths of the other two sides" is also universal, being a principle that retains the same validity at every point on the globe, but it refers to just one specific, well-defined property of reality. On the other hand, when I recite a line of poetry or an entire poem, the words I utter cannot be immediately translated into a fixed *denotatum* that exhausts their meaning, for they imply a series of meanings that expand at every new look, to the point that they seem to offer me a concentrated image of the entire universe. This is how we should understand Croce's often quite ambiguous theory concerning the *totality* of artistic expression.

According to Croce, an artistic representation is a reflection of the cosmos: "Each part of it throbs with the life of the whole, and the whole is in the life of each part. A true artistic representation is at the same time itself and the universe, the universe as individual form, and the individual form as universe. Every accent of the poet, as well as every creature of his imagination, encloses the entire destiny of mankind, with all its hopes, its illusions, its pains, its joys, its grandeur, and its misery, the entire drama of reality, incessantly becoming and growing out of itself, in suffering and pleasure."[1] Croce's words effectively translate the vague emotion many of us have felt at the reading of a poem, but they don't explain it. In other words, Croce does not accompany his observation with a theoretical framework that would account for it. Similarly, when he states that "to give an artistic form to an emotive content is to imprint it with totality, to lend it cosmic inspiration,"[2] he is again insisting on the need for a rigorous foundation (on which to base the equation *artistic form* = *totality*), but without providing us with the philosophical tools necessary to establish the connection he proposes. To say that artistic form stems from the lyrical intuition of feeling does not amount to much more than asserting that every emotive intuition becomes lyrical when it takes the form of art, thereby assuming the character of totality—all aesthetic reflection thus dwindles to suggestive verbalism, or to charming tautologies involving phenomena that are, however, never explained.

Croce is not the only one to dwell on the conditions of aesthetic pleasure without trying to explain their mechanism. Dewey does the same thing when he speaks of "this sense of the including whole implicit in ordinary experiences," a sense which, as he further

notes, the Symbolists have turned into the main object of their art: "About every explicit and focal object there is a recession into the implicit which is not intellectually grasped. In reflection we call it dim and vague." But Dewey is perfectly aware of the fact that the "dim" and the "vague" of a primary experience—which always precede the categorical rigidity imposed on us by reflection—are aspects of its global nature. "At twilight, dusk is a delightful quality of the whole world. It is its appropriate manifestation. It becomes a specialized and obnoxious trait only when it prevents distinct perception of some particular thing we desire to discern." If reflection forces us to choose and focus on just a few elements of a given situation, "the undefined pervasive quality of an experience is that which binds together all the defined elements, the objects of which we are focally aware, making them a whole." Reflection does not generate but, rather, is generated by this original pervasiveness within which it exercises its selectivity. According to Dewey, the very essence of art lies precisely in its capacity to evoke and emphasize "this quality of being a whole and of belonging to the larger, all-inclusive, whole which is the universe in which we live"[3]— hence the religious emotion inspired in us by aesthetic contemplation. This sense of totality is as strongly registered in Dewey as it is in Croce, even though in a different philosophical context, and constitutes one of the most interesting features of an aesthetics which, given its naturalist foundations, could at first sight seem rigidly positivistic. In fact, Dewey's naturalism and his positivism share the same romantic origins, which might well explain why all his analyses, no matter how scientific, always culminate in a moment of intense emotion before the mystery of the cosmos (it is no coincidence that his organicism, though marked by Darwin, stems more or less consciously from Coleridge and Hegel).[4]

This is probably why, on the threshold of the cosmic mystery, Dewey seems to be afraid of taking the last step that would allow him to dissect this experience of the indefinite into its psychological coordinates and declares his failure. "I can see no psychological ground for such properties of an experience save that, somehow, the work of art operates to deepen and to raise to great clarity that sense of an enveloping undefined whole that accompanies every normal experience."[5] Such a surrender is all the more unjustifiable in that Dewey's philosophy already contains the premises for such

a clarification, and that these very premises are reiterated in *Art as Experience,* hardly a hundred pages before the cited passages.

Dewey offers us a *transactional* conception of knowledge that becomes particularly suggestive when set side by side with his definition of the aesthetic object. The work of art, for him, is the fruit of a process of organization whereby personal experiences, facts, values, meanings are incorporated into a particular material and become one with it, or, as Baratono would say, "as-similated" to it. (In other words, art is the "capacity to work a vague idea and emotion over into terms of some definite medium.")[6] The expressiveness of a work of art depends on the existence of "meanings and values extracted from prior experiences and founded in such a way that they fuse with the qualities directly presented in the work of art."[7] In other words, components of our experiences must fuse with the qualities of the poem or the painting to cease being extraneous objects. Thus, "the expressiveness of the object of art is due to the fact that it presents a thorough and complete interpenetration of the materials of undergoing and of action, the latter including a reorganization of matter brought with us from past experience . . . The expressiveness of the object is the report and celebration of the complete fusion of what we undergo and what our activity of attentive perception brings into what we receive by means of the senses."[8] Consequently, "to have form . . . marks a way of envisaging, of feeling, and of presenting experienced matter so that it most readily and effectively becomes material for the construction of adequate experience on the part of those less gifted than the original creator."[9]

If this is still not a clear psychological explanation of what infuses the aesthetic experience with the sense of a totality, it certainly is its philosophical premise. So much so that this and other texts by Dewey are responsible for the emergence of a psychological methodology—called "transactional"—according to which knowledge is a difficult process of transaction, of negotiation: in answer to a given stimulus, the subject incorporates the memory of past perceptions into the current one and, by so doing, gives form to the experience in progress—an experience that is not only the recording of a *Gestalt* already existing as an autonomous configuration of reality (or, for that matter, a subjective positing of the object), but that is also the result of our active participation in the world, or,

better yet, the world that results from this active participation.[10] Thus, the experience of totality (the experience of the aesthetic moment as an openness of knowledge) could very well lend itself to a psychological explanation, the absence of which makes Croce's accounts, and in part Dewey's, somewhat suspect.

From a psychological standpoint, this question involves the very conditions of knowledge, and not just the aesthetic experience— unless, of course, we see it as the liminal condition of all knowledge, its primary and essential phase, which is quite plausible but not exactly pertinent at this stage of our investigation. For the time being, our investigation will be limited to the process of transaction between a perceiving subject and an aesthetic stimulus. To make things even clearer, we are going to focus our analysis on the subject's reaction to language. Language is not an organization of natural stimuli, like a beam of photons; it is an organization of stimuli realized by man, and, as such, an artifact, like any other art form. No need, therefore, to identify art with language in order to pursue an analogy that would allow us to apply to one what we have said about the other. As the linguists have clearly understood,[11] language is not *one* means of communication among others, but rather "the basis of all communication,"or, even better, "language really is the foundation of culture. In relation to language, other systems of symbols are concomitant or derivative."[12]

An analysis of the reader's reaction to three propositions will show us whether the way he responds to an ordinary linguistic stimulus is in any way different from the way he responds to a more particular stimulus generally defined as aesthetic.[13] If these two different uses of language provoke two different types of reactions, then we should be able to distinguish the *characteristics* of *aesthetic* language.

Analysis of Three Propositions

How does one bring the memory of past experiences to bear on a present experience? And how can this same process be translated into an act of communication between a verbal message and its recipient?[13]

As we all know, a linguistic message can have different functions:

referential, emotive, conative (or imperative), phatic, aesthetic, and metalingual.[14] Such a division, however, already presumes a certain awareness of the structure of the message as well as a knowledge of what distinguishes the aesthetic function from the others. It is precisely this distinction that I would now like to verify in the light of my previous discussions. If we accept the division I have just sketched as the result of a completed investigation, then we can turn to a particular dichotomy that was in vogue a few decades ago among scholars of semantics: the distinction between messages with a *referential function* (pointing at something well defined and, if necessary, verifiable) and those with an *emotive function* (aiming at provoking certain reactions in the recipient, stimulating associations, and promoting response behaviors that go well beyond the mere recognition of a referent).

1. Propositions with a Referential Function

Confronted with a proposition such as "That man comes from Milan," our mind will immediately establish a univocal relationship between signifier and signified: adjective, noun, verb, and complement of place (here represented by the preposition "from" followed by the name of a city), each referring to a very specific reality and a well-defined action. Which does not mean that the expression itself possesses all the requirements necessary to signify abstractly the situation it in fact defines once it is understood. The expression itself is merely a juxtaposition of conventional terms that need my collaboration in order to be understood: in other words, I must invest every new term with a certain number of previous experiences in order to be able to understand its current meaning. If I have never heard the term "Milan" before and do not know that it refers to a city, then the amount of communication that is likely to reach me will not be very high. On the other hand, even an addressee who is perfectly aware of the meaning of each term may not receive as much information as another, equally well-informed addressee. Obviously, if I am waiting for some important communication from Milan, the sentence will tell me more and elicit a much stronger reaction from me than it would from someone without similar expectations.[15] Similarly, if, in my mind, Milan is connected to a series of memories, desires, and regrets, then the very

same sentence will provoke in me an array of complex emotions that few other people will be able to share. A sentence such as "That man comes from Paris," uttered in front of Napoleon during his exile on Saint Helena, must have awakened in him a variety of emotions such as we could not even imagine. In other words, each addressee will automatically complicate—that is to say, personalize—his or her understanding of a strictly referential proposition with a variety of conceptual or emotive references culled from his or her previous experience. On the other hand, whatever the number of "pragmatic" reactions that such a plurality of understandings can entail, it is still possible to keep a referential proposition under control by reducing the understanding of different receivers to a single pattern.

In other words, if the proposition "The train for Rome leaves from Central Station at 5:45 P.M., Platform 7" (which has the same referential univocality as the previous one) can also produce different reactions in ten different people—depending on whether the addressee is headed for Rome to conduct business, or to rush to the side of a dying relative, or to collect an inheritance, or to follow an unfaithful spouse—it still relies on a single, basic, and pragmatically verifiable pattern of understanding whereby all ten passengers will be on the same train at the same hour. This collective reaction proves the existence of a common frame of reference that could also be accessible to a properly programmed computer. The computer, however, would not have access to the halo of openness that radiates out of every proposition, no matter how strictly referential, and that accompanies all human communication.

2. Propositions with a Suggestive Function

Let us now look at a sentence such as "That man comes from Basra." Addressed to an Iraqi, this sentence should produce an effect similar to the one produced by the sentence concerning Milan on an Italian. Addressed to someone with no geographic knowledge, it will either produce total indifference or some curiosity as to this unknown place of origin, whose name, lacking a frame of reference, finds absolutely no resonance in him. In yet another person, the mention of Basra might evoke images not of a precise geographic location but of a "fantastic" place described in the

Thousand and One Nights. In this case, the term "Basra" would cease to be a stimulus directly connected to a specific reality, a precise signified, and would become the center of an associative network of memories and emotions, all exuding the same exotic blend of mystery, languor, and magic: Ali Baba, hashish, flying carpets, odalisques, sultry aromas and spices, the wisdom of caliphs, the sounds of oriental instruments, wily Levantine merchants, Baghdad. The less precise the receiver's culture and the more fervent his imagination, the more undefined and fluid his reaction will be, and the more frayed and smudged its contours. Let's not forget the effect that the sign displaying the words "Agendath Netaim" has on Leopold Bloom (*Ulysses,* chapter 4); the "stream of consciousness" it provokes constitutes a precious psychological document. The divagations of a mind prodded by a vague stimulus can cause the suggestiveness of one word (such as "Basra") to permeate the rest of the text: the subject of the sentence ceases to be an insignificant traveler and becomes an individual charged with mystery and intrigue, and the verb "comes," no longer a mere indication of movement from one place to another, begins to evoke images of a fabulous journey, a journey along the paths of fairy tales, the archetypal Journey. In short, the message (the sentence) opens up to a series of connotations that go far beyond its most immediate denotations.

What differences are there between the sentence addressed to an Iraqi and the very same sentence addressed to an imaginary European listener? Formally, none. The referential diversity of the proposition (and, therefore, of its conceptual value) resides not in the proposition itself but in the addressee. And yet the capacity to vary is not totally extraneous to the proposition itself. Uttered by a railroad employee sitting at an information desk, this sentence will be quite different from an identical sentence uttered by someone who is trying to draw our attention to a particular character; indeed, they are *two* different sentences. The second speaker will use the term "Basra" with a specific suggestive intention, aiming to elicit a strong if undefined reaction from his listener. Unlike the railroad employee, when he says "Basra" he does not want to denote a specific town; rather, he is trying to connote (and evoke) an entire world of memories that he attributes to his listener, a world of memories that, as he also knows, will inevitably differ from one listener to the next. On the other hand, if all the listeners belong to

the same, or a similar, cultural (and psychological) context, the speaker will succeed in constructing a communication whose effect is at once undefined and yet limited to a particular "field of suggestivity"—the time and place of his utterance, as well as the audience to which he addresses it, are enough to guarantee a fairly unified range of interpretation. Presumably, the same proposition uttered with the same intentions but in the office of an oil magnate will not produce the same echoes. To avoid unnecessary semantic dispersion, the more allusive speaker will have to give his audience a particular direction. This would be quite easy if his proposition had a strictly denotative value; but when it is meant to provoke a response that is at once undefined and yet circumscribed within a particular frame of reference, he will have to put more emphasis on a certain kind of suggestion, so as to reiterate the desired stimulus by means of analogous references.

3. The Emphatic Suggestion, or the Double Organization of the Aesthetic Object

"That man comes from Basra, via Bisha and Dam, Shibam, Tarib and Hofuf, Anaiza and Buraida, Medina and Khaibar; he has followed the course of the Euphrates to Aleppo." This form of reiteration is rather primitive but nonetheless quite adequate to lend phonic suggestiveness to the vagueness of the references, and to provide auditory substance to the imagination.

This way of enhancing both the vagueness of the reference and its mnemonic appeal by means of a phonetic artifice is characteristic of a particular mode of communication that I shall define as "aesthetic," in the broadest sense of the term. What changes have occurred to transform the initial referential proposition into an aesthetic one? Material data has been deliberately added to the already present conceptual data, sound to sense; deliberately though quite naïvely in this particular case, since all the terms could be replaced by other, similarly suggestive ones, and since the coupling of sound and sense remains fairly casual, and quite conventional, resting as it does on the assumption that most listeners would automatically associate such names with Arabia and Mesopotamia. Confronted with a message of this type, the addressee will not only attribute a signified to every signifier, but will also linger on the ensemble of

the signifiers—which, at this rather elementary stage, means that he will savor them as sonorous events, and read them as "pleasant material." The fact that, in the example at hand, most of the signifiers harken back to themselves indicates that the message is fundamentally *self-reflexive,* and, as such, "poetic." [16]

But if this proposition helps us understand how to attain the aesthetic effect, that is also as far as it goes. To go further we should move to a more fruitful example.

In Racine's *Phaedra,* Hippolytus decides to leave his homeland to look for Theseus, but Theramene knows that is not the real reason for his departure and tries to guess the secret that troubles him. What can prompt Hippolytus to leave the sites of his childhood? Those places, Hippolytus answers, have lost their original sweetness because they have been contaminated by the presence of his stepmother, Phaedra. Phaedra is evil, full of hatred, but her nastiness is more than a mere aspect of her personality. Something else makes her a hateful being, an enemy—something Hippolytus can sense. This something is precisely what makes her the essential tragic heroine, and what Racine must convey to his audience so that the "character" is fixed from the start and all that follows occurs as if by fatal necessity. Phaedra is evil because her race is damned. A hint at her genealogy is enough to fill the audience with horror: her father is Minos, her mother Pasiphaë. Uttered in front of a civil servant, this sentence would have a strictly referential value; but uttered in front of a theater audience, its effect will be much more powerful if undefined. Minos and Pasiphaë are two awful beings: their very names are enough to conjure up the reasons for their repulsiveness.

Minos is terrible because of his infernal character, and Pasiphaë because of the bestial act that made her famous. At the beginning of the tragedy, Phaedra is just a cipher, but the names of her parents are already enough to evoke the myth and create a halo of odiousness around her. Hippolytus and Theramene speak in the elegant alexandrines of the seventeenth century; but the mere mention of the two mythical characters opens up a whole new field of suggestions for the imagination. With just two names Racine is able to achieve the suggestive effect he seeks, but he wants more: he wants to create a form, produce an aesthetic effect. The two names cannot be introduced as a casual communication, merely trusting to the

haphazard emotions that their suggestive power will evoke in the audience. If this genealogical reference is to constitute the tragic premises for everything that follows, then the communication must have a definite impact on the spectator so that the suggestion, once made, will not exhaust itself in the game of references to which the spectator has been invited to participate. Indeed, it is important that the spectator be able to return to the proposed expression as often as he wishes, and that he always find in it a stimulus for new suggestions. The proposition "That man comes from Basra" may have an effect the first time it is heard; but after the first surprise and the first diversion, it loses much of its suggestive power and the listener no longer feels invited to participate in an imaginary journey. On the other hand, if every time I go back to the proposition I feel pleased and satisfied, if what invites me to a mental journey is a material structure with an agreeable appearance, if the formula of the invitation is so successful that its effectiveness surprises me every time I hear it, if, in it, I discover a miracle of balance and economy such that from now on I will be unable to separate its conceptual reference from the stimulus that has invoked it, then the surprise of this union will inevitably give way to the complex play of the imagination. Then I will be able to appreciate not just the indefinite reference but also the way in which this indefiniteness is produced, the very clear and calculated way in which it is suggested to me, the very precision of the mechanism that charms me with imprecision.

Racine entrusts Phaedra's genealogy to one verse, one alexandrine whose incisiveness and symmetry are a real feat of virtuosity: both halves of the verse terminate on the names of the two parents, that of the mother, more resonant with horror, coming last:

> Depuis que sur ces bords les dieux ont envoyé
> La fille de Minos et de Pasiphaë.

> Since to these shores the gods have sent
> The daughter of Minos and of Pasiphaë.

At this point the ensemble of signifiers, along with their heavy baggage of connotations, no longer belongs to itself or to the spectator, ready as he might feel to pursue yet undefined fantasies (from the most morbid and moralizing considerations of bestiality, to the

power of uncontrolled passion, the barbarism of classical mytho-poeia, or its archetypal wisdom). Now the word belongs to the verse, to its unquestionable measure and the context of sounds in which it is steeped, to the irrepressible rhythm of the theatrical dis-course, to the dialectic of tragic action. The suggestions are inten-tional, provoked, and explicitly reiterated, but always within the limits fixed by the author, or, better, by the aesthetic machine that he has set in motion. This aesthetic machine does not ignore the audience's capacities for response; on the contrary, it brings them into play and turns them into the necessary condition for its sub-sistence and its success, while directing them and controlling them.

The emotion (the simple pragmatic reaction that the sheer power of the two names would have provoked) now increases and defines itself, assumes a certain order and identifies with the form that has generated it and in which it rests, but it does not limit itself to it; rather, it increases thanks to it (and becomes one of its connota-tions). Neither is the form limited to one emotion; rather, it in-cludes all the individual emotions it produces and directs as possible connotations of the line—here understood as the articulated form of signifiers signifying, above all, their structural articulation.

The Aesthetic Stimulus

At this point we can conclude that the distinction between *referential* language and *emotive* language, however useful to a study of the aesthetic use of language, does not solve any problem. As shown, the difference between the terms "referential" and "emotive" does not concern the *structure* of the proposition as much as its *use* (and therefore the context within which it is uttered). It is possible to find a series of referential sentences that, under certain circum-stances (mostly concerning the listener), will acquire an emotive value, just as it is possible to find a number of emotive propositions that, under certain circumstances, will acquire a referential value. Some road signs, such as a STOP sign, unambiguously prescribing a course of action while preparing us for the approach of an intersec-tion, are a perfect example of this double linguistic function. As a rule, all linguistic expressions, whatever their specific purpose, en-tail both modes of communication. This is particularly obvious in

the case of suggestive communications whose emotive aura depends on both the intentional ambiguity of the given sign and its precise referential value. The sign "Minos" involves at once a precise cultural-mythological signifier and the stream of connotations that the very memory of the character discloses, along with an instinctive reaction to its phonic suggestiveness (itself fraught with confused and half-forgotten connotations, hypotheses concerning its possible meanings, and other arbitrary significations).[17]

Clearly, the aesthetic value of an artistic expression is no more dependent on the emotive use of language than on its referential function. Metaphors, for instance, rely greatly on references. Poetic language involves at once the emotive use of references and the referential use of emotions, since all emotive reaction is the realization of a field of connoted meanings. All this is attained by means of an identification between signifier and signified, "vehicle" and "tenor." In other words, the aesthetic sign is what Morris defines as the "iconic sign," a sign whose semantic import is not confined to a given denotatum, but rather expands every time the structure within which it is inevitably embodied is duly appreciated—a sign whose signified, resounding relentlessly against its signifier, keeps acquiring new echoes.[18] All this is not the result of some inexplicable miracle. Transactional psychology explains it quite clearly when it defines the linguistic sign as a "field of stimuli." The structure of the aesthetic stimulus is such that its addressee cannot decode it the way he would any other purely referential sort of communication—that is to say, by separating every component of the proposition so as to distinguish the referent of each. In an aesthetic stimulus, it is not possible to isolate a particular sign and connect it univocally to its denotative meaning: what matters is the global denotatum. Each sign, depending as it does on all the other signs of the proposition for its complete physiognomy, can signify only vaguely, just as each denotatum, being inextricably connected to other denotata, can only appear as *ambiguous* when taken singly.[19]

In the field of aesthetic stimuli, signs are bound by a necessity that is rooted in the perceptual habits of the addressee (otherwise known as his taste): rhyme, meter, a more or less conventional sense of proportion, the need for verisimilitude, other stylistic concerns. Form is perceived as a necessary, justified whole that cannot be broken. Unable to isolate referents, the addressee must then rely

on his capacity to apprehend the complex signification which the entire expression imposes on him. The result is a multiform, pluri-vocal signified that leaves us at once satisfied and disappointed with this first phase of comprehension precisely because of its variety, its indefiniteness. Charged with a complex scheme of references mostly drawn from our memories of previous experiences, we then refer back to the initial message, which will be inevitably en-riched by the interaction between those memories and the signi-fieds yielded in the course of this second contact—signifieds that will already be different from those apprehended initially, given the new perspective and the new hierarchy of stimuli of this second approach. Signs which the addressee might have at first neglected may now appear particularly relevant, whereas those originally no-ticed may have dwindled in importance. This transaction between the memory of previous experiences, the system of meanings that has surfaced during the first contact (and will again reappear as a "harmonic background" in the second approach), and the new sys-tem of meanings that is emerging out of a second contact automat-ically enriches the meaning of the original message—which, far from being exhausted by this process, appears all the more fertile (in its own material constitution) and open to new readings as our understanding of it gets more and more complex. This is just the beginning of the chain reaction that characterizes every conscious organization of stimuli, commonly known as "form." Theoreti-cally, this reaction is endless, ceasing only when the form ceases to stimulate the aesthetic sensibility of the addressee; but this is gen-erally the result of a slackening in attention. As we get used to the stimulus, the signs that constitute it and on which we have repeat-edly focused our attention—not unlike an object that we have gazed at too long, or a word whose meaning we have lingered on too obsessively—reach a sort of saturation point, after which they begin to lose their edge, to look dull, whereas in fact it is our sensi-bility that has been temporarily dulled. Similarly, the memories we have integrated into our new perception, instead of remaining the spontaneous products of a stimulated mind, are eventually turned by habit into ready-made schemes, endlessly rehashed summaries. The process of aesthetic pleasure is thus blocked and the contem-plated form is reduced to a conventional formula on which our overexercised sensibility can now rest.

This is what happens after years of listening to the same musical piece. There is a moment when the work is beautiful to us only because we have long considered it such; and the enjoyment we now draw out of it is merely the memory of the pleasure we once felt while listening to it. In fact, it no longer stirs any emotion in us and is thus unable to entice either our imagination or our intelligence into new perceptual adventures. Its form is temporarily exhausted. Often, to rejuvenate our dulled sensibility, we need to put it in quarantine. Then, we might again feel pleasantly surprised at the way the work reverberates in us, and not just because our ear, having grown unaccustomed to the effect produced by that particular organization of stimuli, can again respond to it with freshness, but also because, in the interim, our intelligence has ripened, our memory has expanded, and our culture has deepened, and this is all the original form needs to stimulate certain zones of our sensibility that previously remained untouched.

But time might not be enough to reawaken pleasure and surprise and to resurrect a particular form for us, which means either that our intellectual development has atrophied or that the work, as organization of stimuli, was addressed to an ideal addressee who does not correspond to what we have become. This might in turn mean that that particular form, aimed at a particular cultural context, is no longer effective for us, though it might yet find some resonance in the future. If this is the case, we are participating in the collective adventure of taste and culture and are experiencing the loss of congeniality between a work and its intended addressee that often characterizes a cultural period, and that generally ends up as the subject of a chapter of some literary history under the title "The Fortunes of Such-and-Such a Work." But it would be wrong to assume that the work itself is dead, or that the children of our time are insensitive to real beauty. Such naïve beliefs are based on the presumption that all aesthetic value is at once objective and immutable, and thus quite immune to any transactional process. Whereas, in fact, all means is that for a period of time, whether in the history of humanity or in our own personal history, certain transactional possibilities have been blocked. This sort of blockage is easy to explain when it concerns relatively simple phenomena, such as the understanding of an alphabet: if, today, we cannot understand the Etruscan language, it is because we have lost its code, the comparative table that

gave us the key to Egyptian hieroglyphs. But when it concerns more complex phenomena, such as the understanding of a particular aesthetic form—depending on the interaction of material factors, semantic conventions, linguistic and cultural references, the conditions of a particular sensitivity, and the decisions of a particular intelligence—it is not as easy to explain. Generally speaking, we accept this sudden lack of congeniality as a mysterious occurrence, or we deny it by means of captious critical analyses that try to prove the absolute and eternal validity of incomprehension. The truth of the matter is that aesthetics is unable to give an exhaustive explanation of certain aesthetic phenomena, even when it can allow for their plausibility. The task, then, falls to psychology, sociology, anthropology, economics, and all those other sciences concerned with cultural changes.

The foregoing argument has, I hope, demonstrated that the impression of endless depth, of all-inclusive totality—in short, of openness—that we receive from every work of art is based on both the double nature of the communicative organization of the aesthetic form and the transactional nature of the process of comprehension. Neither openness nor totality is inherent in the objective stimulus, which is in itself materially determined, or in the subject, who is himself available to all sorts of openness and none; rather, they lie in the cognitive relationship that binds them, and in the course of which the object, consisting of stimuli organized according to a precise aesthetic intention, generates and directs various kinds of openness.

Aesthetic Value and Two Kinds of Openness

If, as I have shown, the openness of a work of art is the very condition of aesthetic pleasure, then each form whose aesthetic value is capable of producing such pleasure is, by definition, open—even though its author may have aimed at a univocal, unambiguous communication.

A study of contemporary open works nevertheless reveals that, in most cases, their openness is intentional, *explicit,* and extreme—that is, based not merely on the nature of the aesthetic object and on its composition but on the very elements that are combined in

it. In other words, the variety of meanings that can be drawn out of a sentence from *Finnegans Wake* does not depend on the same kind of aesthetic achievement as the line from Racine we have examined above. Joyce was aiming at something else, something different, which demanded the aesthetic organization of a complex of signifiers that were already, in themselves, open and ambiguous. On the other hand, the ambiguity of the signs cannot be separated from their aesthetic organization: rather, the two are mutually supportive and motivating.

To give a more concrete example of all this, let us compare two passages, one from the *Divine Comedy* and the other from *Finnegans Wake*. In the first passage, Dante wants to explain the nature of the Trinity, the highest and most difficult concept in his entire poem. Already univocally clarified by theological speculation, this concept is no longer open to interpretation, since it can have only one meaning, the orthodox one. The poet, therefore, uses only words with very precise referents:

> O Luce eterna, che sola in Te sidi,
> Sola t'intendi, e, da te intelletta
> Ed intendente te, ami e arridi!

> O Light Eternal, who alone abidest in Thyself,
> alone knowest Thyself, and known to Thyself
> and knowing, lovest and smilest on Thyself![20]

As I have already mentioned, according to Catholic theology the concept of the Trinity can have only one explanation. Being a Catholic, Dante, therefore, accepts one and only one interpretation, the same one he proposes in his poem; but the way he does this is unique. His is an absolutely original reformulation in which the ideas are so integrated into the rhythm and phonic material of the lines that they manage to express not just the concept they are supposed to convey, but also the feeling of blissful contemplation that accompanies its comprehension—thus fusing referential and emotive value into an indissociable formal whole. Indeed, the theological notion so coheres to the manner in which it is expressed that, from now on, it will be impossible to find a more effectively pregnant formulation for it. Conversely, at every new reading of the tercet, the idea of the Trinity expands with new emotion and new

suggestions, and its meaning, though univocal, gets deeper and richer.

In the second passage, drawn from the fifth chapter of *Finnegans Wake,* Joyce is trying to describe a mysterious letter found in a heap of manure, whose meaning is undecipherable and obscure because it is multiform. The letter is a reflection of the *Wake* itself, or, rather, the linguistic mirror of its universe. To define it amounts to defining the very nature of the cosmos, as important to Joyce as the Trinity was to Dante. But whereas the Trinity of the *Divine Comedy* has only one possible meaning, the cosmos-*Finnegans Wake*-letter is a *chaosmos* that can be defined only in terms of its substantial ambiguity. The author must therefore speak of a nonunivocal object, by using nonunivocal signs and combining them in a nonunivocal fashion. The definition extends over a number of pages, though every sentence recasts the same basic idea, or rather the same network of ideas, from a different perspective. Let us choose one at random: "From quiqui quinet to michemiche chelet and a jambebatiste to a brulobrulo! It is told in sounds in utter that, in signs so adds to, in universal, in polygluttural, in each ausiliary neutral idiom, sordomutics, florilingua, sheltafocal, flayflutter, a con's cubane, a pro's tutute, strassarab, ereperse and anythongue athall." The chaotic character, the polyvalence, the multi-interpretability of this polylingual *chaosmos,* its ambition to reflect the whole of history (Quinet, Michelet) in terms of Vico's cycles ("jambebatiste"), the linguistic eclecticism of its primitive glossary ("polygluttural"), the smug reference to Bruno's torture by fire ("brulobrulo"), the two obscene allusions that join sin and illness in one single root, these are just some of the things this sentence manages to suggest— in a first, cursory reading—thanks to the ambiguity of different semantic roots and the disorder of its syntactic construction.

Semantic plurality is not enough to determine the aesthetic value of a work. And yet it is precisely the multiplicity of the roots that gives daring and suggestive power to the phonemes. In fact, a new semantic root is often suggested by the juncture of two sounds, so that, in the end, auditory material and referential repertory are indissolubly fused. On one side, the desire to produce an open, ambiguous communication affects the total organization of the discourse and determines both the density of its resonance and its provocative power; on the other, the formal organization of the

material and the proportional calibration of the relationship between its sounds and its rhythm reverberate against a backdrop of references and suggestions, thereby increasing their echoes. The result is an organic balance such that nothing can be extracted from the ensemble, not even the slightest etymological root.

Theoretically, both Dante's tercet and Joyce's sentence result from an analogous structural procedure: an ensemble of denotative and connotative meanings fuses with an ensemble of physical linguistic properties to produce an organic form. From an aesthetic standpoint, both forms are "open" in that they provoke an ever newer, ever richer enjoyment. But in Dante's case, the source of this pleasure is a univocal message, whereas in Joyce's it is a plurivocal message (not just in what it communicates but also in how it communicates it). Here, aesthetic pleasure is augmented by another value that the modern author is trying to attain—the same one that serial music is after when it attempts to free music from the compulsory tracks of tonality by multiplying the parameters along which sound may be organized and tasted; the same one that "informal painting" is after when it proposes different angles of approach for each and every painting; and the same one that the novel aims at when it no longer offers us one story and one plot per book but tries, rather, to alert us to the presence of more stories and more plots in the same book.

Theoretically, this value should not be confused with aesthetic value: to succeed aesthetically, the project of plurivocal communication must be incorporated into the right form, since this alone can endow it with the fundamental openness proper to all successful artistic forms. On the other hand, plurivocality is so much a characteristic of the forms that give it substance that their aesthetic value can no longer be appreciated and explained apart from it. In other words, it is impossible to appreciate an atonal composition without taking into consideration the fact that it wants to provide an alternative, an openness, to the fixed grammar, the closure, of tonal music and that its validity depends on the degree of its success in doing so.

This value, this second degree of openness to which contemporary art aspires, could also be defined as the growth and multiplication of the possible meanings of a given message. But few people are willing to speak of meaning in relation to the kind of commu-

nication provided by a nonfigurative pictorial sign or a constellation of sounds. This kind of openness is therefore best defined as an increase in information. Such a definition, however, forces us to move our investigation onto a different level and to demonstrate the validity of information theory in the field of aesthetics.

Openness, Information, Communication

In its advocacy of artistic structures that demand a particular in-volvement on the part of the audience, contemporary poetics merely reflects our culture's attraction for the "indeterminate," for all those processes which, instead of relying on a univocal, neces-sary sequence of events, prefer to disclose a field of possibilities, to create "ambiguous" situations open to all sorts of operative choices and interpretations.

To describe this singular aesthetic situation and properly define the kind of "openness" to which so much of contemporary poetics aspires, we are now going to make a detour into science, and more precisely into information theory, hoping it will provide us with a few indications that might prove useful to our research. There are two main reasons for this detour. In the first place, I believe that poetics in certain cases reflects, in its own way, the same cultural situation that has prompted numerous investigations in the field of information theory. Second, I believe that some of the methodo-logical tools employed in these investigations, duly transposed, might also be profitably used in the field of aesthetics (as we shall see, others have already done this). Some people will object that there can be no effective connections between aesthetics and infor-mation theory, and that to draw parallels between the two fields can only be a gratuitous, futile exercise. Possibly so. Before engaging in any kind of transposition, let us therefore examine the general principles of information theory with no reference to aesthetics, and only then decide whether there are any connections between the two fields and, if so, of what sort, and whether it might be profitable to apply to one the methodological instruments used in the other.

I

Information Theory

Information theory tries to calculate the quantity of information contained in a particular message. If, for instance, on August 4 the weather forecaster says, "Tomorrow, no snow," the amount of information I get is very limited; my own experience would have easily allowed me to reach that conclusion. On the other hand, if on August 4 the forecaster says, "Tomorrow, snow," then the amount of information I get is considerable, given the improbability of the event. The quantity of information contained in a particular message is also generally conditioned by the confidence I have in my sources. If I ask a real estate broker whether the apartment he has just shown me is damp or not and he tells me that it is not, he gives me very little information, and I remain as uncertain as I was before I asked him the question. On the other hand, if he tells me that the apartment *is* damp, against my own expectation and his own interest, then he gives me a great deal of information and I feel I have learned something relevant about a subject that matters to me.

Information is, therefore, an *additive* quantity, something that is added to what one already knows as if it were an original acquisition. All the examples I have just given, however, involved a vast and complex amount of information whose novelty greatly depended on the expectations of the receiver. In fact, information should be first defined with the help of much simpler situations that would allow it to be quantified mathematically and expressed in numbers, without any reference to the knowledge of a possible receiver. This is the task of information theory. Its calculations can suit messages of all sorts: numerical symbols, linguistic symbols, sound sequences, and so on.

To calculate the amount of information contained in a particular message, one must keep in mind that the highest probability an event will take place is 1, and the lowest is 0. The mathematical probability of an event therefore varies between 1 and 0. A coin thrown into the air has an equal chance of landing on either heads or tails; thus, the probability of getting heads is 1/2. In contrast, the chance of getting a 3 when rolling a die is 1/6. And the probability that two independent events will occur at the same time is the prod-

uct of their individual probabilities; thus, when rolling a pair of dice, the probability of getting a 1 and a 6 is 1/36.

The relationship between the number of possible events in a series and the series of probabilities connected to each of them is the same as that between an arithmetic progression and a geometric progression, and can be expressed by a logarithm, since the second series is the logarithm of the first. The simplest expression for a given quantity of information is the following:

$$\text{Information} = \log \frac{\text{odds that addressee will know content of message after receiving it}}{\text{odds that addressee will know content of message before receiving it}}.$$

In the case of the coin, if I am told that the coin will show heads, the expression will read:

$$\log_2 \frac{1}{\frac{1}{2}} = 1.$$

Information theory proceeds by binary choices, uses base 2 logarithms, and calls the unit of information a "bit," a contraction of "binary" and "digit." The use of a base 2 logarithm has one advantage: since $\log_2 2 = 1$, one bit of information is enough to tell us which of two probabilities has been realized. For a more concrete example, let's take a common 64-square chessboard with a single pawn on it. If somebody tells me that the pawn is on square number 48, the information I receive can be measured as follows: since, initially, my chances to guess the right square were 1/64, I can translate this into the expression $-\log_2 (1/64) = \log_2 64 = 6$. The information I have received is therefore 6 bits.[1]

To conclude, we can say that *the quantity of information conveyed by a given message is equal to the binary logarithm of the number of possibilities necessary to define the message without ambiguity.*[2]

To measure an increase or a decrease in information, theoreticians have borrowed a concept from thermodynamics that by now has become an integral part of the lexicon of information theory: the concept of entropy. The term has been bandied about long

enough for everyone to have heard of it and, in most cases, to have used it somewhat loosely. We should therefore take a fresh look at it, so as to divest it of all the more or less legitimate echoes it has carried over from thermodynamics. According to the second law of thermodynamics, formulated by Rudolf Clausius, although a certain amount of work can be transformed into heat (as stated by the first law), every time heat is transformed into work certain limitations arise to prevent the process from ever being fully completed. To obtain an optimum transformation of heat into work, a machine must provoke exchanges of heat between two bodies with different temperatures: a heater and a cooler. The machine draws a certain amount of heat from the heater but, instead of transforming it all into work, passes part of it on to the cooler. The amount of heat, Q, is then partly transformed into work, Q_1, and partly funneled into the cooler, $Q - Q_1$. Thus, the amount of work that is *transformed into* heat will be greater than the amount of work *derived from* a subsequent tranformation of heat into work. In the process, there has been a degradation, more commonly known as a consumption, of energy that is absolutely irreversible. This is often the case with natural processes: "Certain processes have only *one direction:* each of them is like a step forward whose trace can never be erased."[3] To obtain a general measure of irreversibility, we have to consider the possibility that nature favors certain states over others (the ones at the receiving end of an irreversible process), and we must find a physical measure that could quantify nature's preference for a certain state and that would increase whenever a process is irreversible. This measure is entropy.

The second law of thermodynamics, concerning the consumption of energy, has therefore become the law of entropy, so much so that the concept of entropy has often been associated with that of consumption, and with the theory stating that the evolution of all natural processes toward an increasing consumption and progressive degradation of energy will eventually result in the "thermic death" of the universe. And here it is important to stress, once and for all, that although in thermodynamics entropy is used to define consumption (thereby acquiring pessimistic connotations—whether or not it is reasonable to react emotionally to a scientific concept), in fact it is merely a *statistical measure* and, as such, a mathematically neutral instrument. In other words, en-

tropy is the measure of that state of maximal *equiprobability* toward which natural processes tend. This is why one can say that nature shows certain preferences: nature prefers greater uniformity to lesser uniformity, and heat moves from a warmer body to a cooler body because a state in which heat is equally distributed is more probable than a state in which heat is unequally distributed. In other words, the reciprocal speed of molecules tends toward a state of uniformity rather than toward a state of differentiation, in which certain molecules move faster than others and the temperature is constantly changing. Ludwig Boltzmann's research on the kinetic theory of gases demonstrated that nature tends toward an elemental disorder of which entropy is the measure.[4]

It is, therefore, important to insist on the *purely statistical* character of entropy—no less purely statistical than the principle of irreversibility, whereby, as proved by Boltzmann, the process of reversion within a closed system is not impossible, only improbable. The collisions of the molecules of a gas are governed by statistical laws which lead to an average equalization of differences in speed. When a fast molecule hits a slow one, it may occasionally happen that the slow molecule loses most of its speed and imparts it to the fast one, which then travels away even faster; but such occurrences are exceptions. In the overwhelming number of collisions, the faster molecule will lose speed and the slower one will gain it, thus bringing about a more uniform state and an increase in elemental disorder.

As Hans Reichenbach has written, "The law of the increase of entropy is guaranteed by the law of large numbers, familiar from statistics of all kinds, but it is not of the type of the strict laws of physics, such as the laws of mechanics, which are regarded as exempt from possible exceptions."[5]

Reichenbach has provided us with the clearest and simplest explanation of how the concept of entropy has passed from the theory of energy consumption to that of information. The increase in entropy that generally occurs during physical processes does not exclude the possibility of other physical processes (such as those we experience every day, since most organic processes seem to belong to this category) that entail an organization of events running counter to all probability—in other words, involving a decrease in entropy. Starting with the entropy curve of the universe, Reichen-

bach calls these decreasing phases, characterized by an interaction of events that leads to a new organization of elements, *branch systems,* to indicate their deviation from the curve.

Consider, for example, the chaotic effect (resulting from a sudden imposition of uniformity) of a strong wind on the innumerable grains of sand that compose a beach: amid this confusion, the action of a human foot on the surface of the beach constitutes a complex interaction of events that leads to the statistically very improbable configuration of a footprint. The organization of events that has produced this configuration, this *form,* is only temporary: the footprint will soon be swept away by the wind. In other words, a deviation from the general entropy curve (consisting of a decrease in entropy and the establishment of *improbable order*) will generally tend to be reabsorbed into the universal curve of increasing entropy. And yet, for a moment, the elemental chaos of this system has made room for the appearance of an order, based on the relationship of cause and effect: the cause being the series of events interacting with the grains of sand (in this case, the human foot), and the effect being the organization resulting from it (in this case, the footprint).

The existence of these relationships of cause and effect in systems organized according to decreasing entropy is at the basis of memory. Physically speaking, memory is a record (an imprint, a print), an "ordered macroarrangement, the order of which is preserved: a frozen order, so to speak."[6] Memory helps us reestablish causal links, reconstruct facts. "Since the second law of thermodynamics leads to the existence of records of the past, and records store information, it is to be expected that *there is a close relationship between entropy and information.*"[7]

We shouldn't, therefore, be too surprised by the frequent use of the term "entropy" in information theories, since to measure a quantity of information means nothing more than to measure the levels of order and disorder in the organization of a given message.

The Concept of Information in the Work of Norbert Wiener

For Norbert Wiener—who has relied extensively on information theory for his research in cybernetics, that is, in his investigation of the possibilities of control and communication in human beings

and machines—the informative content of a message is given by the degree of its organization. Since information is a measure of order, the measure of disorder, that is to say, entropy, must be its opposite. Which means that the information of a message depends on its ability to elude, however temporarily, the equiprobability, the uniformity, the elemental disorder toward which all natural events seem destined, and to organize according to a particular order. For instance, if I throw in the air a bunch of cubes with different letters printed on their faces, once they hit the ground they will probably spell out something utterly meaningless—say, AAASQMFLLNSUHOI. This sequence of letters does not tell me anything in particular. In order to tell me something, it would have to be organized according to the orthographic and grammatical laws of a particular language—in other words, it would have to be organized according to a particular linguistic *code*. A language is a human event, a typical *branch system* in which several factors have intervened to produce a state of order and to establish precise connections. In relation to the entropy curve, language—an organization that has escaped the equiprobability of disorder—is another *improbable* event, a naturally improbable configuration that can now establish its own *chain of probability* (the probabilities on which the organization of a language depends) within the system that governs it. This kind of organization is what allows me to predict, with a fair amount of certainty, that in an English word containing three consonants in a row the next letter will be a vowel. The tonal system, in music, is another language, another code, another *branch system*. Though extremely improbable when compared to other natural acoustic events, the tonal system also introduces, within its own organization, certain criteria of probability that allow one to predict, with moderate certainty, the melodic curve of a particular sequence of notes, as well as the specific place in the sequence where the tonic accent will fall.

In its analysis of communication, information theory considers messages as organized systems governed by fixed laws of probability, and likely to be disturbed either from without or from within (from the attenuation of the text itself, for instance) by a certain amount of disorder, of communication consumption—that is to say, by a certain increase in entropy commonly known as "noise." If the meaning of the message depends on its organization accord-

ing to certain laws of probability (that is, laws pertaining to the linguistic system), then "dis-order" is a constant threat to the message itself, and entropy is its measure. In other words, *the information carried by a message is the negative of its entropy.*[8]

To protect the message against consumption so that no matter how much noise interferes with its reception the gist of its meaning (of its order) will not be altered, it is necessary to "wrap" it in a number of conventional reiterations that will increase the probability of its survival. This surplus of reiterations is what we commonly call "redundancy." Let's say I want to transmit the message "Mets won" to another fan who lives on the other side of the Hudson. Either I shout it at him with the help of a loudspeaker, or I have it wired to him by a possibly inexperienced telex operator, or I phone it to him over a static-filled line, or I put a note in the classic bottle and abandon it to the whims of the current. One way or another, my message will have to overcome a certain number of obstacles before it reaches its destination; in information theory, all these obstacles fall under the rubric "noise." To make sure that neither the hapless telex operator nor a water leak is going to turn my victorious cry into the rather baffling "Met swan," or the more allusive "Met Swann," I can add "Red Sox lost," at which point, whether the message reaches my friend or not, its meaning will probably not be lost.

According to a more rigorous definition, "redundancy," within a linguistic system, results from a set of syntactic, orthographic, and grammatical laws. As a system of preestablished probabilities, language is a *code of communication.* Pronouns, particles, inflections—all these linguistic elements tend to enrich the organization of a message and make its communication more probable. It might be said that even vowels can contribute to the redundancy of a message, because they facilitate (and make more probable) one's ability to distinguish and to comprehend the consonants in a word. The sequence of consonants *bldg* suggests the word "building" more clearly than the vowels *uii;* on the other hand, the insertion of these three vowels between the consonants makes the word easier to utter and to understand, thus increasing its comprehensibility. When information theorists say that 50 percent of the English language consists of redundancy, what they mean is that only 50 percent of what is said concerns the message to be communicated, while the other

50 percent is determined by the statistical structure of the language and functions as a supplementary means of clarification. When we speak of a "telegraphic style," we generally refer to a message that has been stripped of most of its redundancy (pronouns, articles, adverbs)—that is, of all that is not strictly necessary to its communication. On the other hand, in a telegram the lost redundancy of the message is replaced by another set of conventions also aiming at facilitating its communication by constituting a new form of probability and order. Indeed, linguistic redundancy is so dependent on a particular system of probability that a statistical study of the morphological structure of words from any language would yield an x number of frequently recurring letters which, when arranged in random sequences, would reveal some traits of the language from which they have been taken.[9]

Yet this also means that the very order which allows a message to be understood is also what makes it absolutely predictable—that is, extremely banal. The more ordered and comprehensible a message, the more predictable it is. The messages written on Christmas cards or birthday cards, determined by a very limited system of probability, are generally quite clear but seldom tell us anything we don't already know.

The Difference between Meaning and Information

All of the above seems to invalidate the assumption, supported by Wiener's book, that the *meaning* of a message and the *information* it carries are synonymous, strictly related to the notions of *order* and *probability* and opposed to those of entropy and disorder.

But, as I have pointed out, the quantity of information conveyed by a message also depends on its source. A Christmas card sent by a Soviet official would, by virtue of its improbability, have a much higher information value than the same card sent by a favorite aunt. Which again confirms the fact that information, being essentially additive, depends for its value on both originality and improbability. How can this be reconciled with the fact that, on the contrary, the more meaningful a message, the more probable and the more predictable its structure? A sentence such as "Flowers bloom in the spring" has a very clear, direct meaning and a maximal power of communication, but it doesn't add anything to what we already

know. In other words, it does not carry much information. Isn't this proof enough that *meaning and information are not one and the same thing?*

Not so, according to Wiener, who maintains that information means *order* and that entropy is its opposite. Wiener, however, is using information theory to explore the power of communication of an electronic brain, in order to determine what makes a message comprehensible. He is not concerned with the differences between information and meaning. And yet, at a particular point in his work, he makes an interesting declaration: "A piece of information, in order to contribute to the general information of a community, must say something substantially different from the community's previous common stock of information." To illustrate this point, he cites the example of great artists, whose chief merit is that they introduce new ways of saying or doing into their community. He explains the public consumption of their work as the consequence of the work's inclusion within a collective background—the inevitable process of popularization and banalization that occurs to any novelty, any original work, the moment people get used to it.[10]

On reflection, one sees that this is precisely the case with everyday speech, whose very power of communication and information seems to be directly proportional to the grammatical and syntactic rules it constantly eludes—the very same rules deemed necessary to the transmission of meaning. It often happens that in a language (here taken to mean a system of probability), certain elements of disorder may in fact increase the level of information conveyed by a message.

Meaning and Information in the Poetic Message

This phenomenon, the direct relationship between disorder and information, is of course the norm in art. It is commonly believed that the poetic word is characterized by its capacity to create unusual meanings and emotions by establishing new relationships between sounds and sense, words and sounds, one phrase and the next—to the point that an emotion can often emerge even in the absence of any clear meaning. Let's imagine a lover who wants to express his feelings according to all the rules of probability imposed on him by his language. This is how he might speak: "When I try

to remember events that occurred a long time ago, I sometimes think I see a stream, a stream of smoothly flowing, cool, clear water. The memory of this stream affects me in a particular way, since the woman I then loved, and still love, used to sit on its banks. In fact, I am still so much in love with this woman that I have a tendency, common among lovers, to consider her the only female individual existing in the world. I should add, if I may, that the memory of this stream, being so closely connected to the memory of the woman I love (I should probably mention that this woman is very beautiful), has the power to fill my soul with sweetness. As a result, following a procedure that is also fairly common among lovers, I like to transfer this feeling of sweetness to the stream that indirectly causes me to feel it, and attribute the emotion to it as if the sweetness were really a quality of the stream. This is what I wanted to tell you. I hope I have explained myself clearly." This is how the lover's sentence would sound if, afraid of not being able to communicate exactly what he wants to say, he were to rely on all the rules of redundancy. Although we would certainly understand what he says, we would probably forget it shortly thereafter.

But if the lover were Petrarch, he would do away with all the conventional rules of construction, shun all logical transitions, disdain all but the most daring metaphors, and, refusing to tell us that he is describing a memory but using the past tense to suggest it, he would say: "Chiare, fresche e dolci acque—dove le belle membra—pose colei che sola a me par donna" ("Clear, fresh and sweet waters where she who alone to me seems woman rested her lovely limbs").[11] In fewer than twenty words, he would also succeed in telling us that he still loves the woman he remembers, and would manage to convey the intensity of his love through a rhythm whose liveliness imbues the memory with the immediacy of a cry or a vision. Nowhere else have we thus savored the sweetness and violence of love and the languor of memory. This communication allows us to accumulate a large capital of information about both Petrarch's love and the essence of love in general. Yet from the point of view of *meaning,* the two texts are absolutely identical. It is the second one's originality of organization—that is, its deliberate disorganization, *its improbability in relation to a precise system of probability*—which makes it so much more informative.

At this point, of course, one could easily object that it is not just

the amount of unpredictability that charms us in a poetic discourse. If that were the case, a nursery rhyme such as "Hey diddle diddle / The cat and the fiddle / The cow jumped over the moon" would be considered supremely poetic. All I am trying to prove here is that *certain unorthodox uses* of language can often result in poetry, whereas this seldom, if ever, happens with more conventional, probable uses of the linguistic system. That is, it will not happen unless the novelty resides in what is said rather than in how it is said, in which case a radio broadcast that announces, according to all the rules of redundancy, that an atomic bomb has just been dropped on Rome will be as charged with news as one could wish. But this sort of information does not really have much to do with a study of linguistic structures (and even less with their aesthetic value—further evidence that aesthetics cares more about *how* things are said than about *what* is said). Besides, whereas Petrarch's lines can convey a certain amount of information to any reader, including Petrarch, the radio broadcast concerning the bombing of Rome would certainly carry no information to the pilot who has dropped the bomb or to all those listeners who heard the announcement during a previous broadcast. What I want to examine here is the possibility of conveying a piece of information that is not a common "meaning" by *using conventional linguistic structures to violate the laws of probability that govern the language from within.* This sort of information would, of course, be connected not to a state of order but to a state of disorder, or, at least, to some *unusual and unpredictable non-order.* It has been said that the positive measure of such a kind of information is entropy; on the other hand, if entropy is disorder to the highest degree, containing within itself *all* probabilities and *none,* then the information carried by a message (whether poetic or not) that has been intentionally organized will appear only as a very particular form of disorder, a "dis-order" that is such only in relation to a preexisting order. But can one still speak of entropy in such a context?

The Transmission of Information

Let us now briefly turn to the classic example of the kinetic theory of gas, and imagine a container full of molecules all moving at a uniform speed. Since the movement of these molecules is deter-

mined by purely statistical laws, the entropy of the system is very high, so that although we can predict the general behavior of the entire system, it is very difficult to predict the trajectory of any particular molecule. In other words, the molecule can behave in a variety of ways, since it is full of possibilities, and we know that it can occupy a large number of positions, but we do not know which ones. To have a clearer idea of the behavior of each molecule, it would be necessary to differentiate their speeds—that is, to introduce an order into the system so as to decrease its entropy. In this way we would increase the probability that a molecule might behave in a particular manner, but we would also limit its initial possibilities by submitting them to a *code*.

If I want to know something about the behavior of a single molecule, I am seeking the kind of information that *goes against* the laws of entropy. But if I want to know all the possible behaviors of any given molecule, then *the information I am seeking will be directly proportional to the entropy of the system*. By organizing the system and decreasing its entropy, I will simultaneously learn a great deal and not much at all.

The same thing happens with the transmission of a piece of information. I shall try to clarify this point by referring to the formula that generally expresses the value of a piece of information: $I = N \log h$, in which h stands for the number of elements among which we can choose, and N for the number of choices possible (in the case of a pair of dice, $h = 6$ and $N = 2$; in the case of a chessboard, $H = 64$ and $N =$ all the moves allowed by the rules of chess).

Now, in a system of high entropy, in which all the combinations can occur, the values of N and h are very high; also very high is the value of the information that could be transmitted concerning the behavior of one or more elements of the system. But it is quite difficult to communicate as many binary choices as are necessary to distinguish the chosen element and define its combinations with other elements.

How can one facilitate the communication of a certain bit of information? By reducing the number of the elements and possible choices in question: by introducing a code, a system of rules that would involve a fixed number of elements and that would exclude some combinations while allowing others. In such a case, it would

be possible to convey information by means of a reasonable number of binary choices. But in the meantime, the values of N and h would have decreased, and, as a result, so would the value of the information received.

Thus, the larger the amount of information, the more difficult its communication; the clearer the message, the smaller the amount of information.

For this reason Shannon and Weaver, in their book on information theory, consider information as directly proportional to entropy.[12] The role played by Shannon—one of the founders of the theory—in the research on this particular question has been particularly acknowledged by other scholars in the field.[13] On the other hand, they all seem to insist on the distinction between information (here taken in its strictest statistical sense as the measure of a possibility) and the actual validity of a message (here taken as meaning). Warren Weaver makes this particularly clear in an essay aiming at a wider diffusion of the mathematics of information: "The word *information,* in this theory, is used in a special sense that must not be confused with its ordinary usage. In particular, *information* must not be confused with meaning . . . To be sure, this word information in communication theory relates not so much to what you do say, as to what you could say. That is, information is a measure of one's freedom of choice when one selects a message . . . Note that it is misleading (although often convenient) to say that one or the other message conveys unit information. The concept of information applies not to the individual messages (as the concept of meaning would), but rather to the situation as a whole . . . [A mathematical theory of communication] deals with a concept of information which characterizes the whole statistical nature of the information source, and is not concerned with the individual messages . . . The concept of information developed in this theory at first seems disappointing and bizarre—disappointing because it has nothing to do with meaning, and bizarre because it deals not with a single message but rather with the statistical character of a whole ensemble of messages, bizarre also because in these statistical terms the two words *information* and *uncertainty* find themselves to be partners."[14]

Thus, this long digression concerning information theory finally leads back to the issue at the heart of our study. But before going back to it, we should again wonder whether in fact certain concepts borrowed from information theory as tools of investigation can le-

gitimately be applied to questions of aesthetics—if only because it is now clear that "information" has a far wider meaning in *statistics* than in *communication*. Statistically speaking, I have information when I am made to confront all the probabilities at once, before the establishment of any order. From the point of view of communication, I have information when (1) I have been able to establish an order (that is, a code) as a system of probability within an original disorder; and when (2) within this new system, I introduce—through the elaboration of a message that violates the rules of the code—elements of disorder in dialectical tension with the order that supports them (the message challenges the code).

As we proceed with our study of poetic language and examine the use of a disorder aiming at communication, we will have to remember that this particular disorder can no longer be identified with the statistical concept of entropy except in a roundabout way: the disorder that aims at communication is a disorder only in relation to a previous order.

II

Poetic Discourse and Information

The example of Petrarch should have helped us understand that the originality of an aesthetic discourse involves to some extent a rupture with (or a departure from) the linguistic system of probability, which serves to convey established meanings, in order to increase the signifying potential of the message. This sort of information, characteristic of every aesthetic message, coincides with the basic openness of all works of art, as discussed in the previous chapter.

Let us now turn to contemporary art and the ways in which it deliberately and systematically tries to increase its range of meanings.

According to the laws of redundancy, the probability that the article "the" will be followed by a noun or an adjective is extremely high. Similarly, after the phrase "in the event" the probability that "that" will be the next word is fairly high, whereas the probability that "elephant" will be the next word is very low. At least, this is true for the type of English we commonly use. Weaver gives numerous examples of this kind and concludes by saying that, in everyday language, a sentence such as "Constantinople fishing

nasty pink" is quite improbable.[15] And yet such a sentence could be a perfect example of automatic writing as it was practiced by the Surrealists.

Let us now look at a poem by Giuseppe Ungaretti, entitled "L'Isola" ("The Island").

> A una proda ove sera era perenne
> di anziane selve assorte, scese
> e s'inoltrò
> e lo richiamò rumore di penne
> ch'erasi sciolto dallo stridulo
> batticuore dell'acqua torrida . . .

> On a shore where evening was for ever
> Of woods enrapt and ancient, he descended,
> And advanced
> And the sound of wings recalled him,
> Sound unfettered from the shrill
> Heartbeat of the torrid water. . .[16]

There is no need to point out the various ways in which these few lines violate all linguistic probability, or to launch into a protracted critical analysis of the poem to show how, despite its lack of any conventional kind of meaning, it still conveys an immense amount of information about the island. At every new reading, this amount of information increases, endlessly expanding the message of the poem and opening up new and different perspectives, in perfect accordance with the intention of the poet who, while writing, was well aware of all the associations that an uncommon juxtaposition of words would provoke in the mind of the reader.

In other words, and to avoid overusing the technical terminology of information theory, what we most value in a message is not "information" but its aesthetic equivalent: its "poetic meaning," its "quotient of imagination," the "full resonance of the poetic word"—all those levels of signification that we distinguish from common meaning. From this point on if I use the term "information" to indicate the wealth of aesthetic meaning contained in a given message, it will be only to highlight those analogies that I deem most interesting.[17]

To avoid any possible ambiguity, I shall again emphasize that the equation "information = opposite of meaning" has absolutely no

axiological function, nor could it be used as a parameter of judgment. If it could, the nursery rhyme "Hey diddle diddle / The cat and the fiddle" would have greater aesthetic value than a poem by Petrarch, just as any Surrealist *cadavre exquis* (as well as any nasty pink from Constantinople) would have greater worth than a poem by Ungaretti. The concept of information is useful here only to clarify one of the directions of aesthetic discourse, which is then affected by other organizing factors. That is, all deviation from the most banal linguistic order entails a new kind of organization, *which can be considered as disorder in relation to the previous organization, and as order in relation to the parameters of the new discourse.* But whereas classical art violated the conventional order of language *within well-defined limits,* contemporary art constantly challenges the initial order by means of an extremely "improbable" form of organization. In other words, whereas classical art introduced original elements within a linguistic system whose basic laws it substantially respected, contemporary art often manifests its originality by imposing *a new linguistic system* with its own inner laws. In fact, one might say that rather than imposing a new system, contemporary art constantly oscillates between the rejection of the traditional linguistic system and its preservation—for if contemporary art imposed a totally new linguistic system, then its discourse would cease to be communicable. The dialectic between *form* and the *possibility* of multiple meanings, which constitutes the very essence of the "open work," takes place in this oscillation. The contemporary poet proposes a system which is no longer that of the language in which he expresses himself, yet that system is not a nonexistent language;[18] he introduces forms of organized disorder into a system to increase its capacity to convey information.

It is clear that the signifying power of Petrarch's poem is as great as that of any contemporary poem: at each new reading it discloses something new, something previously unnoticed. But let us look at another lyric poem, a contemporary love poem, probably one of the most beautiful ever written, "Le front aux vitres," by Paul Eluard.

> Le front aux vitres comme font les veilleurs de chagrin
> Ciel dont j'ai dépassé la nuit

Plaines toutes petites dans mes mains ouvertes
Dans leur double horizon inerte indifférent
Le front aux vitres comme font les veilleurs de chagrin

Je te cherche par delà l'attente
Je te cherche par delà moi-même
Et je ne sais plus tant je t'aime
Lequel de nous deux est absent.

With brow against the windowpane like those who keep
 sorrowful vigil
Sky whose night I've left behind
Plains so small in my open hands
In their double horizon inert indifferent
With brow against the windowpane like those who keep
 sorrowful vigil

I seek you beyond the waiting
I seek you beyond myself
And I no longer know, so deeply do I love you,
Which of the two of us is absent.

The emotional situation expressed in this poem is fairly similar to that of "Chiare, fresche e dolci acque"; on the other hand, aside from the absolute aesthetic value of the two poems, their communication procedures are completely different. In Petrarch, the partial rupture of the order of the linguistic code introduces a new, unidirectional order which, along with its original organization of phonic, rhythmic, and syntactic elements, conveys a rather ordinary message that can be understood in only one way. In Eluard, on the contrary, it is obvious that the intention is precisely to draw as much poetic meaning as possible out of the very ambiguity of the message: the poet produces emotional tension by suggesting various gestures and emotions from which the reader can choose the ones that, by stimulating his own mental associations, best enable him to participate in the emotional situation evoked by the poem.

What all this means is that the contemporary poet constructs his or her poetic message with devices and according to procedures unlike those used by the medieval poet. Once again, the results are

not at issue here. To analyze a work of art in terms of the amount of information it conveys is not the same as evaluating its aesthetic success, but merely a way of clarifying some of the characteristics and resources of its ability to communicate.[19]

Musical Discourse

Let us now transpose all that has just been said onto a musical level: a classical sonata represents a system of probability that makes the succession and superposition of themes easily predictable. The tonal system institutes other rules of probability, whereby the pleasure and the attention of the listener are stimulated by his expectation of the inevitable resolutions of certain tonal progressions. In both cases, the composer can repeatedly break away from the established scheme of probability and introduce a potentially infinite number of variations into even the most elementary scale. The twelve-tone system is just another system of probability. Not so the more contemporary serial compositions, in which the musician chooses a constellation of sounds that can lend themselves to a variety of possible connections. Thus, he breaks away from the banal order of tonal probability and institutes a degree of disorder that, compared to the initial order, is quite high. By so doing, however, he also introduces new forms of organization which, being more open than the traditional one and therefore more charged with information, permit the development of new types of discourse and, as a result, new meanings. Here again, we are confronting a poetics which, aiming at a greater availability of information, makes of this availability its very method of construction. This, of course, has absolutely no effect on the aesthetic result: a thousand awkward constellations of sounds that have broken away from the tonal system may well provide less information and satisfaction than *Eine kleine Nachtmusik*. Nevertheless, it is important to remember that the main objective of this new music is the creation of new discursive structures that will remain open to all sorts of possible conclusions.

In a letter to Hildegard Jone, Webern writes: "I have discovered a *series* [that is to say, twelve sounds] that includes a number of internal connections, not unlike that old formula

```
S   A   T   O   R
A   R   E   P   O
T   E   N   E   T
O   P   E   R   A
R   O   T   A   S
```

which should be first read horizontally, then vertically, from top to bottom, and from bottom to top." [20] It is rather odd that, to give an idea of his constellation, Webern should have used the same formula used by information theorists to establish the statistical possibilities of two or more series of letters combining, each time yielding a different message. The model is, of course, that of the crossword puzzle, except that, for Webern, this technical stratagem is only *one* means by which a musical discourse can be organized, whereas for crossword puzzles such a combination is the only point of arrival.

A constellation is itself a kind of order; for although the poetics of openness seeks to make use of a dis-ordered source of possible messages, it tries to do this without renouncing the transmission of an organized message. The result is a continuous oscillation between the institutionalized system of probability and sheer disorder: in other words, *an original organization of disorder.* Weaver is well aware of this sort of oscillation, by which an increase in meaning involves loss of information, and vice versa: "One has the vague feeling that information and meaning may prove to be something like a pair of canonically conjugate variables in quantum theory, they being subject to some joint restriction that condemns a person to the sacrifice of the one as he insists on having much of the other." [21]

Information, Order, and Disorder

In his collection of essays titled *Information Theory and Esthetic Perception,* Abraham Moles has systematically applied information theory to music. [22] He clearly accepts the notion that information is directly proportional to unpredictability and sharply distinct from meaning. What intrigues him most is the ambiguous message— that is, the message which is at once particularly rich in information and yet very difficult to decode. We have already encountered this

problem: the highest level of unpredictability depends on the highest level of disorder, where not only the most common meanings but every possible meaning remains essentially unorganizable. Obviously, this is the problem that confronts all music aiming at the absorption of every possible sound, the broadening of the available scale, and the intervention of chance in the process of composition. The dispute between the supporters of avant-garde music and its critics concerns precisely the greater or lesser comprehensibility of a sound event whose complexity transcends all the habits of the human ear and every system of probability.[23] Insofar as we are concerned, the problem still involves a dialectic between form and openness, between free multipolarity and permanence, which inevitably characterizes the system of possibilities of a work of art.

According to information theory, the most difficult message to communicate is the one that, relying on a wider range of sensibility on the part of the receiver, will avail itself of a larger channel, more likely to allow the passage of numerous elements without *filtering them*—that is, a channel capable of conveying a great deal of information but with the risk of limited intelligibility. When, in his *Philosophy of Composition,* Edgar Allan Poe defines a good poem as one that can be read at one sitting (so as not to ruin its intended effect with interruptions and postponements), he is in fact considering the reader's capacity to receive and assimilate poetic information. The question of the limits of a work of art, often broached by early aesthetics, is much less banal than it might seem, since it already reveals a certain concern with the interactive relationship between the human subject and an objective mass of stimuli organized into comprehensible effects. In Moles's study, this question, enriched by more recent discoveries in the fields of psychology and phenomenology, becomes the question of the "*difference threshold* in the perception of duration." Given a brief succession of melodic data reiterated at ever-increasing velocity, there soon will be a moment when the ear, having reached saturation, ceases to perceive distinct sounds and hears an undifferentiated sonic mixture. This measurable threshold represents an insurmountable limit, and is, in itself, further evidence of the fact that a disorder which is not specifically aimed at subjects accustomed to moving among systems of probability will not convey any information. This tendency toward disorder, characteristic of the poetics of openness, must be understood

as a tendency toward *controlled* disorder, toward a circumscribed *potential,* toward a freedom that is constantly curtailed by *the germ of formativity* present in any form that wants to remain open to the free choice of the addressee.

The distance between a plurality of formal worlds and undifferentiated chaos, totally devoid of all possibility of aesthetic pleasure, is minimal: only a dialectics of oscillation can save the composer of an open work.

A case in point is that of the composer of electronic music who, finding the unlimited realm of sounds and noises entirely at his disposal, can suddenly be quite overwhelmed by it: he wants to offer his listener the full and complex freedom of his compositions, but cannot help referring to the editing and mixing of his material, and using abscissas to channel basic disorder into matrices of oriented potential. In the end, as Moles points out, there is no real difference between *noise* and *signal,* except in intent. Similarly, in electronic music, the difference between *noise* and *sound* is resolved by the voluntary act of the creator, who *offers* his audience a medley of sounds *to interpret.* But if he aims at both maximum dis-order and maximum information, he will have to sacrifice some of his freedom and introduce a few modules of order into his work, which will help his listeners find their way through noise that they will automatically interpret as a signal because they know it has been chosen and, to some extent, organized.[24]

Like Weaver, Moles believes he can recognize a system of indeterminacy whereby information decreases as intelligibility increases. But he goes further: considering indeterminacy as a constant in the natural world, he expresses it with a formula that reminds him of the one used to express uncertainty in quantum physics. For if the methodology and logic of indeterminacy, borrowed from scientific disciplines, are cultural phenomena that may affect the formulation of poetics without being able to explain it, this second kind of indeterminacy, based on the correlation between freedom and intelligibility, can no longer be considered as a more or less distant influence of science on art, but should rather be seen as the specific condition of a productive dialectics—or, to use Apollinaire's expression, the constant struggle "de l'ordre et de l'aventure," the only condition by which a poetics of openness can also be a poetics of art.

Postscript

All these points need further clarification. It would indeed be possible to show that the mathematical concept of information cannot be applied to the poetic message, or to any other message, because information (qua entropy and coexistence of *all* possibilities) is a characteristic of the *source* of messages: the moment this initial equiprobability is filtered, there is selection and therefore order, and therefore meaning.

This objection is perfectly correct if we consider information theory only as a complex of mathematical rules used to measure the transmission of bits from a source to a receiver. But the moment the transmission concerns information among human beings, information theory becomes a *theory of communication,* and we need to establish whether concepts borrowed from a technique used to quantify information (that is, a technique concerned with the physical exchange of signals considered independently from the meanings they convey) can be applied to human communication.

A source of information is always a locus of high entropy and absolute availability. The transmission of a message implies the selection of some information and its organization into a signifying complex. At this point, if the receiver of the information is a machine (programmed to translate the signals it receives into messages that can be rigorously referred back to a particular code, according to which every signal signifies one and only one thing), either the message has a univocal meaning or it is automatically identified with noise.

Things are, of course, quite different in a transmission of messages between people, where every given signal, far from referring univocally to a precise code, is charged with connotations that make it resound like an echo chamber. In this case, a simple referential code according to which every given signifier corresponds to a particular signified is no longer sufficient. Far from it, for, as we have already seen, the author of a message with aesthetic aspirations will intentionally structure it in as ambiguous a fashion as possible precisely in order to violate that system of laws and determinations which makes up the code. We then confront a message that deliberately violates or, at least, questions the very system, the very order—*order as system of probability*—to which it refers. In other

words, the ambiguity of the aesthetic message is the result of the deliberate "dis-ordering" of the code, that is, of the order that, via selection and association, had been imposed on the entropic disorder characteristic of all sources of information. Consequently, the receiver of such a message, unlike its mechanical counterpart that has been programmed to transform a sequence of signals into messages, can no longer be considered as the final stage of a process of communication. Rather, he should be seen as the first step of a new chain of communication, since the message he has received is in itself another *source of possible information,* albeit a source of information that is yet to be filtered, interpreted, out of an initial disorder—not absolute disorder but nonetheless *disorder in relation to the order that has preceded* it. As a new source of information, the aesthetic message possesses all the characteristics proper to the *source* of a normal informative chain.

Of course, all this quite expands the general notion of information; but the important thing here is less the analogy between two different situations than the fact that they share the same procedural structure. A message, at the outset, is a disorder whose latent meanings must be filtered before they can be organized into a new message—that is, before they can become not a work to be interpreted but an interpreted work (for example, *Hamlet* is a source of possible interpretations whereas Ernest Jones's reading of *Hamlet,* or T. S. Eliot's for that matter, is an interpreted message that has condensed a disordered quantity of information into an arrangement of selected meanings).

Obviously, neither this filtered information nor the informative capacity of the source-message can be precisely quantified. And this is where and why information theory becomes a theory of communication: it preserves a basic categorial scheme but it loses its algorithmic system. In other words, information theory provides us with only one scheme of possible relations (order-disorder, information-signification, binary disjunction, and so on) that can be inserted into a larger context, and is valid, in its specific ambit, only as the quantitative measurement of the number of signals that can be clearly transmitted along one channel. Once the signals are received by a human being, information theory has nothing else to add and gives way to either semiology or semantics, since the question henceforth becomes one of signification—the kind of signifi-

cation that is the subject of semantics and that is quite different from the banal signification that is the subject of information. On the other hand, it is precisely the existence of open works (that is to say, of the openness proper to works of art, the existence of messages which manifest themselves as sources of possible interpretations) that requires an extension of the notion of information.

It would be fairly simple to show that information theory was not conceived to explain the nature of the poetic message and that, therefore, it is not applicable to processes involving both the denotative and connotative aspects of language—so simple that everybody would immediately agree with the proposition. On the other hand, it is precisely because information theory *cannot* and *should not* be applied to aesthetic phenomena that numerous scholars have tried to apply it to the field of aesthetics; likewise, it is precisely because information theory is not applicable to processes of signification that some have tried to use it to explain linguistic phenomena. Indeed, it is precisely because in their original usage the concepts pertaining to information theory have nothing to do with a work of art that, in this essay, I have tried to determine to what extent they can be applied to it. Of course, if they had been applicable to begin with, there would be no point in trying to find out whether they could be applied or not. On the other hand, the only reason I want to find out is that I think that, in the end, a work of art can be analyzed like any other form of communication. In other words, I believe that, ultimately, the mechanism that underlies a work of art (and this is what needs to be verified) *must* reveal the same behavior that characterizes the mechanisms of communication, including those types of behavior that involve the mere transmission, along one channel, of signals devoid of all connotative meaning, which can be received by a machine as instructions for a sequence of operations based on a preordained code capable of establishing a univocal correspondence between a given signal and a given mechanical or electronic behavior.

On the other hand, the objection would be insuperable if the following points were not now clear:

1. The application to aesthetics of concepts borrowed from information theory has not generated the idea of the open, polyvalent, ambiguous work of art. Rather, it is the ambiguity and polyvalence of every work of art that has induced some scholars to

consider informational categories as particularly apt to explain the phenomenon.

2. The application of informational categories to phenomena of communication has by now been endorsed by a number of scholars, from Jakobson, who applied the idea of *integrated parallelism* to linguistic phenomena, to Piaget and his followers, who have applied the concepts of information theory to perception, all the way to Lévi-Strauss, Lacan, the Russian semiologists, Max Bense, advocates of the Brazilian new criticism, and so on. Such a fertile interdisciplinary and international consensus cannot be seen as a mere fad or a daring extrapolation. What we are confronting here is a categorial apparatus that may provide the key to several doors.

3. On the other hand, even if we were confronting mere analogical procedures or uncontrolled extrapolations, we would have to admit that knowledge often progresses thanks to an imagination that explores hypotheses and dares to take uncertain shortcuts. Too much rigor and an excess of honest caution can often deter one from venturing along paths that could well be dangerous but that could also lead to a plateau whence an entire new landscape would open up, with roads and highways that might have escaped a first, cursory topographic inspection.

4. The categorial apparatus of information theory appears methodologically fruitful only when inserted in the context of a *general semiotics* (although researchers are only now beginning to realize this). Before rejecting informational notions, one must verify them in the light of a semiotic rereading.

Such a semiotic endeavor could not, of course, be encompassed in this essay. The objections I have tried to answer in this postscript were for the most part raised by Emilio Garroni, author of one of the few exhaustive and scientifically sound critiques of *Opera aperta*.[25] And I do not pretend to have satisfactorily answered all his objections here. These comments are intended, in fact, to supply this essay, which still maintains its original structure despite numerous revisions, with a few answers to possible future objections. They are also designed to show how some of these answers were already implicit in the original argument, even though I did not make them explicit until stimulated by Garroni's observations. It is thanks to these observations that I have been motivated to explore this issue further.

III

Information and Psychological Transaction

I hope that this discussion has demonstrated how a mathematical study of information can provide the tools necessary for elucidating and analyzing aesthetic structures, and how it reflects a penchant for the "probable" and the "possible" that mathematics shares with the arts.

On the other hand, information theory evaluates quantity and not quality. The quantity of information concerns only the statistical probability of events, whereas its value can be measured only in terms of the interest we bring to it.[26] The quality of information is related to its value. To determine the value an unforeseeable situation may have for us (unforeseeable but verifiable, whether it be a weather forecast or a poem by Petrarch or Eluard), and the nature of its singularity, *we must consider both the structural fact in itself and the attention we have brought it*. At this point, questions of information become *questions of communication,* and our attention must shift from the message itself, qua objective system of possible information, to the relationship between message and receiver—a relationship in which the receiver's interpretation constitutes the effective value of the information.

The statistical analysis of the informative possibilities of a signal is, in fact, a *syntactic* analysis, in which the *semantic* and *pragmatic* dimensions play only a secondary role, the former to define in what cases and under which circumstances a given message may provide more information than another, and the latter to suggest what kind of behavior this information might entail.

But although the transmission of signs conceived according to a rigorous code, based on conventional values, can be explained without having to depend on the interpretive intervention of the receiver, the transmission of a sequence of signals with little redundancy and a high ratio of improbability demands that we take into consideration both the attitudes and the mental structures by which the receiver, of his own free will, selects a message and endows it with a probability that is certainly already there but only as one probability among many.

This, in turn, means that it may be necessary to add a psychological point of view to the structural analysis of certain communica-

tion phenomena—an operation that may seem to contradict the antipsychological tendency of the various formalist methodologies that have been applied to the study of language (from those of Husserl to those of the Russian Formalists). On the other hand, how could one examine the signifying possibilities of a given message without taking the receiver of the message into account? To consider the psychological aspect of the phenomenon merely means that we recognize that the message cannot have any meaning, at least formally speaking, unless it is interpreted in relation to *a particular situation* (a psychological situation that is also, by extension, historical, social, anthropological, etc.).[27]

It is therefore necessary to consider the transactional rapport that is established, at both an intellectual and a perceptual level, between certain stimuli and the world of the receiver—a *transactional rapport* that constitutes the very processes of perception and reasoning. In the case at hand, this kind of analysis is more than a methodologically necessary stage: it confirms everything I have said up to now concerning the possibility of an "open" *appreciation* of a work of art. In fact, a basic theme of the most recent currents in psychology is that of the fundamental openness of every perceptual and intellectual process.

These perspectives are founded on a critique of Gestalt psychology, which maintains that perception is the apprehension of a configuration of stimuli, that is, of stimuli that already possess an objective organization—recognition more than apprehension, thanks to the fundamental isomorphism between the structures of the object and the psychophysical structures of the perceiving subject.[28]

Later, post-Gestalt schools have reacted against the metaphysical burdens of this psychological theory, and have described the cognitive experience as an experience that occurs in stages, as a process that, far from exhausting the possibilities of the object, highlights those aspects of it that lend themselves to an interaction with the dispositions of the subject.[29]

American transactional psychology, an outgrowth of Dewey's naturalism (and other French currents, of which more later), maintains that although perception is not the reception of physical stimuli, as described by classical associationism, it nevertheless represents a relationship in which my memories, my unconscious persuasions, and the culture I have assimilated (in other words, my

acquired experience) fuse with exterior stimuli to endow them with the *form* and the *value* they assume in my eyes according to the aims I am pursuing. To say that "there is value in every experience" means, to a certain extent, that in the realization of a perceptual experience there is always an artistic component, an "action with creative intentions." As R. S. Lillie once said, "The psychical is foreseeing and integrative in its essential nature; it tends to finish or round off an uncompleted experience. To recognize this property as having its special importance in the living organism is not to ignore or undervalue the stable physical conditions which also form an indispensable part of the vital organization. In the psychophysical system which is the organism, factors of both kinds are to be regarded as equally important and as always supplementing one another in the total activity of the system." [30] Or, as we might say in words less fraught with biological and naturalistic connotations: "As human beings we can sense only those 'togethernesses' that have significance to us as human beings. There are infinities of other togethernesses that we can know nothing about. It will be generally agreed that it is impossible for us to experience all possible elements in any situation, let alone all the possible interrelationships of all the elements." This is why, time after time, we end up relying on our experience as the formative agent of perception: "Apparently the organism, always forced to 'choose' among the unlimited number of possibilities which can be related to a given retinal pattern, calls upon its previous experiences and 'assumes' that what has been most probable in the past is most probable in the immediate occasion . . . In other words, what we see is apparently a function of some sort of weighted average of our past experiences. It seems that we relate to a stimulus pattern a complex, probability-like integration of our past experience with such patterns. Were it not for such integrations, which have been labeled assumptions, the particular perceptual phenomenon would not occur. It follows from this that the resulting perceptions are not absolute revelations of 'what is out there' but are in the nature of probabilities or predictions based on past experience." [31]

In a different context, Piaget also devoted a great deal of attention to the probabilistic nature of perception. In contrast to Gestalt theoreticians, he viewed the structure of a sensorial datum as the

product of an equilibration depending on both innate factors and external factors that constantly interfere with one another.[32]

Piaget's notion of the "open," dynamic nature of the cognitive process is even more exhaustively treated in his analysis of intelligence.[33]

Intelligence tends to compose "reversible" structures whose balance, arrest, and homeostasis are only the terminal stage of the operation, indispensable to its practical effectiveness. In itself, intelligence reveals all the characteristics of what I have defined as an "open" process. The subject, guided by experience, proceeds by hypotheses and trial-and-error to find not the preconceived, static forms of Gestalt theoreticians but reversible, mutable structures that allow him, after he has linked two elements in a relationship, to pull them apart again and go back to where he started. As an example, Piaget cites the relationship $A + A' = B$, which can also be expressed as $A = B - A'$, or $A' = B - A$, or even $B - A = A'$, and so on. This set of relationships does not constitute a univocal process, such as the one found in perception, but rather an operational possibility that allows for various reversals (not unlike those occurring in a twelve-tone musical series that lends itself to a variety of manipulations).

As Piaget reminds us, in its last stage, the perception of forms involves a number of recenterings and modifications that enable us to see the ambiguous outlines of psychology textbooks in different ways. But a system of reasoning involves more than a "recentering" (*Umzentrierung*); it involves a general decentering that permits something like the dissolution, the liquefaction, of static perceptual forms, thus facilitating operational mobility—and thus creating infinite possibilities for new structures. Though it lacks the reversibility characteristic of intellectual operations, the perceptual process does involve certain regulations, partly influenced by the contributions of experience, which already "sketch and prefigure the mechanisms of composition that will become operational once total reversibility is possible."[34] In other words, if at the level of intelligence there is an elaboration of variable and mobile structures, at the level of perception there are a number of uncertain, probabilistic processes that help turn perception itself into a process open to a number of possible solutions (and this despite the percep-

tual constants that our experience does not allow us to question). Both cases involve constructive activity on the part of the subject.[35]

Having thus established that knowledge is at once a process and an "openness," we can now pursue our discussion along two lines of thought that correspond to a distinction I have already proposed.

　1. Psychologically speaking, the aesthetic pleasure evoked by *any* work of art depends on the same mechanisms of integration characteristic of all cognitive processes. This kind of activity, fundamental to the aesthetic appreciation of any form, is what, elsewhere, I have already defined as *openness of the first degree*.

　2. Contemporary poetics places greater emphasis on these particular mechanisms, while situating aesthetic pleasure less in the final recognition of a form than in the apprehension of the continuously open process that allows one to discover ever-changing *profiles* and possibilities in a single form. This may be termed *openness of the second degree*.

　Following these two directions, one realizes that only transactional psychology (more interested in the genesis of forms than in their objective structure) can allow us to fully understand this second, and more complete, sense of "openness."

Transaction and Openness

Let us first examine how art in general depends on deliberately provoking incomplete experiences—that is, how art deliberately frustrates our expectations in order to arouse our natural craving for completion.

　Leonard Meyer has provided us with a satisfactory analysis of this psychological mechanism in his book *Emotion and Meaning in Music*,[36] where he uses Gestalt premises to build an argument concerning the reciprocal relationship between objective musical structures and our patterns of reaction—that is, how a message conveys a certain amount of information which, however, acquires its value only in relation to the receiver's response and only then organizes itself into a *meaning*.

　According to Wertheimer, a thought process can be described as follows: given a situation S_1, and a situation S_2 which represents the solution of S_1 (its terminus *ad quem*), what we call "process" is the

transition from the first situation to the second—a transition during which S_1, structurally incomplete and ambiguous, gradually finds a definition and a solution as S_2. Meyer applies this same definition to his analysis of musical discourse: a stimulus catches the attention of the listener as incomplete and ambiguous, leading him to expect a resolution, a clarification, which arouses his emotions because it is delayed. In other words, the listener's need for an answer is momentarily frustrated or inhibited, and he finds himself in a state of crisis. If his expectations, his need, were satisfied immediately, there would be no crisis and no emotion. This game of postponement and emotional reaction is what provides musical discourse with a meaning. Whereas in daily life numerous critical situations are never resolved and end up disappearing as accidentally as they appeared, in music, the frustration of an expectation becomes meaningful for the very reason that it makes the relationship between expectation and resolution explicit before bringing it to a conclusion. But it is precisely because it eventually arrives at a conclusion that the cycle *stimulus–crisis–expectation–satisfaction–reestablishment of an order* acquires a meaning. "In music, the very stimulus, music itself, provokes expectations, inhibits them, and then provides them with meaningful solutions." [37]

How is an expectation created? What does a crisis consist of? What kinds of solutions can satisfy the listener? For Meyer, all these questions can be answered by Gestalt theory. The psychological dialectics of expectation and satisfaction is, in fact, determined by formal laws: laws of pregnancy, of the *good curve,* of proximity, of equality, and so on. The listener expects that the process will reach its conclusion according to a certain symmetry, and that it will organize itself in the best possible way, in harmony with the psychological models that Gestalt theory has discerned in both our psychological structures and external objects. Since the emotional response is provoked by a blockage of the regular process, the listener's dependence on the right form and his memory of previous formal experiences intervene to create *expectations*—predictions of a solution, formal prefigurations through which the inhibited tendency will find satisfaction. While there is inhibition, there is also the pleasure of expectation, a feeling of impotence in front of the unknown; and the more unexpected the solution, the greater the pleasure when it occurs. So if it takes a crisis to provoke pleasure,

then it is obvious, as Meyer points out, that the laws of form preside over musical discourse only on condition that they be constantly violated during its development. The solutions the listener expects are not the most obvious but rather the least common, a transgression of the rules that will enhance his appreciation of and the pleasure in the final return to legality. According to Gestalt theory, the "right" form is the one that natural data assume by necessity the moment they organize in unitary complexes. Does musical form also manifest the same tendency toward an original stability?

At this point, Meyer tempers his Gestaltism and admits that the notion of *optimal organization,* in music, can refer only to a *cultural datum.* This means that music is not a universal language, and that our tendency to prefer certain solutions to others is the result of our apprenticeship within the context of a musical culture that has been historically defined. Sounds that a particular musical culture considers unexpected may well be, in a different culture, so legitimate as to be banal. The perception of a totality is neither immediate nor passive: it is an act of organization that has to be learned within a sociocultural context. The laws of perception are not natural and innate; rather, they are the reflection of *cultural patterns,* or, as a transactional psychologist would say, they are *acquired forms,* a system of preferences and habits, convictions and emotions, fostered in us by the natural, social, and historical context we inhabit.[38]

As an example, Meyer proposes the complex of stimuli constituted by the letters TRLTSEE. There are various, formally satisfactory ways of grouping these letters. TT/RLS/EE, for instance, for the sake of symmetry and to respect the most elementary laws of contiguity. Of course, an English reader might prefer the combination LETTERS as more meaningful and, therefore, "right" from every standpoint. In this particular case, the letters have been organized according to an acquired experience, a particular linguistic system. The same thing happens with a complex of musical stimuli: the dialectics of crises, expectations, predictions, and satisfactory solutions obeys the laws of a particular cultural and historical context. The auditory culture of the Western world was, at least until the beginning of the twentieth century, tonal. Therefore, it is within the framework of a tonal culture that certain crises can be

crises and certain solutions can be solutions; of course, things would be quite different with primitive or oriental music.

On the other hand, Meyer implicitly relies on a Gestalt tradition even when he analyzes different musical cultures to locate different modes of organization: every musical culture establishes its own syntax which, in turn, directs the listener according to specific modes of reaction. Every kind of discourse has its own laws, which are also the laws of its form, the very same laws on which the dynamics of crises and solutions depends. The average listener tends to find a solution to crisis in rest, to disturbance in peace, to deviation in the return to a polarity defined by the musical habits of a civilization. The crisis is valid only in relation to its solution. The listener aspires to a solution and not to a crisis for the sake of crisis alone. If Meyer has borrowed all his examples from classical music, it is because his argument is, in essence, quite conservative: what he offers us is a psychological and structural interpretation of *tonal* music.

This point of view remains fundamentally unchanged even when Meyer, in his later work, shifts from a psychological approach to information theory. According to him, the introduction of uncertainty or ambiguity into a probabilistic sequence, such as a musical discourse, will automatically provoke an emotion. A style is a *system of probability,* and the awareness of probability is latent in the listener, who can therefore afford to make predictions concerning the consequences of a given antecedent. To attribute an aesthetic meaning to a musical discourse amounts to rendering the uncertainty explicit and experiencing it as highly desirable. Meyer maintains that "musical meaning arises when an antecedent situation, requiring an estimate as to the probable modes of pattern continuation, produces uncertainty as to the temporal-tonal nature of the expected consequent . . . [The] greater the uncertainty, [the] greater the information . . . A system which produces a sequence of symbols . . . according to certain probabilities is called a *stochastic process,* and the special case of a stochastic process in which the probabilities depend on the previous events, is called a *Markoff process* or a *Markoff chain.*" [39] If music is a system of tonal attractions, in which the existence of a musical event imposes a certain probability on the occurrence of a subsequent event, then the event that responds to the natural expectations of an ear will pass unnoticed

and, as a result, the uncertainty and the emotion—and, of course, the information—it entails will be minor. Since, in a Markoff chain, the uncertainty decreases as the distance from the starting point increases, in order to heighten the meaning (read: information) of the musical discourse the composer will have to introduce some uncertainty at every step. This is the sort of suspense used to break the tedium of probability in most tonal processes. Music, like most languages, contains a certain amount of redundancy that the composer tries to remove so as to increase the interest of his listeners.

Having reached this point, however, Meyer goes back to reconsider the persistence of acquired experience and reminds his readers that there are two sorts of noise in musical discourse: *acoustical noise* and *cultural noise*. The latter type is determined by the difference between our habitual reactions (that is, our assumptions) and those required by a particular musical style. According to Meyer, contemporary music, overly intent on eliminating all redundancy, is nothing more than a kind of noise that prevents the listener from understanding the meaning of a musical discourse.[40]

In other words, he sees the oscillation between informative disorder and total unintelligibility, which had already concerned Moles, not as a problem to be solved but as a danger to be avoided. With this distinction between desirable and undesirable uncertainty, Meyer—though he is well aware of the historicity and the capacity for evolution of every system of acquired forms—eliminates the possibility of a real evolution of musical sensibility. For him, musical language is a system of probabilities in which improbability can be introduced only with caution. At which point we may well fear that the repertory of possible uncertainties will eventually become so normal as to enter the realm of recognized probabilities, until what once was pure information becomes sheer redundancy. This is very clearly what has happened in certain fields of popular music, where it would be vain to look for the slightest surprise or emotion: a piece by Liberace is as predictable as a Hallmark birthday card, concocted according to the most banal of laws and totally devoid of any additional information.

Every human being lives within a determinate *cultural pattern* and interprets his or her experience according to a set of acquired forms. The stability of this world is what allows us to move ratio-

nally amid the constant provocations of the environment and to organize external events into a coherent ensemble of organic experiences. The safeguarding of our assumptions against all incoherent mutations is one of the basic conditions of our existence as rational beings. But there is a difference between the preservation of a system of assumptions as an organic whole and the refusal of all possible change, since another condition of our survival as thinking beings is precisely our capacity to let our intelligence and our sensibility evolve by integrating new experiences into our system of assumptions. Our world of acquired forms must maintain its organic structure in the sense that it must evolve harmoniously, without shocks and undue deformations; but *evolve it must,* and in order to evolve it must undergo certain modifications. After all, what most distinguishes Western man from those who live in "primitive" societies is precisely the dynamic, progressive nature of his cultural patterns. What makes a society "primitive" is its inability to let its cultural patterns evolve, its unwillingness to interpret and exploit the original assumptions of its culture, which thus persist as empty formulas, rites, taboos. We have very few reasons to consider the cultural pattern of the West as universally superior, but one of these reasons is its plasticity, its flexibility, its capacity to respond to circumstantial challenges by constantly interpreting new experiences and elaborating new ways to adjust to them (more or less rapidly, depending on the sensibility of the individual or of the collectivity).

Art, in all its forms, has also evolved in a similar fashion, within a "tradition" that may seem immutable but which, in fact, has never ceased to introduce new forms and new dogmas through innumerable revolutions. Every real artist constantly violates the laws of the system within which he works, in order to create new formal possibilities and stimulate aesthetic desire: when Brahms's works were first performed, the expectations aroused by one of his symphonies in a listener accustomed to Beethoven were certainly very different, both in quality and range, from the expectations aroused by a Beethoven piece in a listener accustomed to Haydn. And yet, theorists of contemporary music (and with them, those of contemporary art in general) reproach classical tradition for the fact that all its formal innovations, and the kind of expectations they entailed, would no sooner be introduced than they would become new systems of assumptions aiming at the completion and final

satisfaction of expectation, thereby encouraging what Henri Pousseur calls *psychic inertia*. Most classical compositions were determined by the polarity characteristic of the tonal system, except for a few brief moments of crisis whose function was to comply with the listener's inertia by leading it back to the original pole of attraction. According to Pousseur, even the introduction of a new tonality into the development of a particular piece required a device able to overcome this inertia: what is known as *modulation*. But even modulation violates the hierarchy of the system only so as to introduce a new pole of attraction, a new tonality, a new system of inertia.

There were reasons for all this: both the formal and the psychological requirements of art were a reflection of the religious, political, and cultural demands of a society based on a hierarchical order, on the notion of absolute authority, on the presumption of an immutable, univocal truth, crucial to social organization and celebrated by different forms of art.[41]

The experiences of contemporary poetics (whether concerning music or other art forms) show how much the situation has changed.

In its search for an "openness of the second degree," in its reliance on ambiguity and information as essential values of a work of art, contemporary poetics rebels against the *psychic inertia* that has been hiding behind the promise of a *recovered order*.

Today, the emphasis is on the process, on the possibility of identifying individual orders. The kind of expectation aroused by a message with an open structure is less a *prediction of the expected* than an *expectation of the unpredictable*. The value of an aesthetic experience is determined today not by the way a crisis is resolved but rather by the way in which, after propelling us into a sequence of known crises determined by improbability, it forces us to make a choice. Confronted by disorder, we are then free to establish temporary, hypothetical systems of probability that are complementary to other systems that we could also, eventually or simultaneously, assume. By so doing, we can enjoy both the equiprobability of all the systems and the openness of the process as a whole.

As I have already mentioned, only a psychology concerned with

the genesis of structures can justify this tendency of contemporary art. And indeed, today's psychology seems to pursue its explorations in precisely the same directions taken by the poetics of the open work.

Information and Perception

Information theory has contributed greatly to opening new perspectives for psychological research. In his study of perception as a *deformation* of the object (meaning that the object varies according to the position of the perceiver), the psychologist Ombredane, along with others I have already mentioned,[42] has come to the conclusion that this process of exploration eventually ends when the perceiver chooses one particular form (which, from that moment on, imposes itself on all the others). But Ombredane refuses to give a Gestaltist answer to the question "Where do such forms come from?" Instead, he prefers to examine the genesis of this structural phenomenon in the light of experience.

"If we compare different points of view . . . then we realize that one of the fundamental characteristics of perception is that perception is the result of a process of *fluctuation* that involves a continuous exchange between the disposition of the subject and all the possible configurations of the object—configurations that are more or less stable within a more or less *isolated* spatiotemporal system characteristic of that particular *behavioral episode* . . . Perception can be expressed in terms of probability, like those used in thermodynamics or in information theory." Consequently, the percept is none other than the temporary stabilization of a sensible configuration resulting from the more or less redundant organization of useful information that the receiver has selected from a field of stimuli during the perceptual process. The same field of stimuli can yield an indeterminate number of more or less redundant patterns; what Gestaltists call the "right form" is such a pattern, the one that "requires the least information and the most redundancy." Consequently, the "right form" corresponds to the "maximal state of probability of a fluctuating perceptual whole." At this point we realize that, in terms of statistical probability, the "right form" loses all its ontological connotations, thus ceasing to be the prefixed

structure of all perceptual processes, the definitive code of perception.

The undetermined field of stimuli that can yield various forms of redundant organization is not the opposite of the "right form," just as a nonperceivable, amorphous whole is not the opposite of the percept. The subject chooses the most redundant form out of a particular field of stimuli when he has reasons to do so, but he can disregard the "right form" in favor of other patterns of coordination that have remained in the background.

According to Ombredane, it should be possible to characterize different ways of exploring the field of stimuli from both an operational and a typological standpoint: "There are those who cut their exploration short and opt for a particular structure before having a chance to use all the information they could have gathered; there are those who prolong their exploration and refuse to adopt any structure; and then there are those who reconcile the two attitudes and try to be aware of several possible structures before they integrate them into a progressively constructed unitary percept. There are also those who slide from one structure to the next without being aware of the incompatibilities between them. This is what happens in people suffering from hallucinations. If perception is a form of 'commitment,' there are different ways in which one can commit oneself, or refuse to commit oneself, to seeking useful information."

This brief typological survey ranges all the way from the pathological to the everyday, and allows for a large number of perceptive possibilities which it entirely justifies. There is no need to stress the value that these psychological hypotheses can have for a discussion of art. All one needs to add is that, given such premises, psychologists will have to explain how and to what extent an apprenticeship based on unusual perceptual exercises and intellectual operations might modify the usual schemes of reaction. (Which is to say: Will the use of information theory prevent the violations of codes and systems of expectation from turning into the key elements of a new code, of a new system of expectations?) Aesthetics, art history, and the phenomenology of taste have confronted, if not quite solved, this problem for centuries, at a macroscopic level. How often have new creative modes changed the meaning of form, people's aes-

thetic expectations, and the very way in which humans perceive reality?[43]

The poetics of the open work is an expression of such a historical possibility: here is a culture that, confronting the universe of perceivable forms and interpretive operations, allows for the complementarity of different studies and different solutions; here is a culture that upholds the value of discontinuity against that of a more conventional continuity; here is a culture that allows for different methods of research not because they may come up with identical results but because they contradict and complement each other in a dialectic opposition that will generate new perspectives and a greater quantity of information.

After all, the crisis of contemporary bourgeois civilization is partly due to the fact that the average man has been unable to elude the systems of assumptions that are imposed on him from the outside, and to the fact that he has not formed himself through a direct exploration of reality. Well-known social illnesses such as conformism, unidirectionism, gregariousness, and mass thinking result from a passive acquisition of those standards of understanding and judgment that are often identified with the "right form" in ethics as well as in politics, in nutrition as well as in fashion, in matters of taste as well as in pedagogical questions.

At which point, we may well wonder whether contemporary art, by accustoming us to continual violations of patterns and schemes—indeed, alleging as a pattern and a scheme the very perishability of all patterns and all schemes, and the need to change them not only from one work to the next but within the same work—isn't in fact fulfilling a precise pedagogical function, a liberating role. If this were the case, then its discourse would go well beyond questions of taste and aesthetic structures to inscribe itself into a much larger context: it would come to represent modern man's path to salvation, toward the reconquest of his lost autonomy at the level of both perception and intelligence.

The Open Work in the Visual Arts

Nowadays, to say that a poetics of the "informal" is characteristic of contemporary painting involves a generalization. No longer limited to a critical category, the term "informal"[1] has come to designate a general tendency of our culture and to encompass, along with painters such as Wols and Bryen, the *tachistes,* the masters of *action painting, art brut, art autre,* and so on, at which point we might as well inscribe it under the broader rubric of *the poetics of the open work.*

"Informal art" is open in that it proposes a wider range of interpretive possibilities, a configuration of stimuli whose substantial indeterminacy allows for a number of possible readings, a "constellation" of elements that lend themselves to all sorts of reciprocal relationships. As such, "informal painting" is closely related to the open musical structures characteristic of post-Webern music and to a form of poetry which in Italy goes by the name of *novissima,* whose representatives have already agreed to define it as "informal."

The "informal" can be seen as the last link in a series of experiments aiming at the introduction of "movement" into painting. But this may not be enough of a definition, since the quest for movement has accompanied the evolution of the visual arts for quite some time, and can already be detected in early petroglyphs as well as in the Nike of Samothrace, in the way the fixed line tries to represent the mobility of real objects. Movement can also be suggested by repeating the same figure and thus representing a particular character at different times. This is the technique used on the tympanum of the portal of the Souillac cathedral, which depicts the story of Theophilus the cleric; it can also be seen on Queen Ma-

thilde's tapestries at Bayeux—a truly cinematic sequence, consisting of a number of juxtaposed photograms. But it is a technique that represents movement by means of substantially fixed structures, without involving the structure of the work itself or the nature of the sign.

The structure begins to be affected only in the work of Magnasco or Tintoretto, and later, more clearly, in the work of the Impressionists: to give the impression of inner animation, the sign becomes imprecise, ambiguous. But not so the forms themselves. The ambiguity of the sign lends them a vibrant quality, and, by blurring their contours, puts them into closer contact with other forms, a source of light, and their general surroundings. But the eye of the observer can still recognize them as particular forms even though they are on the verge of liquefaction, of dissolution—as is the case, for instance, with the cathedrals in Monet's later paintings.

The dynamic amplification seen in Futurist forms and the decomposition represented in Cubism are other ways of capturing mobility; but even here, mobility is only a counterpart to the stability of the initial forms, which, moreover, are reasserted by their very deformation or dislocation.

Sculpture shows us yet another way of approaching the open work: the plastic forms of Gabo or Lippold invite the viewer to participate actively in the polyhedral nature of the works. The form itself is so constructed as to appear ambiguous, and to assume different shapes depending on the angle from which it is viewed.[2] Thus, as the viewer walks around the work, he witnesses a continuous metamorphosis. Something similar had already happened in Baroque architecture, with the abandonment of a privileged frontal perspective. Besides, one could easily argue that to be open to different perspectives is a characteristic of sculpture. Seen from the back, the Apollo Belvedere is not the same as it is when seen from the front. On the other hand, apart from works that were designed to be seen only from the front (like the statues that adorn the columns of some Gothic cathedrals), most sculptures, though they can be viewed from different angles, are intended to produce a global impression, the cumulative result of various perspectives. The Apollo Belvedere seen from the back implies and evokes the total Apollo. A frontal perspective will have the same effect. No matter where the viewer stands, the complete form will inevitably emerge out of his memory or his imagination.

This is not the case with Gabo's work. Seen from below, his sculptures make one imagine a variety of possible and mutually exclusive perspectives; and though each perspective is satisfactory in itself, it inevitably frustrates the viewer who would like to apprehend a totality.[3]

Calder goes still further: his forms move before our eyes. Each of his works is a "work in movement" whose movement combines with that of the viewer. Theoretically, work and viewer should never be able to confront each other twice in precisely the same way. Here there is no suggestion of movement: the movement is real, and the work of art is a field of open possibilities. The myriad reflections of Munari's *vetrini* and the "moving works" of the young avant-garde are more extreme examples of the same phenomenon.[4]

"Informal" art, in the broader sense I have given it, belongs here, next to these formal experiments. It is not work in movement, since the painting is there, before our eyes, physically defined once and for all by the pictorial signs that constitute it; neither does it require any movement on the part of the viewer—no more, that is, than any other painting that demands that its viewer be constantly aware of the various incidences of light on the roughness of its surface and the contrasts of its colors. And yet, it is an "open work"— in an even more mature and radical way than any of those mentioned above. Its signs combine like constellations whose structural relationships are not determined univocally, from the start, and in which the ambiguity of the sign does not (as is the case with the Impressionists) lead back to reconfirming the distinction between form and background. Here, the background itself becomes the subject of the painting, or, rather, the subject of the painting is a background in continual metamorphosis. Here, the viewer can (indeed, must) choose his own points of view, his own connections, his own directions, and can detect, behind each individual configuration, other possible forms that coexist while excluding one another in an ongoing relationship of mutual exclusion and implication. At this point we need to ask two questions concerning not only the poetics of the "informal" but the poetics of the "open work" in general:

1. What are the historical reasons for—the cultural background of—such a poetics, and what vision of the world does it imply?

2. Are such works legible? If so, what are the conditions of their

communicability and what are the guarantees that they will not suddenly lapse into either silence or chaos? In other words, can we define the tension between the mass of information intentionally offered to the reader and the assurance of a minimal amount of comprehensibility, and is there a possible agreement between the intention of the author and the viewer's response?

Neither of these questions concerns the aesthetic value of the works under examination. The first presumes that, in order to express an implicit vision of the world and its relationship with an entire aspect of contemporary culture, a work of art must at least partly satisfy the requisites of that particular communicative discourse commonly known as "aesthetics." The second concerns the elementary conditions of communication necessary for the recognition of a potentially richer and deeper meaning, characterized by the organic fusion of various elements, and characteristic of aesthetic value. As for the aesthetic possibilities of informal art, I shall discuss them in the third part of this chapter.

Informal Art as an Epistemological Metaphor

From a cultural standpoint, informal art definitely shares a general characteristic of the open work. Its forms appear as the epistemological metaphors, the structural resolutions, of a widespread theoretical consciousness (not of a particular theory so much as of an acquired cultural viewpoint). They represent the repercussion, within formative activity, of certain ideas acquired from contemporary scientific methodologies—the confirmation, in art, of the categories of indeterminacy and statistical distribution that guide the interpretation of natural facts. Informal art calls into question the principle of causality, bivalent logics, univocal relationships, and the principle of contradiction.

This is not the opinion of a philosopher who is determined to find a conceptual message in every form of art. This is part of the poetics of the artists themselves, whose very vocabulary betrays the cultural influences against which they are reacting. The uncritical use of scientific categories to characterize an artistic attitude is often dangerous; the mere transposition of a scientific term into a philosophical or critical discourse requires a number of tests and a cautious redefinition that would indicate whether the new usage is

merely suggestive or metaphorical. On the other hand, those who are shocked by the use, in aesthetics or elsewhere, of terms such as "indeterminacy," "statistical distribution," "information," "entropy," and so forth, and who fear for the purity of philosophical discourse, forget that both philosophy and traditional aesthetics have often relied on terms (such as "form," "power," "germ," etc.) that once belonged to physics and cosmology. And yet, it is precisely because of a similar terminological nonchalance that traditional philosophy has been called into question by more rigorous analytic disciplines. If we are aware of these problems, when we encounter an artist who uses scientific terminology to define his artistic intentions we will not assume that the structures of his art are a reflection of the presumed structures of the real universe; rather, we will point out that the diffusion of certain notions in a cultural milieu has particularly influenced the artist in question, so that his art wants and has to be seen as the imaginative reaction, the structural metaphorization, of a certain vision of things (which science has made available to contemporary man). Given the context, my discussion here should not be seen as an ontological investigation but rather as a modest contribution to the history of ideas.

Good examples of this tendency can easily be found in museum catalogues or in critical articles. One of these is George Mathieu's article "D'Aristote à l'abstraction lyrique" (From Aristotle to lyrical abstraction),[5] in which the painter tries to retrace the progress of Western civilization from the *ideal* to the *real,* from the *real* to the *abstract,* and from the *abstract* to the *possible.* To this extent, the article is a history of the genesis of the poetics of the informal, of lyrical abstraction, and of all the other new forms discovered by the avantgarde before they make their way into popular consciousness. According to Mathieu, the evolution of forms is parallel to that of scientific concepts: "If we consider the collapse of classical values in the domain of art, we will realize that an equally profound parallel revolution has taken place in the sciences, where the recent failure of concepts concerning space, matter, parity, and gravitation, along with the resurgence of notions of indeterminacy and probability, of contradiction and entropy, seem to indicate the reawakening of mysticism and the possibilities of a new transcendence."

Obviously, at a methodological level, a notion like that of indeterminacy does not postulate any mystical possibilities but only al-

lows one to describe certain microphysical events with all due cau-
tion—caution that should also be used when dealing with the same
notion at a philosophical level. On the other hand, rather than
questioning Mathieu's right to use a scientific concept as a stimulus
to the imagination, we should try to figure out how much of the
original stimulus is left in the structuring of pictorial signs, and
whether there is any continuity between the vision of things im-
plicit in the scientific notion and the one expressed by the new
forms. As I have pointed out elsewhere, Baroque poetics evolved
from the new vision of the cosmos introduced by the Copernican
revolution and already figuratively suggested by Kepler's discovery
of the elliptical shape of planetary orbits—a discovery that called
into question the privileged position of the circle as the classical
symbol of cosmic perfection. Just as Baroque structure reflects the
conception—no longer geocentric and, therefore, no longer an-
thropocentric—of a nonfinite universe, so it is possible, as Mathieu
tries to show in his article, to find a parallel between the non-
Euclidean geometries of today and the rejection of classical
geometric forms by art movements such as Fauvism and Cubism;
between the emergence of imaginary or transfinite numbers in
mathematics and the advent of abstract painting; between Hilbert's
attempts to axiomatize geometry and the appearance of Neoplasti-
cism and Constructivism:

> Von Neumann's and Morgenstern's *Game Theory*, one of the
> most important scientific events of this century, has also proved
> particularly fruitful in its application to contemporary art, as
> Toni del Rienzo has brilliantly shown in relation to *action paint-
> ing.* In this vast domain that now ranges all the way from the
> possible to the *probable,* in this new adventure that sees indeter-
> minism lording it over inanimate, living and psychic matter,
> the problems with which the Chevalier de Mère confronted
> Pascal three centuries ago are as obsolete as Dali's notions of
> *hazard-objectif* and Duchamp's meta-irony. The new relation-
> ship between chance and causality and the introduction of a
> positive and negative anti-chance, are one more proof of our
> break with Cartesian rationalism.

No need to linger on the more or less daring scientific assertions
of the painter I have just quoted, or to question his strange convic-

tion that indeterminism lords it over inanimate, living, and psychic matter. This passage is a clear example of the influence that revolutionary scientific concepts can wield over the emotions and imagination of an entire culture. It is true that neither the principle of indeterminacy nor quantum mechanics tells us anything about the structure of the world, being mostly concerned with ways of describing certain aspects of it; but it is also true that they have shown us how certain values that we believed absolute and valid as metaphysical frameworks (such as the principle of causality or that of contradiction) are neither more nor less conventional than most new methodological principles and are as ineffective as means of explaining the world or of founding a new one. What we find in art is less the expression of new scientific concepts than the negation of old assumptions. While science, today, limits itself to suggesting a probable structure of things, art tries to give us a possible image of this new world, an image that our sensibility has not yet been able to formulate, since it always lags a few steps behind intelligence— indeed, so much so, that we still say the sun "rises" when for three centuries we have known it does not budge.

All this explains how contemporary art can be seen as an epistemological metaphor. The discontinuity of phenomena has called into question the possibility of a unified, definitive image of our universe; art suggests a way for us to see the world in which we live, and, by seeing it, to accept it and integrate it into our sensibility. The open work assumes the task of giving us an image of discontinuity. It does not narrate it; it *is* it. It takes on a mediating role between the abstract categories of science and the living matter of our sensibility; it almost becomes a sort of transcendental scheme that allows us to comprehend new aspects of the world.

This is what we must remember when we read the emotional panegyrics criticism devotes to informal art, and confront the enthusiasm with which it hails the new unexpected freedom that such an open field of stimuli has brought to our imagination.

> Dubuffet deals with primordial realities and the *mana,* the magical currents that connect human beings to the objects that surround them. But his art is much more complex than any primitive art. I have already alluded to his multiple ambiguities and zones of signification. Many of these are produced by complex

spatial organizations of the canvas, by the deliberate confusion of scale, by the artist's habit of seeing and representing things simultaneously from different angles . . . It is a rather complex optical experience not only because our point of view is constantly changing and there are numerous optical dead ends, perspectives creating paths that might end in the middle of a plain or at the edge of a cliff, but also because we are constantly jolted by the painting, by this constantly flat surface on which none of the traditional techniques has been used. But this multiple vision is quite normal: this is how we really see things during a walk in the country, as we climb a hill or follow sinuous paths. This tendency to view things from different spatial perspectives at the same time suggests that the same simultaneity is also possible with time.[6]

Fautrier paints a box as if the concept of box did not exist; more than an object, it is a debate between dream and matter, a tentative groping in the direction of the box, in that zone of uncertainty where the possible elbows the real . . . The artist has the marked impression that things could be quite different.[7]

Fautrier's matter . . . is a matter that never gets simpler; rather, it becomes ever more complicated as it captures and assimilates all sorts of possible meanings, incorporating aspects or moments of reality, and saturating itself with live experience.[8]

The attributes that best suit Dubuffet's representation are quite different: they express in-finity, in-distinction, in-discretion (all these terms should be taken in their etymological sense). The optics of matter in fact demands that we witness the shattering of all notional outlines, the disintegration and disappearance of familiar aspects, in both things and people. And if some trace, some presence of formal definition, persists, this optics demands that we question it, that we inflate it by multiplying it and confusing it in a tumult of projections and dislocations.[9]

The "reader" is excited by the new freedom of the work, by its infinite potential for proliferation, by its inner wealth and the unconscious projections that it inspires. The canvas itself invites him not to avoid causal connections and the temptations of univocality, and to commit himself to an exchange rich in unforeseeable discoveries.

Among such "readings," one of the most substantial and disturb-
ing is certainly that in which Audiberti tells us what he sees in Ca-
mille Bryen's paintings:

> Finally, nothing is abstract, any more than it is figurative. The
> intimate simnel of an ibis's femur—or of a plumber's, for that
> matter—conceals, like a family album, all sorts of postcards:
> the dome of the *Invalides,* the New Grand Hotel at Yokohama.
> Atmospheric refraction makes all mineral tissue echo with
> well-wrought mirages. Hordes of submedullary staphylococci
> line up to draw the outline of the trade tribunal in Menton . . .
> The infinitude of Bryen's paintings seems to me more valid
> than if he limited himself to illustrating the usual relationship
> between the immobility of contemporary painting and what
> preceded it and what will follow it. I must again insist on the
> fact that, in my eyes, Bryen's work has the merit of really mov-
> ing. It moves through space and through time. It plunges into
> the venomous vegetation of the bottom, or soars out of the
> abysses of a gnat's rotten tooth toward the blink of our eye and
> the fist of our hand. The molecules of the chemical pictorial
> substances and of the visionary energy that make it up throb
> and settle under the horizontal shower of our look. Here is the
> phenomenon of continuous creation, or of revelation, in all its
> flagrancy. Bryen's art—a "feather"—does not, like other art
> and everything else down here, attest to the permanent union
> between the stock market and the petty exoticism of spiders
> and woods hawking cobalts. No . . . Even when it is finished,
> presentable and signed—that is, given its social and commer-
> cial proportion, and waiting for the attention or the contempla-
> tion of those who see it and whom it turns into seers—its forms
> or nonforms keep changing in space ahead of both the canvas
> and the paper, ahead of the soul of this seer himself, ahead of
> everything. They give birth: by and by, the star makes its nest
> in decors and secondary outlines that eventually become domi-
> nant. They settle in transparent layers over the background im-
> age. And suddenly, the painting gives way to a sort of cybernet-
> ics, as it is vulgarly called. We see the work of art dehumanizing
> itself, freeing itself from man's signature. It accedes to an auton-
> omous movement that electronic meters (if one knew where to
> plug them in) would love to measure.[10]

Audiberti's "reading" tells us at once about the possibilities and the limits of the open work. The fact that half of his reactions have nothing to do with an aesthetic effect, and are merely personal divagations induced by the view of certain signs, is itself worthy of our attention. Is this, in fact, a limitation of this particular "reader," who is more involved with the games of his own imagination than with the work, or is it a limitation of the work that it should play a role similar to that of mescaline? Whatever the case, this text gives us a clear example of the kind of exaltation that can be derived from conjectural freedom, from the unlimited discovery of contrasts and oppositions that keep multiplying with every new look. To the point that, just as the reader eventually escapes the control of the work, so does the work eventually escape everybody's control, including that of the author, and starts blabbing away like a crazed computer. What remains then is no longer a field of possibilities but rather the indistinct, the primary, the indeterminate at its wildest— at once everything and nothing.

Audiberti speaks of a sort of "cybernetics," a word that brings me back to the heart of the matter and to my main question: What, indeed, are the possibilities of communication of this kind of open work?

Openness and Information

In its mathematical formulations (but not necessarily in its application to cybernetics), information theory makes a radical distinction between "meaning" and "information." The meaning of a message (and by "message" here I also mean a pictorial configuration, even though the way such a configuration communicates is not by means of semantic references but rather by means of formal connections) is a function of the order, the conventions, and the redundancy of its structure. The more one respects the laws of probability (the preestablished principles that guide the organization of a message and are reiterated via the repetition of foreseeable elements), the clearer and less ambiguous its meaning will be. Conversely, the more improbable, ambiguous, unpredictable, and disordered the structure, the greater the information—here understood as potential, as the inception of possible orders.

Certain forms of communication demand meaning, order,

obviousness—namely, all those forms which, having a practical function (such as a letter or a road sign), need to be understood univocally, with no possibility for misunderstanding or individual interpretation. Others, instead, seek to convey to their readers sheer information, an unchecked abundance of possible meanings. This is the case with all sorts of artistic communications and aesthetic effects.

As I have already mentioned, the value of every form of art, no matter how conventional or traditional its tools, depends on the degree of novelty present in the organization of its elements—novelty that inevitably entails an increase of information. But whereas "classical" art avails itself of sudden deviations and temporary ruptures only so as to eventually reconfirm the structures accepted by the common sensibility it addresses, thereby opposing certain laws of redundancy only to reendorse them again later, albeit in a different fashion, contemporary art draws its main value from a deliberate rupture with the laws of probability that govern common language—laws which it calls into question even as it uses them for its subversive ends.

When Dante writes, "Fede è sustanzia di cose sperate" ("Faith is the substance of hope"), he adopts the grammatical and syntactic laws of the language of his time to communicate a concept that has already been accepted by the theology of that time. However, to give greater meaning to the communication, he organizes his carefully selected terms according to unusual laws and uncommon connections. By indissolubly fusing the semantic content of the expression with its overall rhythm, he turns what could have been a very common sentence into something completely new, untranslatable, lively, and persuasive (and, as such, capable of giving its reader a great deal of information—not the kind of information that enriches one's knowledge of the concepts to which it refers, but rather a kind of aesthetic information that rests on formal value, on the value of the message as an essentially reflexive act of communication.

When Eluard writes, "Ciel dont j'ai dépassé la nuit" ("Sky whose night I've left behind"), he basically repeats the operation of his predecessor (that is, he organizes sense and sound into a particular form), but his intentions are quite different. He does not want to reassert received ideas and conventional language by lending them

a more beautiful or pleasant form; rather, he wants to break with the conventions of accepted language and the usual ways of linking thoughts together, so as to offer his reader a range of possible interpretations and a web of suggestions that are quite different from the kind of meaning conveyed by the communication of a univocal message.

My argument hinges precisely on this plural aspect of the artistic communication, over and above the aesthetic connotations of a message. In the first place, I would like to determine to what extent this desire to join novelty and information in a given message can be reconciled with the possibilities of communication between author and reader. Let's take a few examples from music.

In this short phrase from a Bach minuet (found in the *Notenbüchlein für Anna Magdalena Bach,*) we can immediately perceive how adhesion to a system of probability and a certain redundancy combine to clarify and univocalize the meaning of the musical message. In this case, the system of probability is that of tonal grammar, the most familiar to a Western post-medieval listener. Here each interval is more than a change in frequency, since it also involves the activation of organic relations within the context. An ear will always opt for the easiest way to seize these relations, following an "index of rationality" based not only on so-called "objective" perceptual data but also, and above all, on the premises of assimilated linguistic conventions. The first two notes of the first measure make up a perfect F major chord. The next two notes in the same measure (G and E) imply the dominant harmony, whose obvious purpose is to reinforce the tonic by means of the most elementary cadences; in fact, the second measure faithfully returns to the tonic. If this particular minuet began differently, we would have to suspect a misprint. Everything is so clear and linguistically logical that even an amateur could infer, simply by looking at this line, what the eventual harmonic relations (that is to say, the "bass") of this phrase will be. This would certainly not be the case with one of Webern's compositions. In his work, any sequence of sounds is a constella-

tion with no privileged direction and no univocality. What is missing is a rule, a tonal center, that would allow the listener to predict the development of the composition in a particular direction. The progressions are ambiguous: a sequence of notes may be followed by another, unpredictable one that can be accepted by the listener only after he has heard it. "Harmonically speaking, it would appear that every sound in Webern's music is closely followed by either one or both of the sounds that, along with it, constitute a chromatic interval. More often than not, however, this interval is not a half-tone, a minor second (still essentially melodic and connective, in its role as leader of the same melodic field); rather, it assumes the form, somewhat stretched, of a major seventh or a minor ninth. Considered as the most elementary links of a relational network, these intervals impede the automatic valorization of the octaves (a process which, given its simplicity, is always within the ear's reach), cause the meaning of frequential relationships to deviate, and prohibit the imagining of a rectilinear auditive space."[11]

If a message of this kind is more ambiguous—and therefore more informative—than the previous type, electronic music goes even further in the same direction. Here sounds are fused into "groups" within which it is impossible to hear any relationship among the frequencies (nor does the composer expect as much, preferring, as a rule, that we seize them in a knot, with all its ambiguity and pregnancy). The sounds themselves will consist of unusual frequencies that bear no resemblance to the more familiar musical note and which, therefore, yank the listener away from the auditive world he has previously been accustomed to. Here, the field of meanings becomes denser, the message opens up to all sorts of possible solutions, and the amount of information increases enormously. But let us now try to take this imprecision—and this information—beyond its outermost limit, to complicate the coexistence of the sounds, to thicken the plot. If we do so, we will obtain "white noise," the undifferentiated sum of all frequencies—a noise which, logically speaking, should give us the greatest possible amount of information, but which in fact gives us none at all. Deprived of all indication, all direction, the listener's ear is no longer capable even of choosing; all it can do is remain passive and impotent in the face of the original chaos. For there is a limit beyond which wealth of information becomes mere noise.

But, of course, even noise can be a signal. Concrete music and, in some cases, electronic music are nothing more than organizations of noise whose order has elevated them to the status of signal. But the transmission of this kind of message poses a problem: "If the sonic material of white noise is formless, what is the minimum 'personality' it must have to assume an identity? What is the minimum of spectral form it must have to attain individuality? This is the problem of 'coloring white noise.'"[12]

Something similar also happens with figurative signals. Let us take the example of a Byzantine mosaic, a classic form of redundant communication that lends itself particularly well to this kind of analysis. Every piece of the mosaic can be considered as a unit of information: a bit. The sum of all the pieces will constitute the entire message. But in a traditional mosaic (such as *Queen Theodora's Cortege* in the church of San Vitale, in Ravenna), the relationship between one piece and the next is far from casual; it obeys very precise laws of probability. First is the figurative convention whereby the work must represent a human body and a surrounding reality. Based on a precise model of perception, this convention prompts our eye to connect each piece according to the outlines of the bodies and the chromatic differences that define them. But the pieces do not limit themselves to suggesting the outline of a body; they insist on it by means of a highly redundant distribution and a series of repetitions. If a black sign represents the pupil of an eye, a series of other appropriately placed signals, representing eyebrows and lids, will reiterate the message till the entire eye will unambiguously offer itself to our view. The fact that there are two eyes constitutes yet another element of redundancy—let's not forget that modern painting seldom needs more than one eye to suggest the entire face. But in the Ravenna mosaic there are two eyes because that is what the figurative convention demands—a figurative convention which, in information theory, would correspond to the law of probability of a given system. As a result, most traditional mosaics are figurative messages that have a univocal meaning and convey a limited amount of information.

Suppose we take a white sheet of paper and spill some ink on it. The result will be a random image with absolutely no order. Let's now fold the paper in two so that the ink blot will spread evenly on both sides of the sheet. When we unfold the paper we will find

before us an image that has a certain order—i.e., symmetrical rep-
etition, one of the most elementary forms of redundancy as well as
the simplest avatar of probability. Now, even though the drawing
remains fundamentally ambiguous, the eye has a few obvious
points of reference: indications of a particular direction, sugges-
tions of possible connections. The eye is still free, much freer than
it was with the traditional mosaic, and yet it is directed toward the
recognition of some forms rather than others, varied and variable
forms whose very identification involves the unconscious tenden-
cies of the viewer, while the variety of possible solutions they invite
reconfirms the freedom, the ambiguity, and the suggestive power
of the figure. And yet, as I have already mentioned, the figure con-
tains a number of interpretive directions, enough so that the psy-
chologist who proposes the test feels quite disoriented if his pa-
tient's answer falls outside the province of his predictions.

Let's now transform both the ink blot and the pieces of the mo-
saic into the gravel which, crushed and pressed by a steamroller,
becomes pavement. Whoever looks at the surface of a road can de-
tect in it the presence of innumerable elements disposed in a nearly
random fashion. There is no recognizable order in their disposi-
tion. Their configuration is extremely open and, as such, contains
a maximum amount of information. We are free to connect the dots
with as many lines as we please without feeling compelled to follow
any particular direction. This situation is very similar to that of
white noise: an excess of equiprobability does not increase the po-
tential for information but completely denies it. Or rather, this po-
tential remains at a mathematical level and does not exist at the level
of communication. The eye no longer receives any direction.

This is again evidence that the richest form of communication—
richest because most open—requires a delicate balance permitting
the merest order within the maximum disorder. This balance
marks the limit between the undifferentiated realm of utter poten-
tial and a field of possibilities.

This problematic, liminal situation is characteristic of the kind of
painting that thrives on ambiguity, indeterminacy, the full fecun-
dity of the informal, the kind of painting that wants to offer the eye
the most liberating adventure while remaining a form of commu-
nication—albeit the communication of extreme noise endowed
with barely enough intention to deserve the status of signal. Oth-

erwise, the eye might as well contemplate the surface of a road or a stained wall: there is no need to frame these unlimited sources of information that nature and chance have so kindly put at its disposal. Again, it must be emphasized that intention alone is enough to give noise the value of a signal: a frame suffices to turn a piece of sackcloth into an artifact. This intention can, of course, assume all sorts of different forms: our present task is to consider how persuasive they must be in order to give a direction to the freedom of the viewer.

If I draw a square around a crack in a wall with a piece of chalk, I automatically imply that I have chosen that crack over others and now propose it as a particularly suggestive form—in other words, I have turned it into an artifact, a form of communication, simply by isolating it, by calling attention to it in a rather mechanical fashion not unlike the use of quotation marks in literature. But at times this intention may assume a much more complex form, intrinsic to the configuration itself. The direction I insert into the figure may retain a high degree of indeterminacy and yet steer the viewer toward a particular field of possibilities, automatically excluding other ones. This is what a painter does even in his most casual creation, even when he limits himself to scattering his signals across a canvas in a rather random fashion. If, after looking at Dubuffet's *Matériologies*—which are much like a road surface or other bare terrain in their attempt to reproduce the absolute freedom and unlimited suggestiveness of brute matter—somebody had told him that they bore a strong resemblance to Henri IV or Joan of Arc, the artist would probably have been so shocked that he would have questioned the sanity of the speaker.

In a perplexed essay on *tachisme* entitled "A Seismographic Art,"[13] Herbert Read wonders whether the numerous ways in which we can interpret blot of ink on a piece of paper have anything to do with an aesthetic response. According to him, there is a fundamental distinction between objects that are imaginative and objects that merely evoke images. In the second instance, the artist is the person who views the image, not the person who creates it. A blot lacks the element of control, the intentional form that organizes the vision. By refusing to use any form of control, *tachisme* rejects beauty in favor of *vitality*.

If contemporary art merely upheld the values of vitality (as the

negation of form) over those of beauty, there would be no problem: at this particular stage in the evolution of taste, we all could easily make do without the latter. What concerns us here is not the aesthetic value of an act of vitality but rather its power to communicate. Our civilization is still far from accepting the unconditional abandonment to vital forces advocated by the Zen sage. He can sit and blissfully contemplate the unchecked potential of the surrounding world: the drifting of clouds, the shimmer of water, cracks in the ground, sunlight on a drop of dew. And to him everything is a confirmation of the endless, polymorphous triumph of the All. But we still live in a culture in which our desire to abandon ourselves to the free pursuit of visual and imaginative associations must be artificially induced by means of an intentionally suggestive construct. As if that were not enough, not only do we have to be pushed to enjoy our freedom to enjoy, but we are also asked to evaluate our enjoyment, and its object, at the very moment of its occurrence. In other words, we still live in a culture dominated by dialectics: I am supposed to judge both the work in relation to my experience of it, and my experience of it in relation to the work. I might even have to try to locate the reasons for my reaction to the work in the particular ways the work has been realized—if nothing else, in order to judge it as a means to an end, at once process and result, the fulfillment or the frustration of certain expectations and certain goals. For the only criterion I can use in my evaluation of the work derives from the degree of coincidence between my capacity for aesthetic pleasure and the intentions to which the artist has implicitly given form in his work.

Thus, even an art that upholds the values of vitality, action, movement, brute matter, and chance rests on the dialectics between the work itself and the "openness" of the "readings" it invites. A work of art can be open only insofar as it remains a work; beyond a certain boundary, it becomes mere noise.

To define this threshold is not a function of aesthetics, for only a critical act can determine whether and to what extent the "openness" of a particular work to various readings is the result of an intentional organization of its field of possibilities. Only then can the message be considered an act of communication and not just an absurd dialogue between a signal that is, in fact, mere noise, and a reception that is nothing more than solipsistic ranting.

Form and Openness

The lures of vitality are clearly denounced in an essay on Dubuffet by André Pieyre de Mandiargues. He notes that in *Mirobolus, Macadam and Co.* Dubuffet has pushed his art to its extreme limit, showing his audience perpendicular views of the most basic ground formations. All abstraction is gone, and what's left is the immediate presence of matter in all its concreteness. We contemplate the infinite in a layer of dust: "Just before the exhibition, Dubuffet had written to me that he was afraid his 'texturologies' brought art to a very dangerous point where all difference between the object—supposed to provoke thought and act as a screen for the viewer's visions and meditations—and the basest and least interesting material formation had become very subtle and uncertain. It is hence not surprising that art lovers get scared whenever they see art pushed to an extreme where it is nearly impossible to distinguish what is art from what is not." [14]

On the other hand, if the painter is aware of a distinction, then the viewer can either work toward the recognition of an intentional message or abandon himself to the vital and unchecked flux of his most unpredictable reactions. The latter is the attitude Mandiargues assumes when he compares what he feels while contemplating Dubuffet's texturologies to the emotions evoked in him by the powerful, muddy flow of the Nile, or to the real happiness one feels at plunging one's hands into the sand of a beach and then watching it coolly and quickly flow through the fingers while the palms are still soothed by the deep warmth of matter. But if this is indeed the case, why bother with the painting, which is so much more limited in possibilities than the real sand or the immensity of natural matter at our disposal? Obviously because the painting organizes crude matter, underlining its crudeness while at the same time defining it as a field of possibilities; the painting, even before becoming a field of actualizable choices, is already a field of actualized choices. This is why, before launching into a hymn to vitality, the critic celebrates the painter and what he proposes. Only after his sensibility has been thus directed does he feel ready to move on to unchecked associations prompted by the presence of signs which, however free and casual, are nevertheless the products of an intention and, therefore, the marks of a work of art.

The critical analysis that seems to be closest to the Western conception of artistic communication is the one that tries to recognize, at the heart of the "accidental" and the "fortuitous" that are the substance of a work, the signs of a "craft" or "discipline" by virtue of which, at the right moment, the artist is able to activate the forces of chance that will turn his work into a *chance domestiquée,* "a sort of torque, whose poles, when they come into contact, far from nullifying each other, retain their potential difference." Geometry is what finally provides Dubuffet's "texturology" with a check and a direction, so that, in the end, the painter will still be the one "who plays on the keyboard of evocation and reference."[15] Similarly, drawing is what finally controls the freedom of Fautrier's colors by providing them with a dialectics between the presence of a limit and its absence, in which "the sign shores up the overflow of matter."[16]

Even in the most spontaneous expressions of action painting, the multitude of forms that assail the viewer and allow him extreme freedom of interpretation is not like the record of an unexpected telluric event: it is the record of a series of gestures, each of which has left a trace with both a spatial and a temporal direction of which the painting is the only witness. Of course, we can retrace the sign back and forth in every sense, without changing the fact that the sign is a field of reversible directions which an irreversible gesture has imposed on the canvas—a field that invites us to explore all possible directions in search of the original (and now lost) gesture till we finally find it and, with it, the communicative intention of the work. This sort of painting tries to retain the freedom of nature, but of a nature whose signs still reveal the hand of a creator, a pictorial nature that, like the nature of medieval metaphysics, is a constant reminder of the original act of Creation. This sort of painting is, therefore, still a form of communication, a passage from an intention to a reception. And even if the reception is left open—because the intention itself was open, aiming at a plural communication—it is nevertheless the end of an act of communication which, like every act of information, depends on the disposition and the organization of a certain form. Understood in this sense, the "informal" is a rejection of classical forms with univocal directions but not a rejection of that form which is the fundamental condition of communication. The example of the informal, like that of any open

work, does not proclaim the death of form; rather, it proposes a new, more flexible version of it—*form as a field of possibilities*.

Here we realize not only that this art of chance and vitality is still dependent on the most basic categories of communication (since it bases its informativeness on its formativity) but that it also offers us, along with all the connotations of formal organization, the conditions for aesthetic appreciation. Let us take Jackson Pollock's art as an example. The disorder of the signs, the disintegration of the outlines, the explosion of the figures incite the viewer to create his own network of connections. But the original gesture, fixed by and in the sign, is in itself a direction that will eventually lead us to the discovery of the author's intention. Of course, this is possible only because the gesture, unlike a conventional referent, is not extraneous and exterior to the sign (in other words, it is not a hieroglyph of vitality that can be serially reproduced, and which will forever evoke the notion of "free explosion"). Gesture and sign coexist in a particular balance, impossible to reproduce, resulting from the fusion of inert materials and formative energy, and from a series of connections among the various signs that allow our eyes to discern, beyond these, the interrelationship of the original gestures (and the accompanying intentions). Here again we confront a fusion of elements similar to the one that, in the best moments of traditional poetry, weds sound and sense, the conventional value of the sound and the emotion it evokes. Western culture considers this particular fusion as an aesthetic event characteristic of art. The "reader" who, at the very moment in which he abandons himself to the free play of reactions that the work provokes in him, goes back to the work to seek in it the origin of the suggestion and the virtuosity behind the stimulus, is not only enjoying his own personal experience but is also appreciating the value of the work itself, its aesthetic quality. Similarly, the free play of associations, once it is recognized as originating from the disposition of the signs, becomes an integral part of the work, one of the components that the work has fused into its own unity and, with them, a source of the creative dynamism that it exudes. At this point, the viewer can savor (and describe, for that's what every reader of informal art does) the very quality of the form, the value of a work that is open precisely because it is a work.

It becomes clear that quantitative information has led us to something much richer: aesthetic information.[17]

The former type of information consists in drawing as many suggestions as possible out of a totality of signs—that is, in charging these signs with all the personal reactions that might be compatible with the intentions of the author. This is the value all open works deliberately pursue. Classical art forms, in contrast, imply it as a condition necessary to interpretation but, rather than giving it a privileged status, prefer to keep it in the background, within certain limits.

The latter type of information consists in referring the results drawn from the former type back to their original organic qualities, in seizing, behind the suggestive wealth we exploit, a conscious organization, a formative intention, and in enjoying this new awareness. This awareness of the project that underlies the work will, in turn, be another inexhaustible source of pleasure and surprise, since it will lead us to an ever-growing knowledge of the personal world and cultural background of the artist.

Thus, in the dialectics between work and openness, the very persistence of the work is itself a guarantee of both communication and aesthetic pleasure. Not only are the two values intimately connected, but each implies the other—which is certainly not the case with a conventional message such as a road sign, where the act of communication exists without any aesthetic effect and exhausts itself in the apprehension of the referent, without ever inducing us to return to the sign to enjoy the effectiveness of its message in the way it is formally expressed. "Openness," on the other hand, is the guarantee of a particularly rich kind of pleasure that our civilization pursues as one of its most precious values, since every aspect of our culture invites us to conceive, feel, and thus see the world as possibility.

V

Chance and Plot:
Television and Aesthetics

Television has long been the object of so many debates and so many theoretical reflections that some people have begun to speak of a "televisual aesthetics."

In the context of Italian philosophical terminology, "aesthetics" refers to the investigation of art in general, to the human act that generates it, and to the overall characteristics of its objects. We cannot speak of an "aesthetics of painting" or of an "aesthetics of cinema," unless we refer to certain problems that, though they may be particularly obvious in painting or in cinema, are nevertheless common to all the arts, and, as such, likely to reveal certain human attitudes that could become the object of theoretical reflection and contribute to a philosophical anthropology. In order to apply the term "aesthetics" to the technical discourses, stylistic analyses, and critical judgments of a particular art, we would have to give it a different, more concrete meaning, as has already been done in other countries. On the other hand, if we want to remain faithful to traditional Italian terminology (if only for clarity's sake) it may be preferable to speak of *poetics* or of a technical-stylistic analysis—thus acknowledging the importance of such a practice as well as its theoretical perspicuity, often far superior to that of most philosophical "aesthetics."

In this essay, I would first of all like to examine what television, and the structures it generates, can contribute to the field of aesthetic reflection—whether it can reconfirm certain stances or, as a phenomenon that does not fit into any of the existing categories, broaden certain theoretical definitions.

Second, I would like to see whether there is any rapport between

the communicative structures of television and the "open" structures of contemporary art.

The Aesthetic Structures of Live Television

Television has been the object of numerous discussions that have raised a variety of interesting issues, some of them undoubtedly useful for an eventual artistic development of the medium, but none of them quite sufficient to constitute an exciting contribution to the field of aesthetics. In other words, they have not been able to generate any "novelty" that might challenge existing assumptions and demand a redefinition of principles and precepts.

Some of these discussions have dealt with the "space" of television—determined by the dimensions of the screen and the limited depth of field of TV cameras—and with the very particular "time" of television, so often identifiable with real time (in live broadcasts of events and shows, for instance), and always defined by its relationship with televisual space and the psychological conditions of the average TV audience. A good deal of attention has also been given to the very peculiar form of communication that binds the TV screen to its audience, an audience that is both numerically and qualitatively different from the audiences of other spectacles, in that, although it involves far more people, it still allows each one of them his privacy, a form of isolation that is in total contrast to any idea of collectivity. These are the problems that confront TV scriptwriters, set designers, producers, and directors, and are all worthy subjects for a poetics of television.

On the other hand, philosophically speaking, there is nothing new about the fact that even television, like any other means of communication, has a "space" and a "time" of its own, and a particular relationship with its public. The problems that concern television only confirm the philosophical assumption that intrinsic to every "genre" of art is a dialogue with its matter, and the establishment of a grammar and a lexicon of its own. But, in this case, television wouldn't offer the philosopher anything new.

This conclusion could be definitive if we were concerned only with the "artistic" (here meant in its most conventional and limited sense) programs offered by television: plays, operas, soap operas, concerts, comedies, films, other traditional shows. But since a

broader aesthetic analysis can take into consideration all sorts of communication to measure their artistic and aesthetic value, the aspect of television that would seem most interesting and fruitful to our research is also its most characteristic, unique to the medium: namely, live broadcasts.

Some of the features of live broadcasts that seem most relevant to our inquiry have already been the object of a great deal of attention. First of all, their form, so much like that of a montage—"montage" because, as everyone knows, an event is generally filmed by three or more TV cameras at the same time, though only the best image, or the one supposed to be the best, goes on the air—but a montage that is improvised and occurs simultaneously with the event that's being filmed. Filming, editing, and broadcasting, three phases that in cinema remain perfectly separate and distinct, are here fused into one—a fact which, as I have already mentioned, certainly warrants the identification of real time with televisual time, since no form of narration can condense the autonomous duration of the represented event.

Even these few preliminary observations are enough to suggest a whole series of artistic, technical, and psychological problems at the level of both production and reception—one of which is the introduction, into the realm of artistic production, of a dynamics of reflexes that until the advent of television was believed to pertain only to some modern experiences of locomotion and to some industrial activities. But something else brings this "immediate" act of communication even closer to an artistic event.

No live broadcast of a particular event is ever the mirror image of that event: in fact, it is always (even though, on occasion, barely so) an interpretation of it. In order to film a particular event, the TV director will decide where to locate the three or more cameras so as to have three or more complementary points of view, whether or not all three cameras are concerned with the same field of vision (such as an opera singer) or with different ones (such as three different points along a race-track). Obviously, the location of TV cameras is always determined by technical questions, but not so much as to exclude, at least in a preliminary phase, the possibility of a choice.

As soon as the event begins, the director receives the three images filmed by the three cameras on three separate screens. Prior to

this, he has presumably instructed the cameramen as to what kind of image they should try to obtain from their respective fields of vision (what angle to take, what lens to use, what depth to choose, and so on). At this point, the director must choose which image to broadcast and when, in order to provide a coherent continuum of images, a real narrative sequence. For his choices inevitably turn into a composition, a narration, a discursive unification of the images that he has analytically selected from a much vaster set of co-existing and intersecting events.

It is true that most live broadcasts today concern events that do not allow much room for interpretation: the focus of a football game must be the ball. But even here, every technical choice inevitably entails a particular bias: a camera that tends to focus on the particular contributions of individual players is telling us something different from the one that prefers to stress teamwork. On the other hand, certain events are particularly apt to be interpreted and turned into narrative. In 1956, for instance, during the broadcast of a discussion between two economists, the screen insisted on showing the weaker interlocutor nervously twisting his handkerchief around his fingers while the voice of the stronger one boomed on over his bowed head. Clearly, the director of the program was more involved with the emotional aspect of the debate than with its economic value.

The famous wedding of Grace Kelly and Prince Rainier of Monaco is an even better example. It could have been approached from a number of possible angles: as a political event, a diplomatic meeting, a Hollywood parade, an operetta, a Regency romance. Predictably, the broadcast chose the last: it stressed the romantic aspect of the affair, clearly favoring flash over depth. During the military parade, at the moment when the purely decorative American contingent was intoning some military anthem, the camera remained focused on Prince Rainier, who, having soiled his pants by leaning against the parapet of the balcony, had bent to dust them off without, for all that, taking his smiling eyes off his betrothed. Maybe any TV director would have done the same (isn't this the sort of thing that's best known as a "scoop"?). Whatever the case, this initial choice certainly colored the rest of the broadcast. If, at the moment in question, instead of focusing on Rainier the camera had focused on the Americans in full uniform, then, two days later,

during the religious ceremony, it might have focused on the offici-
ating priest rather than on the face of the princess, as it did. Ob-
viously, to give a certain unity to his story, the director had decided
to maintain the same tone frame after frame, chapter after chapter,
since the premises he had established two days earlier were still con-
ditioning his narrative. By so doing, he was probably trying to
satisfy the presumed taste of his audience, but in fact he was also,
though maybe unconsciously, determining it. Despite a number of
technical and sociological restrictions, he had found enough room
to move autonomously and to tell his own story.

A narrative that evolves according to a rudimentary principle of
coherence, and whose realization takes place at the same time as its
conception—isn't this what we would call an *impromptu* story? Im-
provisation: here is an aspect of television that could be of interest
to aesthetics. The songs of the bards and the representations of the
Commedia dell'Arte have already familiarized us with a similar
technique; both forms availed themselves of improvisation but
with much greater creative autonomy, far fewer external restric-
tions, and absolutely no referential obligation toward an ongoing
reality. Today we find an even more extreme expression of the same
phenomenon in those jazz performances known as jam sessions,
where the various members of a group choose a theme which they
then proceed to develop freely, according to the whims of each,
relying on sheer improvisation as well as on a certain congeniality.
The result is a "creation" that is at once collective, simultaneous,
and extemporaneous, yet (at its best) perfectly organic.

This should in itself be enough to make us reconsider certain
aesthetic concepts, or at least to lend them greater flexibility, in
particular those concerning the productive process and the person-
ality of the author, the distinction between process and result, and
the relationship between a finished work and its antecedents (or,
more broadly, what led to it). In the case of jazz, for instance, the
antecedents of a jam session are a certain familiarity with the other
players and their work, and the frequent recourse to traditional
tricks, such as the "riff" or other melodic-harmonic formulas bor-
rowed from a common repertory. Of course, all these "anteced-
ents" somewhat limit the creative freedom of the players, just as
they confirm the theory that certain structural premises play a de-
termining role in the development of an artwork. Translated into

melodic facts, these premises demand certain developments which the players can immediately predict and realize as if by common accord, since they depend on questions of language and musical rhetoric that condition and surround all invention.[1]

The same kinds of problems are also present in live TV broadcasts. Here, as well,

1. process and result are practically indistinguishable—even though, in fact, the process involves three or more simultaneous images, out of which, at the last moment, only one emerges as the result;

2. the work and its antecedents coincide—even though the cameras are positioned in advance;

3. invention is not limited by a repertory but rather by external factors. Which is to say that, all in all, the autonomy of the author is considerably reduced, as is the artistic potential of the medium.

Once again, this could well be a definitive conclusion if we chose to see as a limit the fact that a TV narrative represents autonomous events which, though they can be approached from different angles, have a logic of their own that demands to be respected. But we needn't see this condition as a limit; in fact, we can easily see it as the only real artistic possibility of live TV, for reasons that can be traced all the way back to Aristotle.

Speaking of the "unity of plot," Aristotle notes that "many things, countless things indeed, may happen to one man, and some of them may not contribute to any kind of unity; and similarly he may carry out many actions from which no single unified action will emerge."[2] Likewise, within a certain field of events, there can be some that, although they have absolutely no connection with one another, intersect and overlap, creating a number of situations that will evolve in different directions. Or a certain group of facts, which, considered from a particular angle, seem to evolve toward a certain resolution, may, when considered from a different angle, proceed in a completely new direction. Obviously, all the events that take place within the same field needn't be in close contact with one another to justify their presence: their presence is justified by the very fact that they occur within the same field. On the other hand, this does not change the fact that we need to look at them from a unifying perspective, so much so that generally we tend to

favor those that seem to fit that perspective over those that don't. In other words, we need to group them in a specific form. In yet other words, we need to unify them into experiences.

I am using the term "experience" here because it allows us to refer back to Dewey's definition, which seems to be particularly relevant to the present argument: "We have *an* experience when the material experienced runs its course to fulfillment. Then and then only is it integrated within and demarcated in the general stream of experience from other experiences . . . In an experience, flow is from something to something."[3] According to this definition, only those actions that have been brought to their preestablished conclusion, such as a job well done or a completed game, can be considered experiences.

When we look back on our days, we often distinguish complete experiences from those that have been merely sketched or have remained incomplete. Thus, it may often happen that we discard as useless experiences that are perfectly complete but have so little relevance to our most immediate concerns that we haven't even noticed they took place. Similarly, within a field of events, we inevitably focus on the ones that seem most relevant to the interests, concerns, and emotions of the present moment.[4]

Clearly, what we find most interesting in Dewey's definition of experience is not so much the organic nature of the process (the interaction between the subject and its surroundings) as its formal aspect: the fact that he sees it as an *accomplishment*, a *fulfillment*.

And what is even more interesting in this whole question is the attitude of the observer, who prefers to guess and represent the experiences of others rather than living his own. The observer produces *imitations* (in the Aristotelian sense of *mimesis*) of experiences, thereby enjoying his own experience of interpretation and mimesis.

These imitations of experiences can be considered as having an aesthetic value, since they are at once *interpretations* and *creations—choices* and *compositions*—even though the events themselves may seem to require such choices and such compositions.

The larger the field of events among which we deliberately set out to identify and select experiences, the greater their aesthetic value. This process is the search for, and the establishment of, a coherence, a unity, an order in the midst of chaotic diversity—the search for a unified whole such that "its various incidents must be

so arranged that if any of them is differently placed or taken away the effect of wholeness will be seriously disrupted."[5] Which brings us back to Aristotle and the realization that this effort to distinguish and reproduce experiences is precisely what he calls poetry. History is the exposition not of a single action but "of a single period, and of everything that happened to one or more persons during this period, however unrelated the various events may have been."[6] To Aristotle, history is like a panoramic photo of a whole field of events, whereas poetry is the selection of just a few events out of the many. It involves the identification of a coherent experience, of the genetic relationship that binds different facts together; in other words, poetry organizes according to a perspective of value.[7]

All these observations should allow us to recognize the artistic aspects of live broadcasts, and even see an aesthetic potential in their attempts to isolate experience in as satisfactory a fashion as possible and to organize facts according to a perspective of value.

Consider, for example, a fire. The event itself consists of a number of elements that can be grouped according to different narrative perspectives: the devouring fury of the flames, the intrepid firemen, the bereaved families, the awestruck bystanders, the elusive arsonist, suspected villain of the piece. It is up to the camera to decide what story to tell, what "reality" to offer its viewers, for every representation of reality entails a choice and a judgment. Live TV broadcasts can come very close to the poetics of *cinéma vérité*.

The artistic aspects of the televisual phenomenon, with all that they entail, would be fairly easy to recognize if it weren't for the conditions of improvisation, characteristic of live TV, that somewhat complicate the issue. Dewey, speaking of the experience of logical thought (though his example can actually be applied to all sorts of experiences), notes that "in fact in an experience of thinking, premises emerge only as a conclusion becomes manifest."[8] In other words, the predicative activity is not a mere syllogistical deduction, but rather a relentless effort to achieve a conclusion that—alone— will justify its initial motivation.[9] Thus, both the "before" and the "after" of an experience become apparent only after a prolonged processing of all the data in our possession—data which, of course, already include some purely chronological "befores" and "afters,"

but not the essential ones, the ones that will still be there once the process of predication is over.

A TV director faces the difficult task of having to identify the logical phases of an experience at the very moment when these are still merely chronological. He can isolate a logical thread out of an ensemble of events but, unlike even the most "realist" of artists, who can avail himself of both an a priori and an a posteriori stance vis-à-vis his text, he can neither plan nor revise. In other words, he must stick to his "plot" while it is still unfolding among many other plots. By having the cameras follow a particular point of view, the TV director must essentially invent an event that is still happening, and invent it so that it is the same as the one that is taking place. In other words, he must both guess and predict the time and space of the next phase of his plot. As a result, his artistic activity is fairly limited and yet, from the viewpoint of production, very new, for it must be based on a particular sympathy with the event, an intuition and hypersensitivity (more commonly known as flair) that would allow him to *grow* with the event, to *happen* with the event. Or, at least, to distinguish the event immediately and highlight it before it has passed.[10]

Thus, the development of his narrative is an effect partly of art and partly of nature. The result will be a curious mixture of spontaneity and artifice, in which artifice defines and chooses the spontaneity, and spontaneity determines the artifice both in its conception and its realization. Other arts, such as gardening and hydraulics, have already provided examples of an artifice that determines both the present movements and the future effects of natural forces, and involves them in the organic structure of the work. But with live TV, natural events do not inscribe themselves in any formal scheme that has already foreseen them; rather, they require that such a scheme be developed along with them, simultaneously, at once determining them and determined by them. Even in instances where his work demands the least artistic commitment, a TV director is involved in a creative experience whose very peculiarity is in itself an artistic phenomenon of great interest. Similarly, the aesthetic value of his product, however rough and ephemeral, opens up a number of stimulating perspectives for a phenomenological study of improvisation.

Freedom of Events and Determinism of Habit

With the above descriptive analysis of the psychological and formal structures that characterize the phenomenon of live TV, we can now speculate about the future of the medium, and about the artistic possibilities that this kind of televisual narrative could have beyond its normal uses. Similarly, we can explore the obvious analogy between this kind of creative process, which avails itself of the contributions of chance and the autonomous decisions of an interpreter (the director that follows, albeit with a certain amount of freedom, the theme "what-is-happening-here-now"), and that phenomenon typical of contemporary art which in earlier chapters I defined as the "open work."

Clarifying the second issue may well clarify the first. Live TV certainly establishes a relationship between life, in the most amorphous openness of its myriad possibilities, and plot, the story the director concocts by organizing along a univocal and unidirectional thread, even though on the spur of the moment, the events he has chosen chronologically.

I have already dwelt on the importance of the narrative montage, and have tried to define its structure with the help of Aristotelian poetics, the poetics of plot par excellence which enables one to describe the traditional structures of both the play and the novel, or, at least of the novel that is conventionally recognized as "well constructed."[11]

But the notion of plot is only one element in Aristotle's poetics. Modern criticism has clearly shown that plot is merely an exterior arrangement of facts whose function is that of expressing the deeper sense of the tragic (and narrative) fact: the action.[12]

Oedipus investigates the causes of the plague and, upon discovering that he has murdered his father and married his mother, blinds himself: this is the plot of *Oedipus Rex*. But the tragic action lies at a yet deeper level, where the complex relationship between deed and guilt unfolds according to immutable laws, steeped in existential anguish. The plot is absolutely univocal, but the action is fraught with ambiguity, open to a thousand possible interpretations. Similarly, the plot of *Hamlet* can be exhaustively and correctly described by any high school student, but its action has been

and continues to be responsible for rivers of ink, because it is unitary but not univocal.

The contemporary novel has long tried to dissolve the plot (here understood as a sequence of univocal connections necessary to the final denouement), to construct pseudo-adventures based on "stupid" and inessential facts. Everything that happens to Leopold Bloom, Mrs. Dalloway, and Robbe-Grillet's characters is both "stupid" and inessential. And yet, looked at from a different narrative standpoint, all their experiences appear quite essential to the expression of the action, to the psychological, symbolic, or allegorical development that implies a certain vision of the world. This vision, this implicit discourse that can be understood in a number of ways and that results in a variety of different and complementary solutions, is what we call the "openness" of a narrative work: the rejection of a plot signifies recognition that the world is a web of possibilities and that the work of art must reproduce this physiognomy.

Whereas theater and the novel have long been progressing in this direction (I am thinking of works such as those by Ionesco, Beckett, and Adamov, and *The Connection,* by Gelber), cinema, another art based on plot, has been shying away from it. Its reluctance to follow this trend was probably determined by various factors, primarily its social role. While other arts were experimenting with "open" structures, cinema felt obliged to keep in touch with the broader public and provide it with the traditional dramas our culture legitimately demands. At this point I would like to add, parenthetically, that it would be wrong to believe that a poetics of the open work is the only possible contemporary poetics; I do not mean even to imply this. For, in fact, the open work is only one expression, probably the most interesting, of a culture whose innumerable demands can be satisfied in many different ways—for instance, by using traditional structures in a more modern fashion. A movie as fundamentally Aristotelian as *Stagecoach* is a perfectly valid example of contemporary narrative.

And yet there have been a few movies that have definitely broken away from the traditional structures of plot to depict a series of events totally devoid of conventional dramatic connections—stories in which nothing happens, or, rather, where things happen not by narrative necessity but, at least in appearance, by chance. I am

thinking particularly of movies such as *L'Avventura* and *La Notte,* both by Antonioni.

The importance of these movies resides not only in the fact that they were both experimental works, but also in the fact that they were both accepted by the public—with a great deal of criticism and vituperation, yet nevertheless accepted as debatable but possible visions of the world. It can hardly be a coincidence that this new narrative mode was offered to a public that had already become used to the new logic of live TV—that is, to a kind of narration which, despite an appearance of causality and coherence, relies primarily on the mere sequence of events, and in which the narrative, even though it might have a thread, is constantly spilling beyond its margins, into the inessential, the tangential, the gloss, where for a very long time nothing may happen, and the camera remains focused on the curve of a road waiting for the sudden appearance of the first runner, or, weary, wanders to the façades of the surrounding houses or the expectant faces of the spectators, for no other reason than that this is the way things go, and there is nothing else to do but wait.

L'Avventura often lapses into the long, blank spells of live TV; as do the night revels in *La Notte,* or the heroine's interminable walk amid boys setting off fireworks.

All this seems to suggest that, indeed, live TV may well deserve to be included—both as a source and as a contemporary phenomenon—in any study concerning the openness of narrative structures and the possibility of reproducing life in all its multiplicity, in its casual unfolding beside and beyond any preestablished plot.

At this point, however, we must avoid a possible misunderstanding: life in its immediacy is not "openness" but chance. In order to turn this chance into a cluster of possibilities, it is first necessary to provide it with some organization. In other words, it is necessary to choose the elements of a constellation among which we will then—and only then—draw a network of connections.

The openness of *L'Avventura* is the result of a montage that has deliberately replaced pure chance with "willed" chance. If it lacks a plot it is because the director wanted to provoke a feeling of suspension, of indeterminateness, in his audience—because he wanted to frustrate their "romantic" expectations and plunge them into a fic-

tion (in itself already a filtered life) that would force them to find their way amid all sorts of intellectual and moral dilemmas. In other words, openness presumes the lasting and accurate organization of a *field of stimuli*.

Of course, it is quite possible that a live broadcast may be able to seize, out of a variety of facts, the very ones that lend themselves to an open organization. But at this point two essential factors come into play: the nature of the medium and its social purpose—in other words, its syntax and its audience. It is precisely because of the chance nature of its material that, in order to keep some control, live TV resorts to the most traditional and dependable forms of organization, the most Aristotelian ones, determined by the laws of causality and necessity which, in the end, are none other than the laws of verisimilitude.

At one particular point in *L'Avventura*, Antonioni creates a tense situation: on a scorching hot afternoon, a man overturns an ink-stand onto a freshly finished drawing by a young architect. The tension demands to be resolved. A similar situation, in a western, would culminate in a rousing fight that would psychologically jus-tify both the offender and the offended, and motivate their actions. But in *L'Avventura* nothing happens; the tension is constantly on the point of being resolved by a fight, which, however, never oc-curs, for both deeds and emotions are eventually absorbed into the physical and psychological weariness that dominates the entire sit-uation. Such a radical indeterminateness can result only from a "de-cantation" of the dramatic action. The violation of the most natural (i.e., plausible) expectations is here so deliberate and intentional that it must be the fruit of very rigorous calculation: if everything seems so casual, it is precisely because nothing is. This effect would be impossible to achieve during the live broadcast of a baseball game, where all the tensions and crises accumulated in the course of one or more innings have to be resolved in the temporary finality of a home run, or an RBI, whatever the case may be (and, failing this, a near home run, with the ball landing on the wrong side of the foul line, causing the audience to go wild with frustration). Even admitting that all this is imposed by the journalistic function of the broadcast, which obviously cannot fail to report all the es-sential aspects of the game, once the home run has occurred, the director could choose between focusing the cameras on the deliri-

ous crowd—the appropriate anticlimax, the normal relinquishment of all control after a tense situation—or polemically presenting random scenes on a nearby street (a bum sleeping in a doorway, a cat rummaging through a garbage can, a strutting pigeon) or any other image not even remotely connected to the events of the game. In other words, the director has the choice of confining his cameras to a rigorous presentation of the game, a limited interpretation with a mildly moral or documentary import, or of escaping all interpretation by means of a passive expression of nihilism, which, intelligently carried out, could produce an effect similar to that of the absolutely objective descriptions of the *nouveau roman.*

This is what the director could do if his broadcasts were only apparently live and actually the result of a long elaboration, the realization of a new vision of the world rebelling against that instinctive mechanism that makes us connect events according to the laws of verisimilitude. Let's not forget that according to Aristotle, poetic verisimilitude is determined by rhetorical verisimilitude; that is, it is not only logical but also natural that what happens in a plot is also what all of us would expect to happen in real life, what, according to the conventions of the form, we would think *should* happen given certain premises. The director is generally more than ready to accept, as the normal conclusion of his artistic discourse, what his audience would commonsensically see as the normal culmination of a sequence of real events.

Live TV broadcasts are determined, in their unfolding, by the expectations and demands of their public, a public that not only wants to know what is happening in the world but also expects to hear or see it in the shape of a well-constructed novel, since this is the way it chooses to perceive "real" life—stripped of all chance elements and reconstructed as plot.[13] We shouldn't forget that, after all, the traditional narrative plot corresponds to the habitual, mechanical, yet reasonable and functional way in which we are used to perceiving the events of the world, attributing to them a univocal meaning. The experimental novel, instead, wants to demystify the habitual associations on which we base our interpretations of life, not so as to present us with the image of a nonlife but rather to help us experience life in a new way, besides and beyond all rigid conventions. But this involves a cultural decision, a "phenomenological"

stance, the will to bracket assumptions—a will that the average TV viewer, who watches television in order to gather some information and to find out (quite legitimately) how it will all end, does not have.

Which does not mean that, in real life, toward the end of a real baseball game, at the very moment in which a tie has to be resolved in favor of one or the other team, the overwrought spectators won't suddenly realize the vanity of it all and lapse into the most unlikely behavior, such as falling asleep, leaving the field, starting a fight with their neighbor, and so on. If this were to happen, and the TV director were to film it, he would produce an admirably realistic nonstory that would suddenly open up the currently held notion of verisimilitude. But until then, such a story will continue to be considered unlikely, whereas its opposite—the delirious response of the hopeful fans—will be considered likely, normal, the realistic climax of a realistic story. The public will demand it, and the TV director will feel compelled to give it to them.

But aside from these restrictions, which mostly have to do with the functional relationship between television as a news medium and a public that demands a particular product, there is also, as I have already suggested, another kind of restriction, a syntactic one, determined by the very nature of the production process and the system of psychological reflexes of the director.

Life, by virtue of the element of chance, is already dispersed enough to disorient the director who tries to interpret it narratively. He is constantly in danger of losing the thread and of becoming a mere photographer of the unrelated and the uniform—not of that which is intentionally unrelated but of that which is factually accidental, alien. In order to avoid this sort of dispersion, he must constantly impose some organization on the available data. And he must do it there and then, without preparation and in the shortest possible time.

Obviously, given the limited amount of time at his disposal, he will tend to rely on the psychologically most immediate and easiest way of connecting two disparate events—that is, the way dictated by habit and supported by public opinion. To bring two events together by means of an unusual connection demands critical reflection, and implies an ideological choice as well as a cultural deci-

sion. Of course, things would be quite different if we were more used to looking at the world in an unusual fashion, instinctively aiming at the unrelated, or the oddly related, or, to put it in musical terms, at serial rather than tonal connections.

This education of one's sensibility can be acquired only after a long assimilation of new narrative techniques in which few if any TV directors have had the leisure to indulge, nor does the current organization of our culture demand it of them.

On the other hand, one should also consider the fact that in a sudden confrontation with a vital situation, even a writer who is perfectly familiar with new narrative techniques might resort to more elementary forms of communication based on both habit and a collective notion of causality, since, for the time being, these are still the common points of reference in our daily life.

In the summer of 1961, Robbe-Grillet was involved in an airplane accident from which he escaped unharmed. He was immediately interviewed by a group of journalists, among them a reporter from *L'Express,* who, in a very amusing article, noted how Robbe-Grillet's intensely emotional account of the event had unfolded according to the most traditional, indeed the most Aristotelian, not to say Balzacian, narrative principles: not only did it have a beginning, a middle, and an end, but it was also charged with suspense and extremely subjective. The journalist felt that Robbe-Grillet should have narrated the event in the same objective, impersonal, flat, nonnarrative style he used in his novels. The fact that he did not, the reporter facetiously concluded, proved that he was an impostor and that he did not deserve to occupy the place of patriarch of the new narrative techniques. The article was amusing and highly ironic; on the other hand, had it been written in dead earnest, and had the accusation of insincerity been sincere (in suspecting Robbe-Grillet of having, at a crucial moment, forsaken his vision of the world to assume the one he had always countered), the novelist would have been the victim of a very serious misunderstanding. Nobody, in fact, would expect a scholar of non-Euclidean geometry to use Riemann's geometry to measure his room so that he could build a wardrobe for it; or a supporter of the theory of relativity to adjust his watch according to Lorentz's transformations, after getting the time from the first motorist who happens to zoom by. New parameters can provide us with tools that are per-

fectly suited to experimental situations (whether in a lab or in the pages of a novel) but are not functional in everyday life. Which, of course, should not be taken to mean that they are not valid but that, on a daily basis (at least for the time being), more traditional parameters with a wider diffusion might be more effective.

The interpretation of something that is happening to us now and to which we must immediately respond—or that we must immediately describe televisually—may well be one of those cases in which the more conventional response is also the most effective.

This is the situation of televisual language in a particular phase of its development, and in a particular cultural context which demands that it fulfill a particular function vis-à-vis a particular public. On the other hand, given different historical circumstances, live TV could well become some sort of initiation into a freer exercise of one's sensibility and other enriching associative experiences; in other words, it could be a big step toward another psychological and cultural dimension. For the time being, however, a description of the aesthetic structures of live TV broadcasts must keep in mind the reality of the phenomenon and look at the medium and at its laws in relation to a particular audience. Today, a TV commentary resembling *L'Avventura* would probably still be considered a very bad broadcast, and its cultural reference would appear merely ironic.

For all its contemporariness, the poetics of the open work is not yet suited to every form of artistic communication. The structure with a "plot" in the most Aristotelian sense of the term, is still the most widespread, even at the highest levels (for, after all, aesthetic value doesn't necessarily have anything to do with the novelty of a technique—even though the latter is frequently the symptom of an originality of both thought and method on which art often thrives). As for live TV, as long as it responds to this deep need for a plot that all people feel—a need that will always find satisfaction in some form or other, whether old or new—it will have to be judged according to the demands it satisfies and the structures it uses to satisfy them.

This, of course, does not mean that live TV is doomed to remain a closed form. Not at all, for it already has numerous possibilities for opening its discourse and launching into an exploration of the

profound indeterminacy of daily events. All it has to do is enrich the main event, filmed according to all the laws of verisimilitude, with a variety of marginal annotations, with rapid inquiries into the surrounding reality, with all sorts of images unrelated to the primary action but relevant precisely because of their unrelatedness, given the new perspectives, the new directions, and the new possibilities they propose for the same set of events.

Live TV might then have a rather interesting pedagogical effect: it could give the viewer the feeling, however vague, that life—that even he himself—is not confined to the story he so eagerly follows. These digressive annotations would then jolt the viewer out of the hypnotic spell woven by the plot, and, by distancing him from it, would force him to judge, or at least to question, the persuasiveness of what he sees on the screen.

Form as Social Commitment

A famous columnist who's always keenly aware of what is "in" and what is "out" recently warned her readers to beware of the word "alienation," by now quite outdated and vulgarized, good only for readers of best-sellers or for some contemporary Bouvards and Pécuchets. Of course, philosophers ought not to care whether the technical terms they use are "in" or "out"; on the other hand, why a given word should suddenly become terribly trendy and then, quite as suddenly, lapse into disuse is certainly part of their concerns. Why did the term "alienation" become so popular at the beginning of the 1960s, so long after its first appearance? Might one say that the way in which it has been used and abused is in itself one of the most egregious yet unrecognized instances of alienation in the history of our civilization?

First of all, let's look at the term's origins and correct usage. Its meaning changes depending on whether it is followed by the preposition "from" (as is generally the case in English) or the preposition "in" or "to." Philosophical tradition prefers the latter usage as the more correct translation of the German word *Entfremdung,* which implies renouncing oneself for the sake of something else, abandoning oneself to some extraneous power, becoming "other" in something outside oneself, therefore ceasing to be an agent in order to be acted upon. "Alienation from," in the sense of "estrangement from" something, corresponds instead to the German *Verfremdung* and means something quite different.

In its daily use, however, the term has acquired yet another meaning which implies that the something that is acting upon us, and on which we depend, is something totally extraneous to us, a hostile power that has nothing to do with us, an evil will that has subjugated us despite all our efforts and that someday we may be

able to destroy, or at least reject, since we are ourselves and it is an "other," substantially different from what we are.

Of course, everyone is free to build a personal myth in which the word "alienation" has this particular meaning. But this is certainly not the meaning it had either for Hegel or for Marx. According to Hegel, man alienates himself by objectivizing himself *in* the aim of his work or his actions. In other words, he alienates himself *in* the world of things and of social relationships because he has constructed it according to the laws of subsistence and development that he himself must adjust to and respect. Marx, on the other hand, reproached Hegel for not making a clear distinction between objectification (*Entäusserung*) and alienation (*Entfremdung*). In the first case, man turns himself into a thing; he expresses himself in the world through his creations, thus constructing the world to which he then commits himself. But when the mechanism of this world begins to get the upper hand—when man suddenly becomes unable to recognize it as his own creation, unable to use for his own purposes the things he has produced, and instead ends up serving their purposes (which he might identify with the purposes of other men)—then he finds himself alienated; it is his creations that henceforth tell him what to do, what to feel, and what to become. The stronger the alienation, the deeper man's belief that he is still in control (whereas, in fact, he is being controlled) and that the situation in which he lives is the best of all possible worlds.

For Marx, objectification is a substantially positive and indispensable process, whereas alienation is a historically engendered situation, a situation which, therefore, can find a historical solution—in communism.

In other words, according to Marx, Hegel's problem lies in his having reduced the question of alienation to a process of the mind: consciousness alienates itself in its object and only upon recognizing itself in the object discovers its own effectuality. But this knowledge automatically entails the negation of the object, for the moment consciousness recognizes the object, it gets rid of its alienation by negating the object itself. "Objectivity as such," Marx says of Hegel, "is considered to be an alien condition not fitting man's nature and self-consciousness. Thus, the reappropriation of the objective essence of man, which was produced as something alien and determined by alienation, not only implies the transcendence of

alienation, but also of objectivity. This means that man is regarded as a non-objective, spiritual being . . . The appropriation of the alienated objective essence or the supersession of objectivity regarded as alienation . . . means for Hegel at the same time, or even principally, the supersession of objectivity, since what offends self-consciousness in alienation is not the determinate character of the object but its objective character." [1]

So the consciousness that constitutes itself as self-consciousness not only would eliminate its state of alienation to the object, but, in its furious desire for the absolute, would also kill the object by taking it back within itself. It is not surprising that Marx, interpreting Hegel in this fashion, had to react by asserting that the object created by human activity *exists* just as much as the reality of nature, technology, and society. Hegel's achievement was to define the range and function of human labor; the object of this labor could not be denied, however self-aware one might become and however conscious of the freedom one must acquire in relation to this object. Work must be seen not as an activity of the spirit (so that the opposition between consciousness and the object of its knowledge may be resolved in an ideal play of assertions and negations) but rather as the externalization of the powers of man, who must now deal concretely with what he has created. If man wants to "resume his own alienated essence into himself," he cannot suppress the object (through a spiritual dialectic); rather, he will have to act practically in order to suppress alienation—that is, in order to change the conditions that have brought about this painful and scandalous separation between himself and the object he has created.

The nature of this separation is both social and economic: the capitalistic mode of production allows for the fact that man's work may concretize itself in an object that is fundamentally independent from its producer, so that the more objects the producer produces, the more depleted he becomes. The situation can be summed up as follows: the worker depends on the things he produces; then he inevitably falls under the dominion of the money that represents them; after this, the more he goes on producing the more he becomes like the merchandise he produces. In other words, "he is no longer the product of his own work; so the larger this product, the lesser he will be."

Solution: a system of collective production in which the worker

is no longer working for others but working for himself and his own kin, and thus feels that what he makes is his own product and that he is one with it.

But then, how could Hegel have so easily confused objectification and alienation, as Marx says he did?

From the vantage point of a later historical and industrial reality, we can now reconsider the whole question of alienation in a different light. Hegel did not make any distinction between the two forms of alienation because, in fact, the moment man objectifies himself in the works he has created, and in the nature he has modified, he produces an inevitable tension. The two poles of such a tension are, on the one hand, his domination of the object, and, on the other, his total dissolution in the object, his total surrender to it. This is a dialectic balance that is based on a constant struggle between the negation of what is asserted and the assertion of what is denied. Thus, alienation would seem to be an integral part of every relationship one establishes with others and with things, whether this be in love, in society, or within an industrial structure.[2] The question of alienation would then become (to put it in Hegelian terms, at least metaphorically) "the question of a human self-consciousness, which, unable to conceive of itself as a separate 'cogito,' can find itself only in the world that it itself constructs, and in the other 'I's it recognizes, and, at times, misconstrues. But, this way of finding oneself in the other, this objectification, is always more or less a form of alienation, *at once a loss of oneself and a recovery of oneself.*"[3] Obviously, if the lesson of Hegel sounds much more concrete today than it did to Marx it is because our culture has had the advantage of rereading him through Marx.

At this point, however, it would be somewhat awkward if, after rereading Hegel through Marx, we were to skip Marx and return to Hegel in order to say that since alienation is inevitably a fundamental characteristic of one's relationship with objects and nature, it would be useless to try to eliminate it. Just as it would be awkward to accept alienation as an "existential situation," since we know how ambiguous such an expression can be in the light of a negative existentialism, according to which any attempt to overcome the "structure of existence" would simply throw us back onto it.

Our argument should instead proceed in a different direction.

The kind of alienation Marx speaks of is, on the one hand, the same as that which is studied by political economy, namely that which derives from the use that a society based on private property makes of the objects produced by a worker. (Because he produces for others, he makes himself ugly by producing beauty and mechanizes himself by producing machines.) On the other hand, it is the sort of alienation that is intrinsic to the very process of production. This second kind of alienation is fostered by the worker, who fails to see his work as an end in itself and instead considers it as a means of survival in which he fails to recognize himself (since neither the product nor the work belongs to him).

Since these two types of alienation are necessary for the survival of a particular society, it is conceivable, following a Marxist line of reasoning, that a radical modification of the system of relationships on which that society is based would eliminate alienation.

On the other hand, even though a modification of society may liberate man from this sort of subjection (and give him back the object he produces as well as the productive work he has accomplished both for himself and the collectivity), the constant tension characteristic of his alienation "in" the object would remain (this is where Hegel contributes to a greater understanding of the problem), since the object the worker has produced is constantly threatening to control him. This sort of alienation could indeed be perceived as an existential structure or, if we prefer, as the problem that confronts every subject who, having produced an object, turns to it with the intent either to use it or, simply, to consider it. My remarks here will concentrate on this particular kind of alienation—the one that follows every act of objectification—since I believe that this problem has its own characteristics and that it is part of the relationship between man and the world that surrounds him. Of course, a Marxist point of view could easily maintain that this problem would be confronted with greater freedom and awareness in a society that has eliminated economic alienation. But even in this case, the problem would retain most of its urgency.[4]

As defined here, alienation can be eliminated through both action and awareness, but not forever. If we see alienation even in the relationship between two lovers (since each of them inevitably ends up conforming to the image of the other), then we cannot possibly contemplate a civilization in which the collective sharing of the

means of production will completely eliminate alienation from the dialectic at the basis of life and of every human relationship.

At this point, however, alienation is no longer confined to a particular social structure; rather, it extends to every relationship between man and man, man and object, man and society, man and myth, man and language. As such, it not only serves to explain all those economic relationships which, because of their hold on us, assume the appearance of psychological phenomena, but must also be seen as a form of psychological and physiological behavior whose effect on our personality is so pervasive as to manifest itself in all our social relationships. Alienation will then appear as a phenomenon which, under certain circumstances, goes from the structure of human groups to the most private mental behavior, and under other circumstances, from individual mental behavior to the structure of human groups. The very fact that we live, work, produce, and form relationships means that we exist *in* alienation.

Is there any hope for remission? Not really; neither is it possible to eliminate the negative pole of this tension. This is why, every time we try to describe an alienating situation, just when we think we have identified it we discover that we don't know how to get out of it. Every solution we come up with is merely a reiteration of the same problem, even though at a different level. This situation— which, in a moment of pessimism, we could define as irreducibly paradoxical, "absurd"—is, in fact only dialectic: it cannot be solved by simply eliminating one of its poles. The absurd is nothing but a dialectic situation as perceived by a masochist.[5]

We produce a machine, and then the machine oppresses us with an inhuman reality that renders the relationship we have with it, and with the world through it, disagreeable. Industrial design seems to have found a solution to this problem: it fuses beauty with utility and gives us a humanized machine, a machine cut to human size—the blender, the knife, or the typewriter that advertises its capacities in a pleasant way and invites us to touch it, stroke it, use it. Man could thus be harmoniously assimilated to his function and to the instrument that allows its fulfillment. But this optimistic solution does not satisfy the moralist or the social critic: it is just another form of oppression on the part of an industrial power which, by rendering our relationship to things and the world more pleasant, makes us forget that in fact we remain slaves. A paradoxical

alternative project would be to devise instruments that would make our work as irksome as possible, so that we would never for a second forget that what we are producing is never going to be ours. Such an alternative, however, sounds more like the dream of a madman than like a viable solution. Let's for a moment imagine that these objects are used by people who, instead of working for some extraneous power, work for themselves and the collectivity. Would this better justify the object that tries to integrate form and function in a harmonious way? Not really, since in this case the users will be working as if in a trance, not for a common profit but rather in total surrender to the charm of the object. They would use the object without realizing that they are used by it. Thus, the latest car model can often become a mythic image capable of diverting all our moral energy and of causing us to lose ourselves in the self-satisfied possession of something that is nothing more than a substitute. Nor would the situation change in the instance of a perfectly planned collectivist society in which each member worked to provide himself and his fellow citizens with the latest car model: the contemplation of a pleasing form would ease our integration into our work, and thus it would stifle our moral energy and prevent us from pursuing any goal.

Of course, the dream of a more humane society is also the dream of a society in which everybody can work for the common good: to provide more medicines, more books, and more cars. But even this would not be enough to eliminate alienation. As proof, we have the parallel experiences of the West Coast beatniks and of the "individualist" poets who protest in Mayakovsky Square.

Though intellectuals are always ineluctably drawn to support those who protest, in this particular instance it would be more reasonable to assert that both the beatniks and Yevtushenko are wrong—even though, historically speaking, they fulfill their dialectic function.

They are wrong because their protest often reduces salvation to the idle contemplation of one's own inner void; to them, even the merest search for a remedy is a form of complicity with the alienating situation. On the contrary, the only possible salvation demands an active and practical involvement with the situation. Man works, produces a world of objects, and inevitably alienates himself to them. But then he rids himself of his alienation by accepting

those objects, by committing himself to them, and, instead of annihilating them, by negating them in the name of transformation, aware that at every transformation he will again find himself confronting the same dialectic situation, the same risk of surrendering to the new, transformed reality. What alternative could be more humane and positive than this?

To paraphrase Hegel, man cannot remain locked up in himself, in the temple of his own interiority: he must externalize himself in his work and, by so doing, alienate himself in it. For if he chooses instead to withdraw into himself and to cultivate his own purity and spiritual independence, he will find not salvation but annihilation. He cannot transcend alienation by refusing to compromise himself in the objective situation that emerges out of his work. This situation is the very condition of our humanity. The figure of consciousness that refuses this sort of compromise is that of the "beautiful soul." But what happens to the "beautiful soul"?

"When clarified to this degree of transparency, consciousness exists in its poorest form . . . It lacks force to externalize itself, the power to make itself a thing, and endure existence. It lives in dread of staining the radiance of its inner being by action and existence. And to preserve the purity of its heart, it flees from contact with actuality, and steadfastly perseveres in a state of self-willed impotence to renounce a self which is pared away to the last point of abstraction, and to give itself substantial existence, or, in other words, to transform its thought into being, and commit itself to absolute distinction [that between thought and being]. The hollow object, which it produces, now fills it, therefore, with the feeling of emptiness . . . In this transparent purity of its moments it becomes a sorrow-laden 'beautiful soul,' as it is called; its light dims and dies within it, and it vanishes as a shapeless vapour dissolving into thin air . . . The 'beautiful soul,' then, has no concrete reality; it subsists in the contradiction between its pure self and the necessity felt by this self to externalize itself and turn into something actual; it exists in the immediacy of this rooted and fixed opposition . . . Thus the 'beautiful soul,' being conscious of this contradiction in its unreconciled immediacy, is unhinged, disordered, and runs to madness, wastes itself in yearning, and pines away in consumption."[6]

* * *

In passing, we should note that the dialectic alternative to the "beautiful soul" is the subject's joyful dissolution in the object. Is there a chance of salvation between these two forms of self-destruction?

Today, the dead end of the "beautiful soul" is again proposed (not from a Marxist but from a traditionalist standpoint) by Elemire Zolla in his criticism of mass society: not only does he refute the objective situation (the combination "modern civilization–industrial reality–mass culture–elite culture" that expresses man's situation in an industrial society), but he also proposes a total withdrawal from it by condemning all collective action and by advocating, instead, the contemplation of a tabula rasa that the social critic has himself created with his global refusal.

Zolla maintains that "thought cannot provide remedies, but must understand where things really stand," and that "to understand does not mean to accept." I agree with Zolla when he says that thought is not supposed to provide remedies, but he is very unclear about the true nature of this sort of understanding. In fact, it would seem that his "understanding" is very close to the nihilistic knowledge of the "beautiful soul," which, in order to know itself, has to destroy the object in which it always risks losing itself. According to Zolla, it is important to "understand" the object without becoming implicated in it, whereas in fact, in order to understand the object one *must* implicate oneself in it. The object will thus be understood not as something that must be absolutely denied but rather as something that still bears the traces of the human purpose for which it was produced. Only when the object is understood in these terms, as well as in its negative aspects, will we be free from it. Or rather, our knowledge will be the basis for a free and freeing process. But, from the very start, the object should not be perceived as hostile and extraneous, since in fact we *are* the object, since it is our reflection and bears our mark. To know it means to know who we are. So why should this process of knowledge be totally devoid of charity and hope?

Let me cite an example. In the first pages of his novel *Cecilia,* Zolla describes the physical—indeed, erotic—relationship between his heroine and her car. Driving barefoot, she feels its vibrations in all her muscles, she knows it as one knows a lover, and she responds to its elasticity and its movements with her own body. Cecilia is a

perfect example of the human being who is possessed by a thing—and what is more, by an evil "thing," since cars are later in the novel compared to "swollen ticks," "insects bereft of the sepulchral charm of the hard shell, clumsy and sad." To the reader, Cecilia becomes the stereotype of alienated humanity, and yet . . . to what extent is her relationship with her car alienating?

In fact, most drivers would seem to have a similar relationship with their cars. The most important condition for driving is that we use our foot not only to control the mechanism but also to keep in touch with it; through our foot, we feel the car as part of our own body, so that we know when it is time to change gear, to slow down, to idle, without having to resort to the abstract mediation of the tachometer. Only by lending our body to the car, by extending the range of our sensibility, can we use it humanly: the only way we can humanize a machine is by mechanizing ourselves.

Zolla would say that this is precisely the conclusion he was driving at—namely that alienation is so diffused that even an intellectual could not escape it; far from being simply an epiphenomenon that affects only some deranged natures, it is the symptom of the general and irreversible impoverishment of modern society. Zolla forgets that this kind of relationship (the extension of our body into the object we touch, the humanization of the object and the objectification of ourselves) has existed since the dawn of history, since one of our ancestors invented the flintstone and constructed it so that it would fit the palm of his hand, so that its vibration (during use) would be felt through the nerves of the hand and extend their sensibility, so as to eliminate all distinction between it and the hand that held it.

From the very beginning of time, the ability to extend one's corporeality (and therefore to alter one's own natural dimensions) has been the very condition of *homo faber*. To consider such a situation as a degradation of human nature implies that nature and man are not one and the same thing. It implies an inability to accept the idea that nature exists in relation to man, is defined, extended, and modified in and by man; just as man is one particular expression of nature, an active, modifying expression who distinguishes himself from his environment precisely because of his capacity to act upon it and to define it—a capacity that gives him the right to say "I."

The only difference between Cecilia and the inventor of the flint-stone lies in the complexities of their respective actions, which, otherwise, are structurally very similar. Cecilia is like the caveman who, having seized his tool, starts using it frantically, to crack the nuts he has gathered, to beat the earth on which he is kneeling, until he loses himself so entirely in his savage actions that he forgets why he seized the object in the first place (just as, at certain orgiastic moments, a drummer ceases to play the drums and is himself played by them).

There is an *ante quem* limit; that is, up to this limit, letting a car possess us is a sign of sanity and the only way in which we can really possess the car: to be unable to sense that there is such a limit, and that it is possible to reach it, means that we don't understand the object and therefore destroy it. This is what the "beautiful soul" does, thereby losing itself in its own negations. There is also a *post quem* limit, which is where morbidity begins. And there is a way of understanding the object, the experience we have of it, and the use we make of it, which in its sheer optimism risks making us forget the presence of a limit, the constant danger of alienation.

At the opposite extreme of the beautiful soul's refusal, we find Dewey's philosophy.

Dewey believes in the integration of man and nature, in the realization of a perfect experience, a situation in which the individual, his action, the context in which he acts, and the instrument he uses are so fully integrated that they exude a feeling of harmony and fulfillment. Such a form of integration has all the aspects of a positive situation (and, indeed, Dewey understands it also as a perfect example of aesthetic appreciation), but it can also define a state in which total alienation is perversely accepted and appreciated. "Every experience is the result of interaction between a live creature and some aspect of the world in which he lives. A man does something; he lifts, let us say, a stone. In consequence, he undergoes, suffers something: the weight, strain, texture of the surface of the thing lifted. The properties thus undergone determine further doing. The stone is too heavy and too angular, not solid enough; or else the properties undergone show it is fit for the use for which it is intended. The process continues until a mutual adaptation of the self and the object emerges and that particular experience comes to a close . . . [The] interaction of the two constitutes the total expe-

rience that is had, and the close which completes it is the institution of a felt harmony."[7]

It is easy to see how this particular notion of experience could also define, albeit in an absolutely positive way, a typical instance of alienation, such as the relationship between Cecilia and her car. The tragic suspicion that a relationship with an object may fail precisely because it succeeds too much is absent from Dewey's philosophy. For Dewey, an experience can fail (that is, fail to be a full-fledged experience) only when between the person and the object there is a polarity that cannot be resolved by integration; when there is integration there is experience, and an experience can only be positive. Dewey would see Cecilia's relationship with her car as good simply because it is based on total integration, and is expressive of a harmony in which all the original polarities are combined.

Thus, we have identified two extreme attitudes toward the recurring and ineluctable possibility of alienation present in all our relationships with things and others: the pessimistic attitude, which destroys the object (or rejects it as evil) for fear of being implicated in it, and the optimistic attitude, according to which integration with the object is the only positive aspect of a relationship.

The availability to the world characteristic of the second attitude is fundamental, because it allows us to commit ourselves to the world and to act in it. But the fear that accompanies our every dealing with the world, and the awareness that our adjustment could turn out to be a failure, are also essential to the welfare of the relationship.

In my interaction with my car, in order to keep the right dialectic balance I need only ensure that my operational projects always remain more important to me than the biological harmony I may attain with the engine. For so long as I know what I am doing with the car, what I want from it, and what it allows me to do, I will not risk falling under its spell. The amount of time during which I will let it take over and, as it were, drive me, will be reasonably balanced by the rest of my day and by the fact that, even as I allow myself to be led by it through intersections and traffic lights, I will never be totally absorbed by it, but rather will use it as a sort of sonic or rhythmic background to my thoughts. (This, of course, will also involve a dialectic between the rhythm of my thoughts and the movement of the car: just as my adjustment to the car will affect

my thoughts, so my thoughts will influence my relationship with my car. A sudden intuition may translate into a muscular spasm, an increased pressure on the accelerator, and therefore a variation in speed and in the hypnotic rhythm that could easily have turned me into an instrument of the car. On the other hand, why linger on the reciprocal relationship between the psychological and the physiological when Joyce has already told us everything there is to say about it in his description of Bloom reading on the toilet?)

Once I have become aware of this polarity I will be able to invent a number of "ascetic" stratagems to safeguard my freedom while implicating myself in the object, the last and most banal of which would be to mistreat the car, keep it dirty, deliberately disregard its maintenance, abuse the engine—in other words, do everything in my power to avoid being totally integrated with it. I would thus avoid *Entfremdung* by means of *Verfremdung,* escape alienation through estrangement—a technique similar to Brecht's, who, to prevent his audience from being hypnotized by the events in his plays, demands that the lights be on at all times and that the public be allowed to smoke.

All this should cast some light on a number of procedures. Take, for instance, some lines by Cendrars which Zolla considers a "tragic example of macabre taste":

> Toutes les femmes que j'ai rencontrées se dressent aux
> horizons
> Avec les gestes piteux et les regards tristes des sémaphores
> sous la pluie.

> All the women I have met stand up against the horizon
> With the pathetic gestures and sad faces of semaphores under
> the rain.

We could justly see these lines as a poetic attempt to humanize an aspect of the technological landscape which otherwise would have remained totally alien to us; as a way of rescuing a technical tool from its daily function by lending it a symbolic value; as a new way of dealing with feelings, without resorting to worn out "poetic images" but, rather, by trying to introduce the imagination to new responses. In other words, we could read them as an attempt to recognize the object, to understand it, to see what space it occupies in our lives, and, having done all this, to see how we can use it for

our own ends, however metaphoric, without having to submit to it. What Zolla sees as macabre has nothing to do with the sema- phore, or with any other luminous signal, but it may have some- thing to do with the despair and the squalor of lost loves evoked by Cendrars. In any case, the poem has done its job: it has given new form to an old formula and has offered us the possibility of a new landscape.

The question now becomes: Why do we see the situation of the car driver as more alienating than that of the caveman? Why do we resent the humanization of a semaphore and not that of Achilles' shield? (And we should not forget that the latter is described in the *Iliad* in great detail, including the "industrial" process that pro- duced it, an aspect that must have shocked intellectuals in Homer's day.) Why do we see alienation in the symbiotic relationship that joins a driver to his car and not in the one that joins a rider to his horse when, in both cases, the corporeality of the person is ex- tended into that of the vehicle?

Obviously because nowadays, in our technological civilization, objects have become so pervasive, so sophisticated, so autonomous that we feel threatened by them. The fact that their forms have tended to become less and less anthropomorphic certainly contrib- utes to their otherness. But there is another reason: between the caveman and his tool there was direct contact, an immediate rela- tionship in which the only risk involved was that of total integra- tion between the manipulator and the manipulated object. The car, however, does not simply alienate its driver to itself; it also alienates him to the system of laws that governs the highways, to the race for prestige (the ambition of possessing a new model, a particular ac- cessory, more horsepower), to a market, to a world of competition in which the individual must lose himself in order to acquire the car. In other words, alienation is a chronic condition of human ex- istence at all levels, but it has become particularly prominent in our modern industrial society, as Marx clearly foresaw in his economic analyses.

To modern man, alienation is as much a given as weightlessness is to an astronaut: it is a situation in which we have to learn how to move, how to acquire new autonomy, and how to devise new ways of being free.

We have to realize that we cannot live without an accelerator, and

that maybe we would be unable to love without thinking of semaphores. There are still people who think we can speak of love without referring to traffic lights. One of these is the man who writes the lyrics for Liberace. He has been able to elude the inhuman reality of machines: his universe still revolves around the very human concepts of "heart," "love," and "mother." But the moralist in the know is aware of what lies behind such a *flatus vocis:* a world of petrified values that is used to fool the public. By accepting certain linguistic expressions, the lyricist has alienated himself and his public to something that manifests itself as an obsolete linguistic form.

With this last observation, the discussion has moved from the examination of a direct, real relationship with a situation, to that of the forms through which one organizes one's analysis of the situation. How does alienation manifest itself at the level of art or of pseudo-art forms?

Since I have decided here to use "alienation" in its broadest sense, my argument on this subject will develop along two different, if converging, lines.

First of all, one could speak of the sort of alienation that occurs within a formal system, and which could be more aptly defined as a dialectic between invention and manner, between freedom and formal restrictions. Let's, for instance, consider the system of rhyme.

Rhyme, as such, was elaborated according to a number of stylistic patterns and conventions, not out of masochism but because it was generally assumed that only discipline could stimulate invention and force one to choose the association of sounds that would be most agreeable to the ear. Thanks to these conventions, the poet is no longer the victim or the prisoner of his enthusiasms and emotions: the rules of rhyme restrain him but at the same time liberate him, the way an Ace bandage restrains the movement of an ankle or a knee while allowing the runner to run without fearing a torn ligament. And yet, as soon as we accept a convention we find ourselves alienated in it: the second line is in part determined by the rhyme of the first one. The more a certain practice asserts itself, and the more it pushes us to contemplate creative alternatives, the more it imprisons us. The use of rhyme will result in a dictionary of rhymes, which will start as a compendium of possible rhymes

and end up as a catalogue of common rhymes. So, after a while, a poet will inevitably be more and more alienated in the rhymes he or she uses. A typical example of formal alienation is that of the writer of popular song lyrics who is so conditioned by a certain convention that the moment he comes up with the word "remember," he'll conjure up the image of a sad "September." He is not only alienated to rhyme as a system of possible phonetic concordances; he is also alienated to rhyme as a means of producing the desired effect—that is, of satisfying the demands of the consumer. On the one hand, he is alienated to the linguistic system, and, on the other, to the system of predictable reactions that characterizes his public (not to mention the system of commercial relationships in which the only things that sell are those that satisfy certain expectations).

But even the great poet is conditioned by such systems, even when he decides to pay absolutely no heed to the expectations of the public. The statistical probabilities of finding an unusual rhyme for the word "remember" are fairly limited. As a result, he is either restricted in his rhyming or in his themes, or in both. He will have to avoid using the word "remember" at the end of a line. An artistic achievement requires such a rich interpenetration of sound and sense that the moment the poet uses a sound that has no semantic resonance in an audience whose sensibility responds only to habit, the form he proposes will have very little (if any) power of communication. On the other hand, he will always have the possibility of resorting to an unusual language, a peculiar rhyme pattern, and this will, in turn, determine his themes and the association of his ideas. Even here, he will be acted upon by a situation, but his awareness of it and of his alienation will allow him to turn it to his advantage, to transform it into a means to freedom. Take Montale's unexpected rhymes, for instance: in his poetry, the alienation of a strained dialectic tension has been resolved into a prime example of invention and poetic freedom. Yet every particular solution can, and generally does, become the basis for a new alienating situation. All of Montale's imitators are perfect examples of this: their lack of imagination is the sure sign of their alienation to a particular form (not their own) that determines their actions without allowing them the slightest chance of being original or free.

But this example is much too simple to explain such a complex

situation. In the case of rhyme, the dialectic between invention and imitation manifests itself only at the level of a literary convention that can remain marginal and not affect all the structures of a language. Let's therefore shift our attention to a problem that is more pertinent to contemporary culture.

The tonal system has governed the development of music from the Renaissance to our own day: as a system, and an acquired system at that (nobody believes any longer that tonality is a "natural" fact), the role of the tonal system in music is very similar to that played by rhyme in poetry. The tonal musician composes his pieces by obeying a system he is at odds with. Whenever a symphony concludes triumphantly by insisting on the tonic, the musician has let the system act on its own, since he could do nothing to elude the convention on which it was based. But within this convention, the great musician can always invent new ways to repropose the system.

There are times, however, when a musician feels compelled to move out of the system—Debussy, for instance, does it by using the "hexatonal" scale. He decides to move out of the system because he senses that the tonal grammar forces him to say things he does not want to say. Schönberg breaks definitely with the old system and elaborates a new one. Stravinsky, in contrast, accepts it, but only during a particular phase of his production, and in the only possible way: by parodying it—that is, by questioning it even as he glorifies it.

This revolt against the tonal system, however, concerns more than the dialectic between invention and manner. One does not leave a system merely because its conventions have become too rigid and its web of inventive possibilities has been exhausted. In other words, one does not reject a system merely because one cannot escape the sterile duet "remember/September." The musician refuses the tonal system because its structure mirrors or embodies a world view.

It has been repeatedly said that tonal music is a system in which, once a given tonality has been chosen, the whole composition is articulated through a series of crises and dilations deliberately provoked in order to reestablish, by the final reconfirmation of the tonic, a state of peace and harmony. The final repose is all the more enjoyable the longer it has been delayed. Many people have also

maintained that this type of formal habit has its roots in a society based on respect for an immutable order of things; in other words, tonal music is merely another way of reiterating the basic attitude of an entire educational system at both a social and a theoretical level.[8] Obviously, to postulate such a perfect reflective relationship between a social structure and the structure of a musical language may appear a hasty generalization; yet it is not by chance that, in our day, tonal music has become the music of an occasional community of people, brought together by the ritual of going to concerts—people who like to express their aesthetic sensibility at a particular time of the day, wearing a particular kind of clothing, and who pay the price of admission in order to undergo an experience of crisis and resolution, so that when they leave the "temple" they will feel fully purged by the cathartic effect of art.

A musician becomes aware of the crisis of the tonal system the moment he realizes that certain sonic frequencies have so long been identified with particular psychological states that the listener can no longer hear them without instinctively relating them to a particular moral, ideological, or social reality, to a particular vision of the world. When, in order to escape this dead end, the avant-garde musician founds a new language, a new system of sonic relationships, a new musical form that few people are ready to recognize as such, he condemns himself to noncommunication, to some sort of aristocratic distance. But he does it on purpose, to express his refusal of a system of communication that guarantees him an audience if, and only if, he is willing to submit to an obsolete value system.

So, the avant-garde musician rejects the tonal system not only because it alienates him to a conventional system of musical laws, but also because it alienates him to a social ethics and to a given vision of the world. Of course, the moment he breaks away from the accepted system of communication and renounces its advantages, he will inevitably appear to be involved in an antihuman activity, whereas in fact he has engaged in it in order to avoid mystifying and deceiving his public. By rejecting a musical model, the avant-garde musician actually rejects (more or less consciously) a social model. But it would be wrong to assume that this double rejection involves no affirmation.

The musical system that the avant-garde musician rejects com-

municates only in appearance. In fact, it is exhausted, dried out. It can no longer surprise anyone, since it can produce only clichés. It has become Muzak, or the average popular song, the usual triptych of loss that sees memory fade at an autumnal hearth—"remember," "November," "ember." The situation evoked is sad, depressing; yet cast in those familiar images, it no longer evokes any emotion. We have encountered it too often. It has lost all meaning and has become merely a refrain, a sort of lullabye. Rather than impressing us with the melancholy it depicts, it simply reconfirms all our false assumptions. It tells us that the universe we live in is still as orderly and dependable as it used to be—which, of course, is far from true. Our universe is in full crisis. The order of words no longer corresponds to the order of things: whereas the former still insists on following a traditional system, the latter seems to be mostly characterized by disorder and discontinuity, or so science tells us. Our feelings and emotions have been frozen into stereotypical expressions that have nothing to do with our reality. Social laws still rest on orderly systems that hardly reflect the social instability of our time. In other words, language offers us a representation of the phenomenal world that has nothing to do with the one we encounter on a daily basis. In fact, our world is quite different from the orderly, coherent universe our language still promotes, and much much closer to the dislocated, fragmented vision presented by the avant-garde artist in rupture with the established system.

The artist who protests through form acts on two levels. On one, he rejects a formal system but does not obliterate it; rather, he transforms it from within by alienating himself in it and by exploiting its self-destructive tendencies. On the other, he shows his acceptance of the world as it is, in full crisis, by formulating a new grammar that rests not on a system of organization but on an assumption of disorder. And this is one way in which he implicates himself in the world in which he lives, for the new language he thinks he has invented has instead been suggested to him by his very existential situation. He has no choice, since his only alternative would be to ignore the existence of a crisis, to deny it by continuing to rely on the very systems of order that have caused it. Were he to follow this direction, he would be a mystifier, since he would deliberately lead his audience to believe that beyond their disordered reality there is another, ideal situation that allows him to

judge the actual state of affairs. In other words, he would lead them to trust in the orderly world expressed by their orderly language.

Though it is commonly believed that avant-garde artists are out of touch with the human community in which they live, and that traditional art remains in close contact with it, the opposite is true. In fact, only avant-garde artists are capable of establishing a meaningful relationship with the world in which they live.[9]

By now it should be fairly obvious why the formal structures of contemporary art keep challenging our language as well as other traditional systems. If it is at all possible to speak of the emergence of the open work in painting as well as in poetry, in cinema as well as in theater, it is because certain artists acknowledge the new vision of both the physical and psychological universes proposed by contemporary science, and realize that they can no longer speak of this world in the same formal terms that were used to speak of an orderly cosmos.

At this point, however, the critic of contemporary poetics might suspect that such undue attention to formal structures means contemporary art is much more interested in abstractions and abstract speculations than in man. This misunderstanding would be merely another expression of the belief that art can speak of man only in a traditional form—which essentially means that art can speak only of yesterday's man. To speak of today's man, however, art has no choice but to break away from all the established formal systems, since its main way of speaking is as *form*. In other words—and this amounts to an aesthetic principle—the only meaningful way in which art can speak of man and his world is by organizing its forms in a particular way and not by making pronouncements with them. Form must not be a vehicle for thought; it must be a way of thinking. A few years ago, Sidney Finkelstein, a British music critic, published a little book in which he set out to tell the public at large "how music expresses ideas." Most of the book dealt with the possibility that Brahms, because of his interest in the seventeenth century, was a "reactionary" musician, and that Tchaikovsky, because of his interest in popular issues, was a "progressive" musician. No need to resort to aesthetics to discuss such a point. Suffice it to say that, despite Tchaikovsky's popular concerns, highly melodic compositions have never been able to change the viewpoint of the bour-

geoisie who favored them, whereas Brahms's "return" to the seventeenth century may have been crucial in giving music the direction it took at the end of the century. But Brahms notwithstanding, a musician can be considered "progressive" to the extent he manages to translate a new vision of the world into new musical forms. Schönberg, in his *Warsaw Survivor,* is able to express an entire culture's outrage at Nazi brutality: having worked on forms for a very long time, he was able to find a new way to look at the world musically. Had Schönberg used the tonal system he would have composed not the *Warsaw Survivor* but the *Warsaw Concerto,* which develops the same subject according to the most rigorous laws of tonality. Of course, Addinsel was not a Schönberg, nor would all the twelve-tone series of this world suffice to turn him into one. On the other hand, we cannot attribute all the merit of a composition to the genius of its creator. The formal starting point of a work often determines what follows: a tonal discourse dealing with the bombing of Warsaw could not but lapse into sugary pathos and evolve along the paths of bad faith.

This brings us closer to the heart of the matter: it is impossible to describe a situation by means of a language that is not itself expressed by that situation. All language reflects a system of cultural relationships with its own particular implications. I cannot, for instance, translate the French word *esprit* from a positivist text as the English word "spirit," whose implications are profoundly idealistic.

This also applies to most narrative structures. A novel that begins with the description of a place or a situation, followed by the physical and psychological description of the main characters, automatically implies that its author believes in a certain order of things—in the objectivity of a natural setting in which human beings move and act, in the psychological and ethical dimension of physiological traits, and, finally, in the existence of precise causal relationships that will allow the reader to deduce—from the nature of the context, the peculiarities of the characters, and other concomitant factors—the univocal sequence of events that is most likely to follow.[10]

The moment an artist realizes that the system of communication at his disposal is extraneous to the historical situation he wants to depict, he must also understand that the only way he will be able to solve his problem is through the invention of new formal structures that will embody that situation and become its *model.*

The real content of a work is the vision of the world expressed in its way of forming (*modo di formare*). Any analysis of the relationship between art and the world will have to take place at this level.

Art knows the world through its formal structures (which, therefore, can no longer be considered from a purely formalist point of view but must be seen as its true content). Literature is an organization of words that signify different aspects of the world, but the literary work is itself an aspect of the world in the way its words are organized, even when every single word, taken in isolation, has absolutely no meaning, or simply refers to events and relationships among events that may appear to have nothing to do with the world.[11]

With the foregoing premises, it is now possible to examine the situation of a literature which, aware of the existence of an industrial society, purports to express this reality in both its possibilities and its limitations. The poet who, having sensed the alienation suffered by man in a technological society, decides to describe and denounce it by means of a "common" language (that is to say, the kind of language that can be understood by everybody), used referentially as a vehicle to communicate a "subject" (say, the situation of the worker in contemporary society), can be at once commended for his generosity and condemned for fraud. Let's now try to analyze the communicative situation of a purely imaginary poet necessarily emphasizing to an extreme point its defects and contradictions.

Our poet thinks he has identified a concrete situation shared by all mankind. And he may be right. But he also thinks that he can describe and judge it by using a language that is totally exterior to the situation, and this is where he becomes the victim of a double misunderstanding. If the language allows him to grasp the situation, then it reflects the situation and must be affected by the same crisis. If, on the contrary, his language is exterior to the situation, then it will never be able to fully grasp it.

Let's now examine how someone who specializes in description of this sort of situation—say, a sociologist, or better yet an anthropologist—would deal with the problem. If he (or she) tries to describe and define the ethical relationships of a primitive community by relying on the ethical categories of Western society, he will no longer be able to understand the situation or to make it intelligible

to others. The moment he defines a particular rite as "barbaric" (the way a nineteenth-century traveler would), he fails to help us understand the cultural model in which that rite finds its *raison d'être*. On the other hand, if he chooses to adopt the notion of "cultural model" without any reservation (that is, if he decides to see the society he wants to describe as something absolute, with no relation to other social situations), he will have to describe the rite as the natives see it and will thus be unable to explain it to us. He must therefore realize that since our categories are inadequate to the task, his only other option is to translate, through a series of mediations, the natives' own categories into something analogous to ours, while constantly reminding us that what he is proposing to us is a paraphrase and not a literal translation.

His description will thus rest on a sort of metalanguage that will force him to walk a tightrope between two possible pitfalls: on one side, the risk of judging the situation in Western terms, and, on the other, that of alienating himself entirely to the native mentality and of quite defeating the purpose of his work. In other words, on one side we have the aristocratic attitude of the old-fashioned traveler who passes from one "primitive" civilization to the next, and, being unable to understand any, tries to "civilize" them all in the worst possible fashion—which is to say, he tries to "colonize" them. On the other side, we have the skepticism of some anthropologists who, considering each relativistic cultural model as a self-explanatory and self-justifying entity, provide a series of descriptive vignettes that will never enable anybody to bridge the gap between two different cultures. The best solution, although the most difficult, is, of course, that of the sensitive anthropologist who, in formulating his own descriptive language, keeps in mind the profoundly dialectic nature of the situation and tries simultaneously to provide the tools necessary to understand and accept it and the means to speak of it in familiar terms.

Let's now return to our "model" poet. As soon as he decides that he would rather be a poet than a sociologist or an anthropologist, he renounces the attempt to develop an ad hoc technical language and tries to "poeticize" his discourse on the industrial situation by relying on traditional poetic forms. Within this tradition, he may opt for a more or less commemorative, confessional, or "crepuscular" lyricism; in any case, his discourse will express merely his

subjective reaction to the scandal of a dramatic situation which quite eludes him. And it eludes him simply because his language is limited by a tradition of inner confession and is therefore incapable of grasping an ensemble of concrete and objective relationships. And yet, his language is also a result of the situation he is trying to express—the language of a situation which, refusing to confront its problems, has sought refuge in memory and lyricism, thereby transferring the search for change from the object to the subject.

Let's now assume that a novelist is trying to reproduce the same situation in a language that is apparently related to it, whether it be technical, political, or popular. If he is an anthropologist, he will first list all the relevant forms of communication, which he will then analyze in relation to each other and to the manner in which each is employed. But if he wants to give the situation and its characteristic language a narrative form, he will have to organize all the elements at his disposal in a narrative progression borrowed from the literary tradition. Having thus seized the language of a situation in which human relationships are distorted, betrayed, and, generally speaking, in a state of continuous crisis, he is led to organize it according to a narrative convention that automatically masks its true fragmentary, dissociated nature with an appearance of continuity and order, which quite thwarts his initial intentions. Of course, this appearance of order is not only false but also inappropriate, since, by right, it belongs to narrative structures meant to express the vision of an orderly universe. The very fact that this order is expressed in terms of a language that is extraneous to the situation constitutes a sort of judgment. The narrator has committed himself to understanding a situation of alienation but has failed to alienate himself in it. Rather, he has avoided it by resorting to narrative structures that have drawn him away from his object.[12] The structure of a traditional narrative can be compared to that of a "tonal" composition in music. Its most extreme example is that of the detective story. Here, everything starts within the context of an established order: a paradigmatic series of ethical relationships rationally administered by the law. Something disrupts this order: a crime. There follows an investigation conducted by a mind (the detective's), untainted by the disorder that has led to the crime. From the list of suspects, the detective sorts out those who fit the social and ethical system they inhabit from those who do not. He

then classifies the latter according to the extent of their deviation, beginning with those who are only apparently deviant from those who are really so. In other words, he eliminates all the false clues, whose main function is that of keeping the reader in a state of suspense, and, by and by, he discovers the real causes of the crime, and, among his suspects, the one most likely to be affected by them. After which, the culprit is punished and order is reestablished.

Let's now assume that an author of detective stories, the sort of author who has full confidence in traditional structures (which, at the simplest level, are characteristic of the detective story, but, at a more sophisticated level, are also found in Balzac), decides to describe the situation of a character who works in the stock market. His actions are not necessarily prompted by the parameters of one particular order; they may be inspired by the ethical parameters of the society in which he lives, or by those of an economy based on free enterprise, or by no parameters other than the irrational oscillations of the market—whether they relate to an actual industrial situation or merely to some financial shift whose dynamics, far from depending on individual decisions, quite transcend them, thereby determining them and alienating (really alienating) all those who are caught in this autonomous circuit of interacting factors. Neither the language of such a character nor his value system depends on any one order or any one psychology. His behavior with women may be dictated by a particular psychic disorder (he may, for instance, suffer from an Oedipus complex), but in all his other relationships he will be motivated by the objective configuration of the financial situation, in which case there will be no causal relationship between his actions and his unconscious urges. The author of this sort of story will have to deal with a form of dissociation that is characteristic of our times, and that affects our feelings as well as our language and our actions. He knows that a decision made by his character may not produce the sort of effect that could be predicted by the traditional laws of causality, since the situation from which the character operates may lend his action an altogether different value. Consequently, if the author tries to tell the story of this character according to traditional laws of narrative causality, the character will elude him. If, instead, he assumes the role of the anthropologist and tries to describe the situation in all its

social and economic implications, he will be obliged to provide all sorts of descriptions but will have to leave a conclusive interpretation to a later phase of his research—in other words, he will have to provide all sorts of details for the "model" he intends to depict but will not be able to give any finality to his depiction, as most authors like to do, by enclosing his vision in a formal organization expressing a particular view of reality.

His only other option will be that of describing his character according to the terms of the situation. In other words, he will describe the complexity and imprecision of his character's relationships, and the nonexistence of his behavioral parameters, by consciously calling into question his own narrative parameters.

How does Joyce deal with contemporary journalism? He cannot, nor does he want to, tell us about it by employing a language that is extraneous to it. So he constructs a whole chapter of *Ulysses* out of the casual and perfectly insignificant chitchat of a group of journalists in an average editorial room. Each fragment of the conversation is appropriately titled and boxed, in the best journalistic fashion and according to a stylistic progression that ranges all the way from the most traditional Victorian headline to the syntactically flawed vernacular of an evening scandal-rag. By so doing, not only does Joyce cover all the possible rhetorical figures of journalese, but he also expresses his opinion of mass media. Since he does not feel he has the right to judge a situation if he remains outside it, he decides to turn the situation into a formal structure and let it speak for itself (revealing itself for what it is). In other words, he alienates himself in the situation by assuming its expressions, its methods. But by giving these expressions and methods a formal structure, he can also elude the situation and control it. In other words, he avoids alienation by turning the situation in which he has alienated himself into a narrative structure. This is a classical example. For a more contemporary example, let's turn to the cinema, to a movie such as Antonioni's *Eclipse*.

Antonioni does not tell us anything about our world and its problems, about a social reality that would interest any movie director eager to express an artistic opinion of our contemporary industrial situation—or, at least, not in so many words. Instead, he shows us two people, a man and a woman, who leave each other for no reason, or out of emotional aridity. The woman subse-

quently has an affair with another man, also for no reason and without any emotional commitment. The emotional inertia of the characters and their perfunctory actions are regularly punctuated by the hard and ineluctable presence of objects, which seems to dominate both human relationships and the situation in which these occur. Predictably, the central setting of the movie is the stock market, where fortunes are made and unmade according to no visible logic, for no palpable reason, and with no definite aim. ("What happens to all these billions?" the young woman asks a young broker, who readily admits he does not know. His aggressive manner gives the impression of a strong will in action, but in fact he is a pawn, acted upon by the very situation he is trying to control: he is the perfect example of alienation.) No psychological parameter can explain this situation. It is what it is precisely because nowadays it is impossible to believe in unitary parameters; each individual is fragmented and manipulated by a number of external forces. Of course, an artist cannot express all this as a judgment because a judgment would require, along with an ethical parameter, the syntax and the grammar of a rational system, the grammar of the traditional movie, in which events follow one another causally. The best solution for a movie director is to show the moral and psychological indeterminacy of the situation in the indeterminacy of the sequences: scenes follow one another for no apparent reason; the camera lingers on objects with an intensity that has no motive and no aim. Antonioni lets his forms express the alienation he wants to communicate to his public. By choosing to express it in the very structure of his discourse, he manages to control it while letting it act upon his viewers. This movie about a useless and unlikely love affair between useless and unlikely characters tells us more about contemporary man and his world than a panoramic melodrama involving workers in overalls and countless social confrontations, structured according to the logical, rational demands of a nineteenth-century plot—whose very denouement would imply the resolution of all contradictions into a universal order.[13] In fact, the only order man can impose upon his situation is the order of a structural organization whose very disorder leads to the apprehension of the situation.

Naturally, the artist does not provide a solution. As Zolla points out, thought must understand. Its task is not to provide remedies. At least, not yet.

All this should, of course, lend a clearer meaning to the function of the avant-garde and of its descriptive possibilities. To understand the world, avant-garde art delves into it and assumes its critical condition from within, adopting, to describe it, the same alienated language in which it expresses itself. But by giving this language a descriptive function and laying it bare as a narrative form, avant-garde art also strips it of its alienating aspects and allows us to demystify it.

Another pedagogical function of this poetics could be the following: the new perception of things, and the new way of relating them to each other, promoted by art might eventually lead us to understand our situation not by imposing on it a univocal order expressive of an obsolete conception of the world but rather by elaborating models leading to a number of mutually complementary results, as science does. In this way, even those artistic processes that seem most removed from our immediate concerns may in fact provide us with the imaginative categories necessary to move more easily in this world.

Having reached this conclusion, however, can we assert with any degree of certainty that this process, whose first phase involves the acceptance of the existing situation and our immersion in it in order to possess it from within, will not end in a total objectification of the situation and a passive adherence to the "continuous flux of existence"? Calvino raised this very issue a few years ago when he denounced the disquieting and suffocating presence of a "sea of objectivity." Indeed, there is a great deal of literature that could end up as a mere recording of inaction, as a nearly photographic reproduction of dissociation, as a beatific vision (in Zen-like terms) of what happens.

But, as I have already noted, it is impossible to stand up to the "flux of existence" by opposing it to an ideal human standard of measurement. What results is not an irrational, obtuse, metaphysical datum: it is the world of modified nature, of man-made work. We now see this man-made world as if it existed independently of our labor, as if it had evolved according to its own laws. This world that we have created can now turn us into its tools, but it can also provide us with the elements necessary to establish the parameters for a new human standard of measurement. The flux of existence

would remain essentially unaltered and hostile to us if we lived in
its midst without speaking of it. But as soon as we start speaking of
it, be it only to record its distortions, we judge it, we alienate our-
selves to it, and thus we take the first step toward repossessing it.
To speak, however objectively, of a "sea of objectivity" means that
we have already reduced this objectivity to a human dimension.

But this is not the way Calvino sees it. Quite the contrary. He
seems to take for granted what Robbe-Grillet says when he theo-
rizes on his work. In his ambiguously (I would even say "falsely")
phenomenological poetics, Robbe-Grillet pretends that his narra-
tive technique aims at an uncommitted vision of things, at an ac-
ceptance of things for what they are, beside and beyond us: "The
world is neither significant nor absurd. It *is,* quite simply . . .
Around us, defying the noisy pack of our animistic or protective
adjectives, things *are there.* Their surfaces are distinct and smooth,
intact, neither suspiciously brilliant nor transparent. All our litera-
ture has not yet succeeded in eroding their smallest corner, in flat-
tening their slightest curve . . . Let it be first of all by their *presence*
that objects and gestures establish themselves, and let this presence
continue to prevail over whatever explanatory theory that may try
to enclose them in a system of references, whether emotional, so-
ciological, Freudian or metaphysical."[14]

This sort of statement amply justifies Calvino's alarm. But it
would be wrong to give it more credit than it deserves. What an
artist tells us explicitly is often contradicted by what he tells us
implicitly, in the way he has constructed his work. A work of art,
taken as the successful expression of a way of forming, can refer to
the formal tendencies of an entire culture or an entire period, ten-
dencies which, in turn, reflect analogous procedures in other fields,
such as science and philosophy. The idea of such a *Kunstwollen*
seems particularly suited to a discourse concerning the cultural
meaning of contemporary formal tendencies. And yet, there is
quite a discrepancy between what Robbe-Grillet says he is doing in
his work and what he in fact does. In his books, things do not
appear as extraneous metaphysical entities, totally unrelated to us;
rather, they appear to have a very particular relationship with us, to
be "intentioned" by us. They are assumed and judged, and there-
fore reduced to a human dimension. Robbe-Grillet's work deals
both with objects and with the people who see them and who can

no longer relate to them, though they might yet find a new way of doing so in the future. The fluidity of characterization in *In the Labyrinth*—where objects also appear as fluid—is, in fact, only an expression of a new vision of time and reversibility, such as has emerged from the hypotheses of modern science. (As I have mentioned elsewhere, the temporal structure of *In the Labyrinth* had already been sketched by Hans Reichenbach.)[15] Although, at the level of macroscopic relationships, the only applicable notion of time remains that of classical physics as it is reflected in the structures of traditional narrative—and, more specifically, in the irreversible and univocal relationship between cause and effect—the artist can decide to make an experiment that has absolutely no scientific validity but is characteristic of the way in which an entire culture reacts to new stimuli; he can thus structure his narrative according to a nonclassical notion of time. At this point, such a notion of time is no longer a scientific model used to describe remote microphysical events; rather, it becomes a sort of game that we play from inside and that gives shape to our entire existence.

This is only one possible interpretation of *In the Labyrinth,* and yet the labyrinth could also be used as an apt metaphor for the stock market situation described by Antonioni in *Eclipse*—a place in which people are constantly becoming other than themselves, in which they find it impossible to follow the progress of their investments and to interpret events according to a unidirectional chain of cause and effect.

Of course, I am not saying that Robbe-Grillet meant to do all this in his book. He did not have to. All he had to do was create a structural situation that would lend itself to all sorts of personal interpretations without, for all that, losing any of its basic ambiguity: "As for the novel's characters, they may themselves suggest many possible interpretations; they may, according to the preoccupations of each reader, accommodate all kinds of comment—psychological, psychiatric, religious, or political—yet their indifference to these 'potentialities' will soon be apparent . . . The future hero will remain, on the contrary, *there.* It is the commentaries that will be left elsewhere; in the face of his irrefutable presence, they will seem useless, superfluous, even improper."[16]

Robbe-Grillet is right in thinking that a narrative structure must remain *below* all the interpretations it may elicit, but he is wrong in

thinking that it can entirely avoid them because it is extraneous to them. It can't be extraneous to them, since it is a sort of *propositional function* which can stand for a series of situations that are already familiar to us. It is a propositional function that each of us fills in a different way depending on how we look at it, but that is there to be filled since it is the field of possibilities of a series of relationships that can really be posited—just as the constellation of sounds that constitutes a musical series is the field of possibilities of the series of relationships we can establish among these sounds. Narrative structures have become fields of possibilities precisely because, when we enter a contradictory situation in order to understand it, the tendencies of such a situation can no longer assume a unilinear development that can be determined *a priori*. Rather, all of them appear to us as equally possible, some in a positive fashion and some in a negative, some as a way out of the situation and others as a form of alienation to the crisis itself.

The work thus proposes itself as an open structure that reproduces the very ambiguity of our being-in-the-world, as it is described by science, philosophy, psychology, sociology—just as our relationship with the automobile is a dialectic tension between possession and alienation, a knot of complementary possibilities.

Of course, Robbe-Grillet is only one instance of a much larger problem, an instance which, however, extreme as it is, should help us understand why the authors of the *nouveau roman* were so often on Sartre's side in their endorsement of political manifestos. This baffled Sartre, who could not understand how writers who seemed to keep such a distance from political issues in their narrative could be so eager to be personally involved in them. But, as a matter of fact, all these writers (some more, some less) felt that the only way they could deal with their world in their work was by "playing" with narrative structures, since all the problems which, at the level of individual psychology and of biography, could be considered problems of conscience, in literature could be reflected only in the way the work was structured. Hence, as they refused to speak of a political project in their art, they implied it in the way they looked at the world, and turned this way of looking at the world into their project. This decision may at first appear inhuman, but on second thought it may well be the only form our humanism can assume.

In *Signs,* Maurice Merleau-Ponty defines humanism as follows:

"If there is a humanism today, it rids itself of the illusion Valéry described so well when he spoke of 'that little man within man whom we always presuppose' . . . The 'little man within man' is only the phantom of our successful expressive operations; and the admirable man is not this phantom but the man who—installed in his fragile body, in a language that has already done so much speaking, and in an unstable history—gathers himself together and begins to see, to understand, and to signify. There is no longer anything decorous or decorative about today's humanism. It no longer loves man in opposition to his body, mind in opposition to its language, values in opposition to facts. It no longer speaks of man and mind except in a sober way, with modesty: mind and man never *are;* they show through in the movement by which the body becomes gesture, language an *oeuvre,* and coexistence truth." [17]

Installed in a language that has already done so much speaking: this is the problem. The artist realizes that language, having already done too much speaking, has become alienated to the situation it was meant to express. He realizes that, if he accepts this language, he will also alienate himself to the situation. So he tries to dislocate this language from within, in order to be able to escape from the situation and judge it from without. Since language can be dislocated only according to a dialectic that is already part of its inner evolution, the language that will result from such a dislocation will still, somehow, reflect the historical situation that was itself produced by the crisis of the one that had preceded it. I violate language because I refuse to express, through it, a false integrity that is no longer ours, but, by doing so, I can't but express and accept the very dissociation that has arisen out of the crisis of integrity and that I meant to dominate with my discourse. There is no alternative to this dialectic. As already mentioned, all the artist can hope to do is cast some light on alienation by objectifying it in a form that reproduces it.

 This is the situation sketched by Edoardo Sanguineti in his essay *Poesia informale* (Informal poetry): true, there is a poetry that sounds like the poetry of a nervous breakdown, but this breakdown is, above all, historical. To denounce it, it is necessary to assume its compromised language so that we can place it in front of our eyes and become aware of it; it is necessary to exacerbate the contradictions of the contemporary avant-garde, since the way to freedom

can be found only from within a culture; it is necessary to suffer a massive dose of the very crisis we want to solve; in short, it is necessary to go through the entire *Palus Putredinis,* since "to be innocent is no longer possible," and "in any case, for us, form can come only out of the formless, out of the formless horizon which, whether we like it or not, is our lot." [18]

This stance is obviously quite risky. The last citation recalls the attitude of certain gnostics (Carpocrates, for instance) who believed that, to get rid of the influence of angels, lords of the cosmos, it was necessary to undergo the experience of evil, and delve into baseness to emerge from it totally purified. The historical consequence of such a persuasion took the form of the Templars' secret rites and the liturgical perversions of an underground church whose major saint was Gilles de Rais.

And, indeed, for every artist who tries to grasp his reality by assuming the language of its crisis there is a mannerist who borrows the technique without understanding its purpose and thus turns the work of the avant-garde into sheer mannerism, a self-complacent exercise, just another way of alienating oneself to the existing situation by turning the anxiety of revolt and the bitterness of criticism into a formal exercise that takes place exclusively at the level of structure.

On the other hand, if it is possible to assert that the only way in which one can speak of a situation is by delving into it and by assuming its means of expression, it is impossible to define the limits of the process, or the standard of comparison that would allow us to determine whether the artist has really been able to turn his experience into some sort of revelation or whether, in fact, it has been for him only a pleasant, passive vacation. But this is the task of a critical discourse that analyzes one work at a time and not of a philosophical investigation concerned with a certain attitude of contemporary poetics. We can, at most, propose an aesthetic hypothesis: whenever this process of awareness produces an organic work that expresses itself in all its structural connections, we can assume that this is also evidence of the degree of awareness of both its author and its audience. The form of such a work cannot but refer to the cultural reality it represents—refer to it in the most complete and organic way possible. Every successful form rests on the conscious translation of amorphous matter into a human di-

mension. In order to dominate matter, the artist must first understand it; if he has understood it, he cannot be its prisoner, no matter how severely he has judged it. And even if he has accepted it wholeheartedly, he has accepted it only after seeing its wealth of implications and after discerning, without disgust, the tendencies that may seem negative to us. This is the situation that Marx and Engels saw as perfectly realized in Balzac, whom they considered as both a reactionary and a legitimist. According to them, Balzac was able to sketch and organize the rich substance of the world he chose to narrate with such a visionary depth that his work (that is, the work of a writer totally disinterested in certain issues, and basically in agreement with his world—unlike the work of Eugene Sue, who in the name of progress tried to express a political judgment on the situation in which he lived) is essential for an understanding and evaluation of bourgeois society. In other words, Balzac accepted the situation in which he lived, but he was also able to express it so lucidly in all its connections, that he did not remain its prisoner, or, at least, not in his work.

Balzac conducted his analysis at the level of plot, in the way he presented his subject matter (whose aim was to illustrate the content of his investigation). Contemporary literature no longer analyzes the world in this fashion; rather, it exposes it by means of a structural articulation—so that this articulation is itself the subject, and thereby the content, of the work.

This is how literature—like music, painting, cinema—expresses the discomfort of a certain human situation. On the other hand, we cannot reasonably expect that contemporary society be its only concern. Literature can also realize, in its structures, the image of the cosmos that is promoted by science, the last frontier of a metaphysical anxiety which, being unable to give unitary form to the world on a conceptual level, tries to elaborate its replacement on an aesthetic level, in an aesthetic form. *Finnegans Wake* may well be an example of such a literary direction.

Some people believe that a concern with cosmic relationships is an expression of indifference toward mankind and a way of avoiding more human issues. But this is nonsense. A literature that tries to express, in its openness and indeterminacy, the vertiginous and hypothetical universes perceived by the scientific imagination is still concerned with mankind, since it tries to define a universe that

has assumed its present configuration thanks to a human process; by "process" I mean the application of a descriptive model to an objective reality. Here again, literature would express our relationship to the object of our knowledge, and our concern with the form we have given the world, or the form we have failed to give it, and would try to provide our imagination with schemes without which we might not be able to understand a large part of our technical and scientific activity—which would then really become alien to us, and assume control over our lives.

In any case, the artistic process that tries to give form to disorder, amorphousness, and dissociation is nothing but the effort of a reason that wants to lend a discursive clarity to things. When its discourse is unclear, it is because things themselves, and our relationship to them, are still very unclear —indeed, so unclear that it would be ridiculous to pretend to define them from the uncontaminated podium of rhetoric. It would be only another way of escaping reality and leaving it exactly as it is. And wouldn't this be the ultimate and most successful figure of alienation?

Form and Interpretation in Luigi Pareyson's Aesthetics

To the idealistic notion of art as *vision*, Pareyson's theory of formativity opposes the concept of art as *form*, in which the term "form" means organism, formed physicality with a life of its own, harmoniously balanced and governed by its own laws; and to the concept of *expression* it opposes that of *production* as forming action.

Formativity

According to Pareyson, all human life is the invention and production of forms. Everything mankind does, whether on an intellectual, moral, or artistic level, results in forms—full-fledged, organic, autonomous creations, endowed with a comprehensibility of their own. This includes theoretical constructs as well as civic institutions, daily achievements as well as technical endeavors, paintings as well as poems.

Since every form is an act of invention, the discovery of the rules of production required by the object that is being made, all human work is intrinsically artistic. But once the artistic element in every production of forms is established, it becomes necessary to find the principle of autonomy that distinguishes the work of art from any other kind of form. Croce's idealistic philosophy defined art as the intuition of a feeling, thereby clearly implying that it had nothing to do with either morality or knowledge. Pareyson, instead, insists on the "unitotality" of the individual, who, in turn, lends his (or her) forming activity a speculative, practical, or artistic direction while retaining a unity of thought, morality, formativity: "Only a philosophy of the individual can account for the unity and the difference of every human activity, since, starting from the indivisibil-

ity and the initiative of the individual, it tries to explain how every action demands at once the specification of one activity and a concentration of all the other activities. If action were absolutely spiritual, there would be no distinction between one activity and the next, since all activities could be reduced to one and the same." Just as any speculative undertaking involves simultaneously an ethical commitment, a passion for research, and an artistic sensibility capable of directing the research and organizing its outcome, so artistic action involves morality (not as a set of binding laws but rather as a commitment that turns art into a mission and a duty, and prevents the formative activity from following any law other than that of the work to be realized), emotion (not as the exclusive constituent of art, but rather as the affective tinge that the artistic commitment assumes and into which it evolves), and intelligence (as a constant, conscious judgment presiding over the organization of the work, as a critical check which is not extraneous to the aesthetic operation but accompanies the forming activity from within and is finalized in its outcome).

Given the presence of all these activities in the individual at work, what distinguishes art from other personal initiatives is the fact that in the artistic process all an individual's activities share in the same purely formative intention: "In art, the formativity that invests one's spiritual life and allows for the exercise of other specific operations acquires a certain specificity itself, by assuming an autonomous direction while dominating all the other activities and subordinating them to itself . . . In art, the individual forms for the sake of forming, thinks and acts in order to form."

All these assertions, along with the definition of art as "pure formativity," are likely to be misunderstood, and particularly so if read in the fading light of the eternal opposition between form and content and form and matter. On the other hand, the concept of form as organism should be enough to quiet all formalist objections. For Pareyson, form is a structured object uniting thought, feeling, and matter in an activity that aims at the harmonious coordination of all three and proceeds according to the laws postulated and manifested by the work itself as it is being made.

Moreover, "to form for the sake of forming" does not mean "to form nothing"; the content of every form is the artist—a fact that does not mean, however, that the artist is the object of the work,

the subject of its *narration*. The forming artist is revealed by the work as *style*, as a *way of forming*. The artist is present in the work as the concrete and extremely personalized trace of an action. "The work of art reveals the entire personality of the artist, not just in its subject or its theme, but first and foremost in the unique and very personal way in which it has been formed."

This definition renders meaningless all the debates concerning terms such as "content," "matter," and "form." The content of a work is its creator, who at the same time is also its form, since the artist gives his creation its *style*—this being at once the way the artist forms himself in his work and the way the work manifests itself as such. Thus, the very *subject* of a work is none other than one of the elements in which the artist has expressed himself by giving himself form.

The Matter of Art

Art understood as form cannot but have a physical existence. The Crocean illusion of an interior figuration, whose physical exteriorization is only a corollary event, deliberately ignored one of the richest and most fruitful areas of creativity. According to Croce, intuition and expression were indistinguishable (it was, therefore, impossible to distinguish between an image and the sound or the color that expressed it; indeed, the image was itself an expression), but expression and *exteriorization* were two separate things—as if an image could be born as sound or color without the reference, the support, and the suggestion provided by a physical operation. It is for this reason that at the very moment Crocean aesthetics was at its most influential (and despite its influence), numerous artists and philosophers turned the question of matter in art, the dialogue with matter that is indispensable to any artistic production, into the object of scrupulous analysis. Physicality, here understood as resistance, is necessary to the formative action both as a motive and as an obstacle.

These are the issues that concern Pareyson when he investigates the dialogic activity by which the artist, in the restraint imposed by the obstacle, finds his truest freedom; for this is what allows him to move from the vague realm of aspiration to a concrete awareness of the possibilities of the material at his disposal, whose laws he grad-

ually reinserts into an organization that assumes them as the laws of the work. Pareyson's analysis rests on a vast amount of documentation drawn from the experience of various artists, from Flaubert to Valéry and Stravinsky.

Matter is therefore an obstacle to the inventive activity which will eventually resolve the laws of the obstacle into those of the work. Given this general definition, one of the most personal aspects of Pareyson's doctrine consists in bringing together, under the rubric "matter," all those realities that clash and intersect in the world of artistic production: "means of expression," techniques of transmission, codified precepts, all the traditional "languages," the very instruments of art. All this is included in the general category "matter," the exterior reality on which the artist works. An ancient rhetorical tradition can thus play to a writer the same role as a piece of marble plays to a sculptor: that of an obstacle chosen to suggest action. The very aim of a functional work must be considered as "matter": a set of autonomous laws which the artist must be able to interpret and turn into artistic laws.

According to the aesthetics of formativity, the artist, in forming, effectively invents totally new laws and rhythms, but this novelty does not come out of nothing. It consists of a set of suggestions that both a cultural tradition and the physical world have offered to the artist in the initial form of resistance and coded passivity.

This leads us to yet another aspect of Pareyson's aesthetic doctrine: artistic production is a matter of "trying," of proceeding by means of proposals, drafts, and other patient interrogations of "matter." But this creative adventure has both a point of reference and a term of comparison. The artist proceeds by trial, but every trial is guided by the work as it is to be—that is, by the appeals and the demands which are intrinsic to the process of forming and which direct the productive process. "Trying, therefore, is based on a criterion that is at once indefinable and yet quite firm: an intuition of the outcome, the divination of the form to be." Pareyson calls the form toward which the artist strives "forming form."

The Forming Form and the Formative Process

The concept of "forming form" entails a new concept of the "work" as the guide of its own empirical realization. We might, at

first, be puzzled by assertions according to which a work exists from the very start as a "cue," a germ that already possesses within itself the possibility of expanding into a complete form—in other words, as a work *in nuce*. But this "germ" acquires a value—that is, assumes all its qualities and becomes fertile—only if it is grasped, understood, and appropriated by a person. A brush stroke, a musical phrase, a line of verse (particularly the first line, which, according to Valéry, determines the development of the entire poem) are all germs of forms which, by the mere fact that they are and exist as the premises of future configurations, presuppose the coherence of organic growth. The artist must, therefore, turn the coherence implicit in the cue into his own coherence and must choose, from among the various directions he can take, the most congenial one, the only one that will be fully realized.

This dialectic of artist and "forming form" may at first seem to suggest the possibility of the work as a hypostatized autonomous entity. But the concept of the forming form is based on a belief in the profound congeniality between human work and the natural laws of forms. Forms demand to evolve according to a natural intentionality that is not opposed to human intentionality, since the latter will be productive only in its interpretation of the former. To invent formal human laws does not contradict nature's formativity; rather, it extends it. This adventurous, inquisitive aspect of the formative action leads Pareyson to write a number of dense, incisive pages on the value of improvisation and practice as means for understanding the potential of "matter," and to reconsider the question of inspiration outside the usual romantic or Dionysian schemes.

Once completed, autonomous and harmonious in all its parts, the work will present itself as a finished model. At this point, Pareyson's analysis focuses on the inner coherence of the work and on the reliance of the whole on all its constitutive parts, thus providing the critic with precious indications concerning both the interpretive problems entailed by works that have only partially survived the ravages of time, and the nature and formal potential of the "fragment." This, in turn, brings about a new perspective on the Crocean opposition between "structure" and "poetry," since all the parts of a work are no longer subordinated to isolated instances of "poetry" but rather are seen as integral parts of one artistic orga-

nism: a total form in which all the so-called "padding" has a "structural" value (and here I am using the term "structure" as a synonym for "form," for an artistic entity), since it shares in the perfection and legitimacy of the form that it supports.

What finally unifies all these theoretical formulations is the fundamental premise according to which a form, once it has reached completion and autonomy, can be seen as perfect only if it is *dynamically* considered. Aesthetic contemplation is this active consideration that retraces the process which gave life to form. The work is thus defined as the narration of the effort that went into its making: "form is the very process in its conclusive and inclusive aspect; it is not separable from the process of which it is the perfection, the conclusion, and the totality." Form is at once the "current memory" and the "permanent recollection" of the productive activity that gave it life.

The Theory of Interpretation

Form is the culmination of a process of figuration and the beginning of a series of successive interpretations. As the product of a process of figuration, form is the cessation of the forming process which has reached its conclusion. But since the fact of being form opens it up to an infinity of different perspectives, the process which actualizes itself as form also realizes itself in the continuous possibility of interpretation. The comprehension and interpretation of a form can be achieved only by retracing its formative process, by repossessing the form in movement and not in static contemplation. In fact, contemplation simply follows the conclusion of an interpretation, and to interpret means to assume the point of view of the producer, to retrace his work in all its trials and interrogations of matter, in its response to and choice of cues, in its intuition of what the inner coherence of the work wants it to be. Just as the artist could intuit, in the intrinsic disorder of the cues, the outlines of a future order, so will the interpreter refuse to be dominated by the work as a completed physical whole, and will instead try to situate himself at the beginning of the process and to re-apprehend the work as it was meant to be. Only by doing this will he be able to measure the ideal form (the "forming form") that will gradually appear in his mind's eye against the work as it actually is (the

"formed form"), and thus become aware of the resemblances and the differences between the two. "Every work is identical to its execution, but it also transcends it. It is identical to it in that it surrenders itself to it and finds in it its only way of being; it transcends it because it is at once its stimulus, its law, and its judge." This explains how the difference between the simple reading of a work and a real critical judgment of it is based not on quality but rather on complexity and commitment. They are both interpretive acts; just as translations are interpretive acts, as well as performances, and the transposition of a work into a different medium, and, for that matter, the reconstruction of an unfinished or mutilated work, even—and this might sound like an outrageous assertion, though it is perfectly, if exceptionally, justified by the practice of both critics and performers—the alterations made in a work in the course of its performance. All these instances involve an interpretation that, retracing a formative process from the very beginning, repeats its outcome even though often under different circumstances.

This assimilation of contemplation, performance, and judgment, with all the problems it entails, has led some to suspect that Pareyson's theory might be unable to account for the effective differences in the various arts, thus preventing any discussion of their inner problematics. But this does not seem to be at all the case. In fact, his theory allows one to examine the undoubted operative differences between, say, a musical performance and a translation or a restoration, along with all the possible approaches and particular psychological dispositions each of these activities entails. However, it should be remembered that Pareyson's broader definition of the notion of interpretation is strictly dependent on another notion which, if neglected, will inevitably lead to a misunderstanding of many of his affirmations. This theory of interpretation acquires full meaning only if style is defined as a way of forming.

Style as a Way of Forming

Pareyson's aesthetics postulates a cultural universe that consists of a community of existentially situated individuals who are, however, open to communication because of the substantial unity of their structures. The very notion of form can be better understood if considered as an act of communication between two people. Once

formed, a form does not subsist as an impersonal reality; rather, it actualizes itself as a concrete memory of both a formative process and a forming personality. The formative process and the personality of the forming agent coincide only in the objective texture of the work, in its style. By "style" I mean a very personal, unrepeatable, characteristic "way of forming"—the recognizable trace that every artist leaves in his work and which coincides with the way the work is formed. Thus, the artist gives himself form in the work: to understand a work means to possess its creator in a physical object.

It is important to remember this, in order not to misunderstand the notion of "pure formativity" that Pareyson considers specific to art. Form communicates itself alone, but in it lies the artist, as style. These premises should be enough to undermine any too exclusively naturalist or organicist interpretation of formativity. In the work, the artist forms "his concrete experience, his interior life, his unique spirituality, his personal reaction to the world in which he lives, his thoughts, customs, feelings, ideals, beliefs, aspirations." As already noted, this does not mean that the artist narrates himself in his work; he reveals himself in it as a way of forming.

Against all those doctrines that see art as a way of knowing, the aesthetics of formativity maintains that the only knowledge an artist will necessarily offer is the knowledge of his personality concretized into a way of forming—all of which, of course, does not prevent an artist from proposing, in his art, his own personal viewpoint, or even simply an obscure feeling about the world.

Permanence of the Work and Infinity of Interpretations

This polarity between the concrete personality of the artist and that of the interpreter allows Pareyson to situate the potential for permanence of a work of art in the very infinity of the interpretations it opens itself to. By giving life to a form, the artist makes it accessible to an infinite number of possible interpretations—*possible* because "the work lives only in the interpretations that are given of it," and *infinite* not only because of the characteristic fecundity of the form itself, but because this fecundity will inevitably be confronted with an infinity of interpreting personalities, each with its own way of seeing, thinking, and being. Interpretation is an exercise in "congeniality," based on the fundamental unity of human

behavior, and presuming both an act of fidelity toward the work and one of openness to the personality of the artist—a fidelity and an openness which are, however, manifested by another personality, with its own dislikes and preferences, its sensibilities and inhibitions. All these existential data would be enough to preclude interpretation if its object were closed and well defined. But since form is nothing but the organization of an entire personal world (and through this of an entire historical context) in such a way that it offers itself as a single whole in a thousand different perspectives, the personal situations of the interpreters, far from precluding any access to the work, become occasions for this access. And every access is a way of possessing the work, of seeing it in its entirety, yet with the awareness that it can always be reconsidered from a different point of view: "There is no definitive or exclusive interpretation, just as there is no approximate and provisional interpretation." The interpreter becomes a means of access to the work and by revealing the nature of the work also expresses himself; that is, he becomes at once the work and his way of seeing it.

Of course, at the theoretical level, Pareyson's analyses assume an optimum aesthetic experience. Nevertheless, what this view of interpretation stresses is the intimate relationship, within a work, between genesis, formal properties, and the possible reactions of the interpreter. These three aspects, which the formalists of New Criticism insist on keeping distinct (even though they seem to devote all their attention to the second, to the exclusion of the other two), are inseparable in the aesthetics of formativity. A work consists of the interpretive reactions it elicits, and these manifest themselves as a retracing of its inner genetic process—which is none other than the stylistic resolution of a "historical" genetic process.

Two Hypotheses about the Death of Art

We are closest to waking
when we are dreaming of dreaming.

Novalis

Most interpretations of contemporary art give the impression of being more concerned with historical justifications, or with the definition of a poetics or a procedure, than with aesthetic evaluation (which demands an axiological scheme as well as a critical choice that expresses itself in terms of "ugly" or "beautiful," "poetry" or "nonpoetry," "art" or "nonart," or, more shrewdly, "success" or "failure" in relation to an underlying poetics).

There are reasons for this impression; indeed, one wonders why so few of those who sense it as a bad sign dare denounce it and why so few of those who do not feel threatened by it have the courage to explain it and theorize about it.

This brings up an interesting question: Is this situation due to a choice by contemporary art critics, or does it depend on the new notion of art expressed by most contemporary works?

I myself have been guilty of an action that most defenders of axiological criticism condemn: I have tried to describe some phenomena of contemporary art from the point of view of the intentions (the poetics) underlying the artistic procedure, and of the historical reasons informing these intentions. In other words, what notion of art motivates most of today's artists? To what extent does this new idea reflect the development of a modern aesthetic consciousness? And how do these intentions become methods of procedure, and, therefore, formal structures? The notion of "open work" seemed particularly effective in explaining these phenomena, which is why I proposed it. Obviously, such a choice automatically excluded all critical evaluation of the works in question. It

was understood that I was not going to be concerned with the success or failure of a work, since my approach was not that of a literary, figurative, or musical critic but that of a cultural historian. I was going to be concerned only with the works, both as projects and products of particular formal approaches capable of clarifying certain aspects of contemporary culture. Criticism had nothing to do with it. Obviously, those who condemned this kind of study for avoiding the risk of an axiological distinction between valid and nonvalid works were essentially expecting the historian of poetics to do the job of the critic. It was a little as if, during a historical investigation of the effects of the Sarajevo assassination (how did the event influence other important historical movements such as the Allies' intervention in the war, and the Russian Revolution?), someone had suddenly wondered whether the murderer's act was moral or not. Though perfectly valid in a different context, such an ethical consideration would be totally useless to a historical analysis of causes and effects. And yet, on second thought, that sort of objection is never entirely irrelevant. After all, it is fairly natural that a historian working on a particular period should center his study on the events he deems most relevant. Similarly, the cultural historian who attempts a description of the artistic movements of his times is inevitably led to discuss those art phenomena which, though they may mostly interest him for their implicit or explicit poetics, have also met with his approval as finished works of art; otherwise he would not have noticed them or would not have been able to conceal the irritation, disgust, or boredom they might have provoked in him.

And yet, if our cultural historian had decided to commit himself to a critical analysis, would he have been able to work with categories such as "ugly" and "beautiful," "poetry" and "nonpoetry," or would he have been able only to reiterate his description of structural models and of the poetic intentions they express? Moreover, if it is possible to conduct an effective historical analysis of the poetics of the thirteenth century or of Pericles' times, albeit discriminating between critical judgment and structural analysis, is it possible to express a critical judgment of the more provocative phenomena of contemporary art without inevitably lapsing into a structural analysis that would render any axiological evaluation superfluous?

All this brings us back to our original question: Does a descrip-

tive analysis (what some would define as a "phenomenological" discourse, with no reference to the strict Husserlian implications of the term) depend on a free theoretical choice, or is it made necessary by the nature of contemporary art? In other words, does the description and justification of a poetics that has come to replace the aesthetic evaluation of a work depend on the fact that the speaker wants to be considered as a scholar of poetics or, rather, on the fact that the works he is concerned with can be understood and justified only as the expressions of a particular poetics?

All this leads us to a number of problematic conclusions. Nobody doubts that in order to understand a work it is necessary to understand the poetics that underlies it. The misunderstandings surrounding Dante's *Paradiso*,[1] for instance, were merely the result of the cultural myopia of certain scholars who were unable to consider that theological monument as the most vital and most deeply poetic expression of the medieval artist. On the other hand, it is also true that in modern art, from Romanticism to our day, poetics has not been considered only as a project aiming at the production of an artistic object (and, as such, destined to disappear once the object has been realized). On the contrary, it has become art's main subject matter, its theme, its *raison d'être*. Works of art have become treatises on art. "Poetry of poetry," "poetry about poetry," "poetry to the second power"—these are all examples of the same tendency. Mallarmé wrote poetry to discuss the possibility of writing poetry. As we have already noted, Joyce's *Finnegans Wake* is its own poetics. A Cubist painting is a discourse about the possibilities of a new pictorial space. Oldenburg's entire oeuvre is a long discourse on the stupidity of making art in the traditional sense, a deliberate choice between artistic activity and ethical action (art as protest, as a message of salvation).

None of these examples is saying anything new. What is new, instead, is the intensity and the determination with which we must confront the consequences of this new tendency of contemporary art. Let us assume that: (1) the work of art becomes the concrete enunciation of its own poetics (and of all the theoretical problems that a poetics generally, and more or less consciously, entails: a vision of the world, a notion of the function of art, an idea of human communication, etc.); (2) the most relevant way of approaching a work of art is to acknowledge the procedures that it exemplifies; (3)

these procedures can themselves be reduced to a "model" and therefore to an abstraction, since they can be both described and explained. In this case, won't this sort of discourse exhaust all there is to say about the work? There will no longer be any need to speak of a "beautiful" or "ugly" work, since *the success of the work will have to do solely with whether or not the artist has been able to express the problem of poetics he wanted to resolve.*

First Hypothesis: The Death of Art

It often happens that, once the reader or viewer of contemporary art has understood what the work is all about (that is, the structural idea it wants to realize, such as a new organization of narrative time, a new subdivision of space, or a certain relationship between reader and author, text and interpreter), and particularly if he has understood it thanks to the preliminary declarations of the artist or the critical essay that introduces the work, he no longer feels like reading the work. He feels he has already gotten all there was to get from it, and fears that, if he bothered to read the work, he might be disappointed by its failure to offer him what it had promised.

I recently came across *Composition No. 1,* by Max Saporta. A brief look at the book was enough to tell me what its mechanism was, and what vision of life (and, obviously, what vision of literature) it proposed, after which I did not feel the slightest desire to read even one of its loose pages, despite its promise to yield a different story every time it was shuffled. To me, the book had exhausted all its possible readings in the very enunciation of its constructive idea. Some of its pages might have been intensely "beautiful," but, given the purpose of the book, that would have been a mere accident. Its only validity as an artistic event lay in its construction, its conception as a book that would tell not one but all the stories that could be told, albeit according to the directions (admittedly few) of an author.

What the stories could tell was secondary and no longer interesting. Unfortunately, the constructive idea was hardly more intriguing, since it was merely a far-fetched variation on an exploit that had already been realized, and with much more vigor, by contemporary narrative. As a result, Saporta's was only an extreme case, and remarkable only for that reason.

But one does not need a Saporta to reach this kind of conclusion. As we all know, some interpretations of *Finnegans Wake* risk being more interesting, informative, and entertaining than the work itself. Similarly, the summary of a movie, or a description of the criteria according to which it has been realized, is often more persuasive than the movie itself. Indeed, it often happens that a work falls quite short of the expectations that its poetic intentions have aroused in us. The banal question of the neophyte confronting a work of abstract art ("What does it mean?"), a question that would seem to have nothing to do with aesthetics, criticism, or the history of poetics, is much more illuminating than it seems. The hapless viewer asks what the author of the painting wanted to do, because if he does not know this he won't be able to enjoy the painting. If someone explains it to him, then he may begin to appreciate the work. The work or its rationalization? In any case, his critical approach clearly shows us (as if it were necessary) that in modern art the question of poetics has become more important than the creation of the work itself, that the way in which a work is constructed has become more important than the constructed work, and that form can be appreciated only as the outcome of a formal approach.[2]

If these observations are true and can be applied, though with different emphasis, to all the products of contemporary art, then we have to admit that aesthetic pleasure has gradually changed from the emotional and intuitive reaction it once was to a much more intellectual sort of appreciation. This is only a hypothesis, but if it is correct there is no reason for despair. After all, didn't the medieval reader find pleasure in applying his intelligence to the discovery of many allegorical meanings beneath a literal surface? And wasn't this intellectual discovery colored by emotion? Throughout the centuries, the idea of art has undergone numerous changes. The intuitive spark and emotional shiver that were once thought to accompany all aesthetic revelation are today not only dated but also limited to a particular historical period and a precise set of cultural models, even though it would be wrong to assume that they have lost all their appeal.

But if this is what Art means to contemporary aesthetics, then the intensely self-analytical trend I have just described can certainly be seen as a sign of the decline of art—more than that, of a concrete example of its death.

According to Piero Raffa, "the avant-garde is a trick of history meant to hasten the 'death of art,' or, rather, art's transition from the cultural function it fulfilled in the past to a completely different one. In order to express this concept I have used a metaphor (a 'trick of history') which, however, should not be taken to mean that most avant-garde ideologies are not aware of what is happening. Quite the contrary: most of them are so aware of it that it is all they can speak about . . . This change manifests itself as a surplus of rational self-consciousness in relation to the creative process and the kind of artistic pleasure it is supposed to produce . . . Today's art demands an increasingly keener critical awareness, an 'ideologization' of itself . . . This has resulted in a paradoxical imbalance between what the works actually say and the doctrinal surplus that justifies them."[3]

We can understand how this phenomenon, or this coincidence of phenomena, may, for the sake of description, be defined as "the death of art," but this is not enough to explain what in fact the phrase means. Should it be taken as a facile Hegelianism, implying the dissolution of art into philosophy, or should it instead be seen as the premise of a more subtle speculation? I have in mind the sort of speculation, more philosophical than aesthetic, that one finds in an essay such as "La questione della 'morte dell'arte' e la genesi della moderna idea di artisticità" (The question of the 'death of art' and the genesis of the modern idea of artisticity), with which Dino Formaggio opens his book *L'idea di artisticità*.[4]

In this essay, Formaggio shows how the elements that have preoccupied us in the preceding pages—that is, the emergence of a poetry of poetry and of the critical awareness of this phenomenon—were already present in Schiller, Novalis, and Hegel, not to mention Hölderlin. The careful analysis that he devotes to these authors and to the evolution of the notion of the "death of art" shows that it would be much too simplistic to believe in "a historical end of art," and that it would be much more reasonable to understand the formula in the Hegelian sense of "the end of a certain form of art," part of a historical development in which the advent of a new idea of "art" must appear as the negation of what the same term meant for the preceding culture.

In the course of his essay, Formaggio quotes a page by De Sanctis (1817–1883) in which the famous Italian critic clearly showed how

the idealistic nineteenth century was very much aware of this process. Rather than interpreting it as a symptom of impending death, however, De Sanctis chose to see it as the beginning of a new development born out of dialectic negation. "What's the point of complaining about the state of art and wishing this or that? Science has infiltrated poetry and is here to stay, because this fact corresponds to the current condition of the human mind. We have never been able to look at something beautiful without immediately wondering whether it is also reasonable—and here we are already in the midst of criticism and science! Not only do we want to enjoy, but we also want to be conscious of our enjoyment; not only do we want to feel, but we also want to understand. Today, honest poetry is as impossible as honest faith. Just as we are unable to speak of religion without being irked by doubts ('But is it really true?'), so are we unable to feel without philosophizing about our feelings, or to see without trying to understand our vision. All those who resent Goethe, Schiller, Byron, and Leopardi for constructing, as they see it, a "metaphysics in verse," remind me of those priests who rail and rant against philosophy and bemoan the loss of faith. Unfortunately faith is gone, and poetry is dead. Or rather, since both faith and poetry are immortal, what is dead is one of their particular ways of being. Today, faith springs out of conviction, and poetry out of meditation. They are not dead; they are only different." [5]

Obviously, the situation described by De Sanctis is not our current one; but aside from the fact that it certainly contained the seeds of our situation, what matters in this statement is the dialectic confidence and the lightheartedness with which the great critic accepted the crisis of a notion of art which, until then, had seemed the only possible one. We, too, should be capable of this confidence, even though what lies ahead may for the moment seem quite uncertain. Formaggio is clearly capable of it when he posits, at the very basis of his notion of art, the Hegelian concept of the "dialectic death, within the artistic and aesthetic activity, of certain figures of consciousness, and through this their constant transformation and regeneration in an ongoing self-consciousness." Formaggio sees all contemporary art as stirred by a movement of mortal self-consciousness, recognizable in its "fundamental intention to start again from zero," in its intensely self-reflective attitude. But he sees

this as a positive movement: death as "the death of death," negation as "the negation of negation." All this should lead us to conclude that, even if the proposed hypothesis were valid (by which I mean the prevalence of poetics over poetry and of the abstraction of a rationalized structure over the concreteness of the work itself), far from discouraging us, it should instead invite us to study the new critical categories which could be applied to the works that will be born out of this new idea. And we should not be afraid that, by turning the artistic object into both the pretext for an intellectual investigation and the support of a rationalizable model, the artistic process might forever lose its autonomy. It has happened before: What autonomy did petroglyphs have? Traced for either magic or religious reasons, they were never appreciated for their "artistic" value (since they were always hidden at the back of caves). At most, we should note how avant-garde art—having long polemicized against all art with a propagandistic, political bent (drawings of workers, celebratory poems, ecological symphonies, etc.) for having degenerated into heteronomous activities whose only criterion of judgment was not aesthetic but political—has also lapsed into a similar situation, and must now accept for itself, as a necessary condition, the very heteronomy with which it reproached other poetics. And, indeed, both kinds of art, equally heteronomous, would seem to find their very justification and validity in sharing the same cultural context: on one side propagandistic appeal; on the other, philosophical-scientific reflection. There have been other times in history when two different artistic tendencies, instead of asserting their own autonomy and self-sufficiency, ended up depending on this sort of reciprocally exclusive rapport.

Second Hypothesis: The Recovery of Aesthetic Value

All this talk about autonomy and heteronomy, however, should make us very suspicious about a possible conclusion that we might otherwise have accepted without hesitation. If the contemporary work of art reduces itself to a declaration of poetics, and, through this, to a philosophical declaration concerning its vision of the world—if, in other words, the work of art becomes another prop for knowledge—then how will its procedures differ from those of science or philosophy? If, in the abstraction of its rationalized struc-

ture, the work of art expresses a particular notion of time and space, how will this notion differ from the one elaborated by other disciplines?

The defender of contemporary art could reply that when a work of art expresses certain ideas about the world, or man, or the relationship between the two in the way in which it is constructed, it always does so in a "total" sense, as if the work, or the structural model the work realizes, were a compendium of reality (as seen, for instance, in *Finnegans Wake*), whereas both science and philosophy (at least nonmetaphysical philosophy) seem to proceed in terms of partial definitions, allowing us only a temporary knowledge of separate aspects of reality—since they cannot afford to give us a comprehensive synthesis, or they would become works of imagination and move into the realm of art. For the sake of synthesis, such an answer could be translated into the following one: art offers us an organic knowledge of things—in other words, it acquaints us with things by gathering them into one form. The structural model envisioned by poetics and revealed by the critical discourse is just a configuration, a Gestalt, that can be seized only in its totality. It must not be verified in its isolated elements, but rather accepted as the proposal of an intuitive vision, valid at the level of the imagination, even if rationally analyzable in its various aspects. This sort of answer would lead us back into an autonomous zone reserved exclusively for artistic discourse. And we would realize that if it is true that in contemporary art the formed object tends to disappear behind the formal model it is supposed to express, it is also true that this model assumes all the prerogatives that once belonged to the formed object, and, as a result, it can be not only "understood" but also "enjoyed" for its organic qualities and, therefore, appreciated in an exquisitely aesthetic sense.

In other words, to some the most relevant aspect of *Finnegans Wake* is not the work itself but the project that underlies it. *Finnegans Wake* speaks of the structuring of a circular universe in which it is possible to establish multiple relationships among the various elements, and in which every element can assume different meanings and relational capacities depending on how we want to understand the context—and vice versa. What attracts us most in this text is not so much an actual pun as the possibility of a complete language based on puns, a multiformity of language that will al-

most appear as the image itself of the multiformity of real events. But this entire structural design can itself be enjoyed as a complex and well-calibrated organism, which, when understood, can release the same imaginative mechanisms, the same schemes of intelligence, that presided over the contemplation of the harmonic forms of a Greek temple. Does this mean that we may have recovered aesthetic value in a different way, at a level of greater intellectual rarefication? Or are we speaking of aesthetic value the way we do when we say that a difficult equation, brilliantly solved, has aesthetic value for a mathematician who understands and appreciates it?

But, once again, just as we are about to find an answer to an extreme question, we realize that there is something that does not jell. Is it true, really true, that the only thing we enjoy in our reading of *Finnegans Wake* is the poetics that sustains it, and that the concrete expression of the linguistic event leaves us entirely indifferent? Generally speaking, it is true that the vast array of critical introductions has made it much easier for us to understand the structural mechanism of the work than to delve into the work itself; on the other hand, it is also true that, once we have understood the structural mechanism of the work and have summoned up enough courage to venture into the pages of the book, we keep encountering new incarnations of its structure which make us realize that this is really the first time we have truly savored it. Which, of course, does not mean that we can appreciate the work only when we bump into such individual instances of intense corporeality, and that only those instances allow us to tolerate without irritation the rest of the work and what underlies it. Such an interpretation would commit the same error made by the idealist aesthetics that broke down the entire *Divine Comedy* into "structure" (tolerated as a nonartistic framework) and "lyrical flashes" (the only enjoyable fragments). But there is no contradiction in assuming both (a) that one must appreciate the whole structure of a work as the declaration of a poetics, and (b) that such a work can be considered as fully realized only when its poetic project can be appreciated as the concrete, material, and perceptibly enjoyable result of its underlying project.

To appreciate a work as a perceptible form means to react to the physical stimuli of the object, not just intellectually but also—so to

speak—physically. Fraught with a variety of responses, our appreciation of the object will never assume the univocal exactitude characteristic of intellectual understanding and will be at once personal, changeable, and open. Romantic aesthetics defined the appreciation of art as an act of intuition, precisely in order to underline the fact that the proper understanding of a form involved a number of factors that could not be reduced to a mere intellectual understanding—factors which, together, constituted an organic reaction that could be analyzed only *a posteriori*. We could easily define such an experience as an *aesthetic emotion*—if only it involved, as the Romantics thought, an emotional, nonconceptual response.

On the basis of all this, we can conclude that contemporary works can be evaluated critically in terms of success and failure only if we take these terms in their most *organic* sense (to replace the vague dichotomy between beauty and ugliness, poetry and nonpoetry). Which in turn means that even in those cases in which the structural model of a work appears as the primary value realized and communicated by the form (in other words, when the work appears mostly as a vehicle for a poetics), the work fulfills its fullest aesthetic value only insofar as the formed product adds something to the formal model (so that the work manifests itself as the "concrete formation" of a poetics). The work is something more than its own poetics (which can be articulated also in other ways), since the very process by which a poetic model acquires a physical form adds something to our understanding and our appreciation.

This characteristic was present even in those historical periods in which art appeared as an incorporeal rational construct devoid of all emotional function and impermeable to intuition. Medieval man appreciated a work for its combination of allegorical meanings and rational declarations, but even in his time it was generally understood that underlying any appreciation of a beautiful form was a *visio,* a sensual act, a physical relationship not just with the abstract form of the object but with its complex structure, its substance.

Thus, the aesthetic categories more likely to afford us an evaluation, a judgment, of a work of art are the very ones that have been in constant elaboration ever since De Sanctis, namely: (a) a form is a realized, concrete fusion of "contents" (which, before becoming form, were either intellectual abstractions or obscure psychological urges); (b) a work of art is a fusion, an "as-similation" between a

psychological/cultural universe and a matter capable of assuming a particular, irreplaceable form; and (c) a work of art is the result of a formative activity that has been implemented for its own sake.[6]

This notion of form would solve the problem of contemporary artistic phenomena, just as it had solved other problems before. Formerly it was seen as a concrete solution of the "quarrel" between "form" (here understood as the exterior manifestation of a cultural or psychological content) and "content" (here understood as an ensemble of cultural and emotional elements capable of existing also outside the work in the forms of logical reflection or psychological effusion). Now it appears as the concrete solution of the "quarrel" between the "question of poetics" (here understood as a formal model which has been and can be elaborated within the context of a cultural discourse, and which need not assume the form of a concrete artistic object) and a "physical organism" (which in numerous cases is really only a temporary and inessential vehicle for the ingenious solution of a question of poetics).

A definition of the poetics of a given period is perfectly legitimate and can even be considered a useful tool for a deeper understanding of the works, but it is seldom enough to justify a work. A work can be considered "good" only if, on direct contact, it offers us something richer, more varied, more elusive and allusive. Every time we reread *Ulysses* we understand things that the mere enunciation of its poetics could not have told us, and this, in turn, helps us amplify and verify the enunciation of its poetics.

In the light of this second hypothesis, we can thus bring the possibility of a critical evaluation back within the current aesthetic horizon. In other words, even those works that seemed condemned to be a mere pretext for a cultural description, a structural understanding, a historical justification, can offer us a choice.

This second hypothesis is, in addition to being an alternative to the first one, an attempt to define the conditions which, while allowing for future changes in the very notion of art, can still make room for a critical discourse that has long been part of our culture.

To the skeptics, we can answer that it is not true that contemporary art tries maliciously to elude all possible evaluation; it does not mock the expectations of yesterday's critic, who approaches the work with the best of intentions, with flair, and with a taste for the concrete, only to see it slip away along the tortuous path of intellec-

tual communication and other abstractions. This is not true. Even the most decidedly experimental works cannot cheat—*if* the critic is alert and ready. But in order to be alert and ready, the critic must understand the direction that the notion of art is taking today, so that he will not waste his time looking for "lyrical expressions of feeling" in works which are mostly concerned with giving a concrete, physical expression to a particular poetics and which deliberately exclude all emotional intrusions from their discourse.

And this is precisely why those works that investigate contemporary poetics have a validity that takes precedence over other critical processes: they make room for choice—provided this choice is not expected from the theoretical investigations of aesthetics, on which the very conditions of the choice rest, or from the investigations of cultural history, which are mostly concerned with the historical developments of both poetics and criteria of choice.

IX

The Structure of Bad Taste

Bad taste shares the same lot that Croce saw as characteristic of art: everybody knows what it is and how to detect and predicate it, but nobody knows how to define it. For this, it is often necessary to turn to the experts, the connoisseurs, people "with taste," on the basis of whose behavior we can then define good or bad taste, in relation to particular cultural settings.

At times we recognize bad taste instinctively, in the irritation we feel when confronted by an obvious lack of proportion, or by something that seems out of place—a tactless remark (what we commonly know as a gaffe) or unjustified pomposity: "It was dynamic hatred and loathing, coming strong and black out of the unconsciousness. She heard his words in her unconscious self, *consciously* she was as if deafened, she paid no heed to them"; "Her subtle, feminine, demoniacal soul knew it well" (both examples courtesy of D. H. Lawrence's *Women in Love*). In all these cases, bad taste manifests itself as a lack of measure, a "measure" that is itself very difficult to define, since it varies from place to place and from age to age.

On the other hand, it would be hard to find anything in worse taste than the funerary sculptures of the Cimitero Monumentale in Milan, or Forest Lawn in Los Angeles. And yet, these perfectly legitimate Canovian exercises, representing Pain, Pity, Forgetfulness, etc., can hardly be accused of lacking measure. Formally speaking, this is certainly not their problem. If lack of measure there is, it has nothing to do with the form of the object but rather with history or with circumstances: to imitate Canova in the middle of the twentieth century makes little sense, even though a representation of Pain cannot be considered out of place in a cemetery. What *can* be considered if not out of place at least tactless is the

implicit prescription of the right attitude to assume in that particular circumstance. For the statue is essentially telling us how we should view a visit to somebody's grave, thus leaving us little room for the individual expression of our own personal moods and feelings.

This last example leads us to another possible definition of bad taste, widely accepted, which does not seem to involve any immediate reference to measure, and pertains especially to art: the prefabrication and imposition of an effect.

German culture, maybe in an effort to exorcise a familiar ghost, has devoted particular attention to the study and definition of this phenomenon, for which it has invented a new category, that of Kitsch, so precise as to be nearly untranslatable and, as such, known by the same name in every language.[1]

A Stylistics of Kitsch

The sea whispers in the distance, and in the enchanted silence the wind gently ruffles the stiffened leaves. An opaque silken gown, embroidered with gold and ivory, flowed along her limbs, revealing a smooth sinuous neck swathed in fiery tresses. No light yet burned in Brunhilde's solitary chamber; slender palms rose out of precious Chinese vases like dark, fantastic shadows, in the midst of which flashed, white, the marmoreal bodies of ancient, ghostly statues. Barely visible, on the walls, lurked the subdued glimmer of gold-framed paintings. Brunhilde, her hands softly gliding over the keyboard of the piano at which she was seated, was lost in sweet reflection. Thus, music flowed in somber search, like veils of smoke rising out of incandescent ashes, frayed by the wind, swirling and soaring in fantastic tatters, away from the inessential flame. Slowly and majestically the melody rose, bursting into powerful accents, folding back onto itself with the pleading, enchanting, ineffably sweet voices of children and angelic choirs, whispering above nocturnal forests and solitary vales, ample, ardent, fraught with ancient steles, playing through forlorn rural cemeteries. Clear meadows are thus disclosed, the slenderbodied games of spring, while autumn lurks behind an evil old hag seated under a shower of leaves. It will soon be winter; large bright angels, as tall as heaven above the snow, will bow

over the listening shepherds and will sing about the wondrous child of Bethlehem.

A heavenly enchantment, full of the secrets of the holy Christmas, is thus woven around the wintry vale sunk in peaceful slumber, like the faraway song of a harp, estranged by the noise of day, like the secret of sadness singing of the divine origin. Outside, the nocturnal wind caresses the golden house with tender hands, and stars wander through the wintry night.

This passage is not merely a pastiche but a malicious collage by Walther Killy,[2] consisting of six fragments from as many German authors: five renowned producers of literary pulp, plus an "outsider," who I regret to say is none other than Rilke. As Killy points out, it is not easy to trace the composite origin of the passage, since the characteristic that is common to all six fragments is their desire to produce a sentimental effect, or rather, to offer it to the reader once it has already been exhausted, and duly packaged in such a way that its objective content (the wind at night? a girl at the piano? the birth of the Savior?) remains concealed behind its basic *Stimmung*, as a secondary concern. The main intent here is to create a lyrical atmosphere, and in order to do so the authors use expressions that are already charged with poetic connotations, as well as random elements that already possess in themselves the power to excite emotions (the wind, the night, the sea). But this does not seem to be enough for the authors, who, obviously mistrusting the evocative power of each individual word, seem to have stuffed every expression with reiterations so as to protect the effect against any possible leak. Thus, the silence in which the sea whispers will be "enchanted," and the hands of the wind, as if their tenderness weren't enough, will "caress," while the house above which the stars wander will be "golden."

Killy also calls attention to the "fungibility" of the stimulus, its tendency to spread and grow all over the place—in other words, its redundancy. The passage he quotes has all the characteristics of the redundant message, in which one stimulus supports another by means of accumulation and repetition, since each individual stimulus, corroded by lyrical use, might need extra help to achieve the desired effect.

The verbs (whispers, flows, glides, wanders) contribute to stress the "liquidity" of the text (the condition of its lyricism), so that at

every step one has a sense of the transience, the ephemerality of the effect, always on the point of dissolving in its own echo but never allowed to do so.

Killy cites the example of great poets who have occasionally felt the need to rely on lyrical evocation, even if (as in the case of Goethe) this meant grafting verse onto prose in order to suddenly reveal an essential trait of the story which the narrative, articulated according to a certain logic, was unable to express. But with Kitsch, a change of tone has no cognitive function; it merely reinforces the sentimental stimulus, so that, in the end, this sort of episodic insertion becomes the norm.

Given the way in which it articulates itself, like any other artistic communication whose project is not that of involving the reader in an act of discovery but that of forcing him to register a particular effect (in the belief that therein lies aesthetic pleasure), Kitsch would seem to be some sort of artistic hoax, or, as Hermann Broch puts it, "the element of evil in the value system of art." [3]

As an easily digestible substitute for art, Kitsch is the ideal food for a lazy audience that wants to have access to beauty and enjoy it without having to make too much of an effort. According to Killy, Kitsch is largely a petty bourgeois phenomenon, the cultural pretense of a public that believes it can enjoy an original representation of the world whereas in fact it can only appreciate a secondary imitation of the primary power of the images.

Killy seems to be part of that critical tradition which has spread from Germany to a number of Anglo-Saxon countries and which, having defined Kitsch as a petty bourgeois phenomenon, has identified it with the most glaring expressions of mass culture—of an average, consumer culture.

On the other hand, Broch himself doubts whether any kind of art would exist without at least one drop of Kitsch, and Killy wonders whether the false representation of the world offered by Kitsch is, in fact, only a lie, or whether it doesn't actually satisfy man's unquenchable thirst for illusion. And when he refers to Kitsch as "art's natural son," he deliberately lets us suspect that the presence of this natural son, capable of producing an effect the moment the consumer demands it instead of venturing into the much more difficult and exclusive production of a much more complex and responsible aesthetic pleasure, may well be essential to artistic life as

well as to the destiny of art in society. Arguments such as these are often based on a rather ahistorical notion of art, for in fact it would be enough to consider the function fulfilled by art in other historical contexts to realize that the fact that a work is capable of producing an immediate effect has never been a reason to exclude such a work from the realm of art. If one is to believe Aristotle, in Greece art had the function of producing a psychological effect; such was, at least, the function of both music and tragedy. Whether in that particular context there was actually another meaning given to the concept of aesthetic pleasure, involving the appreciation of the form through which the effect is realized, is another question. Suffice it to say that in certain societies art is so deeply integrated with daily life that its primary function is precisely that of provoking particular reactions (ludic, religious, erotic) as effectively as possible.

The production of an effect becomes Kitsch in a cultural context in which art is seen not as technical ability (as was the case in ancient Greece and in the Middle Ages) but rather as something produced for art's sake. According to this definition, any process that, using "artistic" means, aims at achieving a heteronomous end would fall under the more generic rubric of an "artisticity" that can assume a variety of forms but that should not be confused with art. No matter how much art I might pour into the creation of a cookie, it will never be anything more than a mere effect of artisticity, since in order to be art (in the noblest sense of the term) it would have to be appreciated for its style rather than desired for its taste.[4]

But what allows us to say that an object whose artisticity seems to have a heteronomous end is by definition in bad taste?

A dress designed so as to enhance the charms of its wearer is not, by definition, a product of bad taste (though it would be if it drew the attention of the viewer only to the more obvious attributes of the wearer, thus reducing her personality to a mere prop for one particular physical trait). But if the production of an effect is not in itself enough to constitute an instance of Kitsch, then something else must be needed. This something else emerges out of Killy's analysis the moment we realize that the passage he has brought to our attention wants to be considered as art. And we realize it because of the way it ostentatiously employs modes of expression that have previously appeared in works traditionally considered as

works of art. In other words, Killy's passage is Kitsch not only because it aims at producing sentimental effects but also because it is constantly trying to convince its readers that if they enjoy these effects, then they will share a privileged aesthetic experience.

To become a piece of Kitsch, a passage needs more than the linguistic factors intrinsic to the message: it also needs the author's intent to sell it to his audience, and the audience's intent to appreciate it. Broch is right when he says that Kitsch does not concern art so much as a certain kind of behavior, or a certain kind of person, a "Kitsch-man" who needs such a form of falsehood so that he can recognize himself in it. If we agree with this, then Kitsch will appear as a negative force, a constant mystification, an eternal escape from the responsibilities involved in the experience of art. As the theologian R. Egenter used to say, the Father of Lies would use Kitsch to alienate the masses from all notion of salvation, because he would recognize it as much more powerful, in its mystifying and consoling power, even than scandals, since these have a tendency to awaken the moral defenses of the virtuous at the very moment in which they are most effectively attacking them.[5]

Kitsch and Mass Culture

The definition of Kitsch as a communication aiming at the production of an immediate effect has certainly helped to identify it with mass culture, and to set it in dialectic opposition to the "high" culture proposed by the avant-garde.

The culture industry appeals to a generic mass of consumers (for the most part quite unaware of the complexities of specialized cultural life) by selling them ready-made effects, which it prescribes along with directions for their use and a list of the reactions they should provoke. This technique is very similar to the one used in the sixteenth century to hawk popular prints. Even then, emotional appeal was the best way to awaken the public's need for a certain product. From the titles of sixteenth-century popular prints to today's slogans, via nineteenth-century romances and popular novels, the procedure has not changed a great deal. As a result, while petty bourgeois and mass culture (both fully industrialized) are more interested in the presumed effects of a work of art rather than in the work itself, artists have moved to the opposite extreme: what they

care about is neither the work nor its effects but the process that leads to both.

According to Clement Greenberg's felicitous formula, "Avant-garde imitates the processes of art; Kitsch imitates its effects," Picasso paints the cause of a possible effect, whereas Repin (an oleographic painter particularly favored by Soviet cultural policy under Stalin) paints the effect of a possible cause. Whereas the avant-garde stresses the importance of the processes that lead to the work and turns them into the very object of its discourse, Kitsch focuses on the reactions that the work should provoke in its audience and sees these as its very *raison d'être*.[6] This definition is very much related to that new stance of contemporary criticism according to which, from Romanticism to our own day, poetry has increasingly assumed the traits of a metapoetry (a discourse on poetry and its potential). As a result, today's poetics are much more important than the works themselves, since, after all, the works are nothing more than discourses on their own poetics, or, better yet, *are* their own poetics.[7]

Greenberg, however, does not seem to realize that Kitsch is not the consequence of a rise in the cultural level of the elite; rather, the opposite is true. The industry of a culture geared toward mass consumption and based on the production of easy effects was born before the invention of print. Popular culture spreads when elite culture is still very much in touch with the sensibility and language of society as a whole. Artists begin feeling a different vocation as the industry of mass culture acquires ascendancy and society is invaded by easily consumable messages. Art begins to elaborate the project of an avant-garde (even though the term may not yet have been coined) when popular novels are satisfying the masses' needs for escape and cultural elevation, and when photography starts fulfilling both the commemorative and the practical functions that were once the province of painting. According to many, the crisis was first felt in the middle of the nineteenth century. As Nadar succeeded in satisfying the bourgeois's need to contemplate his or her own features and bequeath them to posterity, the Impressionist painter was free to experiment outdoors, to paint not what people thought they saw but the very process of perception, the very interaction between light and matter that constitutes the act of vision.[8] It is not by chance that the problematics of poetry about poetry was

already evident at the beginning of the nineteenth century: with the birth of journalism and the diffusion of the popular novel in the eighteenth century, the phenomenon of mass culture became a real threat to poets, who, foreseeing the worst, decided to do something about it before it was too late.

As I have already suggested, if Kitsch were nothing more than a series of messages emitted by the culture industry to satisfy certain demands without palming them off as art, there would be no dialectic relationship between Kitsch and the avant-garde. According to some, to consider mass culture a surrogate for art is a misunderstanding that circumvents the real question. And, indeed, if we considered mass communication to be the intense circulation of a network of messages that contemporary society needs for a complex number of reasons, one of which is the satisfaction of a certain taste, then we would no longer find any relationship—any scandalous contradiction between art and a news broadcast, a TV commercial, a road sign, or an interview with the President.[9] This sort of misunderstanding is common among those who decide to elaborate an "aesthetics" of television without bothering to distinguish between television as a generic medium of information, a service, and television as a specific medium of communication with artistic pretensions. What would be the point of debating whether the effect produced by a road sign, whose purpose is to caution motorists, or by a commercial, which aims at the diffusion of a particular product, is in good or bad taste? This is not what is at issue in either case. In the case of the road sign, the issue is civic and pedagogical; psychological pressure is used in order to achieve an end approved by an entire society, for a situation in which, given the psychological state of the average driver, a more rational message would not suffice. In the case of the commercial, the issue is moral, economic, and political, since it concerns the legitimacy of using psychological pressure in order to make a profit.

But the question of the dialectics between Kitsch and the avant-garde is not solved by eschewing all aesthetic evaluation in favor of more serious concerns such as the ones considered above. Quite the contrary, for not only does the avant-garde emerge as a reaction to the diffusion of Kitsch, but Kitsch keeps renewing itself and thriving on the very discoveries of the avant-garde. While the latter, refusing to serve as an experimental laboratory for an ever-growing

cultural industry, is constantly concocting new forms, the former, relentlessly stimulated by the new ideas of the avant-garde, keeps processing, adapting, and diffusing these according to its commercial standards, in the process changing them from procedural forms which try to direct the audience's attention to the causes of their being, into effect-producing formulas.

From this particular standpoint, the anthropological situation of mass culture would seem to hinge on a perpetual dialectic between innovative ideas and acceptable adjustments, in which the former are constantly betrayed by the latter, since the greater part of the public is convinced that it is enjoying the first, whereas it is actually enjoying the second.

Midcult

But the dialectic between the avant-garde and Kitsch is not nearly so simple as this. Theoretically speaking, the formulation of the problem may appear persuasive enough, but before we accept it we should look at a few concrete cases. Let's examine, for instance, some of the lowest examples of mass culture, such as the production of funerary or votive lamps, porcelain knickknacks representing little sailors and sultry odalisques, comic book heroes, detective stories, B westerns. In all these cases, we have a message that aims at the production of an effect (excitement, escape, melancholy, joy, and so on) and assumes the formative procedures of art. In most cases, the most skillful authors will borrow new elements and unusual solutions from the higher culture. And yet, generally speaking, the addresser of the message does not expect the addressee to consider his communication a work of art; nor does he wish that the elements he has borrowed from the avant-garde be recognized and appreciated as such. He has used them only because he thought they might serve his purposes. This does not mean, however, that in creating his porcelain odalisques he may not have vaguely felt the influence of a decadent movement, or responded to the lure of archetypes ranging all the way from Beardsley's Salomé to Gustave Moreau's; just as, responding to similar references, his customer may well end up placing the knickknack in the middle of his living room as a token of culture, a status symbol, a mark of "higher" taste, etc. But when an adman borrows some avant-garde proce-

dure to pitch a particular drink or a new car model, or when Tin Pan Alley transforms Beethoven's "Für Elise" into a dance tune, the use of the cultural product is meant for a consumption that has nothing to do with, and does not pretend to have anything to do with, an aesthetic experience. On the other hand, it is possible that while enjoying such a product the consumer may catch on to a particular phrase, a stylistic element that has kept some of the original's nobility. Even though he may not know where the phrase comes from, he might enjoy its formal arrangement, its function, and in the process take delight in an aesthetic experience which, however, does not claim to replace other, "higher" experiences. These examples open up a different set of issues (the legitimacy of advertising, the pedagogical and social functions of dance) that have little or nothing to do with the problematics of Kitsch. We are dealing with mass products that aim at the production of effects without pretending to be art.

The keenest critics of mass culture have realized this. And, in fact, they have viewed all such "functional" products as phenomena unworthy of being analyzed (since these phenomena do not concern problems of aesthetics, they can have no interest for the cultivated mind) and have instead turned their attention to a different level of cultural consumption: that of the "middle."

According to Dwight MacDonald, the lowest level of mass culture (which he terms "Masscult") finds in its very banality a deep historical impulse, a savage strength similar to that of the early capitalism described by Marx and Engels. It is a "dynamic, revolutionary force, breaking down the old barriers of class, tradition, and taste, dissolving all cultural distinctions. It mixes, scrambles everything together, producing what might be called homogenized culture . . . Masscult is very, very democratic." (In other words, in its thoughtless functionality, Masscult, even though it might follow the models of the avant-garde, never even bothers to refer to a "higher" culture, nor does it bother its audience with it.)

This is certainly not the case with Midcult, Masscult's pretentious bastard, a "corruption of High Culture, which has the enormous advantage over Masscult that, while also in fact 'totally subjected to the spectator,' it is able to pass itself off as the real thing . . . Midcult has the essential qualities of Masscult—the formula, the built-in reaction, the lack of any standard except popularity—

but it decently covers them with a cultural figleaf." To understand what MacDonald means by "Midcult," it is worth following him in his cruel but keen analysis of Hemingway's *The Old Man and the Sea*.[10]

It is indeed possible to follow the dialectics between Kitsch and the avant-garde just by examining Hemingway's opus: at the beginning, his writing is very clearly a means of discovering reality, but by and by, and despite a seemingly unaltered appearance, it bends to the demands of an audience that wants to have access to such an exciting writer. MacDonald quotes the beginning of one of Hemingway's first short stories, "The Undefeated," a bullfighting story he wrote in the 1920s when "he was knocking them out of the park": "Manuel Garcia climbed the stairs to Don Miguel Retana's office. He set down his suitcase and knocked on the door. There was no answer. Manuel, standing in the hallway, felt there was someone in the room. He felt it through the door." Vintage Hemingway. Only a few words—the situation is rendered through the attitudes of its characters. The theme is that of an old-timer getting one last chance. The beginning of *The Old Man and the Sea* also introduces us to an old-timer getting one last chance:

> He was an old man who fished alone in a skiff in the Gulf Stream and he had gone eighty-four days now without taking a fish. In the first forty days a boy had been with him. But after forty days without a fish the boy's parents had told him that the old man was now definitely and finally salao, which is the worst form of unlucky, and the boy had gone at their orders in another boat which caught three good fish the first week. It made the boy sad to see the old man come in each day with his skiff empty and he always went down to help him carry either the coiled lines or the gaff and harpoon and the sail that was furled around the mast. The sail was patched with flour sacks and, furled, it looked like the flag of permanent defeat.

MacDonald notes that the passage is written in the fake-biblical prose Pearl Buck used in *The Good Earth* ("a style which seems to have a malign fascination for Midbrows"), with all those "ands" replacing the more usual commas so as to lend the prose the rhythm of an old poem. The characters are generic (the boy, the old man) and will remain so till the end to create the impression that

they are not individuals so much as universal values and that there-fore, through them, the reader will undergo a philosophical expe-rience, a profound revelation of reality. " 'Undefeated' is fifty-seven pages long, as against *Old Man*'s one hundred and forty; not only does much more happen in it but also one feels that more has hap-pened than is expressed, so to speak, while *Old Man* gives the op-posite impression." Not only does *The Old Man* proceed unsteadily along the edge of a false universality, but it also frequently relies on what MacDonald calls "constant editorializing" (in other words, it advertises itself). At a certain point in the book, Hemingway has the old man say: "I'm a strange old man," to which MacDonald ruthlessly retorts, "Prove it, old man, don't say it!" It is not difficult to see why this tale appeals to the average reader: it still has the exterior trappings of the early Hemingway (raw, distant), but here they are diluted and reiterated till they are fully digested. The hy-persensitivity of Manuel Garcia, who is by now used to bad luck, is suggested, represented in his feeling, through the closed door, the hostile presence of the elusive impresario. The bad luck of the old man is instead explained to the reader, whose sympathy is nudged by the author's waving in front of his eyes, until they well with tears, that tattered sail that looks like "the flag of permanent defeat" (close kin to the enchanted silence and the subdued glimmer that hover over Brunhilde's chamber in the first quoted passage). On the other hand, no average reader would respond to the persua-sive power of that sail if its metaphor did not bring back to his mind the memory of other similar metaphors, from other poetic con-texts, that have by now become part of the literary canon. Once the mnemonic short circuit is provoked, and the impression of poetic-ity registered and felt, the game is over. The reader is aware of having consumed some art and of having recognized Truth in the face of Beauty. At this point, Hemingway is an author that can be appreciated by everybody, and as such worthy of being awarded the Nobel Prize (which, as MacDonald reminds us, had already been awarded to Pearl Buck).

There are representations of the human condition in which this condition is so universalized, not to say generalized, that what we learn about it can be applied to all sorts of experiences and none at all. The fact that this sort of information is often cloaked in the garb of an Aesthetic Experience only confirms its substantial falsehood.

One remembers Broch and Egenter's references to falsehood, and to life reduced to falsehood. In these cases, Midcult becomes synonymous with Kitsch, in the fullest sense of the term. It assumes the function of pure consolation and becomes the stimulus for thoughtless (acritical) evasions: in short, a marketable illusion. On the other hand, if we accept MacDonald's analysis, we must also be wary of the nuances the problem assumes thanks to his keen intuitions. For instance, not all the characteristics of Midcult always occur together. The passage he quotes is a perfect example of Midcult because: (1) it borrows the avant-garde's procedures and bends them out of shape to create a message that can be understood by all; (2) it borrows these procedures after they have already been amply used, and abused, after they are already quite worn out; (3) it constructs the message as a source of effects, (4) sells it as art, and (5) satisfies its consumer by convincing him that he has just experienced culture.

Do all these five conditions always occur in every Midcult product, or is this example a particularly insidious one? Do we still have Midcult if one of these conditions is absent? In his other examples, MacDonald himself seems to waver between different meanings, each of which involves one or more of the five conditions. An example of Midcult is the *Revised Standard Version of the Bible,* "put out several years ago under the aegis of the Yale Divinity School, that destroys our greatest monument of English prose, the King James Version, in order to make the text 'clear and meaningful to people today,' which is like taking apart Westminster Abbey to make Disneyland out of the fragments." In this particular instance, it is fairly clear that MacDonald is much more interested in the aesthetic product than in the improvement of the masses, in their need or their right to understand texts such as the Holy Scriptures (a need which, once recognized, perfectly justifies the publication of the *Revised Standard Version of the Bible* by the Yale Divinity School). In this particular case, Midcult is identified with popularization (point 1), which is then seen as intrinsically bad.

Another example of Midcult is the Book-of-the-Month Club, because it diffuses works such as *The Good Earth* and therefore passes off as art what is in fact only commercial matter (points 4 and 5). *Our Town,* by Thornton Wilder, is also an example of Midcult, since it borrows the Brechtian technique of estrangement in

order to hypnotize and console the audience, not to invite it to participate in a critical process (point 3). But among these examples of Midcult, MacDonald also includes certain products that have reduced old Bauhaus designs into objects of daily use (point 2)—a fact that really shouldn't irritate the critic since, after all, the designers of Bauhaus meant their designs to be diffused at all levels of society. To this, one could object that, in fact, in their author's intentions, the purpose of these designs was to decorate a completely new social and urban setting, and that therefore to use them as mere objects of consumption, in a totally alien context, deprives them of most of their meaning. But this argument is not enough to dispel our suspicion that what really irritates MacDonald is the idea of popularization. In fact, for him, the dialectic between the avant-garde and Midcult is fairly rigid and unidirectional (the passage from High to Mid involves progressive entropy), nor does he ever question the values of "high" art. In other words, he never seems to doubt that the activities of the avant-garde had profound historical motives, and he does not allow for the possibility that some of these motives may have emerged out of the uneasy relationship between the avant-garde and Midcult. For MacDonald "avant-garde" is synonymous with "high" art, the only domain of value; any attempt to mediate its results must be bad, for the very simple reason that the average man, the citizen of modern industrial civilization who requires such mediation, is beyond help. As a result, in MacDonald's view, the formative methods of the avant-garde become dubious the moment they are understood by a majority, a fact which makes one suspect that MacDonald judges the value of a work not just in terms of its nondiffusion but also in terms of its nondiffusibility. In that case, his critique of Midcult may be nothing more than a dangerous initiation into the game of "in" and "out," whereby the moment something that was initially meant for the happy few is appreciated and desired by many, it loses its value as well as its validity.[11] But this would mean that criticism is replaced by snobbery and that sociology and the awareness of the demands of the masses have an extraordinary, if negative, ascendancy over the taste and the judgment of the critic: he will never love what the average man loves, but he will always hate what he loves. In either case it is the average public that dictates the law, and the aristocratic critic becomes the victim of his own game.

To let snobbery infiltrate an aesthetic sociology of the consumption of forms is quite dangerous. Formal procedures sooner or later become worn out, but who can decide what are the best criteria for judging consumption? The difference between critical sensibility and snobbery is minimal: a critique of mass culture can be the ultimate and most refined product of mass culture, whereas the "aristocrat," who merely does what others don't yet do, in fact depends entirely on what they do to know what not to do. Abandoned to individual moods, particular palates, and value judgments, the critique of taste becomes a sterile game, likely to produce a few pleasant emotions but unable to tell us much about the cultural phenomena of an entire society. Good and bad taste thus become flimsy categories that may be of absolutely no use in defining the complex functionality of a message within a given group or society. Mass society is so rich in determinations and possibilities, that it acquires an immensely elaborate network of mediations and reactions between a culture of discovery, a culture of mere consumption, and a culture of popularization and mediation, none of which can be easily reduced to a simple definition of Beauty or Kitsch.

All these supercilious condemnations of mass taste, in the name of an ideal community of readers involved solely in discovering the secret beauties of the cryptic messages produced by high art, neglect the average consumer (present in just about all of us) who at the end of the day may resort to a book or a movie in the hope that it may evoke a few basic reactions (laughter, fear, pleasure, sorrow, anger) and, through these, reestablish some balance in his or her physical and intellectual life. A well-balanced cultural context does not require the eradication of this sort of message; it only needs to keep them under control, dose them, and see to it that they are not sold and consumed as art.

The Structure of the Public Message

The production of effects and *the popularization of consumed forms:* the definition of Kitsch or of Midcult seems to oscillate between these two fundamental poles. The first refers to a formal characteristic of the message; the second, to its historical "destiny," to its sociological dimension.

The two poles can, of course, be brought together and consid-

ered as two corollary aspects of the same situation. When Adorno speaks of the reduction of the musical product to a fetish[12] —and when he points out that this fate befalls not only the popular song but also the artistic product of nobler origins the moment it is popularized—he is trying to tell us that it is not so much a question of knowing whether, listening to a particular composition, the consumer appreciates a message because of the effects it produces in him, as whether, in fact, he appreciates it because he mistakes its obsolete form for that of the original aesthetic experience. According to Adorno, this distinction does not make any difference, since in both cases the average man's relationship to the commercialized artistic product expresses itself in the blind and thoughtless adoration of the fetish. Unable and unwilling to apprehend either good or bad music analytically, he accepts it as it is, as something that it is good to consume because the law of the market has decreed it to be so, thus relieving him of any need to express his own judgment.

This radically negative criticism, which we have already seen to be unproductive, turns mass consumers into a generic fetish and the object of consumption into another, unexplainable fetish, while totally ignoring the great variety of attitudes present at the level of mass consumption.

Consumption and Recovery of Artistic Messages

Any work of art can be viewed as a message to be decoded by an addressee. But unlike most messages, instead of aiming at transmitting a univocal meaning, the work of art succeeds precisely insofar as it appears ambiguous and open-ended. The notion of the open work can be satisfactorily reformulated according to Jakobson's definition of the "poetic" function of language.[13] Poetic language deliberately uses terms in a way that will radically alter their referential function (by establishing, among them, syntactic relationships that violate the usual laws of the code). It eliminates the possibility for a univocal decoding; it gives the addressee the feeling that the current code has been violated to such an extent that it can no longer help. The addressee thus finds himself in the situation of a cryptographer forced to decode a message whose code is unknown, and who therefore has to learn the code of the message from the message itself.[14] At this point, the addressee will find him-

self so personally involved with the message that his attention will gradually move from the signifieds, to which the message was supposed to refer, to the structure itself of the signifiers, and by so doing will comply with the demands of the poetic message, whose very ambiguity rests on the fact that it proposes itself as the main object of attention: "This emphasis of the message on its own self is called the poetic function." [15] When we speak of art as an autonomous process, as form for form's sake, we are stressing a particular aspect of the artistic message which communication theory and structural linguistics would define as follows: "The set (*Einstellung*) toward the MESSAGE as such, focus on the message for its own sake, is the POETIC function of language." [16]

To this extent, ambiguity is not an accessory to the message: it is its fundamental feature. This is what forces the addressee to approach the message in a different fashion, not to use it as a mere vehicle (totally irrelevant once he has grasped the content it is carrying) but rather to see it as a constant source of continually shifting meanings—a source whose typical structure, begging relentlessly to be decoded, is organized so as to coordinate all the addressee's possible decodings and force him to repeatedly question the validity of their interpretations by referring them back to the structure of the message. [17]

What matters to us here is to prove that the addressees of a poetic message find themselves in a situation of interpretive tension precisely because the ambiguity of the message, by expressing itself as a violation of the code, comes to them as a surprise. From the very start, the decoding of this sort of message appears as an adventure into an unusual, unpredictable organization of signs that no code could have foreseen. Committed to the discovery of the new code (new because never used before, and yet connected to the common code, which it at once upholds and violates) and bereft of the support of any exterior code, the addressees have to rely on their sensibility and their intelligence to construct their own hypothetical code. Their understanding of the work is a result of this interaction. [18]

But once it is understood, introduced into a circuit of constantly enriched perception, the work starts to lose its interest for the addressees, who have gradually grown used to it. The way of forming that was once a violation of the code has become one of its new

possibilities, at least to the extent to which every work of art can modify the cultural habits of a community and render even the most "aberrant" expression acceptable. The poetic message thus ceases to surprise its addressee, who, given his familiarity with it, can now decode it merely by applying to it its most recent interpretation, or a formula that sums it up. Its potential for information has been drained; its stylemes have been exhausted.[19]

This fact should be enough to explain the phenomenon commonly known among sociologists as "the consumption of forms" and to clarify the process by which a form becomes a "fetish"— that is, ceases to be appreciated for what it is or can be and instead comes to be coveted for what it represents, for the prestige it is supposed to convey. To love the *Mona Lisa* because it represents Mystery, or Ambiguity, or Ineffable Grace, or the Eternal Feminine, or because it is a more or less "sophisticated" topic of conversation ("Was it really a woman?" "Just think: one more brush stroke and that smile would have been different!") means to accept a particular message not for itself but because of a previous decoding which, having now stiffened into a formula, sticks to the message like a tag. In this case, we are no longer considering Leonardo's painting as a message whose structure is in itself worthy of appreciation, but as a conventional signifier whose signified is a formula diffused by advertising.

We could then say that the term Kitsch can be applied to any object that (a) appears already consumed; (b) reaches the masses, or the average customer, because it is already consumed; and (c) will quickly be reconsumed, because the use to which it has already been put by a large number of consumers has hastened its erosion. Phenomena such as the *Mona Lisa* embroidered on a pillow would only encourage this interpretation.

However, it is impossible to speak of the consumption of poetic messages the way one would speak of the consumption of ordinary messages. A message such as "Do Not Lean Out the Window," commonly affixed below the windows of most European trains, has been repeated and decoded so many times that by now it has lost all effect. To recover some effect, the message needs to be refreshed, reiterated in a novel fashion—for instance, it could be accompanied by a list of the fines incurred by its transgressors, or

sensationalized by means of an unexpected new formula, such as: "Two months ago, Mr. Jones lost his right eye to a protruding branch as he leaned out of this window."

This is not what happens with the poetic message. Its ambiguity is a constant challenge to the absent-minded decipherer, a constant invitation to cryptanalysis. No matter how popularized, consumed, and fetishized, a poetic message will still find someone who will approach it with, as it were, a virginal mind, even if this means that he or she may interpret it *according to a new code that has little or nothing to do with the one initially intended by the author.*

This sort of "misinterpretation" is an inevitable corollary of the "fortunes" of a work of art through the centuries. The Romantic interpretation of the marmoreal "whiteness" of Greece is a perfect example of a message that has been decoded according to an alien code.

Certainly, the reproduction of a famous classical painting bought as a fetish, a status symbol, a cultural alibi, can work for its Kitsch consumer just as the *Mona Lisa* does on a pillow. On the other hand, it is quite possible that, in the course of his inept perusal, this consumer will bump into an aspect of the work—one of the infinite aspects of its structural complexity—that will unexpectedly offer him a tenuous glimpse of a much richer sort of communication, thereby rescuing the work from the basest form of consumption.

Giorgione's *Tempesta,* appreciated only for its most immediately referential aspects (without any of its iconographic connotations—for instance, the shepherd seen as a handsome youth and not as Mercury), Bruegel's *Hay Wagon* taken merely as the imitation of a hay wagon, Manzoni's *The Betrothed* read only in order to know what is going to happen to Renzo and Lucia, the *Wounded Bison* in the caves of Altamira enjoyed merely as a lively sketch of a moving animal with absolutely no reference to its magic function: all these are examples of a partial decoding, yet are nevertheless capable of bringing the viewer closer to the work by revealing to him, albeit in a rudimentary fashion, a few aspects that were part of the author's intention. Throughout the centuries, the life of artworks has been plagued by such misunderstandings, such misreadings, such crass misconceptions, indeed to the point that they almost seem to be the norm; whereas the exemplary decoding (exemplary not because unique, but because rich, complex, and all-encompassing)

often constitutes the ideal criticism. Which only proves that the consumption of a form is not always total and irreversible. Even the structure that is appreciated for only one of its levels will, given the deep kinship that connects all the stylemes to one another, remain intact in the background, like a lurking presence, the unachieved promise of a potentially fuller appreciation.

On the other hand, if an inexact or incomplete reading impoverishes the message, without however entirely obliterating it, the opposite can also occur: a message containing little information, read in the light of an arbitrary code, can often appear much richer than it was meant to be. When the *Wounded Bison* of Altamira is interpreted according to contemporary aesthetic standards, it will automatically acquire a wealth of intentions that for the most part are *contributed by the addressee*. Most archaeological finds are generally interpreted with the help of references that were totally foreign to their authors: the missing arms and the natural erosions of time become the signifiers of an allusive incompleteness fraught with meanings that have been acquired through centuries of culture but were quite unknown to the Greek artisan. And yet, as a system of elements, the object may have also implied this system of signifiers and of possible signifieds. Similarly, to the eyes of an intellectual in search of local lore, certain forms of popular entertainment can appear charged with a Fescennine obscenity of which the comedian is quite unaware; and yet, in his desire to satisfy the presumed taste of his audience, he might have well included in his show a series of references to archetypal behaviors that still function, and are developed and grasped, instinctively.

What happens to a message that is interpreted by means of an overcharged code is very similar to what happens to the *objet trouvé* that the artist pulls out of context and frames as a work of art: in this case, the artist selects certain aspects of the object as the possible signifiers of signifieds that have been elaborated by his cultural tradition. By arbitrarily superimposing a code on a message that has none (a natural object, for instance) or has a different one (some industrial product), the artist in fact reinvents, reformulates, that message. The question here is whether he is arbitrarily imbuing the object with references culled from an extraneous tradition (that of contemporary art, for instance, by virtue of which a stone may resemble a Henry Moore sculpture, and a mechanical assemblage a

work by Jacques Lipchitz) or whether, in fact, it is contemporary art which, in its ways of forming, has included references to natural or industrial modes of being by integrating elements from other codes into its own.[20]

The addressee's reception can thus alter the informative power of the message. Because of its complex structure, the poetic message retains the power to elicit a variety of decodings. The life of messages caught in the whirlwind of mass production and mass consumption, including the life of the poetic message whenever it is sold as a commodity, is much more varied and unpredictable than we might think in our moments of greatest discouragement. Even the most indiscriminate and naïve superimposition of codes and decodings inevitably involves an exchange between message and addressee that cannot be reduced to a simple scheme—an exchange that will remain forever open to investigation, exploitation, and renewal. It is here that tastes are determined and works are rediscovered, despite the thoughtless brutality of a daily consumerism that seems to reduce every message to sheer noise and to thrive on absent-minded reception.

Kitsch as "Pars Pro Toto" or "Boldinism"

A work of art is a system of relationships among several elements (the material elements that make up the object, the system of references that underlies the work, the system of psychological reactions that the work provokes and coordinates) occurring at different levels (the level of visual or sonic rhythms, the level of plot, the level of ideological content, and so on).[21]

The unifying characteristic of this structure, its aesthetic quality, is that it always appears organized according to a recognizable procedure, "the way of forming" that constitutes the *style* of a work and that reflects the author's personality as well as his or her historical and cultural context.[22] Once it is recognized as an organic work, the artistic structure allows for the identification of stylistic elements that we shall here call *stylemes*. Given the unitary character of the structure, each styleme possesses characteristics that connect it to the other stylemes and to the fundamental structure—so much so, that a styleme is enough to suggest the structure of the entire

work, just as it is always possible to reconnect a severed limb to a mutilated statue.

The successful work of art becomes a model and invites imitation. This can occur in two different ways. In the first case, the work of art offers itself as the concrete example of a particular way of forming which may inspire other artists to elaborate their own personal stylistic procedures. In the second case, the work of art provides a whole generation of exploiters with the stylemes necessary to evoke the characteristics of a particular context even after they have been extracted from it (if nothing else, as mere mnemonic aids, so that when a consumer recognizes a given styleme he will instinctively remember its origin and attribute its former success to the new context).

Art is often much too complex for the average consumer, who has only so much time to devote to it. At best, he will be able to appreciate only its most obvious features, or to interpret it according to some formula, the pale ghost of a previous interpretation. So why not help him out by providing him with fragmentary stylemes that have proved particularly effective? If Poe's "tintinnabulation of the bells" has had a strong impact on the collective mind, then why not employ it to advertise a detergent? No matter how successful it is, the ad will never be considered as an aesthetic experience.

Stravinsky's work is full of classical citations, which, openly acknowledged as such, become crucial elements of his compositions, to be reckoned with in any interpretation. This is also the case with collages and "polymaterial" collage paintings, in which the various items that are attached to the canvas are meant to refer back to their origins.

But one of the most salient characteristics of Kitsch is its inability to fully assimilate a citation into a new context. The borrowed styleme sticks out of its new context (which is too shaky to support it, too diverse to integrate with it) like a sore thumb, and yet it is never acknowledged as an intentional citation. Quite the contrary, it is palmed off as the real thing, an original invention. This is why I would like to define Kitsch in structural terms, as a styleme that has been abstracted from its original context and inserted into a context whose general structure does not possess the same characters of homogeneity and necessity as the original's, while the result is proposed as a freshly created work capable of stimulating new experiences.

We find a typical example of this sort of procedure in the work of a painter justly famous with the average public of his time: Giovanni Boldini.

Boldini was a well-known portraitist, a ladies' painter, the creator of portraits that have earned their owners prestige and pleasure. In other words, Boldini's art was in demand. The beautiful woman (be she noble or simply a member of the haute bourgeoisie) who commissions her portrait is not interested in acquiring a work of art; what she wants is a flattering reminder of the indisputable fact that she is a beautiful woman. To achieve this end, Boldini constructed his paintings by the book, with the specific intent of producing the desired effect. The naked parts of his women are painted according to all the canons of a refined naturalism: pleasantly plump, suggestively creamy, teasingly flushed. Their lips are full and wet, their flesh eminently touchable; the look in their eyes can be sweet, daring, malicious, or dreamy, but it is always straightforward, keen, and fixed on the viewer. These women do not evoke an abstract idea of beauty, nor do they turn it into a pretext for formal digressions; they represent specific women, to such an extent that the viewer will end up desiring them. Cléo de Mérode's nudity is meant to excite; Princess Bibesco's shoulders are offered to the desire of the viewer; Marthe Regnier's sex appeal invites direct contact.

But the moment Boldini moves on to paint the clothes of these women, the moment he moves from the cleavage to the corset, and from this to the folds of the skirt, and from these to the background itself, he abandons all pictorial gastronomy to venture into the realm of art: the contours are no longer as precise, the colors glance off the canvas in luminous strokes, things are blobs of paint, objects melt in the light. The lower portion of Boldini's paintings is impressionistic. Here he is clearly trying to be avant-garde, quoting from contemporary painting. If the upper part of his paintings is sheer gastronomy, the lower part is art. Those desirable throats and faces rise out of a pictorial corolla that is there only to be looked at. The client need not feel ill at ease for having been displayed as a courtesan: the rest of her figure aims only to please the spirit, to provoke a purer kind of appreciation, to produce a higher form of enjoyment. Both client and viewers are reassured: not only can they experience art, but they can also respond to it with their senses,

which was not so easy to do with Renoir's impalpable women, or with Seurat's asexual silhouettes. The average consumer consumes his own lie.

But he consumes it as an ethical falsehood, a social falsehood, a psychological falsehood, since in fact it is a structural falsehood. Boldini's paintings are a perfect example of a context that is unable to assimilate the borrowed stylemes. The formal disproportion between the upper and lower parts of his paintings is indisputable. His women are stylematic sirens, to be consumed from the waist up and looked at from the waist down. There is absolutely no formal reason why the painter should change his style as he moves from the face to the feet. The only possible explanation here is that clearly the face was painted to satisfy the demands of the client and the clothes to satisfy the ambitions of the painter, if it weren't for the fact that even the clothes are painted to satisfy the clients, if nothing else by reassuring them that only a respectable face could possibly emerge from such a commendable dress.

The term Kitsch does not apply only to the kind of art that aims at producing an immediate effect; other forms of art, and other respectable activities, have a similar aim. Nor does it simply designate a formal imbalance, since that is a characteristic of most ugly works. Nor does it refer only to the kind of work that has borrowed stylemes which have previously appeared in a different context, since this can happen without lapsing into bad taste. Kitsch refers to the kind of work that tries to justify its provocative ends by assuming the garb of an aesthetic experience, by palming itself off as art.

At times Kitsch can occur, as it were, unawares, as an unwitting and almost pardonable error. These cases are particularly interesting because they display a very obvious mechanism.

Let's take the example of Edmondo de Amicis, a minor Italian author who has unconsciously succeeded in turning a Manzonian styleme to laughable effect. The "borrowed" styleme concludes a famous passage in Manzoni's story of the nun of Monza. The pages that precede it give a lengthy account of the terrible events that have led Gertrude to embrace the wrong vocation. Having succeeded in taming her rebellious nature, she has now resigned herself to being a nun. Or so the reader thinks, until suddenly Egidio makes his unexpected, and fatal, appearance on the scene: "One of his win-

dows overlooked a small courtyard which formed part of Gertrude's quarters. Noticing her once or twice as she passed through the courtyard, or strolled idly round it, he found the difficulty and the wickedness of the enterprise an attraction rather than a deterrent and plucked up his courage to speak to her. The poor wretch answered."[23] Pages and pages of criticism have been devoted to the lapidary efficacy of the last sentence: "La sventurata rispose." The sentence is extremely simple—three words, an article, an adjectival noun, and a verb —and yet, for all its concision, it manages to tell readers all they need to know about Gertrude's response, the complexity of her character, and the author's own moral and emotional response to it. The word "sventurata" is at once a condemnation and an apology; in its role as subject of the sentence, it defines both the character and her entire life, past, present, and future. The verb is anything but dramatic: "rispose"—"answered." It informs us generally about her reaction without telling us anything about the tenor of her answer or its intensity. But this is precisely the reason the sentence is so powerful, so expressive in its suggestion of the abysses of wickedness that that simple gesture implies and discloses—the gesture of a nun who, we now realize, was only waiting, albeit unconsciously, for a spark to explode into rebellion.

The sentence occurs at the right moment, to conclude a lengthy accumulation of details with a funereal note that strikes us as an epitaph. A marvelous example of stylistic economy. Was Edmondo De Amicis aware of it while he was writing one of the most memorable pages of his book *Cuore*? Maybe not, but the analogy is there and deserves some attention. Franti, the bad boy who has been expelled from school, returns to his classroom accompanied by his mother. The headmaster does not send him away because he feels sorry for the woman. She's disheveled, bedraggled, sopping wet. But obviously the author does not think these details are sufficient to produce the desired effect. So he has the poor woman launch into a heart-rending speech, interspersed with loud sobs and exclamation points, in which she tells the headmaster her sad story— violent husband and all. As if this were still not enough, fearing that the reader may still fail to get the picture, the author then wallows in a short description of the woman's exit: she is pale and bowed, her tattered shawl drags on the floor, her head trembles, she can be heard coughing all the way down the stairs.

At this point, as may well be expected, the headmaster turns to young Franti and tells him "with earth-shaking vehemence, 'Franti, you are killing your mother!' Everybody turned to look at Franti. And that rascal smiled." The styleme that concludes this passage is very similar to that used by Manzoni. "E quell'infame rispose": here, too, we have an adjectival noun as the subject and a verb in the past tense. But this is as far as the similarity goes. Given the context in which it appears, this phrase has an altogether different import. First of all, it occurs precisely at the moment the reader is expecting a *coup de théâtre,* both to put an end to the scene and to provide some relief to his overwrought emotions. Second, the adjectival noun that represents the subject is so loaded with condemnation that it becomes almost comic when compared to the boy's actual misdeeds. And third, the verb "smiled" is not nearly so allusive and ambiguous as Manzoni's "rispose." Franti's smile, at this particular point, is the evidence of his cruelty. It says everything there is to say and as definitely as it could be said. This sentence, unlike Manzoni's, does not lead anywhere. This is the way melodrama ends, and shows how a successful styleme can be wasted and corrupted into Kitsch. The only mitigating circumstance in De Amicis's case is that he may have done it unintentionally.

When the intention is obvious, then we have a flagrant example of Kitsch, the kind of Kitsch that is typical of Midcult. Kitsch is Cubism applied to sacred art, as if a geometric Madonna were more appealing to modern taste than its Renaissance counterpart. Kitsch is the winged figure that adorns the hood of a Rolls Royce, a Hellenistic touch meant to evoke the prestige of an object that should instead obey more honest aerodynamic and utilitarian criteria. Kitsch is the Volkswagen beetle that flaunts the hood of a Rolls Royce or the stripes of a swanky sports car. Kitsch is the transistor radio with an inordinately long antenna, quite useless to its reception but necessary to its prestige. Kitsch is the sofa with a chintz cover reproducing Van Gogh's *Sunflowers,* a tea set bearing the effigy of Botticelli's Venus, a bar with decor à la Kandinsky.

The Malayan Leopard

Between the poetic message that invites the reader to enjoy the pleasure of discovery and the Kitsch object that imitates the discov-

ery of pleasure, there are several other kinds of messages, from the ones intended for mass consumption—with no artistic aims or presumptions—to artisanal messages which are meant to stimulate various kinds of experiences and aesthetic emotions and which, in order to attain their ends, borrow methods and stylemes from avant-garde art and then insert them, though without vulgarizing them, into a mixed context aimed at producing various effects as well as at creating an interpretive experience. Because of this double function, such a message can often acquire a particular structure and fulfill a useful task. Between this kind of message and a real poetic message there is the same difference that Elio Vittorini finds between "consumer goods" and "means of production." But often a message that aspires to a poetic function, though it may satisfy the fundamental conditions of this type of communication, reveals a certain imbalance, some structural instability, whereas the message that aims solely at honestly pleasing its public, at being a marketable commodity, often achieves a nearly perfect balance. This indicates that, in the first case, despite the clarity of its intentions, the work is a failure, or at least only a partial success, whereas in the second case we have such a successful commodity that the consumer can even appreciate the perfection of its structure; the commodity has managed to revitalize old stylemes in an effective manner. In this instance, we have a singular phenomenon of recovery whereby a commodity becomes a real work of art which can propose, for the first time in a stimulating fashion, certain ways of forming that others had unsuccessfully tried before. Thus, we have a dialectic between a kind of art that aims at producing original experiences and another kind that aims at the establishment of acquired procedures; in this dialectic it is often the latter that fulfills the fundamental conditions of a poetic message, whereas the former is only a courageous attempt at fulfillment.

Of course, each case deserves a thorough critical investigation. Once again, aesthetic thought can define the optimal conditions for a communicative experience but cannot judge particular cases.

All I wanted to do here, however, was stress the gradations which, within the same circuit of cultural consumption, allow us to distinguish between works of discovery, works of mediation, commodities, and pseudo-artworks—in other words, between avant-garde culture, Masscult, Midcult, and Kitsch.

To further clarify these distinctions, let's look at four examples from literature. In the first, Marcel Proust describes a woman, Albertine, and the impression she makes on the narrator, Marcel, the first time he sees her. Proust is not trying to whet the appetite of his reader; rather, he is looking for a new way to broach an old situation. The subject is banal (the meeting between a man and a woman and the man's response to it), but Proust wants to elaborate a new approach to banal events.

To begin with, he refuses to stake everything on a description of Albertine. Instead, he shows her to us little by little, not as an individual but rather as part of an indivisible whole, a group of girls whose features, smiles, and gestures keeps fusing into a continuous stream of images. To reinforce this sense of fluidity, he uses an impressionistic style in which, even when he describes "un ovale blanc" ("a pallid oval"), "des yeux noirs" ("black eyes"), "des yeux verts" ("green eyes"), the somatic information loses all power of sensual evocation to become one note in a chord (and, in fact, he sees the group of girls as an ensemble "confus comme une musique où je n'aurais pas su isoler et reconnaître au moment de leur passage les phrases, distinguées mais oubliées aussitôt après" ("confused as a piece of music in which I should not have been able to isolate and identify at the moment of their passage the successive phrases, no sooner distinguished than forgotten"). It is difficult to cite passages from this description precisely because it stretches over a number of pages and cannot be reduced to a nucleus of representations; it slowly brings us to recognize Albertine, but always with the feeling that our attention, as well as that of the author, might have missed its real aim. The reader fends his way through the images as one would through a jungle; he is not as struck by the "joues bouffies et roses," ("plump and rosy cheeks") and the "teint bruni" ("dark complexion") as he is surprised at his inability to distinguish even one desirable face among the girls, who "mettaient entre leurs corps indépendants et séparés, tandis qu'ils avançaient lentement, une liaison invisible, mais harmonieuse comme une même ombre chaude, une même atmosphère, faisant d'eux un tout aussi homogène en ses parties qu'il était différent de la foule au milieu de laquelle se déroulait lentement leur cortège" ("established between their independent and separate bodies, as slowly they advanced, a bond invisible but harmonious, like a single warm shadow, a single

atmosphere, making of them a whole as homogeneous in its parts as it was different from the crowd through which their procession gradually wound").

Of course, if we chose to analyze all the expressions one by one, we would find all the elements necessary to make up a fragment of Kitsch, but Proust's adjectives are never aimed at a precise object, and even less at exciting a precise emotion; nor do they create a vague aura of lyricism, because, though the reader is invited to untangle the web of impressions that the passage offers him, he is also constantly expected to dominate these impressions, to be at once receptive and critical, and never to abandon himself to the personal feelings evoked by the context, since they must remain, above all, the feeling of the context. At a particular moment, Marcel is struck by the brown eyes of one of the girls, by the "rayon noir" ("dark ray") that strikes him and troubles him. But the impression is immediately countered by a reflection: "Si nous pensions que les yeux d'une telle fille ne sont qu'une brillante rondelle de mica, nous ne serions pas avides de connaître et d'unir à nous sa vie" ("If we thought that the eyes of a girl like that were merely two glittering sequins of mica, we should not be athirst to know her and to unite her life to ours"). Just a momentary halt, and then the discourse continues, no longer to refuse the emotion but rather to comment on it, to delve into it. Our reading is never allowed to follow a single thread. The passage refuses to hypnotize us. Its suggestiveness is not meant to fascinate us but rather to spur us into interpretive activity.[24]

But if, instead of being described by Marcel, the meeting were described by an honest artisan for a public eager to be charmed, troubled, soothed, and hypnotized, we would have something quite different. This is what happens to Sandokan, the Tiger of Malaya, when, in Emilio Salgari's *The Tigers of Monpracem*, he first meets Marianna Guillonk, better known as the Pearl of Labuan:

> He had barely uttered these words than the Lord was back in the room. He was not alone. Behind him, barely touching the rug, advanced a splendid creature, at whose sight Sandokan was unable to repress an exclamation of surprise and admiration.
>
> She was a girl of sixteen or seventeen, small but slender and elegant, with a superb build, and a waist so slim that a single

hand would have sufficed to encircle it. Her complexion was as rosy and fresh as that of a freshly bloomed flower. Her little head was admirable, her eyes were as blue as sea water, her forehead was incomparably pure and, below this, stood out the sharp outline of two gently arched brows that almost touched.

A blond mane fell, in picturesque disorder, like a rain of gold, over the white corset that covered her breasts.

At the sight of that woman, who looked so much like a child, the pirate was shaken by a shiver that went straight to the bottom of his soul.

No need to comment on this passage: all the mechanisms necessary to produce an immediate effect are there, both in the description of Marianna and in the reaction of Sandokan. On the other hand, this is sheer artisanship with no artistic pretensions; Emilio Salgari never thought he was producing art.[25] All he wanted to do was provide his public with a means of escape, with an attractive dream. His prose needn't be interpreted; it only has to be read. His work is an honest expression of Masscult, too honest to be considered Kitsch. We shall let the pedagogues determine whether the emotions it fosters are good or bad for our youth, or whether its style is appropriate for a respectable high school canon—which generally seems to lean either toward the classics or toward sheer Kitsch.

Let's now take the case of an author with both taste and culture who, out of choice or vocation, decides to provide his public with a product that is at once dignified but accessible, able to produce an effect and yet above the level of Masscult. His approach to the same situation (a meeting between a man and a woman) will be rather ambivalent: on the one hand, he will want to create a character (the woman) capable of stirring the emotions and the fantasy of his readers; on the other, a sense of propriety will bid him control his words by creating a certain amount of critical distance. This is probably how he would describe the meeting between Sandokan and Marianna:

The second lasted five minutes; then the door opened and in came Marianna. The first impression was of dazed surprise. The Guillonk family stood still, their breath taken away; Sandokan could even feel the veins pulsing in his temples. Under

the first shock from her beauty, the men were incapable of noticing or analyzing its defects, which were numerous; there were to be many forever incapable of this critical appraisal.

She was tall and well made, on an ample scale. Her skin looked as if it had the flavor of fresh cream, which it resembled; her childlike mouth, that of strawberries. Under a mass of raven hair, curling in gentle waves, her green eyes gleamed motionless as those of statues, and like them a little cruel. She was moving slowly, making her wide white skirt rotate around her, and emanating from her whole person was the invincible calm of a woman sure of her beauty.

This gastronomic description reveals greater stylistic economy and a better sense of rhythm, but despite the unquestionable *concinnitas* of the passage, absent from the previous one, the communicative procedure is very similar to that used by Salgari. However, the authorial interference in the middle of the passage employs the same styleme used by Proust in the description of Albertine's eyes. It likewise calls into question the effect the author has just suggested. But Proust wouldn't have deigned to write anything so direct and unequivocal, and Salgari would have never been able to moderate his words so cleverly. Giuseppe Tomasi di Lampedusa fits perfectly between the two. The quoted excerpt is in fact a passage from *The Leopard*,[26] in which I have replaced the names of Angelica, the Salinas, and Tancredi with names borrowed from Salgari's book. Angelica's appearance at Donnafugata is structured like the perfect Midcult product, in which, however, the contamination between Masscult stylemes and Hicult allusions does not degenerate into a grotesque pastiche. This passage is not engaged in discovery, as Proust's was, but is nevertheless a perfect example of dignified, well-balanced prose, perfectly suited to the edification of our youth. The borrowed styleme is used with discretion. The result is a commodity that will please without exciting, and that will provoke a certain kind of critical participation without entirely polarizing the attention of the reader onto the structure of the message. Obviously, the passage is not the entire book, but it is an eloquent sample of it. The success of this work is perfectly explained by these structural characteristics, and yet its success would not be enough to define it as either a product of Midcult or of Kitsch. This work is a commodity that also has the advantage of having been

able to tackle a series of sociopolitical issues, which, despite their notoriety, had never reached such a wide readership in such a clear form.

The Leopard is an excellent commodity but not quite a product of Kitsch. No cross-contamination is ever quite so successful as Kitsch, and the thirst for prestige is much more obvious. The following passage is a perfect example of this last category, the basest.

Ray Bradbury, famous among the mid-intelligentsia for being the only science-fiction author to have produced literary works (which in a sense is true, since instead of writing honest sci-fi stories he is always trying to give them the appearance of art by using an explicitly "lyrical" style), once wrote a novella for *Playboy*. As everybody knows, *Playboy* is a magazine that has made its fortune by publishing glossy photos of nude women in more or less enticing postures. Its emphasis is on the excellence of the product it offers, not on its artistic value—an all too common alibi of pornographic publications. To this extent, *Playboy* is not a Kitsch product. Unfortunately, however, *Playboy* has cultural aspirations. Its aim is to be the *New Yorker* of libertines and good-timers, and to this end it invites the collaboration of famous authors who, in the name of tolerance and humor, seldom disdain the improbable combination with the rest of the magazine. Ironically, although *Playboy* seeks this collaboration in order to raise its status and to allay the uneasy conscience of some of its readers by providing them with a cultural alibi ("but it has very good articles"), this is precisely what turns it, as well as the hapless tale of the hapless contributor, into Kitsch. Of course, this is not exactly what happened to Ray Bradbury, since he was already Kitsch to begin with.

Bradbury's novella likewise tells of a meeting between two people. Not between a man and a woman, however, since that situation is obviously much too banal for an author who's so keen on producing "art." So in his story *In a Season of Calm Weather,* Bradbury tells us of the meeting, and the ensuing passion, between a man and a work of art. Bradbury's hero is an American who decides to spend his summer near Vallauris, on the French Riviera, in order to be close to his idol: Picasso. His devoted wife accompanies him. Why Picasso? Because Picasso means art, modernity, and prestige. Because Picasso is very widely known, and because his work, totally fetishized, no longer needs to be interpreted. Picasso is the perfect choice.

One evening, toward sunset, our hero is dreamily strolling along a deserted shore, when, at some distance, he notices a small man busy drawing figures on the sand with a stick. Needless to say, it is Picasso. But our hero does not realize it until, having walked closer, he can see the figures drawn on the sand. Spellbound, he watches the little man draw. He doesn't say a word, doesn't even dare breathe lest the vision vanish. It does, eventually, when, having finished his drawing, Picasso walks away. The lover wants to keep the work, but the tide is rising.

Since a summary cannot possibly do justice to the style of the story, this is what our hero sees as he watches the little old man draw on the sand:

> For there on the flat shore were pictures of Grecian lions and Mediterranean goats and maidens with flesh of sand like powdered gold and satyrs piping on hand-carved horns and children dancing, strewing flowers along and along the beach with lambs gamboling after and musicians skipping to their harps and lyres, and unicorns racing youths toward distant meadows, woodlands, ruined temples and volcanos. Along the shore in a never-broken line, the hand, the wooden stylus of this man bent down in fever and raining perspiration, scribbled, ribboned, looped around over and up, across, in, out, stitched, whispered, stayed, then hurried on as if this traveling bacchanal must flourish to its end before the sun was put out by the sea. Twenty, thirty yards or more the nymphs and driads and summer founts sprung up in unraveled hieroglyph. And the sand, in the dying light, was the color of molten copper on which was now slashed a message that any man in any time might read and savor down the years. Everything whirled and poised in its own wind and gravity. Now wine was being crushed from under the grape-blooded feet of dancing vintners' daughters, now steaming seas gave birth to coin-sheathed monsters while flowered kites strewed scent on blowing clouds . . . now . . . now . . . now . . .
> The artist stopped.

Here again, there's no need for comment. The reader is clearly told what he must see and what he must appreciate—and how—in Picasso's work. Better yet, the passage gives him a quintessence, a summary, a concentrate of Picasso's entire oeuvre, or rather, of the

more facile and decorative period of his oeuvre—which, of course, only serves to make us (or those of us who hadn't yet done so) realize that even Picasso may not have been totally impervious to Kitsch. On the one hand, Bradbury interprets Picasso by means of the purest of codes (for the most part reduced to the cult of the arabesque and a series of facile connections between stereotyped figures and trite emotions); on the other, he constructs his passage by clumsily stitching together a number of stylemes borrowed from the decadents (in it, one can hear faint echoes of Pater, Wilde, the earliest epiphanic Joyce—the bird girl!—and so on) simply in order to accumulate effects. And yet, the main intention behind this message is self-reflexive: the reader is supposed to react to its style, to be awed by an author "who can write so well."

To the Midcult reader, the overall impression will be one of "intense lyrical tension." In other words, the story is not only eminently comestible but also quite beautiful; more than that, it succeeds in conveying a sense of Beauty. The difference between this kind of beauty and that of the nudes that surround it, in *Playboy*, is minimal but significant: whereas the nudes bluntly refer to a reality that not only exists but may also have a telephone number, Bradbury's story tries to cloak its true nature behind the worn veil of "art." Its very hypocrisy is enough to characterize Bradbury's piece as Kitsch.

Conclusion

Thus, we have looked at all the possibilities and found a definition for Kitsch within the context of aesthetics.

Yet let's assume that a reader, excited by Bradbury's novella, would make it his duty to discover Picasso and, confronted for the first time with one of the master's works, would experience something so personal as to quite obliterate the initial literary stimulus, something that would draw him into the world of the painting and compel him to understand the way in which it was formed. Wouldn't this be enough to make us wary of all the theoretical definitions concerning good and bad taste?

The ways of God are infinite, as some would say, forgetting that even illnesses can bring us close to God. But the duty of a doctor is to diagnose and cure them.

We should suspect, a priori, every investigation of mass media that tries to reach a definitive conclusion. Within the anthropological situation of mass culture anything can happen, things can be turned upside down in no time; reception can change the physiognomy of transmission, and vice versa. At times, Kitsch is on the side of the message, at times on the side of the receiver's intention, and, more often than not, on that of the sender who tries to palm his product off for something it is not. Kitsch is Addinsell's *Warsaw Concerto,* with its accumulation of pathetic effects and imitative suggestions ("Hear that? Those are planes dropping bombs"), and its heavy-handed use of Chopin; just as Kitsch is the appreciation of this particular musical passage as described in Malaparte's *La pelle* (The skin). The notes of this fragment are heard during a reunion of British soldiers attended by the author, who at first thinks they are part of a Chopin concerto. He is set straight by one of the officers who, with great satisfaction, informs him that "Addinsel is our Chopin." In this sense, all the music known as "rhythmic-symphonic," because of the way in which it tries to amalgamate dance music with the daring of jazz and the dignity of classical symphonies, produces effects similar to those of Addinsel's piece. But when the composer has a certain knack, he may be able to create a product with a structure so particular as to completely avoid all suspicion of Kitsch and become an acceptable new product, the pleasant popularization of a higher musical universe. Gershwin's *Rhapsody in Blue* is such a piece of music because of the originality of its composition and the freshness with which it translates popular American material into unexpectedly new forms. But the moment this composition is played in a traditional concert hall, by a conductor in tails, for the kind of audience one commonly finds at a classical concert, it inevitably becomes Kitsch because it tries to stimulate reactions that are not suited to either its intentions or its capacities. It is decoded according to an alien code.

Gershwin's dance music, in contrast, will never be Kitsch for the very simple reason that it has always done, and still does, what it set out to do, and does it to perfection. Gershwin never saw his *Lady Be Good* as anything but a means of escape, a stimulus to dance, and that is precisely why he wrote it and how he sold it. At which point one may legitimately wonder whether this kind of escape is conducive to a balanced life, or whether the kind of love

inspired by syncopation is anything more than a superficial flirtation. But this is an altogether different question. If we are ready to accept a situation in which this sort of music is capable of eliciting a particular kind of physiological and emotional excitement, then we have to admit that Gershwin's music fulfills its task both tastefully and appropriately.

Similarly, the above quoted passage from *The Leopard,* very honest in its intention to entertain its public, may seem exceedingly pretentious when it is proposed as a poetic message, as the original revelation of certain aspects of reality that had presumably remained unexplored until its appearance. But in this case, the responsibility of having produced Kitsch is not so much the author's as the reader's—or the critic's, if he is the one who has decoded the message in such a way as to present the mouth with the taste of strawberries, the eyes as green as those of statues, and the nocturnal hue of the hair as the stylemes of a message whose worth resides in the originality of its vision.

Given the spread of mass culture, it would be impossible to say that this sequence of mediations and loans is a one-way street: Kitsch is not the only borrower. Today, it is often avant-garde culture which, reacting against the density and the scope of mass culture, borrows its own stylemes from Kitsch. This is what Pop Art does when it chooses the most vulgar and pretentious graphic symbols of advertising and turns them into the objects of morbid and ironic attention by blowing them up out of all proportion and hanging them on the walls of a museum. This is the avant-garde's revenge on Kitsch, as well as a lesson for it, because in most cases the avant-garde artist shows the producer of Kitsch how to insert an extraneous styleme into a new context without abandoning good taste. Objectivized by a painter, on a canvas, both the Coca-Cola trademark and a comic strip fragment acquire a meaning they did not previously have.[27]

But even here, Kitsch does not waste any time taking its revenge on the avant-garde, by borrowing its procedures and its stylemes for its ads, where once again the only thing that matters is the production of an effect and the display of a higher level of taste. And this is only one episode in a phenomenon that is typical of every modern industrial society, of the rapid succession of standards whereby even in the field of taste every novelty is always the source of a future bad habit.

This is how the dialectic between avant-garde and mass production (which involves Kitsch as well as most products destined for practical uses) reveals both its worrisome rhythm and its possibilities for recovery. But it also allows for the possibility of new procedural interventions, of which the last one that should ever be tried, and the falsest, is the restoration of an apparent adherence to the timeless value of Beauty, which is generally only a cover for the mercenary face of Kitsch.

Series and Structure

Structure and "Series"

In his introduction to *The Raw and the Cooked,* Claude Lévi-Strauss examines the differences between two cultural attitudes which he terms "structural thought" and "serial thought." By "structural thought" he means the philosophical stance that underlies the structuralist method of investigation in the human sciences; by "serial thought" he means the philosophy that underlies post-Webern musical aesthetics—in particular, Pierre Boulez's poetics.

This opposition deserves some attention for two main reasons. First of all, when Lévi-Strauss speaks of serial thought, the object of his polemics is not just the so-called *Neue Musik* but the whole attitude of the avant-garde and of contemporary experimentalism in art as well as in literature. In fact, his critique of serialism is close to the critique of abstract and nonrepresentational painting already sketched in his *Entretiens* —yet another instance of Lévi-Strauss's mistrust for all those art forms presuming to challenge the traditional systems of expectation and formation which Western culture has considered archetypical and "natural" since the Middle Ages. Second, by "structural thought" and "serial thought" Lévi-Strauss means not simply two different methodological stances but two different visions of the world. A detailed analysis of this text is therefore crucial to a proper understanding of the direction structuralism takes when it presents itself as a philosophy.

What are the distinctive features of serial thought? As Boulez defines them, in the essay to which Lévi-Strauss refers:

> Serial thought has become a polyvalent thought process . . . As such, it is in complete contrast to classical thought, according to which form is a preexisting entity and at the same time a

general morphology. Here (within serial thought) there are no preconstituted scales—that is, no general structures within which a particular thought could inscribe itself. A composer's thought, operating in accordance with a particular methodology, creates the objects it needs and the form necessary for their organization each time it has occasion to express itself. Classical tonal thought is based on a world defined by gravitation and attraction; serial thought, on a world that is perpetually expanding.[1]

This hypothesis of an oriented production of open possibilities, of an incitement to experience choice, of a constant questioning of any established grammar, is the basis of any theory of the "open work," in music as well as in every other artistic genre. The theory of the open work is none other than a poetics of serial thought.

Serial thought aims at the production of a structure that is at once open and polyvalent, in music as well as in painting, in the novel as well as in poetry and theater. But the very notion of "open work," the moment it is translated (reasonably, if daringly, as "open structure") entails a problem: Can the instruments provided by structuralism for the analysis of open structures coexist with the notions of polyvalence and seriality? In other words, can one conceive of a series in structural terms? Is there homogeneity between series and structure?

It is significant that, in his text, Lévi-Strauss speaks of "pensée structurale" and not of "pensée structurelle," even though French would have allowed him to use either term. Jean Pouillon, in one of his essays, deals with this semantic nuance and, by so doing, helps us understand how an open work may have nothing to do with the structuralist problematic, and yet refer to it on another level.

In his essay, Pouillon relates the adjective *structurel* to the real configuration of an object as revealed by analysis, and the adjective *structural* to the laws that uniformly govern the various occurrences of structured objects. "A relation is *structurelle* when it plays a determining role within a given organization, and *structurale* when it can manifest itself in several different but equally determining ways within numerous systems."[2] This should make the difference between *structural* and *structurel* quite clear: serial thought produces open-structured (*structurelles*) realities (even when these realities ap-

pear unstructured), whereas structuralist thought deals with structural (*structurales*) laws. As we shall see, they are two fairly distinct areas of research, even though in the end the results of one *must* be translated into the other's terms. But the superficial similarity of the two terms has somewhat confused matters, so that the structuring activities of the avant-garde have often been related to the investigation of structures proper to structuralism. Several rash critics (that is, most cultivated readers and all uninformed ones) have even gone so far as to consider structuralism as the critical or methodological aspect of the artistic activity of the avant-garde. This was often just naïve sophistry: since structuralism is an avant-garde method, then it must be the method of the avant-garde. At other times, however, it was the result of a hasty identification that led some to apply structuralist categories to avant-garde operations, with highly questionable results.

The aim of this chapter is not to separate the area of structuralist interests from that of the avant-garde's artistic effort, but rather to distinguish their respective responsibilities by showing how they involve two different levels of experience. Only after such a clarification will it be possible to envision a language common to both practices.

On the other hand, there were reasons for such a misunderstanding, which may be why, in his introduction to *The Raw and the Cooked*, Lévi-Strauss insists on reminding us that serial thought is a contemporary cultural current that must be carefully distinguished from structuralism precisely because they have so many features in common.

Let's examine, then, how series and structure differ from each other, how they oppose each other, whether their opposition is total or only partial, and whether they should see in each other a demonstration of their respective limitations and an indication of other possible directions.

What are the most important concepts introduced by structuralist methods, following the models proposed by linguistics and, more generally, by communication theory?

(1) *The code-message relation.* Communication occurs to the extent to which a given message is decoded according to a preestablished code shared by both the addresser and the addressee.

(2) *The presence of an axis of selection and an axis of combination.*
Ultimately, these two axes are the basis of the double articulation
of language, since every act of communication takes place when
units of secondary articulation, determined by the selective reper-
tory of the code and endowed with an oppositional value resulting
from their position within the system, emerge out of the choice and
combination of units belonging to the primary level of articulation.

(3) *The hypothesis that every code is based on a more elementary code,*
and that, by retracing an act of communication code by code
through each successive transformation, it might be possible to
reach back to a primary code (formally and logically speaking, an
Ur-code), constituting, by itself, the real Structure of all commu-
nication, all language, all cultural manifestation, all acts of signifi-
cation, from articulate speech to the most complex syntagmatic
chains such as myths, from verbal language to the "language" of
cuisine or fashion.

Conversely, what are the most fundamental concepts of serial
thought?

(1) *Every message calls the code into question.* Every artistic message
is a discourse on the language that generates it. At the extreme,
each message posits its own code; each work is its own linguistic
basis, a discourse on its own poetics, a declaration of freedom from
all those ties that presumed to determine it in advance, the key to
its interpretation.

(2) *The very notion of polyvalence challenges the bidimensional (verti-
cal and horizontal) Cartesian axes of selection and combination.* A series,
qua constellation, is a field of possibilities that generates multiple
choices. It is possible to conceive of large syntagmatic chains (such
as Stockhausen's musical "group"; the "material" ensemble of ac-
tion painting; the linguistic unit extracted from a different context
and inserted, as a new unit of articulation, within a discourse where
what matters are the meanings that emerge out of the conjunction
and not the primary meanings of the syntagmatic unit in its natural
context; and so on)—chains that offer themselves as ulterior in-
stances of articulation in relation to their initial articulations.

(3) Finally, even though it is possible for communication to be
rooted in an *Ur*-code that underlies all cultural exchange, what
really matters to serial thought is the *identification of historical codes in*

order to question them, thereby generating new forms of communication. The main goal of serial thought is to allow codes to evolve historically and to discover new ones, rather than to trace them back to the original generative Code (the Structure). Thus, serial thought aims at the production of history and not at the rediscovery, beneath history, of the atemporal abscissae of all possible communication. In other words, the aim of structural thought is *to discover,* whereas that of serial thought is *to produce.*

Given these differences, it should be easier to understand Lévi-Strauss's objections to serial thought—objections that are perfectly justified from his point of view. Another look at the pages in question should show whether these differences are indeed irreducible or whether in fact it would be possible to find grounds for a mediation that Lévi-Strauss seems to exclude.[3]

Lévi-Strauss's Criticism of Contemporary Art

Lévi-Strauss begins his argument with a comparison between painting and articulate speech:

> If painting deserves to be called a language, it is one in that, like any language, it consists of a special code whose terms have been produced by combinations of less numerous units and are themselves dependent on a more general code. Nevertheless, there is a difference between it and articulate speech, with the result that the message of painting is grasped in the first place through aesthetic perception and secondly through intellectual perception, whereas with speech the opposite is the case. As far as articulate speech is concerned, the coming into operation of the secondary code wipes out the originality of the first. Hence the admittedly "arbitrary character" of linguistic signs . . . Consequently, in articulate speech the primary nonsignifying code is a means and condition of significance in the secondary code: in this way, significance itself is restricted to one level. The dualism is re-established in poetry, which incorporates in the second code the potential, signifying value of the first. Poetry exploits simultaneously the intellectual significance of words and syntactical constructions and aesthetic properties, which are the potential terms of another system which rein-

forces, modifies, or contradicts this significance. It is the same thing in painting, where contrasts of form and color are perceived as distinctive features simultaneously dependent on two systems: first, a system of intellectual significances, the heritage of common experience and the result of the subdivision and organization of sense experience into objects; second, a system of plastic values which only becomes significant through modulating the other and becoming incorporated with it. Two articulated mechanisms mesh to form a third, which combines the properties of both.

It can thus be understood why abstract painting and more generally all schools of painters claiming to be nonfigurative lose the power to signify: they abandon the primary level of articulation and assert their intention of surviving on the secondary one alone.

Lévi-Strauss further elaborates his argument (already sketched in his *Entretiens,* as well as in another structuralist text about serial music, Nicolas Ruwet's essay on Henri Pousseur),[4] by lingering on a few subtle distinctions. Even Chinese calligraphic painting seems to rest on forms that are merely sensible units belonging to the second level of articulation (plastic occurrences, just as phonemes are auditory occurrences devoid of all meaning). But in Chinese calligraphic painting, these units, which seem to be secondary articulations, rest on a preexisting level of articulation, a system of signs endowed with precise meanings that are not completely obliterated by plastic articulation.

The example of calligraphic painting is useful because it allows the argument to shift back from nonrepresentational painting to music; indeed, music, by virtue of its purely sonorous existence, hearkens back to a primary level of articulation created by culture—that is, the system of musical sounds.

This comparison forces Lévi-Strauss to take a stance on another fundamental issue that will become the key to the rest of the argument:

> This is an essential point, because contemporary musical thought, either formally or tacitly, rejects the hypothesis of the existence of some natural foundation that would objectively justify the stipulated system of relations among the notes of the

scale. According to Schönberg's significant formula, these notes are to be defined solely by "the total system of relations of the sounds with one another." However, the lessons of structural linguistics should make it possible to overcome the false opposition between Rameau's objectivism and the conventionalism of modern theorists. As a result of the selection made in the sound continuum by each type of scale, hierarchical relations are established among the notes. These relations are not dictated by nature, since the physical properties of any musical scale considerably exceed in number and complexity those selected by each system for the establishment of its distinctive features. It is nevertheless true that, like any phonological system, all modal or tonal (or even polytonal or atonal) systems depend on physical and physiological properties, selecting some from among the infinite number no doubt available, and exploiting the contrasts and combinations of which they are capable in order to evolve a code that serves to distinguish different meanings. Music, then, just as much as painting, supposes a natural organization of sense experience; but it does not necessarily accept this organization passively.

At this point, Lévi-Strauss begins to define the difference between concrete music and serial music. The very existence of concrete music involves a paradox: if such music retained the representative value of the noises it uses, it would have at its disposal a primary articulation, but since it instead alters those noises in order to turn them into pseudo-sounds, it automatically loses that primary level which would have provided a basis for a secondary articulation.

Serial music, in contrast, elaborates sounds according to a sophisticated grammar and syntax that situate it within the traditional bounds of classical music. Nevertheless, it also lapses into a number of contradictions shared by abstract painting and concrete music. "The serial approach, by taking to its logical conclusion that whittling down of the individual particularities of tones which begins with the adoption of the tempered scale, seems to tolerate only a very slight degree of organization of the tones." Or, to use Boulez's words, serial thought creates the objects it needs and the form necessary for their organization each time it has occasion to express itself. To put it somewhat differently, it abandons the relations that constitute the sounds of the tonal scale, relations that, as Lévi-

Strauss suggests, correspond to the words, the *monèmes,* the level of primary articulation typical of every language aiming at communication. As a result, serial music seems to him to slide toward the heresy of the century (precisely of the century, since, as we have already seen, the debate over serial thought calls into play the totality of contemporary art) in its attempt to construct a system of signs on a single level of articulation.

> The exponents of the serial doctrine will no doubt reply that they have abandoned the first level to replace it by the second, but they make up for the loss by the invention of a third level, which they count on to perform the function previously fulfilled by the second. Thus, they maintain, they still have two levels. We have had in the past the ages of monody and polyphony; serial music is to be understood as the beginning of a "polyphony of polyphonies"; through it the previous horizontal and vertical readings are integrated in an "oblique" reading. But in spite of its logical coherence, this argument misses the essential point: the fact is that, in the case of any language, the first articulation is immovable, except within very narrow limits. And it is certainly not interchangeable. The respective functions of the two forms of articulation cannot be defined in the abstract and in relation to each other. The elements raised to the level of a meaningful function of a new order by the second articulation must arrive at this point already endowed with the required properties: that is, they must be already stamped with, and for, meaning. This is only possible because the elements, in addition to being drawn from nature, have already been systematized at the first level of articulation: the hypothesis is faulty, unless it is accepted that the system takes into account certain properties of a natural system which creates *a priori* conditions of communication among beings similar in nature. In other words, the first level consists of real but unconscious relations which, because of these two attributes, are able to function without being known or correctly interpreted.

In my opinion, this long passage plays on a few sophisms. Its first argument could be restated as follows: serial music is not a language because all language rests on two irreplaceable articulations (that is, the parameters of composition cannot be freely chosen, as serial music pretends they can be; there are words, already

endowed with meaning, and there are phonemes, and that's that—no other solution is possible). Clearly, the argument could be turned around as follows: verbal language is only one form of language, since there are other forms (such as musical language) that are based on other systems of articulation—systems that are freer and capable of different kinds of organization. Pierre Schaeffer answers this argument indirectly but with remarkable acumen in his *Traité des objets musicaux,* when he remarks how, in the *Klangfarbenmelodie,* the optional variant of a previous system, timbre, can assume the function of a phoneme—that is, the function of a distinctive feature, of a significant opposition.[5]

The second argument of the passage goes as follows: the strict and unmodifiable relation between the two levels of articulation is based on a few constants of communication, a few a priori forms of communication—what elsewhere Lévi-Strauss terms "L'Esprit," which, in the final analysis, is none other than the Structure as *Ur*-code. At this point, the only possible answer (which would swing the argument away from what threatens to become structural metaphysics and back within the context of a structuralist method) is this: if the idea of a Code determining all Codes is valid, there is no obvious reason why this should be so hastily identified with one of its historical messages—that is, the system of attractions resting on the principle of tonality—or why the historical existence of such a system should force one to recognize within its parameters the parameters of all possible musical communication.

Lévi-Strauss's objections sound particularly convincing when they give way to emotional appeals:

> Only ideologically can the system be compared to a language, since unlike articulate speech, which is inseparable from its physiological or even physical foundation, it is a system adrift, after cutting the cables by which it was attached. It is like a sailless ship, driven out to sea by its captain, who has grown tired of its being used only as a pontoon, and who is privately convinced that by subjecting life aboard to the rules of an elaborate protocol, he will prevent the crew from thinking nostalgically either of their home port or of their ultimate destination.[6]

On the other hand, confronted by such a cry of alarm (affecting both the listener of serial music and the lover of nonrepresentational painting), one cannot help suspecting that the lament of the structuralist—who should be the administrator of a metalanguage capable of speaking about all historical languages taken in their relativity—is that of the survivor of a historically dated linguistic usage, who, unable to relinquish his own modes of communication, makes the mistake of confusing his own private language with a metalanguage. In other words, he confuses idiolect with metalanguage, a rather awkward move for a semiotician.

But Lévi-Strauss does not hesitate to make this leap: music and mythology are both cultural forms that appeal to mental structures shared by different listeners. And before we have time to agree with this general principle, we are once again face to face with an arbitrary extrapolation: these shared common structures are the same ones that are challenged by serial thought—that is, the structures of the tonal system (as well as of representational painting). Once he has completed this last identification, Lévi-Strauss can draw his final deduction: the fact that structural thought recognizes common mental structures means that it is aware of the series of determinations that act upon the mind, and hence that it is materialistic. Conversely, the fact that serial thought wants to get rid of the tonal system (which represents common mental structures) means that it sets itself up as a conscious product of the mind and an assertion of its liberty, and therefore that it is idealistic. Conclusion:

> [If] in the public mind there is frequently confusion between structuralism, idealism, and formalism, structuralism has only to be confronted with true manifestations of idealism and formalism for its own deterministic and realistic inspiration to become clearly manifest.[7]

Of Generative Structures

For a proper understanding of Lévi-Strauss's arguments and of all their emotional recesses, we must remember how linguistics and ethnological structuralism on one side, and contemporary music on the other, have come to view the question of the universality and determinativeness of the laws of communication.

After centuries of naïve belief in the natural foundations of the

tonal system (the laws of perception and the physiological structure of hearing), music (and, with it, most contemporary arts), availing itself of a more sophisticated historical and ethnographic consciousness, has reached the conclusion that, in fact, the laws of tonality are only the representations of cultural conventions—since different cultures, both in time and space, seem to have conceived of different laws.

Similarly, after modern culture surrendered (following the discovery of America) to the evidence that languages, along with other social systems, differ from population to population and from time to time, structuralism—as well as other linguistic and ethnological schools—is today aiming at the discovery of constant structures, simple, universal articulations capable of generating all the various systems that they underlie.

It is therefore quite logical that whereas structural thought tends to recognize "universals," serial thought prefers to denounce them as "pseudo-universals," mere historical phenomena.

At this point, one should wonder whether these methodological differences reflect distinct philosophical perspectives, or whether in fact they merely represent two different approaches to the same problem.

Let's assume that the notion of a universal structure of communication, an *Ur*-code, is only a working hypothesis. From an epistemological point of view, a solution such as this would eliminate all ontological and metaphysical ambiguity, while, from a heuristic point of view, it would not prevent an analysis of the processes of communication from revealing the presence of such a structure. If this were the case, then serial thought (an activity that involves the production of forms rather than the exploration of their ultimate characteristics) would no longer be threatened by structuralist research—in fact, it would potentially imply it, though without having to be concerned with it. Permanent structures may well underlie all modes of communication, but the aim of a serial technique (technique rather than thought—a technique that may imply a vision of the world, without being itself a philosophy) is the construction of new structured realities and not the discovery of eternal structural principles.

For the time being, however, let's accept the premises of ontolog-

ical structuralism. The structures of communication revealed by linguistic and ethnological research really exist: they are constant, unmodifiable behaviors of the human mind, possibly even the operative systems of the cerebral apparatus, whose own structures are identical in form to those of physical reality. But if this is the case, structural research should try to uncover the deepest structures, the Structure *cujus nihil majus cogitari possit*. Why stop at the structures of tonal music when it would be far more profitable for a scientist to wonder whether in fact there are yet more general structures that include and explain tonal music as well as other kinds of musical logic? Why not think about the deepest generative structures underlying all grammar (including that of tonal music) and all negation of grammar (as implied by atonal music), as well as every selective system that aims at the definition of sounds with distinctive cultural traits in a continuum of noise?

Such research would be precisely what we all expect of a structuralist method, and it would also help explain the historical process that led from Greek, Oriental, and medieval scales to the tempered scale, and from this to the ranges and the constellations of post-Webern music. Nor would it have to waste its time formulating a primary system, such as the tonal; rather, it would have to elaborate a generative mechanism that would underlie every possible opposition of sounds, something like Chomsky's generative grammar.[8]

Lévi-Strauss's pages, instead, give the impression that the main purpose of structural thought is that of opposing serial technique—which is busy making history and producing variations in communication—with preestablished, preexisting structures used as parameters against which to measure the validity of all the types of communication that emerge in opposition to those very parameters. Which is more or less the same as judging a revolutionary gesture according to the standards of the constitution it has violated. The procedure is formally perfect (and, as such, often applied), but historically it is ludicrous. Generally, a scientific investigation is supposed to identify broader parameters that would allow a reciprocal evaluation of both the violated constitution and the revolutionary gesture that has violated it. But all research is inevitably blocked as soon as the system that is opposed is identified with the "immutable nature of things." Such an attitude reminds

one of those who refused to look into Galileo's telescope for fear that it would confuse their ideas, since the Ptolemaic theory of planetary spheres was supposed to constitute the only natural basis for interplanetary "communication." When it clings to views such as these (and only then), Lévi-Strauss's structuralism (and only Lévi-Strauss's) reveals one of its most dangerously conservative aspects. A structuralist methodology that wants to uncover the atemporal abscissae beneath the historical process must wait for particular historical movements to verify whether the structures it has already posited can also explain the present. And particularly so when (and structuralism seems to have become collectively conscious of this tendency) those universal structures are not the result of a total analysis of particular instances, but have been posited as a theoretical model, an imaginary construction that *will have to* explain all the instances to come. It would be quite naïve to refuse a priori all right to life to new modes of communication just because they structure themselves in ways that have not been predicted by theory—a theory that, moreover, was elaborated long before these modes had begun to take shape. Of course, these new modes may well be noncommunicative; on the other hand, it would be wrong not to consider, even if only as a hypothesis, that the theory may not be comprehensive enough. In this case, serialism would call into question every extremely rigid interpretation of the double articulation of linguistic systems, or the belief that all systems of communication are linguistic, or the assumption that all art must communicate.

Without the epistemological rigor mentioned above, it would not be difficult to eliminate the opponent by mere wordplay (such as "Those who are not on our side are not democrats"). This is a strategy Lévi-Strauss does not shun: Since I recognize the presence of determining structures, I am a materialist; since the serialists insist on the possibility of inventing such structures, they are idealists.

If I wanted to affix labels, this is how I would answer: Since Lévi-Strauss believes that beneath every historical process there are natural determining structures, he is a mechanist; and since the serialists admit the possibility that historical evolution might modify, along with the context, the very structures of intelligence and taste, then they are dialectical materialists. But what would be the point?

Yet one should not underrate the importance, within a serial perspective—a perspective that transforms a serial technique into a vision of the world, and therefore into serial thought—of the recognition of the social and historical foundations of codes, the belief that a superstructural act might contribute to change these codes and that every change in the codes of communication entails the formation of new cultural contexts, the organization and continuous restructuration of new codes, and the historical evolution of modes of communication (depending on the dialectic interrelations between a system of communication and its social context). All we need is to remember the correlations posited by Henri Pousseur between the universe of tonal music and an aesthetic of repetition, closure, and cyclicality that involves and reflects the conservative ideology and pedagogy characteristic of a particular political and social structure.[9]

The Illusion of Constants

These observations are applicable whenever the study of cultural phenomena involves the use of structural grids. Of course, a quest for homologies cannot help presupposing the existence of constants. If, as Georges Dumézil reminds us,[10] the triadic representation of one deity is a costume shared by the most diverse populations, we should be aware of it, just as we should know that such a fact may well reflect a permanent need of the human mind—or at least of the religious human mind. But to associate different populations on the basis of the number of gods they have invented rather than, say, on the basis of the attitudes of hate and love they might have toward those gods, already involves a choice motivated by criteria of pertinence. To identify the different ways in which the "spirit" can follow a given norm is neither more nor less important than to identify the different ways in which the "spirit" can break norms and propose new ones.

In a book that studies man as if he were still, at least constitutionally, an ape, Desmond Morris[11] tells us that whenever two primates engage in a battle that is going to draw on their entire potential for aggression, the weaker of the two will eventually signal its desire to surrender (and to calm the aggressiveness of the other) by display-

ing a variety of ritualistic behaviors indicating submission, the most effective of which is that of offering itself sexually.

The same zoologist then notes how such rituals of submission are still quite frequent among humans, even though mostly cloaked under the garb of cleanliness. For instance, what do we do when we want to convince a policeman that he really should not give us a ticket? First of all we admit our guilt, if nothing else to show him we are on his side. Then, we confess our incompetence and, to make sure he knows we are not dangerous, start behaving like idiots: we scratch our chin, rub our hands nervously, stutter. Why? Very simply because we want to show him that our potential aggression is really nothing but another form of weakness and that, in fact, we are perfectly willing to submit to his greater power. How revealing to detect, in the banality of our gestures, the same ancestral behavior signifying surrender. The constant reemerges to denounce the immutability of our primordial instincts.

But if it is important (both to understand our past and to control our present and future) to realize that two such different modes of behavior rest on the same motivation, it is equally interesting to see how the primitive model has evolved to the point of becoming almost unrecognizable.

In other words (and to show how important it is, in any discussion of structural models, to give variants the same importance given to constants), we all have the right to feel intrigued at the discovery that the slight movement of the hand with which we have protested the policeman's ticket reflects and replaces the offering of one's own body to the victorious enemy, but, despite all our structuralist zeal, we also have the right to be struck by how hugely different our meek approach is from such a blatant sexual invitation.

But to return to my initial questions, the objections I have raised do not seem to be enough to assure the victory of serial thought over structural thought. No sooner does one demonstrate how every hypostatization of structural thought finds its own critique in the confrontation with the realities of serial technique (which turn every eternal constant into a historical phenomenon) than one realizes that serial technique itself must be explained (both with regard to its communicative efficacity, and as a valid opposition to the techniques it questions) according to a structural method that can

justify the ultimate parameters to which both old and new forms refer.

The main problem with the structural method (the very term "method" here should indicate that the problem has a solution) is that, in order not to be confused with an antihistorical science, it must constantly avoid any identification between the Structure it seeks and any given series, taken as the privileged manifestation of the universals of communication. Once this ambiguity is removed, the serial method will appear as the other dialectic side of the structural method, the side of becoming as opposed to that of permanence. Series will no longer be a negation of structure; rather, it will be the expression of a structure that questions itself and sees itself as a historical phenomenon—and this not so much in order to deny itself all possibility of research as in order to turn the utopia of an ultimate reality into a regulatory principle for an investigation in progress (which should always push beyond the structure, toward its very basis, toward an ulterior code of which the structure is just a message). In other words, series will be a structure that, recognizing itself as the mere temporal manifestation of an ulterior code, is constantly looking for it within itself, in a state of continuous tension and permanent methodological doubt which alone can produce meaning.

Structure as Constant and History as Process

If Structure is identified with the mechanisms of the mind, then historical knowledge is no longer possible. The notion of a structural unconscious present in every human being as well as in every historical period (retaining both the traits of a historical phenomenon and those of a universal value) can generate only contradictory solutions. The most dramatic example of these contradictions can be found in Lucien Sébag's *Marxisme et Structuralisme*,[12] a valiant attempt at fusing Lévi-Strauss, Lacan, and Marx in a coherent vision of the world.

In this text, the lesson of Lévi-Strauss, laced with Lacanian theory, leads the author to acknowledge the presence of a universal combinatory source underlying every historical culture. Similarly, Dumézil's identification of a theological tripartition in the religious thought of most civilizations leads him to acknowledge "a certain

order . . . independent from the variety of its manifestations," and to discover the only level where "the code can be attained."[13] On the other hand, says Sébag, if at the basis of every civilization there are "primary complexes," why should these be seen as the structures that determine all human expression from the inside rather than as the particular manifestations of human groups that constitute a historian's object of study?[14] This line of thought would allow one to abandon the contradictions of an idealistic structuralism, while recovering the abundance of possibilities inherent in historical development: to identify structures would become the aim of an intellectual activity "that takes apart both causality and relativity to discover its own specific properties."[15] All sociohistorical material could then be submitted to a double reading: on one side, the diachronic study of causes and effects, and, on the other, the synchronic selection of signifying systems that the researcher would no longer consider definitive but instead useful to explain the relationships between different cultural areas at a given moment. This, of course, would in no way invalidate the proposition according to which "all these systems can be considered as so many manifestations, at different levels, of a certain number of operations proper to the human mind" (here "mind" = "unconscious objective laws"). In this case one could also—without having to relinquish a Marxist/historical perspective—study myths independently from the society that has produced them,[16] as "a language that obeys certain laws of which the subjects who utilize them are not conscious."[17] How can one reconcile the emergence of these atemporal structures with the acceptance of historical causality? Simply by believing in historical rationality as "a source of meaning." In other words, the rationality of the historical process would make it possible to trace the systems that manifest themselves in various historical contexts back to unconscious, universal laws, whose very development, like the systems they generate, depends on the same laws. "Marxist analysis always presupposes the possibility of tracing the languages constructed by men back to an original locus, source of every human creation."[18] "Whereas historical science corresponds to the praxis of individuals and groups taken in all their fullness and determinacy, the systems that such a praxis generates at different levels can be considered as the products of the human mind constantly structuring an extremely diversified reality. This is what we must understand."[19]

And this is what Sébag is driving at: "Every society seems to submit to a principle of organization that is never the only one possible, to a reality that can undergo a multiplicity of transformations." All the various messages that are identified can all be viewed in a functional light, and their meanings reflect the social realities that correspond to the interests of that particular society and those particular men.[20] The whole point is to find a level of articulation that would make it possible to understand what I have termed "serial thought" in terms of structural thought, and to consider totality as something that goes beyond the historical structures that can be identified in it. But the project is doomed to failure the moment *historical rationality,* which should make multiple events and readings possible, becomes the objective logic that predetermines facts and one's way of articulating them:

> Intellect in its use as well as in the laws that govern it is as *real* as what it reflects; *and since it is real it takes itself as its own object from the beginning.* As Marx writes, consciousness is not only the consciousness of a reality outside itself but also of its own being. This does not mean that the subject is immediately and intuitively present to itself, but rather implies a system of laws that are not imitated but rather are acquired from and through the progressive use of an intelligence that is coming to grips with a universe of objects. These laws can in turn be transformed into instruments, since the organization of reality, as well as the discovery of the order that underlies it, depends entirely on them; on the other hand, this reality is none other than the very source out of which the intellect draws the meaning of its own logical organization.[21]

What is this reality of the intellect that allows it to evolve substantially so as to form a reality in a state of constant renewal but whose forms, however mutable, always correspond to the original order? Sébag has already answered this question in one of the quoted passages: it is its "resemblance to an original locus."

As it happens, it is precisely the notion of "original locus" that is in opposition to that of "historical process." Or rather, though the theme of the "original locus" assumes a view of history as a continuous chain of events originating from the same place (and for the

time being, the history of thought has failed to provide us with an alternative), the very materiality of the historical process vanishes the moment everything is made to depend on the discovery of their original locus—and philosophy is again turned upside down. On the other hand, it should be remembered that Sébag's "original locus" is not the same as the place of origin of Hegel's dialectic chains, but rather something else. And, just in case the expression he uses were not enough to discourage any philosophical reference, he also adds a note in which he reminds us that the problem of philosophy is not to wonder "What is that which is?" but rather "how to think that which is." Sébag's style is Heidegger's; his philosophy, Lacan's. His last philosophical work, "Myth: Code and Message," [22] abandons all aspiration to keep open the possibility of dialectics and process, and to acknowledge the presence of permanent mental structures by virtue of which "the physical world reveals the organization that transcends it by abandoning itself to our perception." [23]

The original locus, or place of origin, is where Being, masked, reveals Itself in structural events while avoiding all structure. Structure (stable and objective) and process (qua creation of continuously new structures) explode—as should already have happened in Lévi-Strauss—and what is left is no longer structurable.

The Death of the Gruppo 63

I would like to express some personal opinions about an avant-garde movement to which I myself belonged, the "Gruppo 63," a group of writers and critics that set itself up some years ago in Palermo. The fact is, the group is dead. It died in 1969. I cannot talk about a corpse; I can only commemorate it. If I try to discuss what happened, I can only describe events that have already gone down in history: they no longer alarm anybody. They're already packed inside the luggage of culture, with a nice tight string round the parcel.

All right, now that Samuel Beckett has had the Stockholm treatment, the word "avant-grade" can hardly keep its meaning. We can't use it in the same way the heroes and giants used it at the beginning of the century, men like Apollinaire and Breton, Marinetti and Mayakovsky.

The decease of the Italian neo-avant-garde was possibly the last and bravest act that a *soi-disant* literary avant-garde group can perform in this day and age, certainly since May 1968. All the time while our French friends at *Tel Quel* were trying to put together Maoism, the French communist party, and a "théorie subversive de l'écriture," their Italian counterpart has wallowed in a Machiavellian cynicism and a total disregard for literature (in a civilization which has always had a literature, but never a high priesthood of letters) which has allowed them to adjust Apollinaire's eleventh-hour plea: "Have pity on us, soldiers battling constantly at the frontiers of the limitless future, have pity on our failings, on our sins!" so that the prayer becomes: "Have pity on us; from now on society is opening all the gates of the future to us, providing we don't disturb it too much in the present. Help us to see how we can sin a little again, how we may follow Stephen Daedalus' plan and recover the use of

cunning, silence, and exile, compounding a mistake, even a great mistake, a lifelong one lasting perhaps as long as eternity."

So what can we say about the Italian avant-garde of the 1960s? What angle can we examine it from? From a sociologically oriented view of Italian literature? The country which boasted the first avant-garde in the twentieth century, Futurism, and then transformed it into a propaganda machine for early Fascism, and was subsequently careful to nurse arrière-garde movements which were quite possibly anti-Fascist but certainly literary-reactionary—this same country, Italy, produced a set of artists lost in adoration of the word, the page, the ultimate solitude of the creator faced by his writing; at least Italy can take credit for cremating the ideology of writing as an Empyrean Absolute.

Look, shall we try taking a *Reader's Digest* sociological stance? This gives us a bizarre avant-garde with high-ranking celebrants like Sanguineti, a university professor working on Dante like a medieval monk, together with the director of an important publishing firm, the manager of a department in Italian Radio, a journalist on an important daily newspaper, the head of publicity at a major machine-tool company. An avant-garde of university professors, charging up and down the peninsula from one congress to the next, living out of a suitcase and writing their notes in sleeping cars. Oh, other people have suggested this as some kind of denigration, but I myself offered it prophylactically as part of my advance commemoration, because that's how things were: the Italian avant-garde was the cultural sickness of the generation of consumer prosperity.

So all this led to an avant-garde accused by the high priests of the Establishment of being an Establishment itself, but one which wanted to destroy the existing Establishment with Establishmentarian methods. An avant-garde which has been accused of being a secondary appendage of neo-capitalism, and earned the hostility of all those writers who relied on being contributors to the *Corriere della sera* to cultivate their image, and worked out their revolutionary impulses from inside the safe protection of the grant-dispensing industrial complex. For years this avant-garde had been attacked by official communists, those chorus-masters of socialist realism, on the grounds that it constituted the extreme tactic of the formalist right. But the same people, after 1968, realized that it constituted

the extreme tactic of Chinese extremism, and it was very funny to see the official weeklies of the Party quite recently exhorting their younger enthusiasts not to neglect literature and formal values, not to plunge too naïvely into the political adventure of the *prise de la parole.*

Perhaps the most sensible way to approach the history of our group (or to write its funeral eulogy) would be to sketch a generational history of what went on: at the beginning of the last decade a certain number of writers, critics, and scholars—already linked by similarities in their intellectual formation and reading, in their objectives and shared rejections—decided to hold periodic meetings to discuss the problems which exercised them, publish books together, and set up a sort of "front." The group was not an organ for the expression of rebellion on the part of young untested writers who would have suffered at finding themselves excluded from power at the edge of the system. The majority of the group's members were already inside the system and shared in its power right from the opening meeting at Palermo in 1963. Their problem was precisely the definition and analysis of this power which they had been forced to wield.

I say "forced" because that constitutes a specific generational phenomenon. The group gathered together writers who had been formed in the fifties—the years of the great peace, the two so-called "white decades"—at a period when university struggles took place inside the comfortable womb of representative organizations and the individual could choose whether to submit to party bureaucracy or commit himself to a personal cultural specialization. But even the personal cultural choice (which meant taking stock of the new dimensions of an industrial society, of the new systems in communication, hence of the whole new dimension of superstructural processes) condemned these young theorists to a type of invisible integration. We had just graduated from college and did not need to fight too hard to earn a living. And so people used to ask us if we would like to do TV programs in the same way the nineteenth-century Bohemian anarchist student was offered proofs to check or aristocrats' sons to take out for walks.

The Gruppo 63 was born because certain people, working inside established institutions, had made a different choice, both on the front of cultural politics and on that of culture as a political act. On

the former front, the project consisted of blowing up the invisible structures of the "tiny clique" which governed culture. To do this, we had to criticize this literary club's self-masturbatory hermaphrodite machinery, for it constituted a basic power group. We had to pour ridicule on to the whole system of literary prizes, which witnessed aspiring candidates who go out walking the evening before the jury meets, with an electrocardiogram chart in hand and a groping plea to the judges. "You see, I've not got long to live, give me one last chance . . ." All in all it was hardly a profound development, but at least it had an immediate importance. Since we started out from a position of power, it ought to be pretty clear that we hardly ran any risk. We were unloading a surplus which no longer attracted us, and which even caused us a sense of contagion and shame. Certainly we threw away a number of possibilities by acting like this, but it hardly left us begging on the streets. We haven't exactly been what you might call heroes.

On the second front (culture as a political act) the operation was more complex and far-reaching. The goal was to proceed, by way of a criticism of the *miniature system* of official culture, to a critique of the *grand system* of bourgeois society. This had to be carried on without losing sight of the existing status quo. At that time the international situation was "frozen" in a state of peaceful coexistence, while the national political scene was "frozen" in a crucial dilemma: adherence to the Center-Left, or passive rejection of the Center-Left? Since we had inherited and grown up in a field of exclusively cultural possibilities, there was no direct way we could affect root structures. Of course, there were certain political choices open to us, movement toward one particular party rather than another. But these were only individual decisions which did not reach out to commit all of us.

In fact, only one path was open to us: we had to call into question the grand system by means of a critique of the superstructural dimension which directly concerned us and could easily be administered by our group. Hence we decided to set up a debate about language. We became convinced (and nobody has gone back on this idea) that to renew forms of communication and destroy established methods would be an effective and far-reaching platform for criticizing—that is, overturning—everything that those cultural forms expressed.

At all events, we had one clear idea: if one was moving toward a point of total rupture at the level of literature, art, and philosophy—at that level of "culture" which constitutes the global communication by which a society continues to exist—it was absolutely no use to "communicate" our plans by way of known and tested *media;* on the contrary, we had to smash the very *media* of communication. This was the "poetics" of the Gruppo 63—and the single common aim at the heart of a group of writers who each had their own private axe to grind anyway.

Immediately in this kind of sociological sketch, in these initial reflections about a poetics and an ideology, an inevitable question comes to mind: In what sense did the new avant-garde differ from or match the historical one? Perhaps we can take Renato Poggioli's valuable study *Teoria dell'arte d'avanguardia* and try to trace the recurring features in movements of the avant-garde down through history:

1. Activism	Adventure; Aktion; Sturm; Excitement
2. Antagonism	Antitradition; Bloodymindedness; Opposition to other movements
3. Nihilism	Terrorism; Scourge of institutions
4. Demagogism	Self-propagandizing; I'm the king of the castle
5. Cult of youth	Production; Creation; Rejuvenation
6. Cult of modernity	Futurism; No more Latin in class
7. Games	Dada; Let the children have their fun
8. Self-sacrifice	The individual dies to allow the rebirth of another
9. Revolutionism	
10. Domination of the opus by its poetics	

Of all these elements, apparently only numbers 9 and 10 were present in our avant-garde.

Nanni Balestrini's aim, in his organization and public relations work, was to use the periodic meetings of the Gruppo 63 to forge a model of literary activity which could terrorize the Establishment. The image projected by these young writers who met in public, after the fashion of the German *Gruppe 47,* to discuss their work in progress without necessarily giving each other support, in fact quarreling and tearing themselves to pieces with unimaginable fe-

rocity, was an image calculated to strike terror into the hearts of all but the bravest. I myself heard an established Italian novelist, for example, express alarm at the idea of violating his solitude as a writer faced by the blank page and coming down with us to Palermo to talk about uncompleted pages. However, if we allow some of the theoreticians to express their views, we shall see that the terrorist attitude gradually gave way to a more measured assessment of the historical situation and generational opportunities that faced the group.

Guglielmi: "At the present moment there is no reason for avantgarde activity in the historical sense of the term. What we need at present is a new critical conscience. Terrorism itself is reactionary. We have the advantage of being in a state of absolute availability (what Marcuse would have called repressive tolerance), so what gates should we break through, since all gates are open to us?

"Contemporary culture is in the same situation as a city from which the enemy have retreated after sowing every street with mines. Of course, one is not going to march into the city like some conquering hero and then get blown to bits like an idiot. It's a better plan to send in reconnaissance patrols equipped with geiger counters. Better take an experimental attitude.

"How can we approach the situation? For a writer there's only one approach: language. For language is not detached in any way from the historical reality of a situation. The anonymous stereotyped language typical of modern Italy, a language which hasn't developed from an evolution of dialects, but in fact represents the percolation downward of mass media communications, is one which acutely reflects a social condition. It mirrors an alienation which the writer can only fight against by working with signs and language rather than things and contents."

Giuliani: "The measure of poetry for us consisted in the degradation of meanings and in the constantly shifting physiognomy of the verbal world into which we were plunged.

"These were the years of restoration in which Lampedusa's *The Leopard* seemed to have reinjected Italian culture with a taste for grandiose reflection on history in the Romanesque manner. The world was justified by way of language.

"Let's be quite clear about one thing: language as a means for the representation of reality is by now a machine gone out of control,

an instrument that needs to see a psychiatrist. So it will have to transfer itself inside the very heart of reality by using its concrete form to imitate the actual processes that go on inside a situation which language cannot judge from the outside but submits to judgment by the way it chooses to articulate itself. In other words, if language is prepared to stay on the outside of reality, it must understand that its way of describing it is neither objective nor unchallenged. So language must be prepared to place between reality and itself a series of filters and lenses, the schizophrenic arc of humor. Who are its master-performers in this sense? Pound, Joyce, Beckett, Musil, Proust, Picasso. So you can see what kind of avant-garde we are dealing with: one whose main task was to recover their literary fathers and at the same time kick out against their own brothers when they were too closely linked with their grandfathers, as if they were the trustees of some kind of legacy."

Fausto Curi: "Neo-capitalist society has accepted the avant-garde poet. The avant-garde poet has accepted neo-capitalist society. The image of the harassed *poète maudit* is becoming more and more unusual. Nowadays avant-garde artists have accepted order and society both to the extent that they have radicalized the demystification of Bohemian *mauditisme* and taken it to its extreme logical conclusions, and also insofar as historical materialism has made them aware that the effectiveness of disorder is in strict proportion to its ordered distribution."

Anyone will notice the hint of arrogance in this contradiction, the lack of any integrity in this form of masochistic complaisance. It is easy to detect the clear influence of the negative dialectic preached by Adorno and the Frankfurt school, an influence which began to insinuate itself into Italian culture after the war—that is, well before Marcuse became the prophet and hero of the conflict between the generations. Hence the Marxism of the Italian avant-garde took on more and more of a negative dialectic in its ideological position.

We meet the same attitude, tinged with a Dantesque-cum-medieval apocalyptic Messianism, in the pronouncements of Edoardo Sanguineti, who has grown up on an intellectual diet of classical reading and a Marxism which draws half from Adorno and half from pro-Chinese filibustering. With Sanguineti, dialectic leads to a taste for compromise which is followed through to the

ultimate acceptance of the historical impossibility of rebellion; it gives him a tinge of the gnostic, and at one stage I insinuated this without ever getting a clear refutation of my suspicion. In fact, he gave me a shifty smile when he heard me suggesting it aloud.

For the gnostic Carpocrates, the only way to deliver himself from the tyranny of the angels, lords of the cosmos, was to give in to the worst ignominies they could force on him, in order to find some way of releasing himself from the debts contracted with each one of them. It's only by committing all possible actions that the soul can gain release from action and recover its original purity. By this interpretation, Jesus became the man who came to know all possible forms of evil but was able to triumph over it.

Now, Sanguineti's poetic theory, deriving as it does from a Marxist type of historical judgment, recognizes the existence of a state of alienation which it is the main undertaking of poetry to represent objectively. But poetry can record a historical alienation only by way of its reflection on language, language as a historical depository. The historical exhaustion of language, its ability to play out every variation, though in a deceptive style, its potential evocation of myths which no longer offer us any release—these are Sanguineti's themes, and he brings a prodigious verbal *virtuosité* to play on the double keyboard of an individual nervous breakdown and the collective nervous breakdown of Western history. One must cross the whole rotten swamp of language to reach a subsequent release: *Palus putredinis, Laborinthus,* these are the recurring formulas in Sanguineti's work. Quotations from medieval poets like Benvenuto da Imola and Evrard the German. In this swamp of culture a whole range of alchemical and Jungian symbols seethe like larvas, made up of quotations from Pound, Eliot, and Marx. Sanguineti's language has all the features of High Middle Age pastiche; it achieves a grotesque, tragicomic leveling of any myth that has ever nourished our hope for redemption. The historical avant-garde, with its taste for contamination, multilingualism, scissors-and-paste work, clever collage, and all the rest, in fact attempts to reach its point of no return here. So what is his program?

"Turn the avant-garde into an art for museums, plunge ourselves into the labyrinth of formalism and irrationality, into the *Palus putredinis* of anarchism and alienation, with the hope of really escaping from it, perhaps with dirty hands but certainly with the mud left safely behind us."

If Sanguineti saw the situation as a plunge into the *Mare magnum* of the culture of the past, others in the group took an opposite view: they envisaged their insertion into contemporary reality in its most violent and triumphant manifestation. A close attention to the world of technology has been a constant feature of this neo-avant-garde, just as it had been of the historical avant-garde. However, if the historical avant-garde had seen the use of technical and machine imagery in terms of a symbol of hope, from the Italian Futurists to Russian Futurism, the Gruppo 63 found its meeting with the world of technology (never unequivocal in this kind of love-hate dialectic) positively ironic. There was irony, for example, in the way Nanni Balestrini put together poems by using the flotsam of everyday speech, the detritus of pulp literature, and combining it with scraps and cuttings from the press.

Antonio Porta is a Catholic in a crisis, haunted by the presence of evil, whereas Balestrini is ecstatically obsessed by the presence of printed and spoken nonsense, and Sanguineti is haunted and obsessed, besides being sure that he is able to escape this obsession, by the presence of universal culture as an ideological mask. Porta's technique is a scissoring-up which could be compared to the New Wave of cinema, perhaps to Godard, a process applied to events which are in themselves neutral, part of a traditional poetics, perhaps, but which reemerge from the scissor-work charged with a simultaneously moral and physical menace.

If we take another look at Porta's and Balestrini's publicly stated poetics at the beginning of the sixties, we can detect an attitude that is closely akin to that of Sanguineti (simply transposed into a different key, one might say). This attitude posits a universe which poetry does not set out to judge. Rather, the aim of poetry is to capture and fix it in all its *disponibilité,* its myriad connotations and equivocations, its potential Otherness, its implicit capacity to vouchsafe to the poet something not yet known to him. This is precisely why he can invite the reader to follow him into an open-ended adventure where neither of them enjoys a privileged point of view, neither of them has special messages to transmit, but instead there is a maze of multiple-choice footpaths to enter and cross.

The aesthetic model of the "open work," which I proposed to these poets after they had got me interested in it, was also prompted by similar developments in the field of contemporary music, par-

ticularly the work of Luciano Berio, who eventually produced "musical activities" with libretti by Sanguineti, such as *Passaggio, Laborinthus,* and so on. I thought I could relate this model to a parallel epistemological situation evinced by contemporary physics, which is governed by the principles of indeterminacy and complementarity.

This all went to emphasize the difference between our Italian avant-garde and the cogenerational French avant-garde, which preferred to take structuralism as its operational model. In Italy it would have been impossible to speak of structuralist activity as part of the avant-garde's artistic program, the way Roland Barthes did in France.

Elsewhere I've tried to underline the differences between structuralist thinking and what Lévi-Strauss called "serial thought" in his "Ouverture" to *The Raw and the Cooked.* The musical ideas of a Boulez or a Berio are set in serial thought, and so is Sanguineti's notion of informal poetry and his adoption of the lesson of the New Music. In its own way, seriality is dialectic thought, intellection of the diachronic rather than the synchronic.

A brief discussion should make some of the differences between structuralist thinking and serial thought clear. What are the most important concepts introduced by structural methods following the lesson of linguistic research and the theory of communication in general?

Point 1: the relationship between *code* and *message.* All communication is valid to the extent that its message is decodable by reference back to a preestablished code.

Point 2: the reality of a selective and a combinative axis, which is the ultimate justification of the concept of language's double articulation.

Point 3: the hypothesis that every code, every language, is based on the existence of more elementary codes and that all forms of communication can be traced from one code back to another toward a single unique code, the first. This code is first from the logical and ontological points of view, and constitutes the only real structure of all communication, of all languages, all cultural operations and levels of signification.

What, on the other hand, are the fundamental concepts of serial thought?

Point 1: All messages call into question their code; every act of words constitutes a discussion of the language to which it gives life. In its extreme sense this means that every message postulates its own code, that every work of art is the linguistic foundation of itself, the discussion of its own poetic system. It releases itself from the bonds which previously claimed to define and circumscribe it: every work of art is thus the key for its own reading.

Point 2: Polyvalence: the whole notion of plurality of meaning overturns the Cartesian axes of the vertical and the horizontal, paradigm and syntagm. Series is a clustered constellation offering a field of infinite possibilities and multiple choice.

Point 3: What matters in serial thought is the identification of historical codes and the production of new modalities of communication by calling them into question. The effect of serial thinking is the evolution of codes and the discovery of new codes, not a progressive recoil toward the original foundational code. Series is not an investigation of history aimed at uncovering absolute axes of communication, but simply the permanent transformation of the past, the production of a new ancient history.

(It is obvious that when French Experimentalists came into contact with structuralism, they did not simply experience a static obstacle; by the mediatory stance of Lacan they were enabled to locate the extreme point in a written text where language develops its infinite combinatory resources to create both itself and its users. This also facilitated a linguistic revolution in which Sade is wedded to Saussure in a ceremony where Freud is both bridesmaid and best man.)

Nevertheless, one is bound to admit that the Italian avant-garde messed up its theoretical consciousness of the language problem. Perhaps this was a lucky mistake. Political themes were promoted far more directly and energetically by them. Their critique of language was designed not to be a summary of the existential situation but a critique of the political status quo. A critique of the ultimate structure of all vocabulary was abandoned in favor of the summary of ideology as a term smitten with word-fatigue and arteriosclerosis. This was accompanied by a constant terror that the avant-garde's pet word, "revolutionary," might come down with the same disease.

At the 1965 Palermo congress one of the key-phrases had been: "Emergency: that which was Other is on the way to becoming the

Same." Sanguineti's coup was pulled off: museum culture was on the way to gobbling up the avant-garde.

All this meant that our experimental avant-garde operating from sleeping cars and station restaurants eventually acquired the very attributes of the historical avant-garde which it claimed to repudiate: Activism, Antagonism, Terrorism, Demagogism, Cult of Youth, and Revolutionism. As we shall see, it still lacked the concept of risk through sacrifice. It failed to realize that it had to pass through the valley of death, and thus it gave birth to the journal *Quindici*.

Quindici was born in 1967, initially conceived as a lively magazine with lots of illustrations, halfway between a *Playboy* with a full-length pinup of Gertrude Stein as "playmate of the month" plus the layout of the *New York Review of Books* and a *Sunday Times* weekend supplement specially for university heads of department.

The Gruppo 63 had no trouble finding financial backing for a magazine like this. We belonged to the Establishment, as I have said. But the birth of *Quindici* in fact constituted our first escape pang.

After lengthy discussions, we decided to pay for *Quindici* out of our own pockets and produce it in a bulky unattractive format, without any photography, nothing but columns of print, with extremely long articles, none of them less than five or ten thousand words. The result was something of a success, given the layout and the number of people in Italy interested in problems of literary criticism.

The journal started up with another peculiarity. Literature and books were certainly its primary interest, but it turned out that poets began to analyze the Middle East crisis, linguisticians discussed the Pope's latest encyclical, and novelists explained whom they were going to vote for in the next elections. All this was still a personal authoritarian analysis conducted by a group of writers for their own fan club. Then came the outbreak of student unrest, a few months before France's May 1968. The students of Turin University had occupied their lecture buildings, set up a free university with its own courses, and were exgurgitating a mass of political material which the official news media completely ignored. *Quindici* quickly faced up to its responsibilities: our generation had criticized the previous one for consolidating and embattling itself on its

own conservative positions (in questions of culture even more than politics) without attempting to understand progressive change. The Gruppo 63 had to avoid stumbling into the same pitfalls. By no means all of us were convinced that the students were in the right, or that they had found the best solutions for their problems. But we were all agreed on one thing: that we had to give them a platform for their views. There was a sudden, unexpected escalation of events. *Quindici* became the place where for a long while the budding *groupuscles* could publish their polemic texts before they brought out newspapers of their own. The circulation of the journal increased to four times its original issue, until eventually *Quindici* was being read by very young militants who were not interested in literature at all, but only in politics.

At first this was a supremely amphibious operation. Side by side with programs for a permanent social revolution there continued to come out a series of programs for linguistic upheaval produced by "avant-gardistes" who had by now been absorbed back into traditional postures. In a matter of weeks our own so-called "young" generation had become the generation "in between." So *Quindici* represented an effort to come to grips with this new historical role for the Gruppo 63, and to fulfill it honorably.

In order to fulfill such a role, it was absolutely essential to emerge from the glorious isolation of people who were offering a platform to the young but failing to take an active part in what they had to say. A section of the editorial board took upon itself a kind of examination of our political conscience. We began to ask ourselves what it meant to be writing in the new perspective that had come into being since May 1968.

A series of articles followed. Perhaps their argument could be summarized as follows: the act of *prise de la parole,* by inviting all sorts of different people to scribble on the walls of the Sorbonne perhaps the most beautiful texts of the contemporary artistic-literary avant-garde, robbed real poets of their privileged function as self-elected representatives of language.

Our whole attempt to extricate the structures of language was suddenly unmasked for what it really was: an experimental study of *class* language. We were brought face to face with the real language of factory workers and angry students. The French avant-garde had posed Lacan's question "Who is to speak?" whereas the

problem of the contemporary literary avant-garde in Italy had suddenly become: "Who is one speaking to? How is one to do it? Why? Should one go on speaking (i.e., writing) at all?" Some of the group even began refusing to write at this point. People like Balestrini began to collect and publish documents concerning the working-class movement in factories.

Quindici stumbled on for three more numbers and then committed hara-kiri. At least it achieved the last feature of any avant-garde: sacrifice of self, the Dionysian fantasy of a beautiful death in order that something new might be formed in its stead. In the sixteenth number of *Quindici* I tried myself to list some of the problems facing our avant-garde, if it wanted to transform itself into something new and vital. But the agony had begun without finding an avant-garde ready to submit to it. Many of our friends wanted to go on playing a game that was already over. Maybe they are right today in believing that literature still has something to say. They were wrong, in my opinion, in *those days*. *Quindici* lost its unity. It quit. Hence the end of *Quindici,* split by two irreconcilable hypothetical stances, marked the demise of the Gruppo 63.

In my view, the Gruppo 63 died because it lacked the theoretical energy to state and resolve this whole crisis. However, I believe that it agreed to die because it became aware that to go on living would have made it into an ossified relic. It gives me pride to be able to declare that our death was in fact a suicide.

Notes

1. The Poetics of the Open Work

1. Here we must eliminate a possible misunderstanding straightaway: the practical intervention of a "performer" (the instrumentalist who plays a piece of music or the actor who recites a passage) is different from that of an interpreter in the sense of consumer (somebody who looks at a picture, silently reads a poem, or listens to a musical composition performed by somebody else). For the purposes of aesthetic analysis, however, both cases can be seen as different manifestations of the same interpretative attitude. Every "reading," "contemplation," or "enjoyment" of a work of art represents a tacit or private form of "performance."

2. Henri Pousseur, "La nuova sensibilità musicale," *Incontri musicali* 2 (May 1958): 25.

3. For the evolution of pre-Romantic and Romantic poets in this sense, see L. Anceschi, *Autonomia ed eteronomia dell'arte,* 2nd ed. (Florence: Vallecchi, 1959).

4. See W. Y. Tindall, *The Literary Symbol* (New York: Columbia University Press, 1955). For an analysis of the aesthetic importance of the notion of ambiguity, see the useful observations and bibliographical references in Gillo Dorfles, *Il divenire delle arti* (Turin: Einaudi, 1959), pp. 51ff.

5. Edmund Wilson, *Axel's Castle* (London: Collins, Fontana Library, 1961), p. 178.

6. Pousseur, "La nuova sensibilità musicale," p. 25.

7. J. Schérer, *Le "Livre" de Mallarmé: Premières recherches sur des documents inédits* (Paris: Gallimard, 1957). See in particular the third chapter, "Physique du livre."

8. Werner Heisenberg, *Physics and Philosophy* (London: Allen and Unwin, 1959), ch. 3.

9. Niels Bohr, in his epistemological debate with Einstein; see P. A. Schlipp, ed., *Albert Einstein: Philosopher-Scientist* (Evanston, Ill.: Library of Living Philosophers, 1949). Epistemological thinkers connected with

quantum methodology have rightly warned against an ingenuous trans-position of physical categories into the fields of ethics and psychology (for example, the identification of indeterminacy with moral freedom; see P. Frank, *Present Role of Science,* Opening Address to the Seventh International Congress of Philosophy, Venice, September 1958). Hence, it would not be justified to understand my formulation as making an analogy between the structures of the work of art and the supposed structures of the world. Indeterminacy, complementarity, noncausality are not *modes of being* in the physical world, but *systems for describing* it in a convenient way. The relationship which concerns my exposition is not the supposed nexus between an "ontological" situation and a morphological feature in the work of art, but the relation between an operative procedure for explaining physical processes and an operative procedure for explaining the processes of artistic production and reception. In other words, the relationship between a *scientific methodology* and a *poetics.*

10. Edmund Husserl, *Méditations cartésiennes,* Med. 2, par. 19 (Paris: Vrin, 1953), p. 39. The translation of this passage is by Anne Fabre-Luce.

11. Jean-Paul Sartre, *L'être et le néant* (Paris: Gallimard, 1943), ch. 1.

12. M. Merleau-Ponty, *Phénoménologie de la perception* (Paris: Gallimard, 1945), pp. 381–383.

13. Ibid., p. 384.

14. On this "éclatement multidirectionnel des structures," see A. Boucourechliev, "Problèmes de la musique moderne," *Nouvelle revue française* (December–January, 1960–61).

15. Luigi Pareyson, *Estetica: Teoria della formatività,* 2nd ed. (Bologna: Zanichelli, 1960), pp. 194ff, and in general the whole of chapter 8, "Lettura, interpretazione e critica."

2. Analysis of Poetic Language

1. Benedetto Croce, *Breviario di estetica,* 9th ed. (Bari: Laterza, 1947), p. 134.

2. Ibid., p. 137.

3. John Dewey, *Art as Experience* (New York: Minton Balch, 1934), ch. 9, pp. 194–195.

4. Dewey has even been accused of idealism. See S. C. Pepper, "Some Questions on Dewey's Aesthetics," in *The Philosophy of J. Dewey* (Evanston and Chicago: Northwestern University Press, 1939), esp. p. 371 et passim. According to Pepper, Dewey's aesthetics brings together two incompatible tendencies: organicism and pragmatism.

5. Dewey, *Art as Experience,* ch. 9, p. 195.

6. Ibid., ch. 4, p. 75.

7. Ibid., ch. 5, p. 98.

8. Ibid., ch. 5, p. 103. Whereby it follows that "the scope of a work of art is measured by the number and variety of elements coming from past experiences that are organically absorbed into the perception had here and now" (ch. 6, p. 123).

9. Ibid., ch. 6, p. 109. Thus, one can say that "the Parthenon, or whatever, is universal because it can continuously inspire new personal realizations in experience" (ch. 6, pp. 108–109).

10. See F. P. Kilpatrick, *Explorations in Transactional Psychology* (New York: New York University Press, 1961).

11. Nicolas Ruwet, "Preface" to Roman Jakobson, *Essais de linguistique générale* (Paris: Editions de Minuit, 1959), p. 21. See also Roman Jakobson, *Selected Writings* (The Hague: Mouton, 1981).

12. Jakobson, *Selected Writings,* vol. 2, p. 556.

13. In the following analysis, I shall often rely on the notions of the *referential* (or *symbolic*) and the *emotive* uses of language; see C. K. Ogden and I. A. Richards, *The Meaning of Meaning* (London: Kegan Paul, Trench, Trubner, 1923; rpt. New York: Harcourt, Brace, 1946), esp. ch. 7. The referential or symbolic use of language implies: (1) that there is a corresponding reality; (2) that the correspondence between the linguistic symbol and reality is indirect—that is to say, mediated by a reference to a concept, a mental image of the real thing. The emotive use of language, instead, relies on the symbol's power to evoke feelings, emotions, intentions. This, of course, does not mean that we make an equation between the emotive and the aesthetic uses of language, or that we make a drastic distinction between its referential and its emotive uses; quite the contrary, as the following pages will clearly show. Occasionally, I shall also use the terms *sign* and *denotatum* proposed by Charles Morris to designate, respectively, the *symbol* and the *referent.* See Morris, "Foundations of the Theory of Signs," in *International Encyclopedia of Unified Science,* vols. 1 and 2 (Chicago: Chicago University Press, 1938); also *Signs, Language, and Behavior* (New York: Prentice -Hall, 1946), ch. 2. The following analysis will also take for granted the subdivision of the speech act into four distinct parts: the *addresser,* the *addressee,* the *message,* and the *code* (which, as we have seen, are not only abstract logical categories but also encompass, and account for, emotive attitudes, tastes, and cultural habits).

14. Jakobson, *Selected Writings,* vol. 3, pp. 18ff. ("Linguistics and Poetics").

15. See Charles Morris, *Signs, Language, and Behavior,* ch. 8. The meaning of a word can be determined by the psychological reaction of the listener: this is what we call its *pragmatic* aspect. Its *semantic* aspect concerns

the relationship between *sign* and *denotatum,* and its *syntactical* aspect the organization of words within a given discourse.

16. See Jakobson, *Selected Writings,* p. 218. "The set (Einstellung) toward the MESSAGE as such, focus on the message for its own sake, is the POETIC function of language." (See also "Linguistics and Poetics," in *Selected Writings,* vol. 3, p. 25.)

17. We can attenuate the rigor of Ogden and Richards's distinctions with Charles Stevenson's conclusions, according to which "the growth of emotive and descriptive [referential] dispositions in language does not represent two isolated processes." In a metaphoric expression, the cognitive aspects of the total discourse affect its emotive aspects. As a result, the descriptive and the emotive meaning of an expression are "distinguishable *aspects* of a total situation, not 'parts' of it that can be studied in isolation." Then, after examining a third type of meaning (neither descriptive nor emotive but rather the result of a grammatical incoherence that produces a sort of "philosophical perplexity"), which he terms "confused meaning" (and here we cannot help thinking of Joyce's ambiguous, open words), Stevenson concludes by saying that "there will be emotive meaning dependent on descriptive meaning . . . but there will also be emotive meaning dependent on confused meaning." See Charles Stevenson, *Ethics and Language* (New Haven: Yale University Press, 1944), ch. 3, pp. 71, 76, 78. The studies of the Russian Formalists have yielded analogous results. In the twenties, Shklovsky and Jakubinsky had classified poetry as an example of the *emotive function* of language. Their point of view was eventually changed thanks to the increasing formalization of poetic expression. In 1925, Tomashevsky had relegated the communicative function of language to the background in order to stress the absolute autonomy of the *verbal structures* and the *laws of immanence* that govern poetry. In the thirties, the Prague Structuralists tried to distinguish a *multidimensional structure* of poetry that included the semantic level. "While a 'pure' Formalist brashly denied the existence of ideas and feelings in a work of poetry, or declared dogmatically that 'it is impossible to draw any conclusion from a work of literature,' the Structuralist would emphasize the inevitable ambiguity of the poetic statement, poised precariously between various semantic planes." Victor Erlich, *Russian Formalism* (The Hague: Mouton, 1965), p. 200.

18. According to Charles Morris, "a sign is *iconic* to the extent to which it itself has the properties of its denotata" (*Signs, Language, and Behavior,* p. 23). This seemingly vague definition is, in fact, quite restrictive: as Morris goes on to explain, a portrait cannot really be iconic, "since the painted canvas does not have the texture of the skin, or the capacities for speech and motion, which the person portrayed has." In fact, Morris sub-

sequently reamplifies his definition by admitting that iconicity is a matter of degree: onomatopoeia may well be considered an excellent example of linguistic iconicity (p. 191), just as one can find iconic characteristics in those poetic manifestations where style and content, matter and form are perfectly in accord (pp. 195–196). In cases such as those, iconicity becomes synonymous with the organic fusion of the elements of a work of art that I have discussed throughout this chapter. In a later work, Morris defines the iconicity of art by stating that "the aesthetic sign is an iconic sign that designates value" ("Science, Art and Technology," in *Kenyon Review* 1 [1939]), since what the addressee seeks in an aesthetic sign is its sensible form, the way in which it reveals itself. René Wellek and Austin Warren characterize the aesthetic sign in a similar way: "Poetry organizes a unique and unrepeatable scheme of words, each of which is at once object and sign and each of which is used in a fashion that no other system could predict" (*Theory of Literature* [New York: Harcourt, Brace, 1942]). Similarly, Philip Wheelwright defines the aesthetic sign as a *plurisign*, the opposite of the *referential monosign*, and insists on the fact that the plurisign is "*semantically reflexive*, insofar as it is a part of what it means" ("The Semantics of Poetry," *Kenyon Review* 2 [1940]). See also Galvano della Volpe, *Critica del gusto* (Milan: Feltrinelli, 1960); according to della Volpe, the poetic discourse is *plurisenso* (polyvocal, whereas the scientific discourse is univocal), by virtue of its *organic* and *contextual* nature.

19. Charles Stevenson insists on the fact that the ambiguity (he uses the term "vagueness") of a poetic message is not limited to the semantic level (as is often the case with ethical terms), but rather extends to its syntactic construction, and, consequently, to the pragmatic level of psychological reaction. Similarly, Jakobson asserts that "ambiguity is an intrinsic, inalienable character of any self-focused message, briefly a corollary feature of poetry. Let us repeat with Empson: 'The machinations of ambiguity are among the very roots of poetry' . . . The supremacy of poetic function over referential function does not obliterate the reference but makes it ambiguous" (*Selected Writings*, p. 238). As for the poetic word, cloaked with every possible meaning, see Roland Barthes, "Y a-t-il une écriture poétique?" in *Le degré zéro de l'écriture* (Paris: Seuil, 1953). These are essentially the same issues raised by the Russian Formalists: "The aim of poetry is to render the texture of words perceptible in all its aspects" (Boris Eikhenbaum, *Lermontov* [Leningrad, 1924]). In other words, for the Formalists the essence of the poetic discourse lay not in the absence of meaning but rather in its multiplicity.

20. *The Divine Comedy: Paradiso*, tr. Charles S. Singleton, Bollingen Series, vol. 80 (Princeton: Princeton University Press, 1975), canto 33, ll. 124–126.

3. Openness, Information, Communication

1. See Stanford Goldman's exhaustive study, *Information Theory* (New York: Prentice-Hall, 1953), as well as A. A. Moles, *Information Theory and Esthetic Perception*, tr. Joel E. Cohen (Urbana: University of Illinois Press, 1966).

2. This definition can be traced back to a principle adopted by linguists, namely that, in phonology, every distinctive feature implies a choice between the two terms of an opposition. See N. S. Troubetskoy, *Principes de phonologie* (Paris: Klincksieck, 1949), esp. pp. 15, 33; Roman Jakobson, *Essais de linguistique générale* (Paris: Editions de Minuit, 1959), p. 104; and G. T. Guilbaud, *La Cybernétique* (Paris: Presses Universitaires de France, 1954), p. 103. As F. Boas has very clearly shown, the choice of a grammatical form by the speaker presents the listener with a definite number of bits of information. To give a precise meaning to a message such as "The man killed the bull," the addressee must choose among a number of possible alternatives. In information theory, linguists have found a privileged tool for their investigation. Thus, the dialectics between *redundancy* and *improbability* in information theory (of which more later) has been measured against the dialectics between *basis of comparison* and *variants*, between *distinctive features* and *redundant features*. Jakobson speaks of a *granulary structure* of language that lends itself to quantification.

3. Max Planck, *Wege zur physikalischen Erkenntnis* (Leipzig: S. Hirzel Verlag), ch. 1.

4. Ibid.

5. Hans Reichenbach, *The Direction of Time* (Berkeley: University of California Press, 1956), pp. 54–55. Unlike Reichenbach, Planck considers entropy a natural reality that excludes a priori all those facts that would seem empirically impossible.

6. Ibid., p. 151.

7. Ibid., p. 167.

8. Norbert Wiener, *The Human Use of Human Beings* (Boston: Houghton Mifflin, 1950; rpt. New York: Avon Books, 1967), p. 31. In short, there is an equiprobability of disorder in relation to which order is an improbable event because it is the choice of only one chain of probability. Once a particular is realized, it becomes a system of probabilities in relation to which all deviation appears improbable.

9. For instance, a sequence of letters randomly drawn from the most probable trigrams in Livy's language will yield a certain number of pseudo-words with an unmistakable Latin sound: *ibus, cent, ipitia, vetis, ipse, cum, vivius, se, acetiti, dedentur.* See Guilbaud, *La Cybernétique*, p. 82.

10. Wiener, *The Human Use of Human Beings*, p. 163.

11. *Penguin Book of Italian Verse,* ed. George Kay (Harmondsworth: Penguin, 1958).

12. R. Shannon and W. Weaver, *The Mathematical Theory of Communication* (Urbana: Illinois University Press, 1949).

13. See Goldman, *Information Theory,* pp. 330–331; and Guilbaud, *La Cybernétique,* p. 65.

14. Shannon and Weaver, *The Mathematical Theory of Communication,* pp. 99–100, 104, 106.

15. Ibid., pp. 101–102.

16. Giuseppe Ungaretti, "L'Isola," in *Life of a Man,* tr. Allen Mandelbaum (New York: New Directions, 1958), pp. 54–55.

17. The Russian Formalists had been dealing with the same question, though not in terms of information, when they came up with the theory of "estrangement," or "defamiliarization" (*priëm ostrannenija*). Extraordinarily enough, Shklovsky's article "Iskusstvo kak priëm" [Art as device]—which he wrote in 1917—already anticipated all the possible aesthetic applications of an information theory that did not yet exist. "Estrangement," for him, was a deviation from the norm, a way of confronting the reader with a device that would frustrate his systems of expectations and thereby draw his attention to a new, different poetic element. In this essay, Shklovsky is mostly concerned with illustrations of some of Tolstoy's stylistic techniques, in which the author describes familiar objects as if he had never seen them before. A similar concern with deviations, and violations, of the narrative norm is also present in Shklovsky's analysis of *Tristram Shandy.*

18. As did the Dadaists, and also Hugo Ball, who, in 1916, at the "Cabaret Voltaire" in Zurich, used to recite poetry in a strange, fantastic jargon. Similarly, certain contemporary musicians like to abandon themselves entirely to the whims of chance. All these, however, are marginal examples whose main experimental value is that they help set certain limits.

19. In other words, the fact that a work of art provides its audience with a certain kind of information certainly helps determine its aesthetic value—that is, the way in which we "read" and appreciate it. This information plays a role in the total system and affects the form of the work. On the other hand, to believe that an analysis dealing exclusively with the informative value of a work might provide a satisfactory evaluation of that work would be somewhat naïve. For an example of such naïveté, see the symposium on "Information Theory and the Arts," in *Journal of Aesthetics and Art Criticism,* June 1959.

20. See *Briefe an H. Jone und J. Humplick* (Vienna, 1959).

21. Weaver, *The Mathematical Theory of Communication,* p. 117.

22. Moles, *Information Theory and Esthetic Perception.* Articles on the

same subject have appeared in various issues of the *Cahiers d'études de radio-télévision.*

23. See *Incontri musicali,* vol. 3 (1959), the exchange between Nicolas Ruwet and Henri Pousseur.

24. Moles, *Information Theory and Esthetic Perception,* pp. 78–79. "There is no absolute structural difference between noise and signal. They are of the same nature. The only difference which can be logically established between them is based exclusively on the concept of intent on the part of the transmitter: A noise is a signal that the sender does not want to transmit." "If the sonic material of white noise is formless, what is the minimum 'personality' it must have to assume an identity? What is the minimum of spectral form it must have to attain individuality? This is the problem of coloring white noises" (p. 82). This is also the problem that confronts the composer of electronic music.

25. This essay was originally written in 1960 for the fourth issue of *Incontri musicali.* The postscript was written six years later. Garroni's critique was entitled *La crisi semantica delle arti* (Rome: Officina Edizioni, 1964), of which ch. 3 dealt with *Opera aperta.*

26. Goldman, *Information Theory,* p. 69.

27. If information theory corresponds to a statistical study of physical phenomena (seen as "messages"), this step will take us toward a *communication theory* that will deal specifically with human messages. The notion of "message" can operate on both levels, though we should not forget Jakobson's objection to much theoretical work in communication: "Attempts to construct a model of language without any relation either to the speaker or to the hearer, and thus to hypostasize a code detached from actual communication, threaten to make a scholastic fiction out of language." Roman Jakobson, *Selected Writings* (The Hague: Mouton, 1981), vol. 2, p. 576.

28. "Knowledge does not create the organization of its message; it imitates it to the extent that it is true and effective. Reason does not dictate its laws to the universe; rather, there is a natural harmony between reason and universe, since both obey the same general laws of organization." P. Guillaume, *La psychologie de la forme* (Paris: Flammarion, 1937), p. 204.

29. "Several facts show that the perceptual interpretations of primary sensorial data are remarkably plastic, and that the same material, under given circumstances, may elicit very different reactions." H. Pieron, in *La Perception,* a symposium volume (Paris: Presses Universitaires de France, 1955), p. 11.

30. R. S. Lillie, "Randomness and Directiveness in Evolution and Activity in Living Organisms," *American Naturalist* 82 (January–February, 1948): 17.

31. J. P. Kilpatrick, "The Nature of Perception," in *Explorations in Transactional Psychology* (New York: New York University Press, 1961), pp. 41–49.

32. "In perception, as well as in intelligence, nothing can be explained in terms of experience alone, and yet nothing can be explained without recourse, more or less substantial depending on the situation, to current or prior experience." Jean Piaget, in *La Perception*, p. 21. See also Piaget, *Les mécanismes perceptifs* (Paris: Presses Universitaires de France, 1961), p. 450: "The reason for the interactions between subject and object seems to be quite different from the one the founders of Gestalt theory have borrowed from phenomenology. The notion of a perceptual equilibrium suggested by facts is not the same as that of a physical field with a precise, automatic balance of the forces involved; rather, it entails active compensation on the part of the subject who is trying to moderate exterior disturbances."

33. Jean Piaget, *La psychologie de l'intelligence* (Paris: A. Colin, 1947), chs. 1 and 3.

34. Piaget, in *La Perception*, p. 28.

35. Piaget, *La psychologie de l'intelligence*, ch. 3. For a probabilistic study of perception, see *Les mécanismes perceptifs*, where, after distinguishing between the operative processes of intelligence and those of perception, Piaget maintains that between the two "there is in effect an uninterrupted series of intermediaries" (p. 13). Experience itself occurs as a "progressive structuration and not as a simple reading" (p. 443).

36. Leonard Meyer, *Emotion and Meaning in Music* (Chicago: University of Chicago Press, 1959).

37. This theory of emotions is clearly borrowed from Dewey, as is the notion of a perfectly *fulfilled cycle* of stimuli and responses, of crises and solutions: it is the notion of *experience* (ibid., pp. 32–37).

38. See H. Cantril, *The "Why" of Man's Experience* (New York: Macmillan, 1950).

39. Leonard B. Meyer, "Meaning in Music and Information Theory," *Journal of Aesthetics and Art Criticism* (June 1957); idem, "Some Remarks on Value and Greatness in Music," ibid. (June 1959). Quotation is from "Meaning in Music and Information Theory," p. 418.

40. In the polemic with Pousseur (see *Incontri musicali*), Nicolas Ruwet (analyzing the notion of the musical *group* in light of linguistic methodology, and trying to identify distinctive units within a sonic *group*) notes that some systems of opposition recur in every language because they possess structural properties that make them particularly apt for that usage. This fact prompts him to wonder whether, in music, the tonal system does not also possess these same privileged characteristics. In this case, Webern's

tragedy might have originated in his awareness that he was evolving on structurally unstable ground without having either a solid *basis of comparison* or an adequate *system of opposition*.

41. See Henri Pousseur, "La nuova sensibilità musicale," in *Incontri musicali* (May 1958); and idem, "Forma e pratica musicale," ibid. (August 1959).

42. Ombredane's contribution to the symposium volume *La Perception*, pp. 95–98.

43. In answer to Ruwet's criticism (see note 40 above), I shall say that a *system of opposition* can be considered stable only to the extent that it corresponds to fixed and privileged *patterns* of the nervous system. If, on the contrary, these processes can change and adjust according to the evolution of the entire anthropological situation, wouldn't this cause a break in the ideal isomorphic chain that is supposed to join the structures of a language to those of perception and intelligence? And, in this case, wouldn't there arise, between the structures of the language and the structures of the mind, a dialectic relationship in which it would be very difficult to determine what modifies and what is modified?

4. The Open Work in the Visual Arts

1. In his work *Ultime tendenze dell'arte d'oggi* (Milano: Feltrinelli, 1961), Gillo Dorfles defines "informal art" as "a form of abstract art without any will to figurate and with no semantic intention" (p. 53). However, since in this essay I deal with those "open" forms of contemporary art whose organic parameters don't always fit within the traditional notion of "form," I shall use the term "informal" in a much broader sense. This is, after all, the criterion used in the special issue of *Il Verri* (June 1961) which is entirely devoted to "informal art" and which contains contributions by numerous painters, philosophers, and critics, including G. C. Argan, R. Barilli, and E. Crispolti. This chapter, which appeared in that issue, was written before the end of the "season of the informal"—that is, before the various antithetic experiences it discusses (kinetic art and so on) assumed such labels as "op art." This, however, in no way invalidates its analysis of "informal art."

2. Apparently, Gabo's poetics does not fully agree with the notion of the open work. In a letter to Herbert Read written in 1944 and quoted by Read in his book *The Philosophy of Modern Art* (Cleveland: World Publishing Company, 1954), Gabo refers to the absolute character and the exactitude of lines, to images of order rather than of chaos: "We all construct the image of the world as we wish it to be, and this spiritual world of ours will always be what and how we make it. It is Mankind alone that is shaping it

in a certain order out of a mass of incoherent and inimical realities. This is what it means to me to be Constructive" (p. 273). We should, however, compare these statements to what Gabo had said in 1924 in the *Constructivist Manifesto:* order and exactitude are the parameters on the basis of which art reproduces the organicism of nature, its inner formativity, the dynamism of its growth. Though art is an achieved and defined image, through its kinetic elements it still can reproduce that continuous process which is natural growth. Like a landscape, a contour of the earth, or a stain on a wall, the work of art lends itself to various visualizations and reveals an ever-changing profile. Thanks to its characteristics of order and exactitude, art can reflect the mobility of natural events. In other words, it is a defined work that represents an "open" nature. Despite his diffidence vis-à-vis other forms of plastic ambiguity, Read notes: "The particular vision of reality common to the constructivism of Pevsner and Gabo is derived not from the superficial aspects of a mechanized civilization, nor from a reduction of visual data to their 'cubic planes' or 'plastic volumes' . . . but from an insight into the structural processes of the physical universe as revealed by modern science. The best preparation for a true appreciation of constructive art is a study of Whitehead or Schrödinger . . . Art—it is its main function—accepts this universal manifold which science investigates and reveals, but reduces it to the concreteness of a plastic symbol" (p. 263).

3. Ezra Pound was similarly impressed by Brancusi's work: "Brancusi had set out on the maddeningly difficult exploration toward getting all the forms into one form; this is as long as any Buddhist's contemplation of the universe . . . Or putting it another way, every one of the thousand angles of approach to a statue ought to be interesting, it ought to have a life (Brancusi might perhaps permit me to say 'divine' life) of its own . . . But even the strictest worshiper of bad art will admit that it is infinitely easier to make a statue which can please from one side than to make one that gives satisfaction from no matter what angle of vision. It is also conceivably more difficult to give this 'formal satisfaction' by a single mass, or let us say to sustain the formal-interest by a single mass, than to excite transient visual interests by more monumental and melodramatic combinations." "Brancusi," *Literary Essays of Ezra Pound* (New York: New Directions, 1968), pp. 442–443.

4. Besides Munari's famous *vetrini,* one might also consider some experiments of the last generation: for example, the *Miriorama* of the Group T (Anceschi, Boriani, Colombo, Devecchi), Jacov Agam's transformable structures, Pol Bury's "mobile constellations," Duchamp's *rotoreliefs* ("the artist is not alone in accomplishing his act of creation, since the spectator is the one who puts the work in contact with the exterior world by deci-

phering and interpreting its profound qualities, and thus he contributes to the creative process"), Enzo Mari's tranformable objects, Munari's articulated structures, Diter Rot's mobile sheets, Jesus Soto's kinetic structures ("These structures are kinetic because they use the spectator as a motor. They reflect the movement of the spectator as well as that of his eyes. They foresee his capacity to move and solicit his activity without constraining it. They are kinetic structures because they do not contain the forces that animate them, they borrow their dynamism from the spectator," as Claus Bremer notes), Jean Tinguely's machines (which, manoeuvered by the spectators, keep drawing different configurations), and Vasarely's forms.

5. In *L'Oeil* (April 1959).

6. James Fitzsimmons, *Jean Dubuffet* (Brussels, 1958), p. 43.

7. A. Berne-Joffroy, "Les Objets de J. Fautrier," *Nouvelle revue française* (May 1955).

8. G. C. Argan, "De Bergson à Fautrier," *Aut Aut* (January 1960).

9. R. Barilli, *J. Dubuffet: Matériologies* (Milan: Galleria del Naviglio, 1960).

10. Jacques Audiberti, *L'Ouvre-boite* (Paris: Gallimard, 1952), pp. 26–35.

11. Henri Pousseur, "La nuova sensibilità musicale," *Incontri musicali* 2 (1958).

12. See Abraham Moles, *Information Theory and Esthetic Perception* (New York: Prentice-Hall, 1953) p. 82, as well as the section "Information, Order, and Disorder," in Chapter 3 above.

13. In Herbert Read, *The Tenth Muse* (London: Routledge and Kegan Paul, 1957), pp. 297–303.

14. "Jean Dubuffet ou le point extrême," *Cahiers du musée de poche* 2: 52.

15. See Renato Barilli, "La pittura di Dubuffet," in *Il Verri* (October 1959), in which he also refers to Dubuffet's *Prospectus aux amateurs de tout genre* (Paris, 1946)—in particular, to the section titled "Notes pour les fins-lettrés."

16. See Palma Bucarelli, "Jean Fautrier: Pittura e materia," *Il Saggiatore* (Milan, 1960), for an analysis (p. 67) of the constant opposition between the effervescence of matter and the limits of the outline, as well as for the distinction between the suggested freedom of the infinite and the anguish caused by the absence of a limit, considered as negative to the work. P. 97: "In these *Objects,* the outline is quite independent from the blotch of color, which nonetheless exists: it is something that goes beyond matter, that indicates a space and a time—in other words, something that frames matter in the dimension of consciousness." These critical readings are limited to the works in question, and they do not provide a categorial system valid

for every kind of "informal" experiment. In cases where there is no dialectics between outline and color (I am thinking of Matta, Imai, or Tobey), our investigation would have to follow a different course. In Dubuffet's later work, the geometric subdivisions of the texturologies no longer exist, but we can still search the canvas for the suggestion of a direction and a choice.

17. An example of this relationship between *iconographic* meaning and *aesthetic* meaning already exists in classical figurative art. The iconographic convention is an element of redundancy: an old bearded man flanked by a ram and a child is—according to medieval iconography—Abraham. The convention *insists* on both the character and his personality. Erwin Panofsky cites the example of Maffei's *Judith and Holofernes;* see Panofsky, "Zum Problem der Beschreibung und Juhaltsdeutung von Werken der bildenden Kunst," *Logos* 21 (1932). The woman represented in this painting is holding a tray on which rest, side by side, a head and a sword. The first item could lead the viewer to think she is Salomé, but according to Baroque iconography Salomé is never represented with a sword. On the other hand, Judith is often represented carrying Holofernes's head on a tray. Another iconographic element will further facilitate the identification: the expression of the beheaded is more like that of a wretch than like that of a saint. The redundancy of the elements casts more light on the meaning of the message and conveys some quantitative information, however limited. But this quantitative information, in turn, contributes to the aesthetic information of the canvas, to one's appreciation of the composition, and to one's judgment of the artistic realization. As Panofsky notes, "Even simply from an aesthetic point of view, the painting will be judged in a completely different way depending on whether it is seen as the representation of a courtesan who is carrying the head of a saint or as that of a heroine, protected by God, who is holding the head of a sinner."

5. Chance and Plot

1. On the mechanics of (individual) improvisation, see W. Jankelewitch, *La Rhapsodie* (Paris: Flammarion, 1955).

2. Aristotle, *Poetics,* 1451a, 15. The quotation is taken from *Aristotle, Horace, Longinus: Classical Literary Criticism* (Harmondsworth: Penguin, 1965), p. 42.

3. Dewey, *Art as Experience* (New York: Minton Balch, 1934), pp. 35–36.

4. According to this definition, an experience is the predication of a form whose ultimate objective causes remain unclear.

5. Aristotle, *Poetics,* 1451a, 30, p. 43

6. Ibid., 1459a, 20, pp. 65–66.

7. See Luigi Pareyson, *Il verisimile nella poetica di Aristotele* (Torino, 1950).

8. Dewey, *Art as Experience*, p. 38.

9. See Luigi Pareyson, *Estetica: Teoria della formatività*, 2nd ed. (Bologna: Zanichelli, 1960), chs. 2 and 5.

10. This attitude involves the disposition of parts in relation to a whole that does not yet exist but that already gives a direction to the process. This sort of "wholeness," which leads to its own discovery within a circumscribed field, recalls the Gestalt model. The event that is going to be narrated prefigures itself by determining the very act that is supposed to lend it a form. Except that—as transactional psychology would point out—this wholeness can be attained only through a series of choices and limitations that will inevitably betray the personality of the "author" at the precise moment in which he submits to the very wholeness he intuits. This wholeness, once attained, will appear as the realization of a subjectively intuited objectivity.

11. See Joseph Warren Beach, *The Twentieth-Century Novel: Studies in Technique* (New York: Appleton-Century, 1932).

12. See F. Ferguson, *The Idea of a Theater* (Princeton: Princeton University Press, 1949; Anchor Books, 1953); and H. Gouthier, *L'oeuvre théâtrale* (Paris: Flammarion, 1958), ch. 3, "Action et intrigue."

13. Naturally, life resembles *Ulysses* more than *The Three Musketeers*, but we prefer to think of it as the other way around.

6. Form as Social Commitment

1. All the quotations from Marx come from *Economic and Philosophical Manuscripts* (1844), "Critique of Hegel's Dialectic and General Philosophy," in *Karl Marx: Selected Writings*, tr. David McLellan (Oxford: Oxford University Press, 1977), pp. 101–102, 105.

2. See André Gorz, *La morale de l'histoire* (Paris: Seuil, 1959).

3. See Jean Hyppolite, *Etudes sur Marx et Hegel* (Paris: Rivière, 1955). Hyppolite's notion of alienation, like Gorz's, is based on a rereading of Hegel. In other words, the possibility of alienation is always present in any kind of society, even after the modification of those objective conditions which Marx considered the cause of alienation.

4. Marx seems to be aware of the possible persistence of such a dialectic even after the elimination of "economic" alienation: to establish socialism as the most positive expression of human self-consciousness, and as the realization of a positive reality, communism must first suppress religion and private property. But it is precisely in this negation of a negation that

communism becomes an affirmation: "Communism represents the positive in the form of the negation of the negation and thus a phase in human emancipation and rehabilitation, both real and necessary at this juncture of human development. Communism is the necessary form and dynamic principle of the immediate future, but communism is not as such the goal of human development, the form of human society" (Marx, "Private Property and Communism," in *Karl Marx: Selected Writings*, p. 96). These pages could be read in light of the formulation proposed above: a revolutionary action could eliminate economic alienation by modifying certain social structures, and this could well be the first step toward the elimination of other, persisting, forms of alienation to the object.

5. If I am correctly interpreting what Gianni Scalia says in "Dalla natura all'industria" (*Menabò* 4, p. 96), above and beyond all the contradictions existing between a capitalist society and a collectivist society, what exists today is an *industrial society*, which suffers from many of the same problems as the others, at least at the level of alienation. I realize that some writers (for instance, Raymond Aron) refer to an "industrial society" precisely to deemphasize the opposition between capitalism and collectivism. On the other hand, the notion of an industrial society remains valid and should be kept in mind, even when one respects the classical distinction between the two kinds of economy. This is why all the examples I examine in the following pages have been taken from an industrial society and could be found in *any* industrial society.

6. G. W. F. Hegel, *The Phenomenology of Mind*, tr. J. B. Baillie (New York: Harper Torchbooks, 1967), pp. 665, 666, 667, 676.

7. John Dewey, *Art as Experience* (New York: Minton Balch, 1934), pp. 44–45.

8. For a stimulating defense of the tonal system, see Leonard Meyer, *Emotion and Meaning in Music* (Chicago: Chicago University Press, 1959). For a historical interpretation of the meaning of tonality (in the sense I have proposed), see Henri Pousseur's illuminating essay "La nuova sensibilitá musicale," in *Incontri musicali* 2; and Niccolò Castiglioni's *Il linguaggio musicale* (Milano: Ricordi, 1959).

9. Actually, the problem is much more complex than it might appear from the generalization I have resorted to here for the sake of theoretical convenience, in order to isolate a particular discourse. What I have defined above—with the example of Schönberg, an artist who finds himself at the very beginning of a new musical evolution, at a crucial juncture, and whose validity and good faith are absolutely unimpeachable—is a "model" avant-garde act, the *Ur-avant-garde* (in which *Ur-* indicates not just a chronological order but also a logical one). In other words, my argument would be quite simple and indisputable if, in the course of cul-

tural evolution, there had been only one instance of the avant-garde. But, in fact, contemporary culture is a "culture of avant-gardes." How can we explain such a situation? We can no longer make a clear distinction between a rejected tradition and an avant-garde that proposes a new order, because every avant-garde is the negation of a previous avant-garde, which, however, given its relative contemporaneity, cannot yet be considered as a tradition in relation to the avant-garde that is negating it. Hence, the suspicion that a valid act of *Ur-avant-garde* may often be the stimulus for an avant-garde manner, and that, today, "to be avant-garde" may well be the only way of belonging to a tradition. This situation is often seen as the neocapitalist conversion of artistic rebellion. In other words, the artist is a rebel because the market wants him to be one. Therefore, his rebellion has no real value, since it is only a convention. But on close inspection, it is not difficult to realize that what we are again confronting here, in this "denunciation," is the natural dialectic between invention and manner which has always existed in the history of art. Every time an artist invents a new form that involves a profound change in the vision of the world, he is immediately imitated by a legion of pseudo-artists who borrow the form of his art without, however, understanding its implications. It is precisely because of the inevitability of such a phenomenon, and of its frequency in a civilization such as ours (where things are used up so rapidly and change is so sudden that no novelty is ever new for long) that it is particularly important that every avant-garde action be immediately negated by a newer invention and thus prevented from becoming manner. The combination of these two dialectics produces a constant alternation between apparent innovations, mere mannerist variations on a theme, and real innovations, the negations of these variations. Thus, forms that have been negated by a number of successive avant-gardes often retain a power that the newer ones do not have.

On the other hand, we should also note that if avant-garde methods are often the swiftest and most direct way of confronting and dismantling a declining artistic situation, they are not the only way. Another exists within the very order that is being negated: parody, the ironic imitation of such an order (Stravinsky's alternative to Schönberg). In other words, a worn out, alienating form of expression can be negated in one of two ways: one can dismantle the modes of communication on which it is based, or one can exorcise them via parody. Parody and irony can thus be seen as viable, subtler alternatives to the more common, revolutionary ardor of the avant-garde. There is also a very dangerous, but plausible, third possibility: one can adopt the communicative forms of a particular system in order to question and challenge that very system—critically use mass media to raise the consciousness of that part of the audience which

would only feel negatively provoked by the more destructive and less accessible acts of the avant-garde.

10. As an example I shall cite a situation familiar to any reader who, while visiting a foreign city, has walked into a bar, both to kill time and (with a generally vain, often unconscious hope) to alleviate loneliness. It is difficult to imagine a more unbearable or a more depressing situation; yet we all understand it, and accept it as quite "literary." Why? Because literature has told us that if we sit alone at a bar something will happen to us: a voluptuous blonde may suddenly appear, as in a detective novel, or, as in Hemingway, there may be a subtler but equally inevitable revelation of *nada* in the course of the most banal dialogue. Thus, a squalid, meaningless situation becomes perfectly acceptable thanks to the false glamor cast on it by the application of narrative structures that demand a solution for every premise, an acceptable conclusion and an end for every beginning—since these structures do not allow for a beginning without an end, unlike some other narratives and some movies (Antonioni's, for instance), which dare show us incomplete situations, such as we often find in life, without the consolation of a finale, the reassuring return to the tonic, to conclude everything we start.

11. For the notion of *modo di formare* ("way of forming"), see Luigi Pareyson's *Estetica*.

12. As Elio Vittorini has justly noted in a recent issue of *Menabò*, "today, that narrative that concentrates in its language the full weight of its responsibilities toward the world is much closer to assuming a historically active meaning than any literature that approaches things via their presumed pre-linguistic content, treating them as themes, issues, and so forth."

13. Thus, narrative technique becomes the real content of the movie and its most important statement. If the story appears unclear to the viewer, it is because it is also unclear to the author, the director—who, however, prefers to respect this obscurity as real rather than to impose on it a false order. In other words, he prefers to let the situation create his movie than to create a situation through his movie. Another example of this sort of movie is Godard's *A bout de souffle* (*Breathless*), whose development is seemingly affected by the same psychic disorder that affects its hero. As a literary example, we can cite *Conjectures on Jacob*, by Johnson, in which the inner split of the narrator, expressive of the moral, political, and geographic division of Germany, is also reflected in its narrative technique.

14. Alain Robbe-Grillet, *For a New Novel* (New York: Grove Press, 1965), pp. 19, 20, 21.

15. See Umberto Eco, "Il tempo di 'Sylvie,'" in *Poesia e critica 2*.

16. Robbe-Grillet, *For a New Novel*, p. 22.

17. Maurice Merleau-Ponty, *Signs,* tr. Richard C. McCleary (Evanston, Ill.: Northwestern University Press, 1964), p. 240.

18. In *I Novissimi,* Milano, 1961. Whereas Sanguineti fends his way through the swamp of culture making use of all the words and phrases that have been fatally compromised by tradition, Nanni Balestrini prefers to go through the daily swamp of newspapers, commercials, and common talk. Those who see Balestrini's experiments (his handwritten poems, not his electronic compositions) as expressions of Dadaism forget that when Dada pulls words apart and randomly glues them back together elsewhere, its aim is to provoke the reader and stimulate his mind by replacing the order of his reasoning with an unexpected and fertile disorder. Balestrini, instead, maintains that he does not create disorder by upsetting an order but rather discovers this disorder in place of order.

8. Two Hypotheses about the Death of Art

1. Eco is referring to what in Italy was known as "idealistic criticism," according to which Dante's *Paradiso* was less "artistic" than his *Inferno* since it dealt with theological (that is, "conceptual") matter, whereas the latter was concerned with more "human" passions.— *Translator's note.*

2. To verify this point, Nanni Balestrini and I once decided to write a precise and accurate "description of seven lost, or never written, poems," in which we would give an exhaustive explanation of their stylistic features, the structure of their lines, their use of blanks, their lexical choices, punctuation, use of foreign or invented words, and so on. Then we planned to add a critical essay explaining the meaning of the poems, and why their structure was so important that, once described, it was unnecessary to write the poems. This would not have been a game. Quite the contrary. In fact, the idea was so serious and fraught with consequences that it immediately invalidated our project of writing either the description of the poems or the essay, since the very idea of such a kind of writing was already more meaningful and important than the writing itself. In short, we started a sort of circular process that would never have ended had I not put a sudden halt to it by deciding to write this essay, which, being a description of the very circularity of this situation, has become its metadiscourse. But the essay has managed to elude the centripetal pull of that vertiginous situation, just as its epigraph manages to remain on the brink of the oneiric abyss it evokes. In other words, this essay is the direct result of the terror felt at the mere contemplation of such an abyss.

3. "Anticipazioni sulla 'morte dell'arte'" [Anticipations on the death of art], in *Nuove prospettive della pittura italiana* (Bologna: Edizioni Alfa, 1962).

I would like to correct Raffa's point as follows: rather than making a distinction between the works and the doctrinal surplus that justifies them, we could speak (at least insofar as the more successful ones are concerned) of works that are the doctrinal communication of themselves, their own justification, their own surplus.

4. Milan: Ceschina, 1962.

5. Francesco de Sanctis, "Alla sua donna" (Torino: Einaudi, 1960; orig. pub. Leopardi, 1855), p. 400.

6. I am thinking of Luigi Pareyson's "aesthetics of formativity," and, in particular, of the relationship he draws between style, content, and matter in art, and of the idea of critical interpretation as a penetration, mediated by congeniality, into a physical universe of formed matter in which every procedural project would find its solution in a *modo di formare*, a particular "formal approach." When Pareyson defines art as "formativity for formativity's sake," he is not escaping into the irresponsible realm of formalistic (not to say calligraphic) complacency; nor is he excluding the possibility that an artist may be motivated by very precise and compelling moral and political ideas; nor is he excluding the possibility that these ideas may in fact lend value, taste, and vigor to the work. Rather, he is trying to restrict the context of the artistic process to those formal activities that do not want to turn the art object into the pretext for an end that's essentially extraneous to the object itself (whether this end be the presentation of a poetic, or a prayer, or mere propaganda). According to Pareyson, to form artistically means to lend value to all the elements that participate in this form, so that they may be appreciated, interpreted, and judged as one formed object. An artist can elaborate a poetics on a theoretical level, and the words he will use to do so will be a convenient vehicle for his ideas; but the moment he sets out to produce a work that is also its own poetics, he must form this poetics in order to give it an organic consistency which, in turn, will allow it to be enjoyed as object and not as an abstract model.

9. The Structure of Bad Taste

1. Ludwig Giesz, in *Phaenomenologie des Kitsches* (Heidelberg: Rothe Verlag, 1960), suggests a few etymologies for the term. According to the first, it would date back to the second half of the nineteenth century, when the American tourists who visited Munich and wanted to buy a cheap painting would ask for a "sketch." As a result, the German term *Kitsch* started to be applied to all the knickknacks bought by people eager to undergo an "aesthetic experience." On the other hand, the verb *kitschen* (to gather mud along the road) already existed in the Mecklenburg dialect. The same verb could also mean "to retouch furniture in order to give it a

'vintage' look," whereas the verb *verkitschen* means "to sell cheaply."

2. Walther Killy, *Deutscher Kitsch* (Göttingen: Vandenhock & Riprecht, 1962). Killy's essay introduces an anthology of characteristic fragments drawn out of German literature. The authors he used for his pastiche are, in order: Werner Jansen, Nataly von Eschtruth, Reinhold Muschler, Agnes Günther, Rainer Maria Rilke, Nathanael Jünger.

3. Hermann Broch, "Einige Bemerkungen zum Problem des Kitsches," in *Dichten und Erkennen*, vol. 1 (Zurich, 1955). Translated as "Notes on the Problem of Kitsch," in *Kitsch: The World of Bad Taste*, ed. Gillo Dorfles (New York: Universe Books, 1969).

4. Luigi Pareyson, in "I teorici dell' Ersatz," *De Homine* 5–6 (1963), a short essay that reiterates the main theoretical issues already discussed in his *Estetica*. In his polemic against the calm recognition of the "digestibility" of the artistic product, Pareyson makes a distinction between the generic "artisticity" that pervades all human work, and art as the "culmination and the climax" of this attitude, as "norm and model," education of taste, proposal of new "ways of forming," intentional forming for form's sake. According to him, the product of the cultural industry would be nothing more than simple expressions of "artisticity," and, as such, subject to both consumption and wear. Of course, among the processes of artisticity, Pareyson does not include all those works of art which, on the basis of a particular poetics, or of the general tendency of a historical period, intentionally aim at the attainment of heteronomous ends (whether pedagogical, political, or utilitarian). In these cases, there is art only insofar as the artist manages to embody his intentions in his formal project, and insofar as the work, though aiming at something outside itself, also manifests itself as a form for its own sake.

5. R. Egenter, *Kitsch und Christenleben* (Ettal, 1950), as quoted by Giesz.

6. Clement Greenberg, "The Avant-Garde and Kitsch," in Dorfles, ed., *Kitsch: The World of Bad Taste*.

7. See Chapter 8, "Two Hypotheses about the Death of Art."

8. In his "Salon de 1859," Baudelaire expresses great irritation at photography's ambition to replace art, and exhorts all photographers to confine their activity to the utilitarian recording of images rather than try to infiltrate the realm of the imagination. But is it art that begs industry not to invade its turf, or is it industry that is pushing art out into other fields? On Baudelaire's attitude toward this new situation, see Walter Benjamin, "On Some Motifs in Baudelaire," in *Illuminations* (New York: Schocken, 1969).

9. See Gerhart D. Wiebe, "Culture d'élite et communications de masse," in *Communications* 3. For the sake of a more rigorous method of investigation, Wiebe proposes a distinction between the characteristics of

art and those of mass communication, even though they are often joined in one product. Except that his notion of the functions of "mass media" seems fairly "integrated": "I would almost go so far as to say that the more popular TV programs fulfill a regulating social and psychological function—that is, they tend to preserve a balance in a context that can be much more turbulent than we think . . . People would not spend so much time watching these programs if they did not satisfy a need, if they did not redress certain distortions, if they did not fulfill certain desires."

10. See Dwight MacDonald, *Against the American Grain* (New York: Random House, 1952), pp. 40–43, and in general the chapter "Masscult and Midcult."

11. T. W. Adorno, "Über den Fetischcharakter in der Musik und die Regression des Hörens," in *Dissonanzen* (Göttingen, 1985).

12. Ibid.

13. See Roman Jakobson, "Linguistics and Poetics," in *Selected Writings,* vol. 3 (The Hague: Mouton, 1981).

14. As mentioned, the notions of code and decoding can also be applied to nonlinguistic communications—for instance, to visual or musical messages as organizations of perceptual stimuli. But is it possible to decode such messages at a semantic level? This should not be too difficult in the instance of figurative or symbolic painting, since their mimetic nature can entail semantic references as well as iconographic conventions. On the other hand, there could very well be an interpretive code, maybe not quite as cogent as the linguistic system, based on a cultural tradition, in which every color would have a precise referent. As for music, Claude Lévi-Strauss speaks of it as a code because it refers to a precise grammar (whether tonal or dodecaphonic); see G. Charbonnier, *Conversations with Lévi-Strauss,* tr. John and Doreen Weightman (London: Jonathan Cape, 1969), pp. 120–121. Yet he realizes that the notion of code does not apply so well to serial music, and therefore he elaborates the hypothesis that, in serial music, grammar operates only as prosody, "since the essential feature of linguistic rules, the feature which makes it possible to express different meanings by means of sounds which in themselves are arbitrary, is that these sounds are part of a system of binary oppositions." In serial music, in contrast, "the idea of opposites remains, but the positions of the notes are not articulated as a system. In this sense, the code would seem to be more expressive than semantic." Lévi-Strauss's objection is important, since it can be applied to abstract painting. But it also applies to tonal music, which is constructed on the basis of a grammatical code that has no semantic dimension.

15. Jakobson, *Selected Writings,* vol. 3, p. 558. The message can communicate precise meanings, but the primary one is the message itself. One

can speak of a "poetic" or "artistic" meaning even in the case of nonseman-tic arts. There are artistic messages with very open and imprecise semantic references and a very precise syntactic structure (Jackson Pollock's paint-ings, for instance). Most of the time, the semantic efficacy of these partic-ular messages depends on the degree of awareness that we bring to their system of contextual relationships. In architecture, for instance, one can speak of the semantic value of a building not only because each of its elements refers to specific functions but also because of the symbolic na-ture that the general object assumes, in the way it articulates itself structur-ally and in the way it relates to its urban context; see Gillo Dorfles, "Valori comunicativi e simbolici nell'architettura, nel disegno industriale e nella pubblicità," in *Simbolo, comunicazione, consumo* (Torino: Einaudi, 1962). This can also happen with the formal procedures of music, which often can assume such a precise referential value (to ideological situations, for instance) that they can be said to have a semantic function. And it certainly happens with painting, where even a style can assume (thanks to an in-terpretive process acquired through tradition) an almost conventionalized significative value. For instance, an art director may agree to illustrate the jacket of a Robbe-Grillet novel with a painting by Mondrian, but he or she would never use the same painting for a book of Beckett plays. In none of these instances, obviously, is the relationship of signifier to signified as precise as it is in spoken language; but this relationship is secondary to a poetic message, just as it is called into question in the structuring of a linguistic message with poetic pretensions. In a poetic message, the struc-turing of the signs coordinates not only the signifiers but also emotions and perceptions, as is the case in the decorative arts and in music. Thus, when Lévi-Strauss accuses abstract painting of lacking "the essential at-tribute of the work of art, which is to offer a kind of reality of a semantic nature," he is either confining the notion of art to a certain kind of art, or is simply refusing to recognize that, in a poetic message, the semantic function must be articulated in a different way.

To avoid this dead end, A. A. Moles has developed a distinction be-tween the semantic and the aesthetic aspect of the message, in which the latter is connected to the structuring of its elements. See A. A. Moles, *Information Theory and Esthetic Perception,* tr. Joel E. Cohen (Urbana: Uni-versity of Illinois Press, 1966).

16. Jakobson, *Selected Writings,* vol. 3, p. 25. This does not mean that the signifieds (when they are there) do not count. On the contrary, the poetic message so effectively forces us to question the signifieds to which it refers that we often have to return to the message in order to find, in its patterns of signification, the roots of their problematic nature. Even in the case of preexisting signifieds (say, the Trojan War in the *Iliad*), the poetic

message casts a new, richer light on them, thereby becoming a means to further knowledge.

17. The Russian Formalists had already elaborated the postulates of this position before the Prague structuralists. See Victor Erlich, *Russian Formalism* (The Hague: Mouton, 1955).

18. See Chapter 2, "Analysis of Poetic Language."

19. See Dorfles, *Kitsch: The World of Bad Taste.*

20. See Umberto Eco, " Di foto fatte sui muri," *Il Verri* 4 (1961); and idem, "Introduction," *I colori del ferro* (Genoa: Italsider, 1963). On the semantic problematics of the "ready made," see Claude Lévi-Strauss in Charbonnier, *Conversations with Lévi-Strauss.* According to Lévi-Strauss, the object pulled from its habitual context and inserted into another context causes a "semantic fission"—that is, it disrupts the usual relationship between signifier and signified. "But this semantic fission also allows for a fusion, because the mere fact of placing this object in contact with other, new objects can reveal some of its latent structural properties."

21. For the notion of the work of art as a "system of systems," see René Wellek and Austin Warren, *Theory of Literature* (Harmondsworth: Penguin, 1973; orig. pub. 1949).

22. For the notion of *modo di formare* ("way of forming"), see Luigi Pareyson, *Estetica: Teoria della formatività,* 2nd ed. (Bologna: Zanichelli, 1960). See also note 4, above.

23. A. Manzoni, *The Betrothed,* tr. Bruce Penman (Harmondsworth: Penguin, 1972), p. 206.

24. Marcel Proust, *Under a Budding Grove,* tr. C. K. Scott Montcrief (New York: Random House, 1982).

25. It could be argued that the physical description of characters specifically aimed at exciting the reader is not just characteristic of pulp novels. The great narrative tradition of the nineteenth century did it all the time. On the other hand, there are various ways of doing it. Salgari's description of Marianna is totally "generic"—it has no depth. Her features could be those of any other "heroine." Balzac's descriptions of his characters may at first seem to be similar to those of Salgari, but in fact they are closer to Proust's (even though they could be easily appreciated by Salgari's readers). Balzac describes Colonel Chabert some thirty pages into the novel, when we already know something about the psychology of the character and can thus easily connect each of his physical attributes to some deeper trait—aside from the fact that there is nothing in the description of his face that could be defined as "generic" or that could be applied to other faces. The effect the description produces on the reader is immediately problematized by the rest of the page.

26. Lampedusa's stylemes already have a history that could easily be traced back to Guido da Verona's *Il libro del mio sogno errante.*

27. As instances of Kitsch employing the residue of art, and avant-garde art employing the residue of Kitsch.

It would be interesting to look at the stylistic procedures of both from the point of view of Lévi-Strauss's notion of *bricolage* (see *La pensée sauvage* [Paris: Plon, 1962]). Both avant-garde and Kitsch would then seem to be involved in some kind of reciprocal *bricolage,* avowed in one case (and aiming at the discovery of new dimensions), tacit in the other (and trying to pass for an original invention, "the real thing").

10. Series and Structure

1. Pierre Boulez, *Relevés d'apprenti* (Paris: Seuil, 1966), p. 297.

2. Jean Pouillon, "Présentation," *Les temps modernes* (November 1966), issue titled *Problèmes du structuralisme.*

3. "Ouverture," *The Raw and the Cooked* (New York: Harper and Row, 1969), pp. 18–27.

4. *Incontri musicali* 3 (1959).

5. Pierre Schaeffer, *Traité des objets musicaux* (Paris: Seuil, 1966), pp. 300–303.

6. Lévi-Strauss, *The Raw and the Cooked,* p. 25.

7. Ibid., p. 27.

8. In which case we should probably abandon the Saussurean hypothesis of a code qua constituted *system,* inventory, taxonomy, to approximate a notion of "competence" as a finite mechanism capable of an infinite activity. In relation to this deeper structure, any system, such as the tonal one or the serial one, would be a "superficial" structure—in Chomsky's sense of the word. As concerns the possibility of a "serial" discourse, Chomsky further distinguishes between a creativity that's determined by rules ("competence") and a creativity that changes the rules ("performance"). Of course, the mere possibility of serial thought would automatically call into question the universals of language to which Chomsky refers; on the other hand, as I have already noted, a generative matrix could preside over both the formation and the destructuration of rules. Chomsky's work has opened a door to the study of an open combinatorial grammar, but at this particular stage of research it would be premature to translate the propositions of transformational grammar into the broader terms required by a semiological discourse, and particularly so, considering that Chomsky himself has referred to his model—often redefined—as "still rudimentary." See E. H. Lenneberg, "The Formal Nature of Language," in *Biological Foundations of Language* (Melbourne, Fla.: Krieger, 1967), p. 430. I have

also found particularly useful Nicolas Ruwet's suggestions in "Introduction à la grammaire générative," *Langages* 4 (1966). See also Gualtiero Calboli, "Rilevamento tassonomico e 'coerenza' grammaticale," *Rendiconti* (1967): 15–16.

9. Henri Pousseur, "La nuova sensibilitá musicale," *Incontri musicali* 2 (1958).

10. *Jupiter, Mars, Quirinus* (Torino: Einaudi, 1955).

11. Desmond Morris, *The Naked Ape* (New York: McGraw-Hill, 1967).

12. Lucien Sébag, *Marxisme et structuralisme* (Paris: Payot, 1964).

13. Ibid., p. 121.

14. Ibid., p. 123.

15. Ibid., p. 125.

16. Michel Foucault, *The Order of Things* (New York: Random House, 1970). After showing how the distinction between "physiocrats" and "utilitarians," in the eighteenth century, can be expressed in the transformation of the same structural scheme, Foucault notes: "Perhaps it would have been simpler to say that the Physiocrats represented the landowners and the 'utilitarians' the merchants and entrepreneurs . . . But though membership of a social group can always explain why such and such a person chose one system of thought rather than another, the condition enabling that system to be thought never resides in the existence of the group" (p. 200).

17. Sébag, *Marxisme et structuralisme*, p. 127.

18. Ibid., p. 128.

19. Ibid., p. 144.

20. Ibid., p. 147.

21. Ibid., p. 148.

22. *Les temps modernes* (March 1965).

23. Ibid., p. 1622.

Index